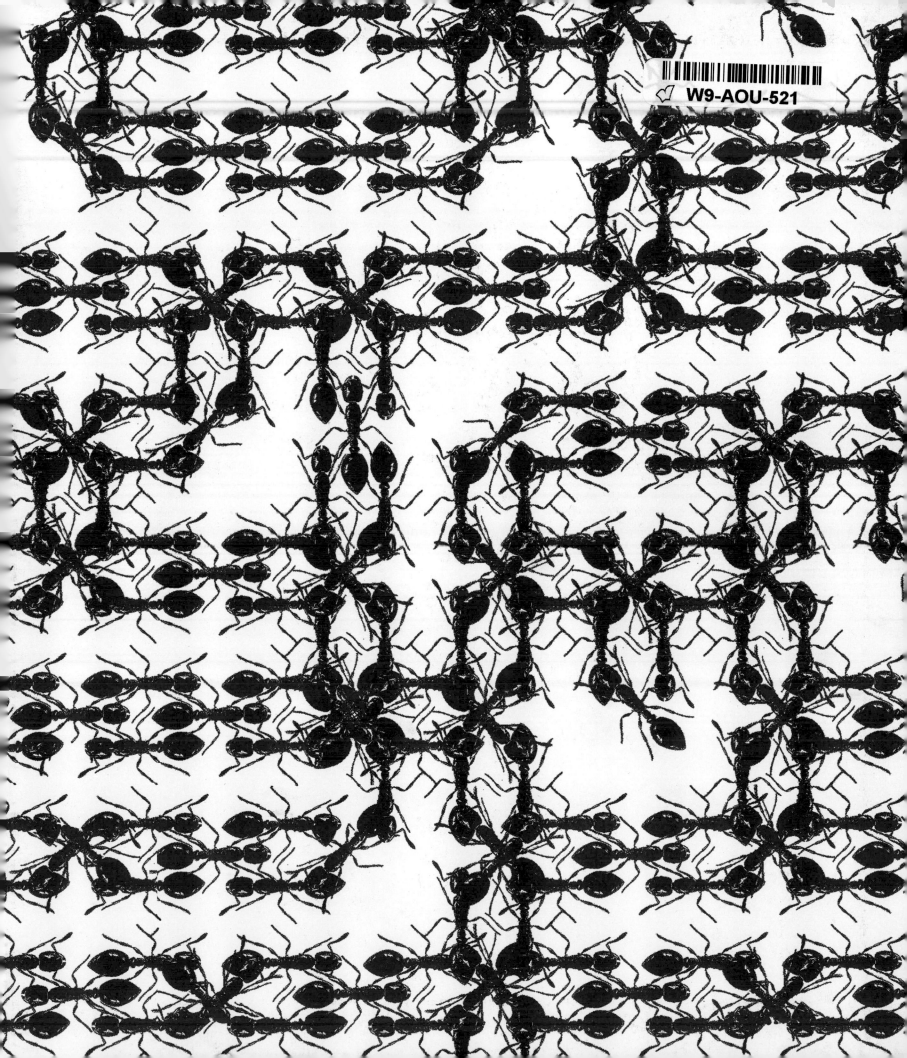

eye on europe

Arman / John Armleder / *Art-Language* / *Art & Project Bulletin* / Atelier Populaire / Fiona Banner
Georg Baselitz / Christiane Baumgartner / Carole Benzaken / Joseph Beuys / Jean-Charles
Blais / John Bock / Christian Boltanski / KP Brehmer / Marcel Broodthaers / Joan Brossa
Günter Brus / Daniel Buren / Rafael Canogar / Patrick Caulfield / Jake and Dinos Chapman
Christo / Carlfriedrich Claus / Francesco Clemente / Claude Closky / Michael Craig-Martin
Adam Dant / Hanne Darboven / Tacita Dean / *Décollage* / Peter Doig / Helen Douglas
Olafur Eliasson / Equipo Crónica / Öyvind Fahlström / Hans-Peter Feldmann / Stanisław
Fijałkowski / Robert Filliou / Ian Hamilton Finlay / Sylvie Fleury / Lucian Freud / Katharina
Fritsch / Hamish Fulton / *futura* / Gilbert & George / Liam Gillick / *Gorgona* / Richard Hamilton
Mona Hatoum / Juan Hidalgo / Damien Hirst / David Hockney / Peter Howson / Jörg Immendorff
Interfunktionen / IRWIN / Kassettenkatalog / Ivana Keser / Anselm Kiefer / Martin Kippenberger
Per Kirkeby / Yves Klein / Milan Knížák / Peter Kogler / *Krater und Wolke* / Langlands & Bell
Maria Lassnig / Paul Etienne Lincoln / Richard Long / Sarah Lucas / Markus Lüpertz
Mangelos / Piero Manzoni / Wolfgang Mattheuer / Chad McCail / Annette Messager / *Migrateurs*
Jonathan Monk / François Morellet / Paul Morrison / Otto Muehl / Antoni Muntadas
Museum in Progress / Olaf Nicolai / Hermann Nitsch / Paul Noble / OHO / Julian Opie / Blinky
Palermo / Eduardo Paolozzi / *Parkett* / Simon Patterson / A. R. Penck / Giuseppe Penone
Dan Perjovschi / Grayson Perry / Pawel Petasz / Jaume Plensa / *Point d'ironie* / Sigmar
Polke / Markus Raetz / Arnulf Rainer / Gerhard Richter / Bridget Riley / Dieter Roth / Niki de Saint
Phalle / David Shrigley / Daniel Spoerri / Telfer Stokes / Joe Tilson / Leonid Tishkov / Endre Tót
Rosemarie Trockel / Ben Vautier / Wolf Vostell / Gillian Wearing / Franz West / Rachel Whiteread

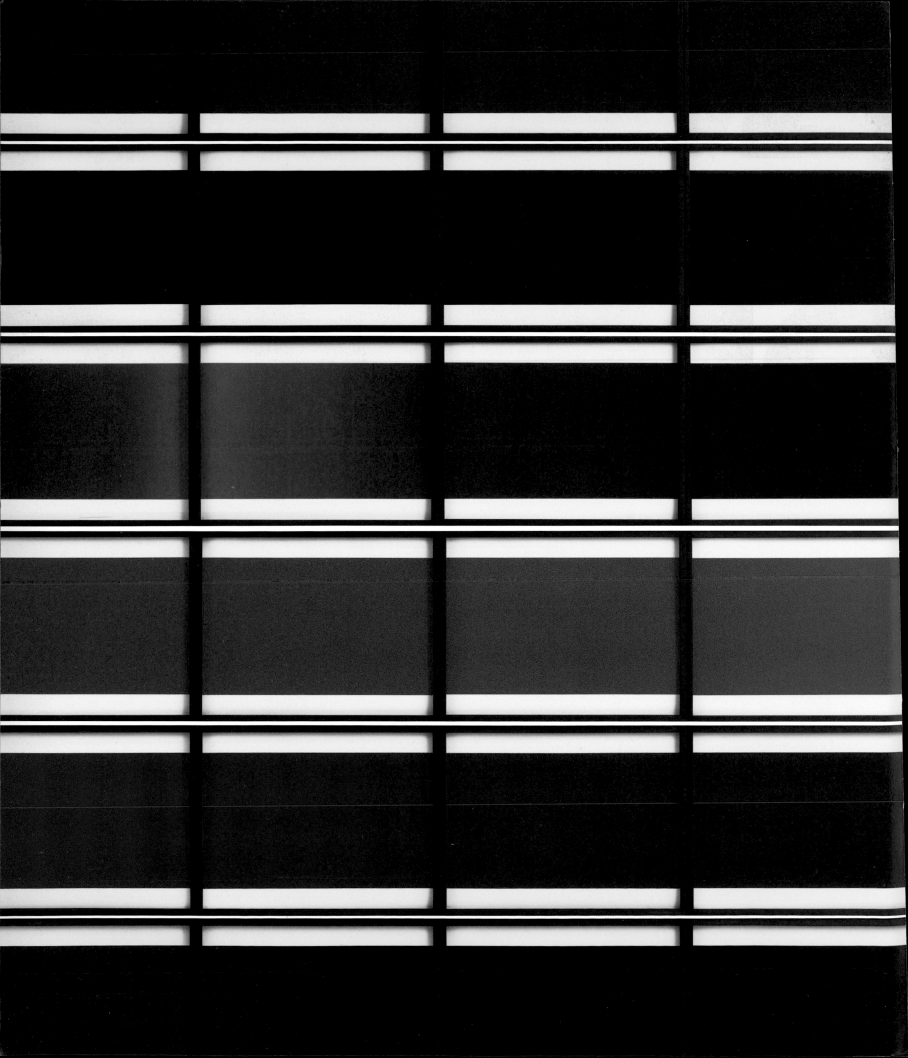

eye on europe

prints, books & multiples / 1960 to now

Deborah Wye / Wendy Weitman

The Museum of Modern Art / New York

contents

The Museum of Modern Art's commitment to

contemporary art is fundamental to its mission. That commitment includes the acquisition of works of art for the permanent collection as well as an exhibition and publishing program presenting the artists of this period and the thematic and historical issues associated with it. *Eye on Europe: Prints, Books & Multiples / 1960 to Now* astutely fulfills this mission with the many works on view from the Museum's collection, with the interpretive structure of its organization, and with the scholarly documentation appearing in this publication.

Since its beginnings, MoMA has viewed artistic developments from an international perspective. This is reflected not only in our collections and programs for the early years of modern art, but also in the contemporary area. Historically, our closest ties have been with Europe, and we continue to collect and study the art issuing from its many countries. In recent years, a number of artists who appear in *Eye on Europe* have had solo exhibitions here, including Joseph Beuys, Annette Messager, Gerhard Richter, and Dieter Roth. Several others, Olafur Eliasson and John Bock among them, have appeared as emerging artists in our Projects series. And group exhibitions over the years have provided still further opportunities to exhibit contemporary European art at MoMA.

Eye on Europe, for its part, provides a historic perspective on more than four decades. Organizers Deborah Wye, The Abby Aldrich Rockefeller Chief Curator, and Wendy Weitman, Curator, of the Department of Prints and Illustrated Books, have identified common threads in the work of 118 artists, collectives, and journals from twenty countries. They offer a synthetic overview that reflects the rich and varied fabric of art across the continent since 1960. Along the way they have enriched the Museum's collection with many new acquisitions, and have enjoyed the support of an enthusiastic Committee on Prints and Illustrated Books, under the leadership of Trustee Chair Anna Marie Shapiro. In addition, the department's Associates, a long-standing educational and support group, have been exceedingly generous in their gifts to the collection, chosen under the guidance of the two curators especially for this project.

The Collection of Prints and Illustrated Books, the largest curatorial collection at MoMA, represents the work of artists in depth while also surveying various movements and trends in breadth. About two-thirds of the works included here are from the Museum's permanent collection, with the rest generously loaned by individuals and institutions. The works from the collection also highlight the remarkable holdings of the Museum's Library, which serves as a major repository of artists' books, journals, and printed ephemera.

Such an ambitious project as this has certainly been a daunting task, and Ms. Wye and Ms. Weitman deserve both our utmost praise and recognition for tackling it and our congratulations for their extraordinary achievement. Both have been members of MoMA's curatorial team for over twenty-five years, and their shared enthusiasm for prints, books, and multiples—and their insights into the role these mediums play within the totality of contemporary art—are clearly evident here. They have also inspired a large team, most importantly within the Department of Prints and Illustrated Books, but also throughout the institution. Such a major undertaking requires the cooperation of Museum staff members across the board, and all who have been involved deserve to share in its success.

This inventive survey will, of course, be of great interest to those already familiar with prints, books, and multiples. But its great merit lies in the fact that it also presents a fresh look at the period it covers. *Eye on Europe* is both thought-provoking and abundant in visual pleasures. We are sincerely grateful to the institutions and collectors across Europe and the United States who have temporarily parted with their works to enrich this exhibition. Finally, we acknowledge the very supportive funders who helped to make *Eye on Europe* a reality. We extend our heartfelt thanks to the Sue & Edgar Wachenheim Foundation and Anna Marie and Robert F. Shapiro, without whose generosity this project would not have been possible. We also offer our appreciation to the entities that have helped support this endeavor: BNP Paribas, Pro Helvetia, Swiss Arts Council, the Cultural Services of the French Embassy, The Consulate General of The Netherlands in New York, The International Council of The Museum of Modern Art, The Contemporary Arts Council of The Museum of Modern Art, and The Cowles Charitable Trust. They have our utmost gratitude.

Glenn D. Lowry, DIRECTOR
THE MUSEUM OF MODERN ART

///// **acknowledgments** ////////////////

An exhibition of this broad scope would have

been impossible without the contributions of a wide network of individuals, including knowledgeable colleagues and generous lenders, the extraordinary staff at The Museum of Modern Art, and the very supportive funders, who together helped make this project a reality. Our efforts were inspired, of course, by the artists whose work is seen here, and whose creativity and talent have made the field of prints, books, and multiples in Europe in this period such a rewarding area of research.

Our travels to print rooms, print organizations, publishers, and dealers throughout Europe enlightened us enormously and fostered new relationships that will surely continue into the future. In museums with major collections, curators offered us their extensive knowledge and access to their holdings, introducing us to artists we were not aware of as well as showing us works in-depth by those we were. In particular, our thanks must be extended to Wolfgang Holler, Director, and Hans-Ulrich Lehmann, Chief Curator and Assistant Director, Dresden Kupferstich-Kabinett, where days were spent looking at prints. At the Albertina in Vienna, Director Klaus Albrecht Schröder generously discussed broad issues regarding prints in museum contexts. In addition, Veronika Birke, art historian and former Vice Director, provided access to the Albertina's vast collection. At the Kupferstichkabinett in Berlin, Alexander Dückers, former Director; Hein-Th. Schulze Altcappenberg, Director; and Andreas Schalhorn, Research Associate, offered the services of the print room as well as their knowledge and insights regarding our topic. At the Staatsgalerie Stuttgart, Ina-Maria Conzen, Chief Curator of Classical Modernism, and Ilona Lütken, Head of Archives at Archiv Sohm, brought out many exceptional examples from their holdings and also shared their expertise of this unique collection. At the Neues Museum Weserburg Bremen, Germany, Anne Thurmann-Jajes, Director of the Research Centre for Artists' Publications, presented a memorable selection of highlights from their outstanding archive of printed formats, ranging from artists' books to postcards. Stephen Coppel, Curator, Modern Prints and Drawings, at The British Museum in London; Marie-Cécile Miessner, Curator, Le Département des Estampes et de la Photographie at the Bibliothèque Nationale de France in Paris; Christophe Cherix, Director, Cabinet des Estampes du Musée d'Art et d'Histoire

in Geneva; and Ulrike Gauss, Director, Graphische Sammlung at the Staatsgalerie Stuttgart, all discussed this subject at length with us, answering our many questions and deepening our understanding of printed art and its impact in their respective countries as well as across Europe during the contemporary period.

Several specialized print centers also willingly opened their facilities to us, revealing the variety of resources available for the study of prints and books. In particular, we would like to thank Catherine de Braekeleer, Director, and Jacques Ghys, Administrator, at Le Centre de la Gravure et de l'Image Imprimée in La Louvière, Belgium; Sylvie Boulanger, Director, Centre National de l'Estampe et de l'Art Imprimé (CNEAI), in Chatou, France; and Lilijana Stepančič, Director, Breda Škrjanec, Senior Curator, and Božidar Zrinski, Curator, at MGLC, International Centre of Graphic Arts in Ljubljana, Slovenia, all of whom welcomed us to their innovative institutions and generously shared their knowledge and experience. In Rome, at the Istituto Nazionale per la Grafica, we saw and heard about an aspect of printmaking research that was entirely new to us. Viewing their collection of historical copperplates and visiting the conservation and documentation facilities for these matrices gave us a broader perspective on printmaking generally. We wish to thank Serenita Papaldo, Director; Alida Moltedo, Curator, Prints and Drawings Department of the Calcografia; Ilaria Savino, Assistant, Contemporary Art Department; and Antonella Renzitti, Curator, Education Department, for their time and attention.

Other specialists who shared their knowledge with us include Pat Gilmour, former Director of the Print Department at the Tate Gallery, and Jeremy Lewison, former Director of Collections at the Tate Gallery, both experts in the field of prints; and Anne Moeglin-Delcroix, a professor at the Sorbonne, and Clive Phillpot, an independent curator in London and our former colleague as Director of the Library at The Museum of Modern Art, who are both leading authorities in the area of artists' books. The scholarship of these individuals contributed significantly to our research. Hans-Ulrich Obrist, now Co-Director of Exhibitions and Programs and Director of International Projects at the Serpentine Gallery in London, discussed his extensive experiences as an editor and curator and his inventive approaches to printed art. We would also like to thank Lynne Allen, Director, the School of Visual Arts, Boston University; Roman Berka of Vienna's Museum in Progress; Alan Cristea of Alan Cristea Gallery in London; Dirk Dobke, Director, Dieter Roth Foundation in Hamburg; Laura Hoptman, Senior Curator, New Museum of Contemporary Art in New York; Steven Leiber of San Francisco; and Branka Stipančić, an independent curator in Zagreb, for their advice and input. And, of course, many of the artists in this exhibition, or representatives of their archives or foundations, were enormously helpful and patient with our requests. Our thanks extend also to their publishers and dealers, who provided much-needed documentation.

The staff of The Museum of Modern Art is unparalleled in its knowledge and professionalism. The team that devoted its exceptional talents to this project runs across the institution. In the Department of Prints and Illustrated Books, Sarah Suzuki, The Sue and Eugene Mercy, Jr. Assistant Curator, brought her breadth of skills and indispensable insights to bear on this monumental task while sharing our own enthusiasm for the topic. She worked tirelessly on every phase of the project, contributing her extraordinary research and writing abilities, organizational talents, subtle diplomacy, and collegial spirit to its success. Research Assistant Anjuli Lebowitz was the other team member devoted entirely to this exhibition and catalogue. She compiled research on hundreds of artists, coordinating the bibliography and library work impeccably. While keeping track of the ever-changing checklist and staying on top of so many details, her calm and thoughtful manner never failed. Ms. Suzuki and Ms. Lebowitz also wrote dozens of the biographies of artists and publishers that appear in this volume. Assistant Curator Starr Figura, Assistant

Curator Judith Hecker, and Curatorial Assistant Gretchen Wagner also wrote extensively for the biographical entries. Their knowledge of our field and dedicated efforts under pressure are warmly appreciated. Our thanks also go to Amy Gordon, Editorial and Research Assistant in the Museum's Development and Membership Department, for her help with this aspect of the catalogue. Curatorial Assistant Raimond Livasgani catalogued scores of works from the Museum's collection, which comprise nearly two-thirds of this exhibition. Interns Caroline Shea and Frances Jacobus-Parker assisted in this task as well. Department Coordinator Lexi Lee balanced numerous administrative tasks with the help of Department Assistant Sarah Chung, who also helped on the project's research phase. The Department's valued seasonal interns have also contributed greatly to this project. In particular we would like to thank Yaelle Amir, Natalia Bard, John Blakinger, Robin Footitt, Berit Homburg, Jessica Kreps, and Nicole Root. Preparator Jeffrey White continually pulled and refiled works from our storage area as they were needed for study. He also worked with other members of the staff to digitize thousands of contemporary European prints and books from our holdings in order to facilitate our research.

The preparation of this book demanded the gifts of the exceptional team in the Museum's Department of Publications. Our thanks go to Christopher Hudson, Publisher, and Kara Kirk, Associate Publisher, for their support. Paul Carlos and Urshula Barbour of Pure+Applied, the book's designers, were sensitive to the special characteristics of prints and books and beautifully integrated the wide scope of the art presented here, while always remaining patient with our many requests. They were a pleasure to work with. We are grateful to Elisa Frohlich, Associate Production Manager at MoMA, for the high standards she applied to the book's reproductions and the overall coordination of the publication. Our warm appreciation goes to Libby Hruska, Editor, whose task in editing the various components of this volume could have been overwhelming. She not only offered countless thoughtful opinions and insights that have enriched these texts but also maintained a gentle persistence and unflappable demeanor that kept all of us on track. Intern Sirka Laass assisted with helpful comments and careful reading of many texts. Our gratitude extends also to Erik Landsberg, Head, Collections Imaging, and to Robert Kastler, Production Manager; John Wronn, Collections Photographer; Thomas Griesel, Collections Photographer; David Allison, Projects Collection Photographer; and Roberto Rivera, Production Assistant.

The gifted staff of the Museum's Department of Conservation guided the care of the artworks. Our sincerest thanks go to Senior Conservator Karl Buchburg for his overall counsel, and to Associate Conservator Erika Mosier, who was especially dedicated to this project. Our thanks also go to Sculpture Conservation Research Fellow John Campbell. Peter Perez, Foreman, Frame Shop, always applies his talents to presenting the works to their best advantage. Exhibition Designer/Production Manager Lana Hum deserves our deep appreciation for her help in the design of the exhibition's installation and supervision of the myriad details, from the production of wallpaper to the installation of extensive vitrines. Our warm thanks also go to Preparator Jack Siman. We are also grateful to Jerome Neuner, Director of Exhibition Design and Production, for his valuable input. The Department of Exhibitions, under the direction of Jennifer Russell, Senior Deputy Director of Exhibitions, Collections, and Programs, ably coordinated the exhibition's many facets: Maria DeMarco Beardsley, Coordinator of Exhibitions; Carlos Yepes, Associate Coordinator of Exhibitions; Ramona Bannayan, Director of Collection Management and Exhibition Registration; Heidi O'Neill, Associate Registrar, Exhibitions; Sacha Eaton, Senior Registrar Assistant, Exhibitions; and Steven Wheeler, Senior Registrar Assistant, Collections. Other members of the Museum's staff who deserve our thanks include Burns Magruder, Senior Graphic Designer, and Claire Corey, Production Manager, in the Department of Graphic Design; Todd Bishop, Director, Exhibition

Funding; Mary Hannah, Assistant Director, Exhibition Funding, and Nicole Goldberg, Assistant Director, in Development and Membership; Meg Blackburn, Senior Publicist, Department of Communications; and Tom Grischkowsky, Archives Specialist, Museum Archives. We express our thanks to Allegra Burnette, Creative Director, and Shannon Darrough, Media Developer, in Digital Media, for their efforts on the exhibition's elaborate Web site. A special debt of gratitude goes to Anh Tuan Pham and Sacha Sedriks of For Office Use Only for their remarkable creativity and talent in making the Web site its own distinguished part of this project.

The Museum's Library deserves special mention both as a world-class research facility and an extraordinary collection of rare material that merits further recognition for its contributions to MoMA's collections as a whole. We hope this project will bring some of that recognition. Over one hundred artists' books and periodicals from the Library have been included in the exhibition, and many are illustrated in this catalogue. The supportive staff has tirelessly made these and hundreds more available to us as we made our selections. They also assisted with the countless volumes studied during the research conducted for this catalogue and for the compilation of the bibliography. We would like to extend our warmest gratitude to Milan Hughston, Chief, Library and Archives; Jenny Tobias, Librarian, Collection Development; Karan Rinaldo, former Library Assistant; and David Senior, Acquisitions Assistant, for their generous loans, their unstinting efforts on behalf of this project, and their continuing enthusiasm and patience.

Our utmost thanks must go to the lenders to the exhibition, without whose cooperation this show would not have been possible. We appreciate that parting with often rare and fragile works, even for a short time, presents considerable hardship. We must also reiterate the sentiment of the Museum's Director, Glenn D. Lowry, in gratefully acknowledging the generosity and support of the funders of this project.

Several artists have contributed special projects for this exhibition and publication. We are grateful to Leonid Tishkov for his whimsical and satiric page art and to Antoni Muntadas for his provocative sheet of stickers inserted in this volume. We extend thanks to Peter Kogler for his wallpaper installation as well as his design for the Museum's entrance ticket. This ticket and the shopping bag displaying David Shrigley's woodcut bring this project beyond the confines of the galleries and ably demonstrate the potential of printed art to enrich our visitors' experience. We must conclude by paying tribute to all the artists in this exhibition who have contributed their profound creative talents to providing the many narratives encompassed by contemporary art. By generating imagery and ideas that both inspire and provoke us, they have offered new insights into the complex story of art in our time. To them we owe the greatest debt of gratitude.

Deborah Wye, THE ABBY ALDRICH ROCKEFELLER CHIEF CURATOR
Wendy Weitman, CURATOR
DEPARTMENT OF PRINTS AND ILLUSTRATED BOOKS

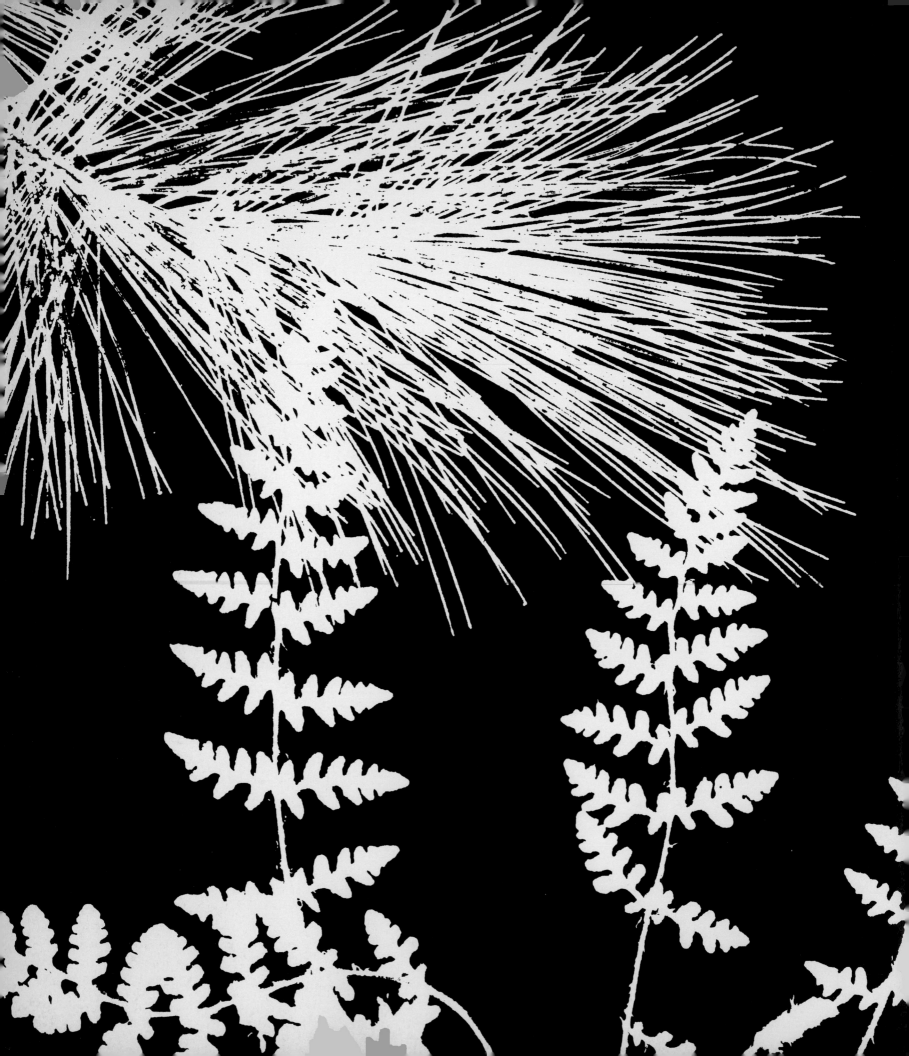

////// **deborah wye & wendy weitman** //////////////
///////////////// **extending a heritage** ///

// **european prints, books, and multiples** //////////////////

//////////////////// **and their institutional network** //////

In a period of instant communication

and growing interdependence throughout the world, there is undoubtedly a need for greater knowledge and understanding of cultural similarities and differences. It is remarkable that the contemporary art history of Europe, surely the continent with the closest ties to the United States, has not been more widely exhibited and understood outside the realm of specialists. There was a time, beginning in the late 1940s and reaching into the 1970s, when American art, and particularly that created in New York, was at the forefront of critical and popular artistic thinking, with scant attention paid to work produced elsewhere. American art was not only widely seen in European museums and galleries but also had an impact on European artists. This represented a shift following the end of World War II, as Europe rebuilt and America's economic and political structures dominated. The capital of the art world was said to have moved from Paris to New York, and artists such as Jackson Pollock and Andy Warhol became first American and then international art stars. But as recent decades have unfolded, more contemporary art from Europe has been shown in the United States, particularly since the 1980s, and it has become clear that its rich history and contributions deserve further attention.

As radical voices emerged from Paris to Turin, Brussels to Düsseldorf, artists from the 1960s to the present overturned accepted notions of artistic practice. Painting and sculpture took on new subjects and new structures; art began demanding new kinds of participation from the audience; and longtime traditions were reinvigorated. As artists expanded their creative visions, printed and editioned formats, with their inherent properties of transference, reproduction, sequencing, and multiplicity, were essential vehicles for enhancing and further articulating their practices. This study examines 118 artists, collectives, and journals from twenty countries with an inclusive approach to these mediums that reflects the inventive choices made by leading figures of the period. Artists from Richard Hamilton and Gerhard Richter through Daniel

Paul Morrison.
Black Dahlias (detail). 2002.
One from a portfolio of
twelve screenprints
COMP.: 28⁷/₈ x 38³/₄" (73.3 x 98.5 cm).
PUBLISHER: The Paragon
Press, London. PRINTER:
Coriander Studio Ltd., London.
EDITION: 45. The Museum of
Modern Art, New York. Gift of
Charles Booth-Clibborn and
The Paragon Press, 2006

Buren, Marcel Broodthaers, Hanne Darboven, Joseph Beuys, Dieter Roth, and Georg Baselitz set the stage; the preoccupations of their work are the foundation of thematic sections here that explore etchings, lithographs, woodcuts, and screenprints as well as artists' books, multiples, journals, mailers, and printed ephemera. Younger artists demonstrate recent concerns that both carry on the traditions established in the 1960s and 1970s and also break new ground, from reconceiving everyday wallpaper to exploring digital technologies.

FIG. 1. K. R. H. Sonderborg. *Composition*. 1958. Aquatint, PLATE: 16 ⁹/₁₆ x 22 ¹/₁₆" (45 x 56 cm). PUBLISHER AND PRINTER: unknown. EDITION: 75. The Museum of Modern Art, New York. Gift of Heinz Berggruen, 1959

//
A New Sensibility

By 1960 the immediate traumas of World War II had receded and economic recovery was widespread across much of Europe. An impulse toward cooperation and communication had begun to take hold as a fledgling Common Market between European nations was established in 1957.[1] In the world of art, many modern masters were still working in 1960, among them Pablo Picasso and Joan Miró, though they had been supplanted in avant-garde practice by a generation of abstractionists, particularly the expressionists of *Informel*. The dominance of this movement had begun in the late 1940s and included artists like Jean Fautrier and Wols, whose work was often likened to the existential philosophy of Jean-Paul Sartre. By the 1950s and into the 1960s it had spawned broad trends with individualized styles, represented by Gerhard Hoehme and K. R. H. Sonderborg (FIG. 1) in Germany, Pierre Alechinsky and the CoBrA group in northern Europe, Antonio Saura and Antoni Tàpies (FIG. 2) in Spain, and Emilio Vedova and Alberto Burri in Italy, among others. In 1959 the international exhibition known as documenta, held in the German city of Kassel, "hailed abstraction as the language of the entire world."[2]

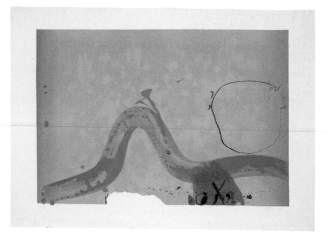

FIG. 2. Antoni Tàpies. *Untitled*. 1960. Lithograph, COMP.: 20³/₈ x 29" (51.7 x 73.6 cm). PUBLISHER: Sala Gaspar, Barcelona. PRINTER: FotoRepro, Barcelona. EDITION: 50. The Museum of Modern Art, New York. Gift of Mr. and Mrs. Ralph F. Colin, 1963

Around the same time, certain artists under consideration in this study emigrated from the East, along with thousands of other citizens. The "economic miracle" witnessed by the West had not materialized there, and governmental restrictions impeded freedom of activity. Georg Baselitz went from East to West Germany in 1957, while Gerhard Richter crossed over in 1961, before the construction of the Berlin Wall later that same year. The restrictive dictates of a Socialist Realist style in those countries under Soviet influence led to an art that was geared to a celebration of the state and the proletariat. This was particularly unfulfilling as artists learned of new artistic practices in the West. For some who stayed in the East, where private art galleries were scarce, alternative routes emerged, ultimately creating an underground network that bypassed the official cultural apparatus.

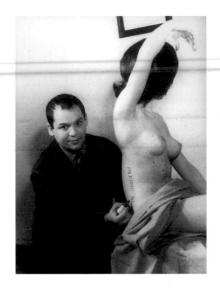

FIG. 3. Piero Manzoni signing *Living Sculpture* at Galleria La Tartaruga, Rome, 1961

FIG. 4. Yves Klein, public presentation of *Anthropométries de l'époque bleue* at the Galerie Internationale d'Art Contemporain, Paris, 1960. Naked models, covered in blue paint, follow the artist's instructions and leave impressions on white paper lining the floor

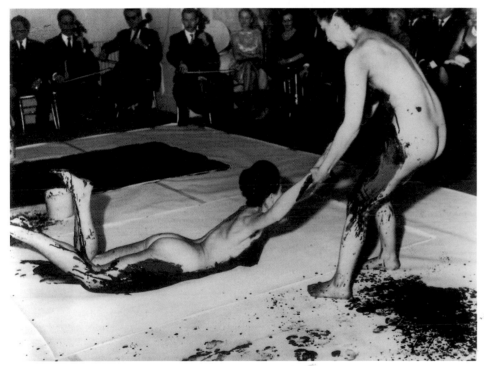

The 1960s indeed signaled the beginning of something new, ushering in a decidedly new sensibility—one determined to resist the status quo. As critic Pierre Restany pointed out, "1960 has been the key year for Germany as well as for the rest of Western Europe: the uprising of the second postwar generation."[3] The vocabulary of *Informel* became increasingly academic in the hands of many practitioners, even though abstract modes would continue to evolve. Meanwhile, other imaginative voices were heard. Artists like Piero Manzoni and Yves Klein initiated bold artistic practices that questioned past conventions and, with an impulse typical for the avant-garde, sought to redefine art by reformulating its function and the role of the artist. With distinct irony, they undertook performative actions, deeming them artworks in and of themselves, or used such actions to engender other works (FIGS. 3 & 4).

Others co-opted the popular culture permeating everyday life, appropriating the subjects and strategies of advertising and new media. Further jabs at bourgeois complacency came from the collective group of international artists, performers, and musicians known as Fluxus, whose first event occurred in 1962 in Wiesbaden, West Germany. These figures created a movement that transgressed conventional artistic boundaries in attempts to link art and life, and their antics could be compared to the anti-art tactics of Dadaists earlier in the century.

In the area of printed and editioned mediums, as well, the 1960s proved to be a period of innovation. Longtime traditions were challenged by a variety of new methods and formats. Some artists employed unconventional materials and exploited printing techniques more commonly seen in commercial applications. Others introduced small-scale, three-dimensional objects issued in editions and known as multiples, with wide distribution potential. This new sculptural form, along with the artist's book, also introduced at this time, would become enduring forms of artistic expression.

Long-established publishing enterprises and workshop printers—essential forces in the development of printmaking—responded to these new challenges. This open attitude occurred even amid the dominance of traditional lithography for some two decades in the work of School of Paris artists. Newcomers also entered this field, bringing a fresh enthusiasm to these time-honored practices. Some private galleries encouraged inventive editioned projects that displayed a spirit matching the energy of the new art. In 1960, for example, Galerie Iris Clert in Paris sent out a sardine can that Arman conceived as the announcement for his upcoming show. It contained a crumpled invitation along with bits of refuse, hinting at the contents of the exhibition itself: a gallery filled with trash, collected from the streets and inventoried (FIG. 5). Other artists issued self-published works in an effort to circumvent systems long in place. In Paris, Klein produced a four-page newspaper picturing himself miraculously leaping out a window and distributed it from the city's newsstands (FIG. 6).

These and other new approaches upset the economic hierarchies of the art world. Political events of the time prompted other experiments with printed forms that could disseminate provocative imagery and ardently felt positions outside normal channels. Ephemera was elevated to artistic status, and resulted in mailers, stickers, and stamps, among other formats, that could be distributed widely and at low cost. Such impulses were fundamental new developments in contemporary art and continue to motivate artists to this day, even as traditional printmaking techniques ebb and flow in importance and new technologies offer alternative avenues of exploration.

FIG. 5. Arman, installation view of *Full Up* at Galerie Iris Clert, Paris, 1960

FIG. 6. Yves Klein, *Dimanche—Le journal d'un seul jour* displayed on a newsstand, Paris, 1960

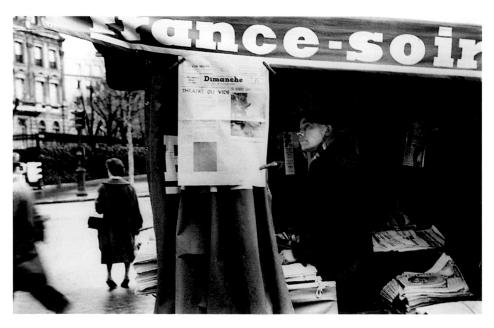

///

The Medium and the Message

A subject as vast in scope as the one we explore here could be tackled in a variety of ways. To our minds, a full chronological survey would have been nearly impossible. Given Europe's geopolitical fluctuations, and particularly the growing European Union, a national breakdown also seemed inappropriate. A traditional study arranged by print technique would have been far too rigid, while simply tracing significant artistic movements would have distorted our focus on the editioned mediums, since they appear more definitively in some periods than in others. Instead we chose a thematic approach that follows a loose chronology, but more importantly sets out to identify the significant ways prints, books, and multiples have enriched the artistic discourse. The six sections here—Mass Mediums, Language, Confrontations, Expressionist Impulse, Recent Projects, and British Focus—help to organize this broad and sometimes disparate array of art into manageable concepts while continuing to focus on the aesthetic meanings and resonance of individual works.

Mass Mediums

In London in the 1960s, artists, including Eduardo Paolozzi and Richard Hamilton, lifted photographic imagery from magazines, comic books, and pulp novels to create collagelike compositions. Vivid and dense color characterized much of this art of the Pop movement, as artists responded to the brashness of the pervasive consumer culture. These artists looked for "popular" techniques to represent this new vocabulary, and found it in commercial printing. Up to this point the screenprint medium had been used mostly for advertising and poster projects, and that made it an appealing choice. With its ability to create broad areas of flat, opaque color and to easily reproduce photographic images, screenprint was ideally suited for the Pop generation. That it offered clean, crisp outlines made it equally appropriate for Pop-inspired hard-edge abstraction that also flourished at that time. Bridget Riley chose screenprint for her dizzying optical visions, as did abstract artists who would later explore visual systems in their art, such as Blinky Palermo.

Gerhard Richter and Sigmar Polke turned to another commercial medium: offset lithography. Their interpretations of consumer culture and the media possessed an edgy, critical viewpoint, which the mechanically processed look of offset printing, particularly in black and white, enhanced. If one compares Warhol's screenprinted Day-Glo rendering of Mao Tse-tung with Richter's muted, ambiguous offset version, the differences become immediately apparent. Daniel Buren also adopted offset, which allows for cheap reproduction in vast quantities, to print striped posters that were not only exhibition announcements but also the material of the exhibition itself, as seen in his installation outside and inside Wide White Space Gallery in Antwerp (FIGS. 7 & 8).

FIGS. 7 and 8. Daniel Buren, installation views of exhibition at Wide White Space Gallery, Antwerp, 1969

Language

The use of language in art became another impetus for artists to explore prints and books in the late 1960s and the 1970s. Marcel Broodthaers and Joan Brossa had careers first as poets, and they used letters and texts as components of their visual vocabularies as well. Broodthaers also worked extensively in the medium of artists' books, as did many leading figures of the Conceptual art movement, such as Hanne Darboven, whose concerns with time found a natural extension in this sequential format. Symbolic codes resembling language also characterized work of this period, as is evident in the early prints and books of A. R. Penck, who lived in East Germany until 1980. Personal syntax distinguishes the prints of Stanisław Fijałkowski, of Poland, and Mangelos, of Croatia. Mangelos's books contain invented words in poetic script set out in provocative visual arrangements.

Because communication was fundamental to Conceptualism, artists developed innovative means for disseminating ideas. Unusual new book formats arose. Some journals included original page art while others, such as Britain's *Art-Language*, can be considered artworks in themselves. Some exhibition catalogues became three-dimensional editioned objects, and art was even sent through the mail as flyers. There was also a proliferation of printed ephemera—from postcards to stickers to exhibition announcements—as artists creatively engaged these large-edition formats for their cerebral investigations. In talking about her own response to such artistic practices across the continent at the time, American critic Lucy Lippard noted: "We began to see that Europe was more fertile ground than the United States for these new networks and means of dissemination....The generous government funding in Europe (and more curatorial sympathy on the intellectual/political level) and, in Germany, the Kunsthalle system made more and quicker experimentation possible."[4] Perhaps a less market-driven atmosphere, compared to the gallery system by then entrenched in the contemporary art world of the United States, made new approaches more acceptable. Portable, decentralized, and easily communicated forms of Conceptual art meant artists could participate in these new ideas across national boundaries.

Confrontations

The political ferment of the late 1960s and early 1970s led to a torrent of printed statements—from the anonymous poster brigade known as Atelier Populaire that plastered the streets of Paris during the May 1968 civil strife (FIG. 9) to Wolf Vostell's powerful printed indictments of the Vietnam War. More ambiguous yet highly symbolic images came from East German Wolfgang Mattheuer, who used the graphic potency of black-and-white woodcut for metaphoric statements on universal struggle that implied rebellion.

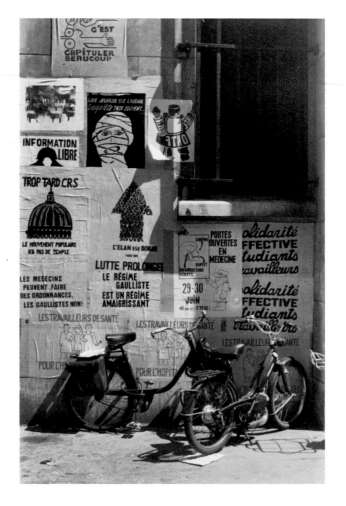

FIG. 9. Atelier Populaire posters, Paris, May 1968

FIG. 10. Joseph Beuys and publisher Wolfgang Feelisch, of Edition VICE-Versand, with *Intuition*, 1968, unlimited multiple of wooden box, outside the Kunstakademie Düsseldorf, 1972

Joseph Beuys and Dieter Roth each confronted the meaning and materials of art with pioneering outputs of printed and editioned works. Beuys used the power of the multiple to spread fervent missives for social and political reform, furthering his belief that everyone is an artist. Roth, on the other hand, devised radical technical inventions. His "pressings" and "squashings" of organic materials, and their subsequent decay and metamorphosis, remain as revolutionary today as they were when he made them in the late 1960s. His passion for books, and the iconoclastic methods he used to devise them, resulted in works that have redefined the conventions for this age-old format.

Among other confrontational developments in art of the 1960s was the emergence and subsequent proliferation of the multiple. Initiated by Daniel Spoerri with his Edition MAT in 1959, this new format arose with the *Nouveaux Réalistes* in France, who challenged the elite status of the art object. This philosophy was furthered by Fluxus, which emerged in West Germany but soon extended its reach internationally. With an assault on all that is precious in art, and rebellious attempts to break down the commodity nature of the object, Fluxus fostered extensive publishing efforts and a voluminous production of inexpensive multiples. Beuys, who was loosely aligned with this group, became the most prolific of multiple makers, creating nearly six hundred editioned objects that range from a man's felt suit to an empty wooden box meant to encourage progressive thinking (FIG. 10) to a plastic shopping bag printed with his political agenda.

Expressionist Impulse

Alongside tendencies toward a more conceptual production incorporating elements of everyday life or aping strategies of commerce, a strong expressionist tradition continued to thrive. Going back to the time of Albrecht Dürer, German artists, in particular, have carved and printed woodblocks to express primal concerns about life and death, identity, and the deep anxieties inherent to the human condition. This tendency garnered renewed attention in the late 1970s and the 1980s when a group of artists were deemed Neo-Expressionists, even though many of them, as well as others, had been working in this vein for some time. Anselm Kiefer explored aspects of German history and mythology and found a fitting outlet in woodcut. Per Kirkeby employed it for haunting landscapes that conjure up a primordial past. The aggressive action of carving a woodblock can be matched in intensity by the fierce scratching of a copperplate, and many artists working in an expressionist idiom, such as Arnulf Rainer and Hermann Nitsch, turned to etching to evoke the visceral, often violent qualities of their aesthetics. Its process could parallel the will toward simultaneous destruction and creation found in their work overall.

Recent Projects

In recent years, artists have continued to show a sustained interest in thematic issues generated in earlier decades while also investigating new artistic concerns. Several, including Martin Kippenberger and Franz West, have challenged the tradition of the poster—which had also been exploited by Joseph Beuys and others in the late 1960s and the 1970s—subverting its traditional communicative function in provocative series. Nonobjective forms have also inspired serial projects in printmaking and, in the hands of John Armleder, an ironic approach to the conventions of abstraction. In a 2003 portfolio, *Supernova*, he offers interactive possibilities, encouraging collectors to select any arrangement and orientation for the individual sheets. Austrian Peter Kogler uses abstraction to create allover designs for wallpaper and mural projects. From motifs of streaming ants to construction pipelines, Kogler plays on the decorative patterning of the Vienna Secessionists with his hypnotic, disturbing environments (FIG. 11). The theme of dystopic nature has inspired other artists who exploit the serial potential of printmaking, from Rosemarie Trockel's distorted webs fashioned by spiders on narcotics to Paul Morrison's landscapes of irradiated black-and-white flora. Journals, books, and multiples have also been arenas for young artists to explore. The Swiss journal *Parkett* has given many artists the opportunity to insert their aesthetics into, onto, and around this critical art periodical. Leonid Tishkov and Dan Perjovschi have both produced books that fuse sardonic humor with inventive draftsmanship in narratives that could easily be compared to comics. Installation artists John Bock and Sylvie Fleury have each created multiples that are both ironic and amusing, while crystallizing their aesthetic concerns. Printed ephemera continues to inspire as well, notably in the work of Antoni Muntadas, who uses stickers, brochures, bookmarks, and newspaper inserts to spread his charged points of view. And even the oldest printmaking medium, the woodcut, still interests young artists, as seen in the work of Christiane Baumgartner, who integrates photography with printmaking, testifying to the potency and relevance of both mediums.

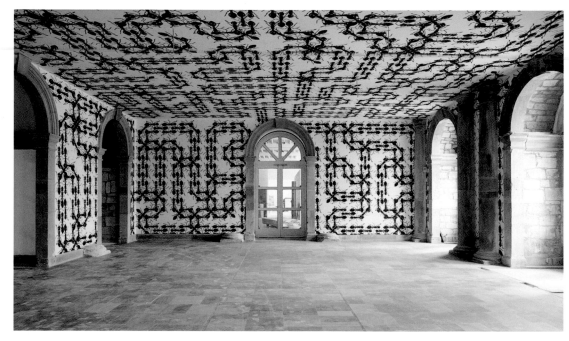

FIG. 11. Peter Kogler, wallpaper installation at *documenta 9*, Museum Fridericanum Kassel, Germany, 1992

Photography, which has had a clear influence on the visual arts from the 1960s on, has also resonated in printed work. While found photographs from popular culture dominated the Pop movement, the rise of Conceptual art gave this medium new uses as a documentary tool and an instrument to investigate issues of perception and illusion. Along the way, printmaking technology evolved as well, first with plates, stones, and screens routinely photosensitized to allow artists to easily incorporate photographic imagery, and more recently with digital capabilities permitting them still further possibilities for manipulation and animation. In many cases, such techniques are so intertwined today that it is difficult to separate components, and traditional distinctions between mediums become almost meaningless. One example is Jean-Charles Blais's haunting series *Panoply*. Produced in a traditional French lithography workshop, equipped with autographic, photographic, and electronic facilities, Blais's prints integrate digitally manipulated photographic imagery with lithography and were printed on a traditional press (FIG. 12).

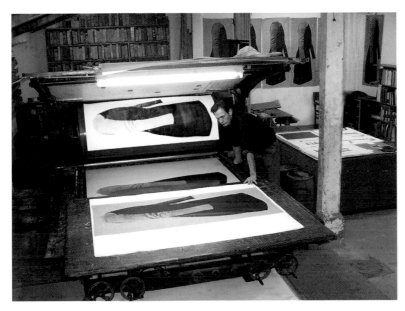

FIG. 12. Printer and publisher Franck Bordas proofing *Panoply* by Jean-Charles Blais, Atelier Bordas, Paris, 2000

British Focus

Over the last fifteen years Britain has witnessed an explosion of printed art, coinciding with the creative energy in painting, sculpture, and installation art that came from the generation coined the YBAs, or Young British Artists. Comparable in many ways to the outpouring of Pop art and attendant printmaking in Britain in the 1960s, the recent work has encompassed print mediums and formats from etchings to ephemera. Innovative publishers, such as The Paragon Press and Alan Cristea for prints, as well as Book Works and The Multiple Store, have capitalized on this energy and encouraged editioned projects from a wide range of artists. Etching has also flourished. Senior figures, such as Lucian Freud and Richard Hamilton, have led the way, creating masterful bodies of work in this medium, and their younger compatriots, such as Jake and Dinos Chapman, Mona Hatoum, and Damien Hirst, have followed with extensive portfolios. Pop-inspired approaches by Michael Craig-Martin, Julian Opie, and Chad McCail have resulted in brightly colored screenprints and digital projects. Following the precedent of the landmark "postal sculptures" by the audacious team of Gilbert & George, ephemera has thrived, as seen in self-published pamphlets by such figures as Adam Dant. Among the most inventive developments has been the proliferation of artist-designed wallpapers, including examples by Hirst, Sarah Lucas, Paul Noble, and Simon Patterson, illustrating new ways contemporary artists are exploiting printed formats.

European Prints in Context

A complex "print world"—made up not only of publishers and workshops that issue printed and editioned art but also the institutions, archives, associations, biennials, and journals that collect, exhibit, and interpret it across Europe—provides an important context for the varied practices explored in this study. In Europe, governments—with multifaceted infrastructures of national, regional, and local entities—have played the major supporting role for the arts, rather than the corporations, private entities, and patrons more common in the United States. This ongoing assistance has encouraged research, collecting, and public appreciation of contemporary art, and remains fundamental to cultural activity in Europe today. In addition, new organizations have arisen to encourage specifically contemporary developments, sometimes sustained by government entities but also championed by artists and the collectors inspired by new directions in art.

In undertaking this study we relied on European colleagues who oversee many of these institutions and organizations and who share our interests in the preservation, documentation, exhibition, and interpretation of this important tradition.[5] As specialists, we have been fascinated to visit collections available for those undertaking scholarly endeavors in this field, in both the historic and modern periods. Such resources are also available to members of the general public seeking the aesthetic pleasures offered by these mediums, and to the many artists working today who maintain the vitality of prints, books, and multiples as means of expression. For such artists, these collections provide a potent example.

Major Print Collections

Among the national institutions devoted to printmaking is a model unfamiliar in the United States. Known as a chalcography, which means both the art of engraving on copperplates as well as an organization that collects the engraved plates, these institutions began as royal or papal collections. The three largest chalcographies are in Italy, France, and Spain. The Istituto Nazionale per la Grafica in Rome, founded in 1738 by Pope Clement XII, oversees the largest of the three, comprising more than 23,000 copperplates dating from the Renaissance to the present, and also encompassing the Gabinetto Disegni e Stampe, with a collection of over 130,000 prints and drawings (FIG. 13). Its mission is to collect and preserve the matrices used by Italian printmakers and to conduct art historical studies on these matrices to verify attributions, dates, and other valuable details informing our knowledge of the prints themselves. In addition to galleries for exhibitions, including those devoted to contemporary printmaking, the institute houses a print workshop. This shop was traditionally used to reprint from the chalcography's plates and provide the public with inexpensive impressions of old masters. They also commissioned architectural and topographical views to preserve the national patrimony. Such practices are limited today, though artists are occasionally invited to create new works on these presses.

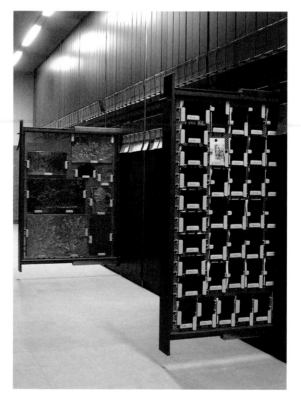

FIG. 13. Storage facility at the Istituto Nazionale per la Grafica, Rome, showing racks with copperplates

Established in the late eighteenth century, the Calcografía Nacional in Madrid and the Chalcographie du Louvre in Paris have missions similar to that of the Rome institute, but both devote more energy to publishing, including commissioning new editions from contemporary artists and reprinting from their collection of historic copperplates. The Chalcographie du Louvre has an extensive sales program with a shop in the museum dedicated to selling these modestly priced restrikes. Since 1992 they have begun again to commission artists to create unlimited editions.[6] The Madrid institution also has a program for commissioning prints from contemporary artists and now includes a separate digital print research and development center. It also offers an annual award for printmaking: the Premio Nacional de Arte Gráfico. In addition to maintaining galleries for an exhibition program, a stunning permanent installation displays Francisco de Goya's copperplates and a printing press from the artist's era (FIG. 14).

FIG. 14. Francisco de Goya Room at the Calcografía Nacional, Madrid, with the artist's copperplates displayed on a ledge around the room

FIG. 15. Study hall of the Dresden Kupferstich-Kabinett

In cities across Europe, major print collections—many referred to by terms like *Graphische Sammlungen*, *Kupferstichkabinette*, and *cabinets des estampes*—are made available to the public through an institution's print room. A fundamental component of each country's cultural heritage, now often supported by city and state governments, many of these collections also include drawings, and sometimes photography. Their documentation of the history of printmaking traces developments from the earliest years of the printing press to the present day. While modern and contemporary periods usually do not represent particular strengths, the power of printmaking's long tradition is vividly communicated through their holdings. Access to these collections is possible through focused exhibitions and specialized catalogues, as well as through print rooms, a long-standing resource for the purpose of study, where works in storage are brought to visitors in a quiet, monitored area, much like a library reading room.

Such institutions exist in Eastern Europe as well as in the West, but the repercussions of World War II and the isolation of the Cold War years presented difficulties for them. In some cases collections were dispersed, and recent curatorial activities have focused on reconstituting them to prewar status. The Dresden Kupferstich-Kabinett, one of the world's oldest and most distinguished, lost nearly four hundred works of the German Expressionist period to Hitler's "degenerate art" policies. In addition, in the postwar period, much of their collection was transferred to the Soviet Union. Even today there are some 50,000 works unaccounted for. But with a newly renovated print room and exhibition galleries, the Kupferstich-Kabinett has an active curatorial program (FIG. 15). Its publications on modern and contemporary subjects have ranged from Scandinavian artists Asger Jorn and Per Kirkeby to major German figures, including Ernst Ludwig Kirchner and Otto Dix, as well as Eberhard Havekost of the current generation. Prints by Gerhard Altenbourg, Wolfgang Mattheuer, and Carlfriedrich Claus, among many others who were working in East Germany in the postwar period, can also be studied in this print room.

In Vienna, the Albertina's vast holdings number some 45,000 drawings and close to 1 million prints, representing artists including Albrecht Dürer, Michelangelo, Raphael, and Rembrandt van Rijn. The collection also extends to the twentieth century, with works by artists ranging from such early modern masters as Gustav Klimt, Egon Schiele, and Oskar Kokoschka to later figures, like Robert Rauschenberg, Andy Warhol, and Georg Baselitz. The exhibition program presents the work of contemporary national figures, Maria Lassnig among them, as well as Austrian movements, with Viennese Actionism of the 1960s and 1970s as one example. Among the Albertina's important catalogues for this period is one surveying Polish printmaking and another on the highly innovative prints and books of Dieter Roth. Most recently the focus has been on interdisciplinary exhibitions, with prints and drawings seen in the context of paintings and other mediums.

FIG. 16. Reading room of Le Département des Estampes et de la Photographie, Bibliothèque Nationale de France, Paris

Major repositories of prints are also found in national libraries, with the Bibliothèque Nationale de France in Paris as a prime example (FIG. 16). The origins of its Cabinet des Estampes (now Le Département des Estampes et de la Photographie) can be traced to the seventeenth century, as can its system of *dépôt legal*, which stipulates that every print published in France be included in the collection. Comprising nearly 15 million works, with almost 200,000 of these dating from the twentieth and twenty-first centuries, the Bibliothèque Nationale is the largest such collection in the world. In addition to its exceptional holdings of individual masters is a group of posters made during the student protests in Paris in May 1968 and over 4,000 contemporary artists' books. The Département also issues *Nouvelles de l'estampe*, an indispensable journal for scholars, curators, collectors, and artists.

Switzerland has public collections of prints and drawings in several cities, with the Graphische Sammlung of the Eidgenössische Technische Hochschule (Swiss Federal Institute of Technology), known as the ETH, in Zurich and the Cabinet des Estampes of the Musée d'Art et d'Histoire in Geneva among those noteworthy for their commitments to modern and contemporary prints. As a university collection, the ETH's Graphische Sammlung was established by a professor of art history and archeology for study purposes in the mid-nineteenth century, and opened to the public in 1890. Since that time it has grown to number some 150,000 works, with a concentration on printmaking but also including drawings and illustrated books. While a range of international figures are represented, the primary focus here is on Swiss artists, including the complete printed work of such figures as Bernhard Luginbühl, as well as an archive from Erker-Presse, a publisher and printshop located in the Swiss town of St. Gallen. Recently the ETH collection acquired nearly all the books by Dieter Roth, whose innovative practice so strikingly redefined this traditional medium.

The Cabinet des Estampes in Geneva, with its collection of over 300,000 works from the fifteenth century to the present, has made a significant contribution to scholarship in the field of modern and contemporary prints. One focus has been the production of catalogues raisonnés, with thorough documentation on the work of, among others, Markus Raetz of Switzerland, Geneviève Asse of France, and Ivana Keser of Croatia, an artist whose invented newspapers push the boundaries of conventional printed art. Avant-garde movements are also chronicled in Geneva's collection, ranging from Russian prints and books created in the 1910s and 1920s to artist-designed bulletins issued by the Dutch gallery Art & Project in the Conceptual art period of the late 1960s and early 1970s. In recent years, the Cabinet's relationship to contemporary art has been further enhanced by a cooperative program with MAMCO, Geneva's Musée d'Art Moderne et Contemporain.

The legendary printmaking tradition in Germany might explain the proliferation of highly significant collections in that country and the wealth of scholarly publications documenting them. Among such repositories, several pay close attention to modern and contemporary art along with their concentration on historical figures. Berlin's Kupferstichkabinett, for example, comprises some 110,000 drawings and 550,000 prints by artists from Sandro Botticelli to Joseph Beuys. And, since the 1960s, there has been a particular focus on modern and contemporary art. Most recently, gifts devoted to the avant-garde encompass European and American Conceptual art and *Arte Povera* and the *Transavanguardia* of Italy. A special concentration represents Moscow Conceptualism. The Kunstbibliothek in Berlin, situated near the Kupferstichkabinett, holds a significant complementary collection of artists' books, periodicals, and ephemera. One of its recently published catalogues documents the Marzona Collection, numbering some 50,000 examples of printed ephemera.

London has several public collections that include prints. The British Museum's Department of Prints and Drawings is among the most important in the world, with more than 2 million prints and 50,000 drawings. A busy study room is available for visitors (FIG. 17) and a schedule of exhibitions and numerous scholarly publications round out the program. While the modern holdings are not comprehensive, they comprise some 22,000 prints from the twentieth and twenty-first centuries. The Department's published studies of German Expressionism and early modern American and modern British prints have become standard references, and curators there have also turned attention to lesser-known areas of study, such as Czechoslovakian and Scandinavian printmaking. A recent bequest of film critic Alexander Walker added some two hundred modern and contemporary prints and drawings to the collection.

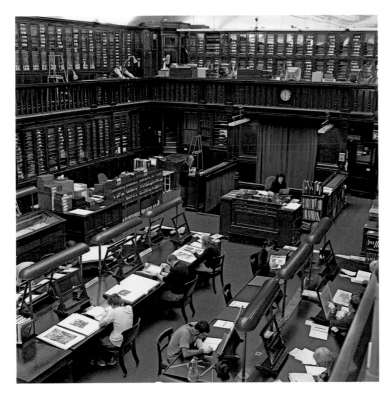

FIG. 17. Study room in the Department of Prints and Drawings, The British Museum, London

27

The British Museum's prints and drawings collection is complemented by the holdings of London's British Library, which contains concentrations of British fine press books as well as contemporary artists' books and a collection of Russian avant-garde books that is among the finest in the world. London also boasts the collections of the Victoria & Albert Museum, specializing in graphic design and decorative arts. Fine art prints and books are included, with a particular strength in the area of unique bookworks of the last two decades. Finally, the Tate deserves mention for its attention to recent art. Prints are integral to the Tate's holdings, since a department for this medium was founded in the mid-1970s.[7] Though the collection is relatively small, with 13,000 works, the study of these works is encouraged in a print room for public use and through an extensive website that lists all prints, most with images. In addition, the library at the Tate houses 4,000 artists' books, and these too are posted online and are searchable as a discrete collection.

Specialized Museums, Organizations, and Centers

In addition to these institutional collections in Europe's major cities, there are also centers off the beaten path. The most active regional institution in France is the Musée du Dessin et de l'Estampe Originale, established in Gravelines in 1982. With a collection of 10,000 prints that runs from Albrecht Dürer to the present, a permanent installation on the history and techniques of printmaking, and a program of both historic and contemporary exhibitions, the museum brings a stimulating center for printmaking to the northwest of the country. Its impressive catalogues spread scholarship on prints to an even broader community. Germany's Kunstmuseum Spendhaus is devoted primarily to the medium of woodcut. Opened in 1989 in Reutlingen, near Stuttgart, and financed by the local government, the museum began with a nearly complete collection of native HAP Grieshaber's woodcuts. Its holdings now trace the modern and contemporary woodcut from Art Nouveau and German Expressionism to contemporary figures, and its exhibition program complements this medium-based focus.

Other institutions, such as Le Centre de la Gravure et de l'Image Imprimée in La Louvière, Belgium, are devoted to furthering the appreciation of contemporary printed art. Financed primarily by the French Community of Belgium, the collection encompasses 5,500 prints, 5,000 posters, and five hundred artists' books and portfolios dating from the 1970s to the present. The center organizes exhibitions ranging from important monographic subjects, such as the recent study of the prints, books, and multiples of Spaniard Jaume Plensa, to historical thematic topics, technique-based shows, and collection installations. A varied program of educational activities, including public access to an impressive library on contemporary printmaking, also comprises part of their mission. In Malo, Italy, an unusual collection of contemporary printed art is open as a private association, established with the holdings of collector Giobatta Meneguzzo. Founded in 1978 in an antique palazzo, Museo Casabianca encompasses 1,200 prints, books, and multiples created since the 1960s. The collection includes experimental and provocative developments in the medium as well as classic Pop art images, and represents more than seven hundred artists.

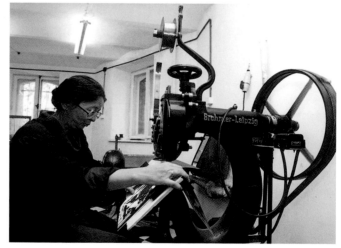

FIG. 18. Jadwiga Tryzno, cofounder of the Book Art Museum, Lodz, Poland, working on one of the museum's presses

While many institutions collect and exhibit artists' books as well as prints, the field of books also has its own network of museums, centers, galleries, and specialist events devoted to formats from the deluxe *livres d'artistes*, encompassing original prints, to mass-produced and inexpensive artists' books in offset.[8] A notable example is the renowned Herzog August Bibliothek in Wolfenbüttel, Germany, with its wide-ranging program of scholarly activities and its distinguished collection of illuminated manuscripts and *livres d'artistes*, including more than 3,000 works from the twentieth century. The ever-expanding interest in and study of artists' books has spawned related organizations as well. The activities of the Centre des Livres d'Artistes in Saint-Yrieix-la-Perche, France, stand out. Founded in 1987, this organization houses a collection of more than 2,500 artists' books made since 1980, including in-depth holdings by specific artists and publishers. Since its opening it has also sponsored Les Éditeurs, La Foire, a biennial artists' book fair. Yet another institution dedicated to contemporary books is the Book Art Museum, in Lodz, Poland (FIG. 18). Founded in 1993, it acts as an exhibition space as well as a publisher, inviting one artist each year to collaborate on its presses. In addition to promoting developments in Polish books, the museum exhibits books from other regions, including recent showings of works from Israel, Greece, and Bulgaria.

Among Europe's most unusual and innovative institutions devoted to contemporary printmaking is the Centre National de l'Estampe et de l'Art Imprimé in Chatou, France, just outside of Paris. Housed in the former studio of André Derain and Maurice de Vlaminck, CNEAI, as it is known, is an integrated exhibition space, publishing house, sponsor of contemporary art events, and overall think tank for contemporary art in multiple formats. Established in 1997, CNEAI's philosophy is embedded in the possibilities for art's accessibility and diffusion. Utilizing both its own printshop as well as others around France, it collaborates on projects ranging from traditional etchings to printed installations. Working with some two hundred artists, CNEAI has produced an extraordinary body of artists' publications, including prints, books, posters, notebooks, wallpaper, bookmarks, stickers, and billboards; its own collection of printed ephemera numbers approximately 9,000 pieces (FIG. 19). A hybrid model unknown in the United States, CNEAI is a government-supported art center and publisher devoted to printed art's central role in contemporary art.

FIG. 19. Archives at the Centre National de l'Estampe et de l'Art Imprimé (CNEAI), Chatou, France. Antoni Muntadas, *Meeting II*, 2000, screenprint published by CNEAI, displayed on the wall

Archives

The Graphische Sammlung of the Staatsgalerie Stuttgart stores its collection, comprising over 400,000 works, in a new building that includes storage, library, and print room facilities as well as airy exhibition galleries conducive to the installation of recent art. Twentieth-century art has been a longtime focus of the collection and, together with its twenty-first century holdings, accounts for 60,000 works. In addition, the Staatsgalerie houses specialized archives relevant to the study of modern and contemporary editioned art. The Marcel Duchamp Kabinett was established in 1985 with a collection that had begun more than a decade earlier. Now this archive includes the complete prints of Duchamp as well as objects in multiple format. Proofs, drawings, letters, manuscripts, and other study material further distinguish this archive.

The Staatsgalerie Stuttgart's Archiv Sohm, established in 1981, constitutes a highly significant collection assembled by Hanns Sohm, a dentist who lived in a nearby town (FIG. 20). Encompassing a range of avant-garde tendencies outside the mainstream, like Fluxus, Concrete poetry, Viennese Actionism, and Happenings, this archive is among the most important of many across Europe devoted to artists' publications, ephemera, and other alternative art forms.[9] It provides scholars with primary documentation, including artists' correspondence, photographs, catalogues, periodicals, and film and video. It also mounts exhibitions of its holdings and produces scholarly publications.

Artists themselves have also made specialized archives, sometimes as a component of a Conceptual art project. Leif Eriksson, who established the Swedish Archive of Artists' Books in Malmö, would qualify as such a figure, as would Maurizio Nannucci, who, along with other artists, has organized the Zona Archives in Florence. Its collections includes artists' books, artists' records, and ephemera. Romanian artists Lia and Dan Perjovschi began gathering materials related to contemporary art in the early 1990s. Their books, catalogues, postcards, slides, and videos became the Contemporary Art Archive and is now the Center for Art Analysis, which fosters a variety of cultural initiatives. Artist Ben Vautier, who claims he cannot throw anything away, has amassed a collection of ephemera in Nice, numbering some 2,500 items from 1956 to the present and listed chronologically on his Web site, www.ben-vautier.com/archives. Guy Schraenen, on the other hand, is a collector and curator, originally based in Antwerp, who established the Archive for Small Press and Communication in 1974, which included the kinds of artists' publications that began to appear in the late 1960s. Schraenen's archive now forms the basis of the Research Centre for Artists' Publications at the Neues Museum Weserburg Bremen, Germany, which comprises some 60,000 artists' books, magazines, posters, invitations, Mail art, Stamp art, and other ephemera (FIG. 21). While the core of this unusual collection is material from the 1960s and 1970s, it also includes recent examples of publishing activities by artists. The center sponsors conferences, exhibitions, and scholarly catalogues and makes its collection available in a study center, all contributing to what can be considered an institutional model committed to demonstrating the role that printed and editioned art plays in contemporary art history.

Documentation of alternative art practices during the period of relative isolation for Eastern Europe presents a special case. Commenting on a mostly underground network, one scholar noted: "The main state institutions did not want to occupy themselves with such matters, but the new forms of art were taken care of by marginal student and youth centres and other alternative spaces."[10] One such collecting venue, and among the most important in the East, is Artpool, a Budapest archive whose objective is "to register changes in art, to present and document the most interesting art experiments and to promote artistic communication."[11] Founded in 1979 by György Galántai and Júlia Klaniczay, who salvaged remnants of an underground movement within the prohibitive atmosphere of a socialist state, Artpool's collection includes a range of experimental printed art, with some 1,000 bookworks, 4,000 postcards, and 20,000 stamps, among other examples of the activities of the Hungarian and international avant-garde.

FIG. 20. Archiv Sohm, Staatsgalerie Stuttgart

FIG. 21. Study center at the Research Centre for Artists' Publications/ASPC, Neues Museum Weserburg Bremen, Germany

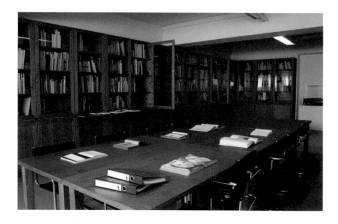

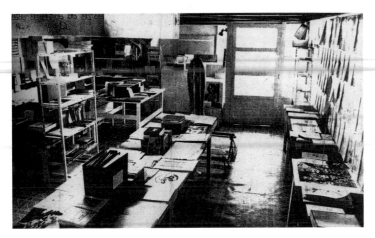

FIG. 22. Ulises Carrión's bookshop Other Books and So, Amsterdam

A variation of the archive concept as outlined here is the specialized bookshop that can be understood as a public meeting place for the exchange of ideas, as much as a business. Many such shops include publishing activities, exhibitions, and lecture series as part of their program and handle both artists' books and multiples. The idea of the bookshop itself as a "medium"[12] can certainly be applied to an establishment known as Other Books and So, founded by artist and theorist Ulises Carrión in Amsterdam in the 1970s (FIG. 22). His shop soon evolved into a growing archive and remained so until Carrión died in 1989 and the collection was dispersed. Other shops and galleries continue to proliferate, serving the ever-broadening interest in artists' publications. Among those are Harry Ruhé's Galerie A and Boekie Woekie in Amsterdam, with Johan Deumens nearby in Heemstede; Barbara Wien's gallery in Berlin; Florence Loewy's shop in Paris; and the mega-operation of Walther König in Cologne that runs satellites in other cities as well, such as the bookshop in the Hamburger Bahnhof in Berlin.

Journals

Another important facet of the network of print-related activities are journals devoted to the subject of printmaking, providing information as well as links between members of the printmaking community. Foremost among these is *Nouvelles de l'estampe*, of the Bibliothèque Nationale, and cited above. It presents articles on artists and prints represented in the collection of the Bibliothèque Nationale, and also profiles publishers and printers. Finally, it compiles listings for exhibitions, biennials, and prize competitions, in France and internationally, for the printmaker and print enthusiast. Of a scholarly nature, and primarily geared to specialists and collectors, is *Print Quarterly*, established in London in 1984 with a distinguished editorial board of international members. Covering the entire historical spectrum, *Print Quarterly* encompasses substantial articles on topics of new art historical research as well as reviews of recent exhibitions and publications in the field. *Grapheion*, published in Prague but written in both Czech and English, focused on contemporary developments and aimed at a slightly broader audience. Issued quarterly between 1997 and 2000, it has been published only sporadically since then, devoting issues to special initiatives. This copiously illustrated and critically impressive publication provided an important editorial voice from Eastern Europe, and also brought international news to the print community there through scholarly articles, interviews with artists, discussions of international print-related events, and reports on major print rooms. *Printmaking Today* provides a forum aimed specifically at printmakers, but is also of interest to the print field generally. Established in London in 1990, it favors a more journalistic slant, focusing on contemporary artists, thematic issues, reviews of exhibitions and publications, and detailed technical information. Lists of open call print exhibitions and workshops are included as well, for the working artist.

Print Biennials

Recurring contemporary print exhibitions, held either biennially or triennially, are integral to the European print world infrastructure. Dozens of such exhibitions occur across the continent, from Finland and Russia to Switzerland, Italy, and Spain. Typically based on a selection made by a jury of experts from an open call for submissions to artists, they may include all techniques or be devoted to only one; some are even restricted to prints of a certain size.[13] Over the years noteworthy print biennials, like the one held in Bradford, England, lost momentum and were discontinued. Others, including the Biella (Italy) Biennial, established in 1963, endure, but with new frameworks that offer greater relevance to the contemporary art world at large.[14] For the 2006 version, the Biella exhibition was turned over to a single curator who chose the artists and prints to be included. This exhibition and its catalogue offer a critical overview of the field at present, and emphasize the relationship of printmaking to more general preoccupations of contemporary art.[15]

Eastern Europe has long been an important venue for such recurring print exhibitions, which played a political as well as cultural role during the isolation of the Cold War years. The longest running such project is the biennial held in Ljubljana, Slovenia. Looking back to the founding of the biennial in 1955, the mayor of that city pointed out that "the first Biennial of Graphics was…a bold attempt to reopen the door leading to the outside world."[16] In the words of the biennial's present director, "it symbolized the victory of progressive trends in art that were opposed to socialist realism."[17] With prints being relatively inexpensive and easy to transport, the exhibitions in Ljubljana afforded the rare opportunity for artists in the region to see firsthand the work of celebrated figures from the West, among them Eduardo Paolozzi, Robert Rauschenberg, Antoni Tàpies, and Joe Tilson, all of whom were invited to participate alongside open and juried submissions.

With the help of the Ministry of Culture and private sponsors, the Ljubljana Biennial was institutionalized in 1986 through the founding of the Mednarodni Grafični Likovni Center (MGLC, International Centre of Graphic Arts), situated in the town's Tivoli Castle (FIG. 23). The professional staff of the center is the organizational force behind the biennial, and also presents a range of complementary print exhibitions. In addition, the center coordinates a year-round calendar of printmaking programs and houses a collection of approximately 4,000 prints and eight hundred artists' books. Constantly reevaluating the form and function of print mediums, it has mounted a variety of adventurous exhibitions focusing on formats ranging from ephemera to billboards.[18]

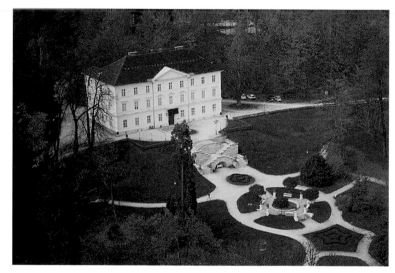

FIG. 23. MGLC, International Centre of Graphic Arts, Tivoli Castle, Ljubljana, Slovenia

Among the special contributions of biennial exhibitions have been the opportunities provided for artists and print specialists to gather together for a continuing dialogue on the state of the field. A new international forum, called Impact, also serves this purpose. Convening in a different location every two years, Impact was initiated by the Centre for Fine Print Research at the University of the West of England in Bristol in 1999, and organizes a range of exhibitions, lectures, symposia, and presentations for artists, curators, and other specialists, as well as the general public.[19] Particularly important for relatively isolated communities, such conferences and biennial exhibitions not only provide a network for the printmaking community but also generate publicity and tourism for that locale.

Kunstvereine and Print Clubs

Another critical component of the print scene in Europe is the activity of the *Kunstvereine*, civic art associations most notably in Germany and Switzerland that foster an interest in contemporary art and, through subscription prints, encourage collecting. Leading citizens interested in cultural advancement formed these organizations in large and small cities alike "to meet the needs and educate the taste of a new kind of collector."[20] Some were founded as early as the first decades of the twentieth century, and they continue to flourish today. The parameters of individual associations vary but each has a subscription program that entails commissioning contemporary artists each year to make prints for its members.

The Kestner Gesellschaft, for example, was formed in Hannover in 1916. With exhibitions and catalogues, lectures, concerts, and tours, the Kestner Gesellschaft offers an exciting program for its more than 4,000 members. For an annual fee members receive a series of prints each year as well as the option to acquire other prints, known as the *Kestnereditions*, at a reduced price (FIG. 24). Similarly, the Griffelkunst-Vereinigung was founded in Hamburg in 1925, and its membership has grown from seventy-nine to approximately 4,200 today.[21] With an annual fee of less than 120 euros and a truly democratic outreach, Griffelkunst allows its members to choose four from a group of more than thirty-five to forty commissioned prints each year. The edition size of these signed prints is determined by demand of the membership. Griffelkunst has published more than 1,500 editions, establishing it as a vital participant in the contemporary German print world.

A slightly different model exists in Zurich's Schweizerische Graphische Gesellschaft, known as SGG. Founded in 1918, SGG's membership is restricted to 125 members. The period before and after World War I was a time of great cultural initiatives in Switzerland, and the SGG was part of that cultural expansiveness.[22] With a distinguished list of participating artists stretching from Paul Klee (FIG. 25) in the 1920s to John Armleder now, SGG's program is so popular that there is a waiting list to join.[23] The complete collection of their prints, numbering more than two hundred, is now represented in the Graphische Sammlung of the ETH in Zurich.

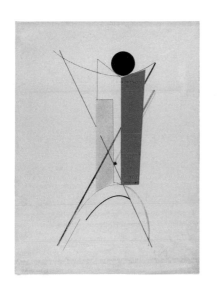

FIG. 24. El Lissitzky. *Untitled* from the portfolio *Proun*. 1919–23. Lithograph
SHEET: 23 5/8 X 17 3/8" (60 X 44.1 cm).
PUBLISHER: Kestner Gesellschaft, Hannover. PRINTER: Robert Leunis & Chapman, Hannover. EDITION: 50. The Museum of Modern Art, New York. Purchase, 1935

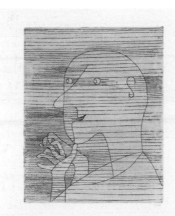

FIG. 25. Paul Klee. *Rechnender Greis (Old Man Figuring)*. 1929. Etching, PLATE: 11 3/4" X 9 3/8" (29.8 x 23.8 cm). PUBLISHER: Schweizerische Graphische Gesellschaft, Zurich. PRINTER: Hans Klinger, Leipzig. EDITION: 130. The Museum of Modern Art, New York. Purchase, 1947

No single volume has yet synthesized European developments in the mediums of prints, books, and multiples during the groundbreaking years from the 1960s to the present, tracing the contemporary aesthetic they represent. We attempt to accomplish that synthesis here, and have relied on much valuable research conducted by our colleagues. Important studies have singled out and examined specific formats, such as artists' books and multiples, as well as the printed ephemera of postcards and record jackets. Others have encompassed more traditional prints, especially documenting moments of high production, such as the "print boom" of the 1960s in London or the Neo-Expressionism that arose, especially in Germany, Austria, and Italy, in the 1980s. Collection catalogues have published major institutional holdings, while publications accompanying medium-specific exhibitions, like those on woodcut and etching, have provided further original research. Catalogues raisonnés of individual artists have done the same. Focused studies on innovative publishers and printers, from Kelpra Studio and The Paragon Press in London to Griffelkunst and Klaus Staeck in Germany, have also offered essential documentation. Finally, the many catalogues associated with biennials from various countries across Europe have been an invaluable resource.

We look forward to future projects on this subject by our European colleagues, knowing they will add new perspectives on this complex subject. At the same time, we acknowledge that our own view is from an American vantage point, most specifically from New York. We hope it provides a fresh look at the editioned mediums as they appeared in these many countries and enlightens the ever-expanding audience for vanguard art.

Notes

1 Two studies of Europe in the postwar period are recommended: Flora Lewis, *Europe: Road to Unity* (New York: Simon & Schuster, 1992); and Tony Judt, *Postwar: A History of Europe since 1945* (New York: Penguin Press, 2005).

2 Walter Grasskamp, "'Give Up Painting,' or the Politics of Art: A West German Abstract," in *Breakthroughs: Avant-Garde Artists in Europe and America, 1950–1990* (New York: Rizzoli in association with Wexner Center for the Arts, The Ohio State University, 1991), p. 133.

3 Pierre Restany, "1966: L'Allemagne à la seconde année Zéro," *Domus* 437 (April 1966): 35.

4 Lucy R. Lippard, "Escape Attempts," in Ann Goldstein and Anne Rorimer, *Reconsidering the Object of Art: 1965–1975* (Los Angeles: The Museum of Contemporary Art; Cambridge, Mass.: The MIT Press, 1995), p. 34.

5 The authors, in their tenures of over twenty-five years in MoMA's Department of Prints and Illustrated Books, have visited many print rooms and other print-related organizations across Europe. Preparations for this project required still further visits. Much of the general information in this section comes from conversations and e-mail exchanges with colleagues, or from organizations' Web sites.

6 In addition to those unlimited editions, which are unsigned, a signed and numbered edition of 9 of each print is also made. For additional information on this program, see Rainer Michael Mason, *At the Louvre and at Present: Contemporary Prints for the Chalcographie du Louvre* (Paris: Chalcographie du Louvre; Éditions de la Réunion des Musées Nationaux, 2001), p. 7.

7 For further information on the formation of the Tate's Print Department, see Pat Gilmour, "Setting up Departments, I: Prints at the Tate Gallery," *Print Quarterly* 22, no. 2 (June 2005): 159–62.

8 For more information on museums, libraries, galleries, exhibitions, artists, dealers, and fairs specializing in artists' books, see the comprehensive website www.kuenstlerbuecher.de.

9 For a discussion of archives, as well as specialized bookshops, galleries, and publishers for avant-garde editioned art, see Harry Ruhé, *MULTIPLES, et cetera* (Amsterdam: Tuja Books, 1991).

10 Zdenka Badovinac, "Body and the East," in Badovinac, *Body and the East: From the 1960s to the Present* (Ljubljana, Slovenia: Moderna Galerija, 1998), p. 15.

11 For the mission statement and more on Artpool, see www.artpool.hu.

12 Axel John Weider, "Independent Distributing," in *Put About: A Critical Anthology on Independent Publishing*, ed. Maria Fusco with Ian Hunt (London: Book Works, 2004), p. 161.

13 A current listing of a range of such exhibitions can be found on the Web site for the International Print Triennial in Cracow. See www.triennial.cracow.pl.

14 "Big Names Take over Biella Prize," *Printmaking Today* 11, no. 4 (Winter 2002): 16.

15 Jeremy Lewison, ed., *Premio Biella per l'incisione 2006: Arte nell'età dell'ansia/Biella Prize for Engraving 2006: Art in the Age of Anxiety* (Milan: Skira, 2006).

16 Jože Strgar, preface to *20th International Biennial of Graphic Art* (Ljubljana, Slovenia: MGLC, International Centre of Graphic Arts, 1993), p. 4.

17 Lilijana Stepančič, "The Thrust of a Regularly Recurring Exhibition," in *Sunek/Thrust: 26th Biennial of Graphic Arts Ljubljana* (Ljubljana, Slovenia: MGLC, International Centre of Graphic Arts, 2005), p. 12.

18 Most recently it mounted *Street Art: Stencils, Posters and Stickers/A Low-Tech Re-action!*

19 Conferences have since been held in Helsinki in 2001; Capetown in 2003; and Poznan (Poland) and Berlin, in 2005. In 2007 it will take place in Tallinn, Estonia.

20 Frank Whitford, "German Prints and Their Public," *Print Quarterly* 8, no. 3 (1991): 311.

21 For more about the Griffelkunst-Vereinigung, see *Griffelkunst Verzeichnis der Editionen, 1976–2000*, 2 vols. (Hamburg: Griffelkunst-Vereinigung, 2002–04).

22 For more on SGG, see Paul Tanner, *Im Auftrag. Druckgraphik 1918 bis 1998 für die Schweizerische Graphische Gesellschaft* (Zurich: Graphische Sammlung der ETH, 1998).

23 Christophe Cherix, correspondence, February 2006.

essays & plates

Essays and accompanying plates are arranged thematically. Countries
and nationalities are cited throughout according to current geopolitical
borders. For prints, foreign titles appear in their original language followed
by English translations. For books, titles generally appear in their original
language only, except for some Eastern European examples. Dates refer
to year of publication for prints, books, and multiples, and to span of operation
for journals and special projects. Unless otherwise noted, all artists' books and
ephemera are offset printed, and printing firms are not cited. Certain commercial
fabricators of multiples are also omitted. Dimensions given are plate, composition,
or sheet size for prints; page size for books. Height precedes width for prints
and books; height precedes width precedes depth for three-dimensional objects.
For works in the collection of The Museum of Modern Art, the year of acquisition
appears at the end of the credit line.

mass mediums

Daniel Buren
Patrick Caulfield
Richard Hamilton
François Morellet
Blinky Palermo
Eduardo Paolozzi
Sigmar Polke
Gerhard Richter
Bridget Riley
Dieter Roth

In the spring of 1952 Eduardo Paolozzi gave a radical

slide lecture titled "Bunk" at London's Institute of Contemporary Arts. In it he projected collages he had made from "found" ephemera taken from his voluminous scrapbooks brimming with printed stuff—engineering diagrams and Disney characters, newspaper ads and comic book clippings. This now legendary talk signaled the birth of the Independent Group, an intellectual discussion and exhibition group, including artist Richard Hamilton, critic Lawrence Alloway, and architects Alison and Peter Smithson, whose concerns centered on the impact of popular culture, technology, and science on contemporary art and society. The group's imaginative thinking about art and the mass media spearheaded the development of a Pop aesthetic.

American pulp magazines brought back from members' trips to the United States provided the source material for the group's study of mass culture. In the early 1950s the British economy was plagued by rationing and other austerity programs as the government suppressed consumption in favor of reestablishing a strong export market. In this milieu, it was the American commodities featured in the new glossy media, which "possessed a subversive glamour," that found their way into the art of the emerging Pop scene in London.[1]

The Rise of Screenprint

Eduardo Paolozzi's collages metaphorically suggest the disordered, random quality of everyday life and echo the bombardment of visual stimuli he felt characterized postwar culture. Surrealist collage practices were a formidable influence on the young artist, who lived in Paris from 1947 to 1949, but Paolozzi's work always emphasized the complexity of contemporary imagery and the growing presence of technology in modern society. He was dissatisfied, however, with the often tattered and handmade nature of collage and sought something more mechanical, more permanent. He and other members of the Independent Group turned to photography and commercial photomechanical techniques to present their processed renderings of the everyday and refresh an artistic expression they felt had become academic and irrelevant.[2] In the 1960s Paolozzi discovered screenprint, a medium that easily reproduces photographic imagery and whose industrial history as a process used primarily for advertising posters appealed to his antielitist attitudes.[3] The populist medium enhanced the popular imagery and became part of the content of the work. This idea is behind the remarkable ascendancy of screenprint as a tool for fine art expression that occurred in the 1960s and contributed to the rise of the Pop art movement.

The realization of the artistic potential of this commercial medium came about in London largely because of the talents of a great artisan and master printer, Chris Prater, who in 1957 opened what would become the renowned

screenprint shop Kelpra Studio. Prater trained in a government-sponsored program and apprenticed with commercial screenprint shops all over London in the early to mid-1950s, before going out on his own. First producing posters for the British Arts Council, he slowly began working with artists. The turning point came in 1964 when Richard Hamilton persuaded London's Institute of Contemporary Arts to issue a benefit portfolio of screenprints. Hamilton chose the twenty-four artists to be included and enlisted Prater to do the printing.[4] The project allowed Prater to give up his commercial work and devote himself fully to fine art printing. For many of the artists involved, the ICA project was their first exposure to screenprint, and several went on to work with Prater again and again.[5]

Prater proved to be among the most inventive and experimental technicians in screenprint's short history, and transformed the medium from a means for reproduction of advertising displays into a collaborative vehicle and significant artistic tool. Paolozzi perhaps best articulated Prater's genius when he wrote, "Reinterpreting a series of collages into a sound homogenous graphic is a printer's nightmare. The interpretations by Prater were highly innovative and became, in most artists' views, highly inventive or, in some cases, another art form."[6] Paolozzi first collaborated with Prater in 1962, but it is his landmark portfolio *As Is When* (P. 48) from 1965 that is considered a Pop masterwork in screenprint.

Comprising thirteen plates, *As Is When* is a tour-de-force explosion of found printed imagery, from toy advertisements and Woolworths wrapping papers to needlepoint diagrams and electronic designs, presented as dazzling patterns and abstractions. Begun in the spring of 1964, the suite is based on the life of Viennese philosopher Ludwig Wittgenstein, who was based in Cambridge for much of his life and with whom Paolozzi, with his Italian heritage, felt kinship as an outsider living in England. Paolozzi's passion for games and puzzles also attracted him to the philosopher's study of linguistic systems. Judicious fragments of Wittgenstein's texts appear on each sheet, and while most of the prints are abstract in nature, three deal directly with his life.[7]

As Is When exemplifies Paolozzi's underlying approach of deconstruction and reconstruction. In one of the plates, *Parrot*, he fused the classical sculpted form of Laocoön with Mickey Mouse, creating a dynamic figure of stripes, checkerboards, and crosshatchings against a gridded background. The print is a further reconfiguration into two dimensions of one of the artist's best-known mechanical-looking sculptures of curving metal tubes. For some plates in the portfolio, Paolozzi cut up rejected proofs and rearranged them to form new compositions. He also began experimenting with variations in this edition, printing screens in different colors and in different orders for each impression of a print, making every portfolio a series of unique variants. He accompanied the suite with his own stream-of-consciousness text, similarly fragmenting and repositioning found passages, combining references to military aircraft, film production, and music in a collage of language inspired by Surrealist writer Raymond Roussel.[8]

Paolozzi went even further in his emulation of printed mass media formats in his unbound book *Moonstrips Empire News* (P. 49) of 1967. Also printed with Kelpra Studio, *Moonstrips* is a psychedelic compendium of texts and images comprising 101 screenprints. Paolozzi's text pages are printed in a plethora of typefaces and colors and on a variety of colored papers.[9] Several pages are even printed on clear sheets of Mylar, a newfangled product symbolic of mass production processes. In several cases the text pages appear to be lifted directly from newspapers and magazines and merely reprinted in the book's format. Paolozzi presents the sheets without a predetermined order, inviting the owner to arrange and rearrange them, editing or curating the book as they see fit. The shape of the magenta plastic box that houses the suite—another reference to high-tech, mass-produced materials—is modeled on that of an office filing tray.[10] Prater's painstaking stencil cutting, photomechanical dissection, and screenprinted reconstitution enabled Paolozzi to create a coherent vision throughout this morass of seemingly random clippings of contemporary culture. The process embodied the technological developments he championed, presenting a complete integration of art and the mass media.

As Is When and *Moonstrips Empire News* were both issued by the London publisher Editions Alecto. Begun rather casually by two Cambridge University students in 1960, Alecto came to embody the new upbeat and confident mood that characterized London in the early 1960s. Founders Paul Cornwall-Jones and Michael Deakin originally planned to commission architectural prints depicting sites around England's prep schools and universities to sell to nostalgic alumni. In 1962, upon relocating to London, their plans evolved into publishing ventures with the young artists

of the Pop generation emerging from the Royal College of Art. They opened a very visible gallery, The Print Centre, in 1963 and began a lively exhibition program, interspersing displays of their own publications with shows of contemporary European and American prints, most of which were being shown to a London audience for the first time.[11] They also embarked on an unprecedented marketing campaign for prints, sending traveling shows around Europe and featuring prints in mass-circulation magazines and newspapers as well as art and design publications.[12] Although they remained a major client of Kelpra's, in 1964 Alecto moved and opened its own printmaking studios with facilities for etching, lithography, and screenprint, which allowed for a greater focus on publishing. Alecto's elaborate printshops encouraged a collaborative atmosphere between artist and printer, and became the most professional, large-scale operation in the country. In addition to Paolozzi, their publications include important works by British artists David Hockney, Patrick Caulfield, and Allen Jones and Americans Jim Dine and Claes Oldenburg. Also among their landmark projects are several early screenprints by Hamilton.

Hamilton was the senior statesman of the British Pop art movement. In the late 1950s he turned his critical eye to the contemporary consumer culture that Britain had embraced. And, like Paolozzi, it was the mass media's interpretation of this culture, and its influence on our perceptions of reality, that fascinated him. Hamilton's inspiration was not the everyday objects around him but the advertisements, billboards, and commercial reproductions that portrayed such objects. Photography allowed him to use these processed depictions in his art, and by the early 1960s it had become integral to his prints. In fact, Hamilton's work epitomizes the fundamental role photography began to play in printed art beginning in the 1960s. As the artist has said, "Assimilating photography into the domain of paradox, incorporating it into the philosophical contradictions of art is as much my concern as embracing its alluring potential as a medium."[13]

Hamilton wanted to make art without a signature appearance, and recycling mass media photographs into new compositions became his fundamental approach. As one scholar has written, "Style became a matter of media paraphrase rather than the result of the artist's hand."[14] Hamilton's approach to "paraphrasing" involved screenprinting complex manipulations of photographs. He has written that screenprint "has a certain appeal also because it is less autographic than etching or litho—it hasn't their dependence on the hand of the artist: in that sense it is a modern printmaker's medium."[15] Hamilton made his first screenprint, *Adonis in Y Fronts* (P. 52), closely based on a painting of the prior year, in 1963 at Kelpra Studio with Prater.[16] In it he fused a medley of media clippings from the popular press, including a *Life* magazine photograph of the classic Greek sculpture of Hermes by Praxiteles, a *Playboy* photograph of a male model wearing a fashionable sweater, and a *Mr. Universo* advertisement for a chest expander for bodybuilders. The title is another media borrowing—a subtle play on the pop song "Venus in Blue Jeans."

As he contrasts these renderings of the idealized male physique, Hamilton also juxtaposes types of printmaking by abutting the photographic techniques used for the model's arms, torso, and face with the hand-cut stencils of the background. He simultaneously underscores the corresponding emotional impacts created by these varying techniques, stressing the nostalgia evoked by the figure's processed, reproduced appearance. He has said, "I was less interested in the subject matter than in the print structure, the way the image is transmitted."[17]

My Marilyn (P. 53), published in 1966, follows this collage model, but here Hamilton complicates both the process and the design. He began by enlarging publicity stills of Marilyn Monroe he found in a British tabloid magazine shortly after the star's death.[18] Eschewing any indication of the artist's touch, he constructed a collage and used a series of elaborate printing techniques, including masking, negative reversals, and several color overprintings, to create a ghostly, bleached-out memorial to the icon. The Xs—Monroe's own vetting marks—are the only personal marks on the print, yet Hamilton captures an unexpected array of visual and emotional effects from this medium known, until very recently, mainly for its commercial applications.

The glamour of Hollywood and the cult of the celebrity were recurrent themes in Pop art, and they reveal another aspect of Hamilton's fascination with the mass media and its influence.[19] In *My Marilyn* he underscores the sense of vulnerability and exposure that defined Monroe's life in the media spotlight. That sentiment also inspired a series he began in 1968 that examines the notoriety and sensationalist media coverage surrounding an incident involving his art dealer, Robert Fraser, and rock star Mick Jagger. Here Hamilton lifted a photograph from

London's *Daily Mail* newspaper showing the two men handcuffed together in a police van after being arrested on drug charges. Typical of Hamilton's working method, this image progressed through various iterations. His first rendering was an offset collage of press clippings about the story, highlighting media manipulation of the public's perception of the event. He followed this with an etched close-up of the arrest scene and six paintings.

In 1972 Hamilton was approached for help by Release, an organization that offered free legal assistance to people in trouble with the law, usually for drug offenses. He turned to the same *Daily Mail* photograph for this benefit project, and created a haunting screenprint interpretation, aptly titled *Release* (P. 54). The depiction of the camera's flash communicates a strong sense of the reporters' invasiveness and also focuses the viewer's attention on the handcuffs, enhancing the sense of being trapped. Hamilton made another screenprint from the Fraser/Jagger photograph, a dazzling work titled *Swingeing London III* (P. 54). Although he reused several of the screens from *Release* for the new print, he notably omitted the black photographic screen, creating a flat, diagrammatic depiction of dense, saturated color.[20] The work exudes an artificial, and less ominous, sensibility; its decorative power seems to comment on the streamlined, reductive impact of Pop art practices. In comparison to *Release*, *Swingeing London III* establishes a tension between illusionistic strategies and photographic "reality," illuminating Hamilton's deeply held interest in methods of image-making.

Other forms of mass-produced printed ephemera proved important to artists of the period as well. Hamilton's close friend Dieter Roth was obsessed with picture postcards. Arguably best known for his revolutionary prints made by sending foodstuffs through a printing press, Roth was also prolific in more traditional forms of printmaking, such as etching, lithography, and screenprint, and he often used screenprint in combination with postcards. His interest in this popular printed format began when he moved to remote Iceland and embarked on postcard correspondences with friends abroad. Roth completed several important print series appropriating commercial postcards of popular tourist attractions in ways similar to Pop artists' borrowing of found magazine and newspaper photographs.[21] The series of prints titled *Hat* (P. 55) was his first such project.

Roth moved to Providence in 1965 to be an instructor in printmaking at the Rhode Island School of Design,

where he experimented widely with the medium. He also commuted to New Haven during that year to teach at Yale. From his earliest screenprints in the late 1950s he had played with altering his editions, changing his print sequences and frequently adding hand additions. The screenprints from *Hat* exemplify this approach. Each work in the series comprises several layers. Roth first abutted two existing postcards illustrating a bay in Iceland to form a mirror image of the landscape. He made a photomechanical enlargement of the composite and screenprinted it in different colors onto several different papers. He then stenciled the background, outlining the shape of a bowler over the postcard images. Finally, he layered hand-applied and spray-painted additions on top.[22] The bowler hat also appears in one of Roth's well-known self-portraits and may be a stand-in for the artist himself, here accompanied by a glimpse of his adopted homeland peering through.[23] Roth veils the underlying postcard image to varying degrees throughout this series, portraying a banal, mass-produced yet picturesque image as though floating in and out of his own nostalgic thoughts.

Screenprint also appealed to painters trying to evoke the brashness of the contemporary consumer culture with vivid, often psychedelic effects. The process allows for heavier ink deposits than other printmaking mediums, which, in turn, produce the densest, most saturated color, and its masking and stencil-cutting techniques can achieve crisp edges and clean outlines. These features made it particularly attractive to Patrick Caulfield. Caulfield's realist paintings of everyday objects are distinguished by an austere economy of means. Composed of flat, vibrant blocks of colors and broad, black outlines, his schematic compositions naturally lent themselves to screenprint. Hamilton introduced Caulfield to the medium when the latter participated in the 1964 ICA benefit portfolio, and following that experience Caulfield became an enthusiastic printmaker. Screenprint's potential for unmodulated and anonymous surfaces ideally suited the cool and detached aura of his paintings. His early work frequently depicted angular, often gridlike objects, and when he returned to Kelpra in 1968 he completed a series of several rectilinear objects that hang on a wall—a bathroom mirror and a café sign among them. *Bathroom Mirror* (P. 50) engages the viewer with its straightforward presentation and disorienting interplay of two grids. Caulfield's whimsical use of the mirror's reflection

to suggest foreground and background spaces is typical of his perceptual games between surface realities and three-dimensional illusion. This print also evokes the tension between abstraction and representation that animates many of his early works. *Café Sign* (P. 50) alludes to Cubist painting, a passion of Caulfield's, with its common café motifs, and the trompe l'oeil nails that attach the sign to the wall are a direct Cubist borrowing. Its bold, limited palette and graphic clarity—even its sans-serif typeface—display the distilled virtuosity that made Caulfield one of the leading proponents of screenprint's revival in England during this period.

Bridget Riley's work perhaps best illustrates the capabilities of the screenprint medium as an aesthetic tool for abstract art. Like Caulfield, Riley eschews the autographic mark of the artist and requires a carefully crafted precision, two qualities that correspond perfectly with screenprint's capabilities. Her nonrepresentational art involves a translation of experience into pure visual sensation, one that conjures involuntary visceral and emotional responses. Her black-and-white works of repeated geometric bands vibrate with a kinetic energy that aligned her with the Op art movement, although her work possesses a psychological as well as a formal impact.

A sporadic printmaker, the visual excitement of her series of seven screenprints, *Fragments* (P. 51), rivals that of any of her paintings. Riley also worked at Kelpra Studio and found the collaborative atmosphere there quite natural, since it paralleled the working method she had established with the assistants in her painting studio. In talking about *Fragments*, Riley has noted, "During the preparatory work for a painting, I may make images which are tangential to the problems posed by the particular painting. Some of these images I return to and develop later, others remain as fragments of a theme. These prints are a selection from such fragments in my folios and cover a period from 1962–1965."[24] One of the most distinctive features of the works in this series is their support; instead of paper, Riley printed on the verso of clear plastic sheets, first the black patterns and then the white background. The use of plastic meant the prints did not need to be framed with glass, which was one of Riley's initial attractions to the material. Synthetics like plastic also symbolized the forward-looking attitude and passion for the novel that characterized the Swinging '60s. Riley has said, "We were excited about trying new materials—we all wanted the new."[25] This inspired choice fused with her optical imagery created a seamless expression of contemporary artistic ideas.

Many other artists exploring hard-edge abstract work were also attracted to screenprint. In Germany, one of the oldest and most prolific screenprint workshops, Edition Domberger in Stuttgart, developed an expertise in precision printing and worked with artists ranging from Willi Baumeister and Herbert Bayer to François Morellet and Victor Vasarely, though they collaborated with artists across other stylistic tendencies as well.[26] In the late 1960s and early 1970s several artists working with the serial systems of Conceptual art also tried screenprint.

In France, Morellet was a pioneer in the field of systemic art and, beginning in 1961, transformed his mathematically derived optical patterns into more than 150 print projects. For nearly twenty years he worked almost exclusively in screenprint, preferring the medium's crisp edges and sleek surfaces for the depiction of his geometric patterns. He completed several portfolio projects, finding the format's sequential nature an excellent vehicle to investigate his permutations of patterns. In *8 Wefts 0°90°* (PP. 66–67) Morellet progressively tightens his checkerboard grid across a series of eight sheets. Beginning with single black bands bisecting the sheet vertically and horizontally, he increased the number of bands on each sheet from three, to five, to seven, and so on, until he attained a dense, nearly impenetrable network that reads as an overall black image. Notably, he printed on both sides of the eight sheets, the verso displaying the same system using thin, delicate lines instead of wide bands.

Another artist whose work examined Conceptual systems is Blinky Palermo. His emphasis was on color and the manipulation of space. Screenprint's thick deposits of ink approximate the physical presence of paint better than any other printmaking medium, and Palermo exploited this potential. He made his first print, a screenprint of a blue triangle, in 1966, but did not embark on the medium seriously until 1970, when he made *4 Prototypes* (P. 63). For this portfolio Palermo printed four of the quasigeometric forms that became his hallmarks in the late 1960s—loosely drawn blue and green triangles, a black square, and a gray cloudlike oval. He combined them here not only as representatives of his "models" or "prototypes" but to play with their interrelationships and discover new solutions. The blue triangle, in particular, appeared in many other formats beginning in 1965—as painted object, multiple, and individual screenprint—and Palermo enjoyed reprising

this form in new contexts. In *4 Prototypes* he fixed the order of the images as well as their installation, indicating they be hung either as a horizontal row or in a block of two over two.[27] After this portfolio Palermo went on to experiment actively with screenprint's rich surfaces.

Advantages of Offset

Issues surrounding mass media techniques and sources were also fundamental to the artistic thinking of Gerhard Richter and Sigmar Polke in Germany in the 1960s, and such preoccupations arose in their printmaking as well as their painting. The two artists, separated in age by nine years, met at the Kunstakademie Düsseldorf, where the older Richter enrolled after emigrating from East Germany in 1961. Sharing a common heritage—Polke, too, had emigrated from the East when he was much younger—the two artists formed a close friendship that nourished their artistic development into the early 1970s. They not only exhibited together, but occasionally even worked on joint art projects.[28]

During their years at the academy, the two artists were students of Karl-Otto Götz, a respected *Informel* painter. Given Richter's earlier study and practice of government-dictated Socialist Realism in the East, Götz's abstracted expressionist style was surely a sign of artistic freedom. Yet both would rebel against the notions of subjective expression and painterly touch that were the hallmarks of *Informel*. Drawn to more mechanized qualities in art, Richter and Polke adopted photographic imagery, gathered from newspapers and magazines. As Richter has noted: "The photograph, which plays an enormous part in everyday life, took me by surprise. Suddenly I could see it quite differently: as an image which, deprived of all the conventional criteria which I had till then associated with art, provided me with a new way of seeing."[29]

In printmaking, both artists turned to techniques that could easily depict such imagery, including offset lithography, which predominates in their work even to this day. A technique in use since the early twentieth century for commercial purposes, in the 1960s and 1970s offset gained appeal with artists who valued the fact that it is easy and fast to produce, can generate large editions, and is relatively inexpensive, since it does not require traditional workshops and specialized printers. In addition, it has the advantage of producing imagery that is not reversed, as is the case in most printmaking techniques.

The visual appearance of an offset print is somewhat difficult to describe, since it does not involve the expressive marks or tactility of an etching or woodcut, the painterly effects traditionally associated with lithography, or the thick, opaque surfaces of screenprint. Through photomechanical means, offset faithfully reproduces its source materials, adding little of what has been described as individualized "syntax."[30] Such "transparency" perfectly suited the needs of Richter and Polke for the mass media imagery they adopted at this time.[31] In fact, since this source material was itself produced photomechanically, their prints shared many characteristics of the ephemeral visual culture that surrounded them. What they added were elements of ambiguity and critique, achieved through manipulations of this material that often gave it a degraded quality.

Presented here are Pop-inspired examples of their work from the mid-to-late 1960s as well as prints from the early 1970s that adopt strategies of Conceptual art, all created with techniques that easily manipulate photographic imagery. In the 1960s Richter and Polke, and others in their circle, were enamored of the Pop art emanating from the United States and Britain and known to them through traveling exhibitions and reproductions in art magazines. They were also drawn to the antic behavior of the Fluxus group, whose impact was felt across Europe. In fact, through the invitation of artist Joseph Beuys, another teacher at the Kunstakademie Düsseldorf, a Fluxus festival was staged in that city in 1963. Richter has noted: "I was very impressed with Fluxus. It was so absurd and destructive. It inspired me to try out some real nonsense, like copying photographs in oil paint."[32] And it was this spirit that also characterized *Life with Pop: A Demonstration for Capitalist Realism*, the proto-performance piece staged by Richter and fellow student Konrad Lueg (later, art dealer Konrad Fischer) in 1963 in a local furniture store. With irony, the term Capitalist Realism referenced both Soviet-style Socialist Realism of East Germany and the rampant commodity culture sweeping West Germany in this period of "economic miracle."

In 1967 the young René Block of Berlin, who had been running "one of the most important and progressive" galleries in Germany,[33] issued a portfolio titled *Graphics of Capitalist Realism*, with prints by Polke, Richter, and Lueg, as well as KP Brehmer, K. H. Hödicke, and Wolf Vostell. Polke's *Weekend House* (P. 60), a screenprint from that port-

folio, derives from a newspaper advertisement that evinces consumer desire for leisure-time pursuits. Another of his prints, *Girlfriends I* (P. 60), from the same year but not in that portfolio, reflects similar sources and content, and employs the technique of offset. Both prints display what would become one of Polke's signature stylistic motifs: the dot matrix pattern used in commercial printing. Though typically so small it is not evident to the naked eye, Polke makes the pattern immediately visible, declaring the artificiality inherent in his picture's construction. Deprived of the illusion of glamour, the dream house and the frivolous bathing beauties instead become subjects of irony and skepticism, alluding to the superficiality of so many objects of desire. Describing his dot patterning, Polke has said: "I like the...cliché quality... I like it for its impersonal, neutral, fabricated quality.... It dissects, disperses, organizes and makes everything the same."[34]

Richter turned to certain political themes in prints of this period and, like Polke, found material in newspaper photography. *Elisabeth II* (P. 59) of 1966 portrays a celebrated subject but emanates a sense of strangeness, the result not only of the enlarged and visible dot pattern but also of the blurriness that Richter achieved by first rephotographing a news clipping.[35] Affected by such manipulations, we begin to lose confidence in the "reality" we think we know through the mass media. Similarly, in the 1968 print titled *Mao* (P. 58), Richter makes an immediately recognizable figure elusive. He has again blurred his source image[36] before employing the photomechanical printing technique of collotype, which maintains the softened contours and mysterious shading he produced through photography. The ghostly apparition that results produces a combination of awe and foreboding. At this time Mao's ideas, as presented in his *Little Red Book* of quotations and brought to fruition in China's Cultural Revolution, were capturing the imaginations of progressives worldwide.[37] The large edition of this print, comprising five hundred examples, underscores the idea of dissemination. For *Airplane II* (P. 56), a screenprint depicting fearsome fighter planes, Richter again embeds his imagery with a sense of irony by selecting a bright, Pop-like palette.[38] With his color choice and off-register printing, Richter reminds us that this is a constructed reality. Further, by giving us an image so decadently glamorous he also seems to suggest that demonstrations of military strength contain an element of the erotic.

The late 1960s and early 1970s saw many artists turning to conceptually based ideas in their work, and this direction applies to Richter and Polke as well. Their pictorial structures remained photographic, however, and their printmaking followed suit with photomechanical means. In Polke's *TV Picture (Kicker) I* (P. 62), the strange apparatus depicted in a shadowy atmosphere is first perceived almost as a Surrealist abstraction. The title may provide some clue as to the subject, but the overall quality of the image is mysterious and otherworldly. To achieve this look, Polke first made a blurry, close-up photograph of an existing photograph of a table soccer game. He wrinkled this new photograph into a ball, then smoothed it out and photographed it again.[39] The final step was to create the offset print version, adding yet another degree of separation. Distracting elements, like the creases left by wrinkling the paper and the random light reflections caused by them, add to the disquieting mood of the overall image. In completing the edition Polke unexpectedly combined the commercial technique of offset with handmade papers of different colors, simulating variant inkings. Perhaps he is poking fun at printmaking conventions and traditional connoisseurship, since the prints were published by Griffelkunst-Vereinigung, a society that fosters print collecting.

The photography incorporated in two cloud studies by Richter, *Cloud* and *Clouds* (P. 57), was not gleaned from mass media sources but rather was taken by the artist himself. Over the years Richter has shot countless photographs of sky and clouds from the windows of airplanes. Such views are archived in a celebrated compendium titled *Atlas*, containing not only his own photographs but also all kinds of found imagery, and totaling thousands of examples.[40] Among the seascapes, cityscapes, landscapes, and skyscapes found there are some that have been cut apart and montaged with fragments of others. Richter exploits this aesthetic in both *Cloud* and *Clouds*, though the evidence of his cutting and pasting is obliterated by the offset technique he employs to transfer the collage into a print. These two scenes appear at first glance to be conventional studies, but closer inspection reveals an eerie disequilibrium. In *Cloud*, Richter brings the single floating white mass far too close to the surface of the ocean; in *Clouds*, he turns the top portion upside-down. With these images Richter seems to pose questions—perhaps presciently, given the widespread use of computer-manipulated photographs today—about how one both perceives the world

Eduardo Paolozzi

[BRITISH, 1924–2005]

Parrot and **He Must**, **So to Speak**,
Throw Away the Ladder
from **As Is When**, 1965
Two from a portfolio of
thirteen screenprints

PAGE: 37¹³⁄₁₆ x 25⁷⁄₈" (96 x 65.7 cm)
PUBLISHER: Editions Alecto, London
PRINTER: Kelpra Studio, London
EDITION: 65

The Museum of Modern Art, New York.
Joseph G. Mayer Foundation Fund, 1967

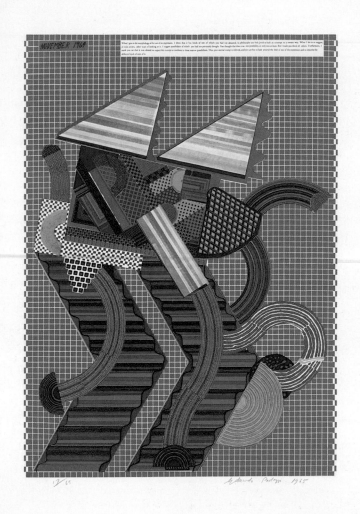

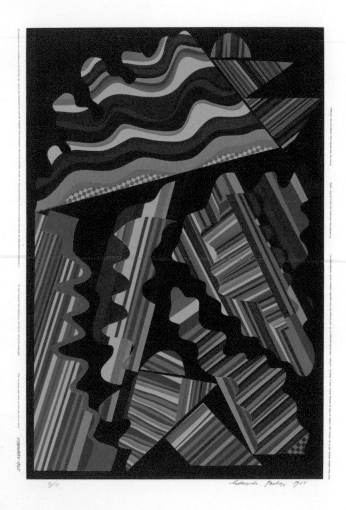

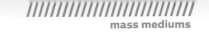

Moonstrips Empire News, 1967
Illustrated book with 101 screenprints

PAGE: 14 15/16 x 9 15/16" (38 x 25.2 cm)
PUBLISHER: Editions Alecto, London
PRINTER: Kelpra Studio, London
EDITION: 500

The Museum of Modern Art, New York.
Gift of the artist, 1967

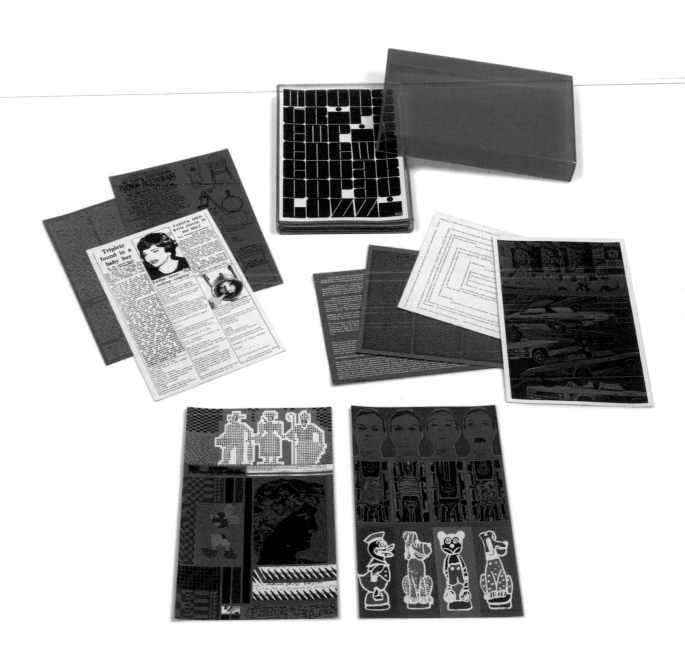

Patrick Caulfield

[BRITISH, 1936–2005]

Bathroom Mirror, 1968
Screenprint

SHEET: 27 15/16 x 36 11/16" (71 x 93.2 cm)
PUBLISHER: Leslie Waddington Prints, London
PRINTER: Kelpra Studio, London
EDITION: 75

The Museum of Modern Art, New York.
Marnie Pillsbury Fund, 2005

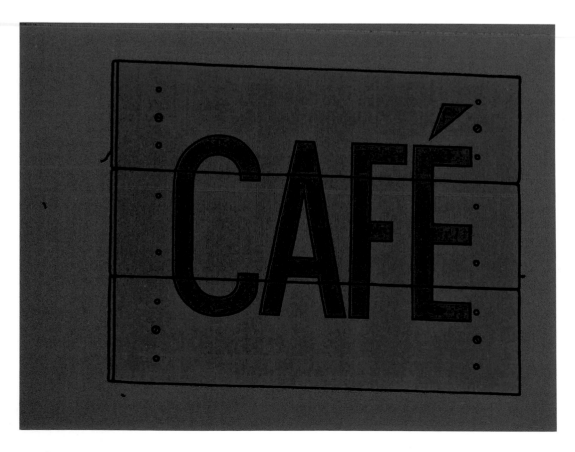

Café Sign, 1968
Screenprint

SHEET: 27 15/16 x 36 3/4" (71 x 93.3 cm)
PUBLISHER: Leslie Waddington Prints, London
PRINTER: Kelpra Studio, London
EDITION: 75

The Museum of Modern Art, New York.
Marnie Pillsbury Fund, 2005

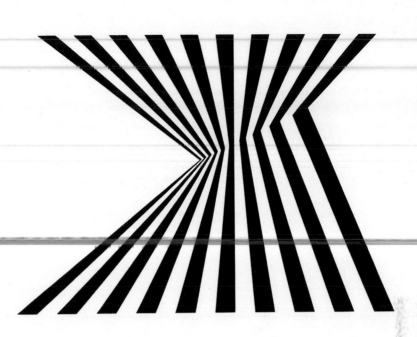

Bridget Riley

[BRITISH, born 1931]

Untitled (**Fragment 1**) (top) and
Untitled (**Fragment 3**) (bottom)
from **Fragments**, 1965
Two from a series of seven screenprints
on Perspex

SHEET: 26¹/₂ X 33" (67.3 x 83.8 cm) (top);
24⁷/₁₆ X 31¹¹/₁₆" (62.1 x 80.5 cm) (bottom)
PUBLISHER: Robert Fraser Gallery, London
PRINTER: Kelpra Studio, London
EDITION: 75

The Museum of Modern Art, New York.
Edward John Noble Foundation Fund, 2005 (top)
Private collection, London (bottom)

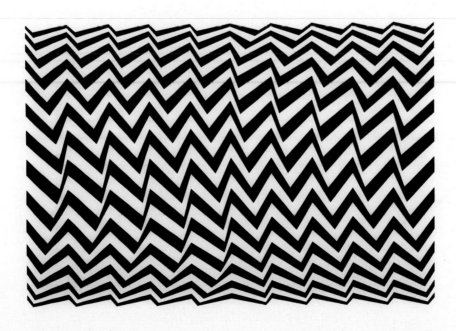

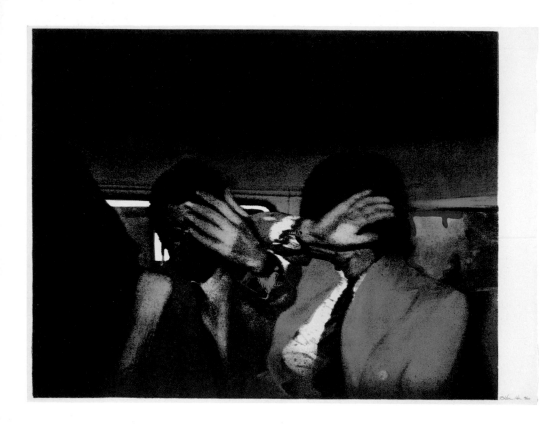

Richard Hamilton
[BRITISH, born 1922]

Release, 1972
Screenprint with collage additions

SHEET: 27⅝ X 37³/₁₆" (70.1 X 94.4 cm)
PUBLISHER: Petersburg Press, London,
for the National Council for Civil Liberties
(NCCL), and Release, London
PRINTER: Kelpra Studio, London
EDITION: 150

The Museum of Modern Art, New York.
Johanna and Leslie J. Garfield Fund, 2006

Swingeing London III, 1972
Screenprint with collage additions

SHEET: 27⁹/₁₆ X 37⅛" (70 X 94.3 cm)
PUBLISHER: Petersburg Press, London
PRINTER: Kelpra Studio, London
EDITION: 19

Collection of Johanna and Leslie J. Garfield

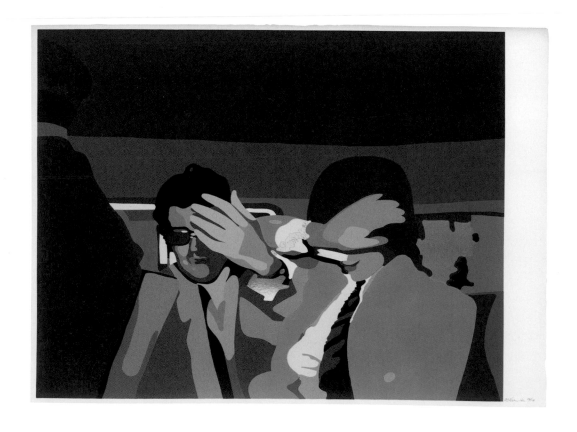

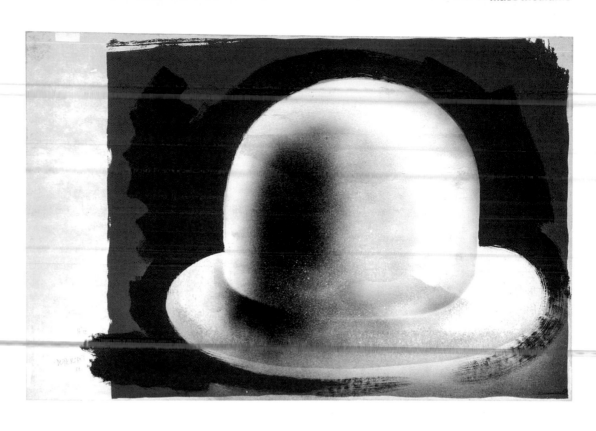

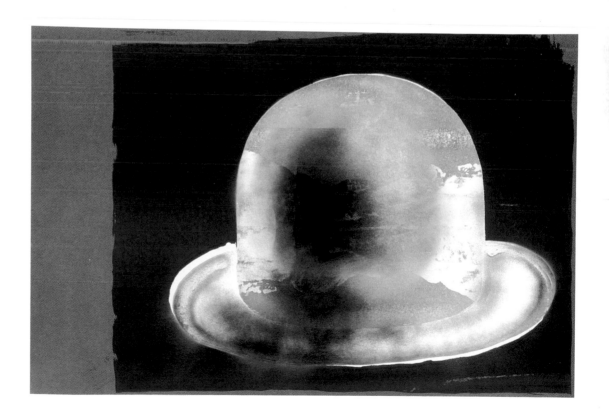

Dieter Roth

[SWISS, born Germany. 1930–1998]

Hut (**Hat**), 1965
Screenprints on offset,
with hand additions

SHEET: 25 9/16 X 35 7/16" (65 x 90 cm)
PUBLISHER AND PRINTER: the artist,
New Haven, Conn.
EDITION: 2 of 50 variants

Dieter Roth Foundation, Hamburg

55

Gerhard Richter

[GERMAN, born 1932]

Flugzeug II (Airplane II), 1966
Screenprint

SHEET: 24 x 33⅞" (61 x 86 cm)
PUBLISHER: Galerie Rottloff, Karlsruhe, Germany
PRINTER: Löw, Stuttgart
EDITION: 20

The Museum of Modern Art, New York.
Ann and Lee Fensterstock Fund, Alexandra
Herzan Fund, and Virginia Cowles Schroth
Fund, 1998

Wolke (Cloud), 1971
Offset
SHEET: 25 1/8 X 23 9/16" (63.8 X 59.8 cm)
PUBLISHER: Kunstring Folkwang,
Essen, Germany
PRINTER: Richard Bacht, Essen, Germany
EDITION: 150

The Museum of Modern Art, New York.
Gift of the Cosmopolitan Arts Foundation, 1978

Wolken (Clouds), 1969
Offset
COMP.: 17 11/16 X 15 11/16" (45 X 39.9 cm)
PUBLISHER: Griffelkunst-Vereinigung, Hamburg
PRINTER: unknown
EDITION: 300

Collection Griffelkunst, Hamburg

Gerhard Richter

[GERMAN, born 1932]

Mao, 1968
Collotype

SHEET: 33 x 23 3/8" (83.9 x 59.4 cm)
PUBLISHER: Galerie h, Hannover
PRINTER: Hannover Lichtdruck, Hannover
EDITION: 22; plus an unsigned edition of 500

The Museum of Modern Art, New York.
Jeanne C. Thayer Fund, 1993

Elisabeth II, 1966
Offset

SHEET: 27 9/16 X 23 3/8" (70 X 59.4 cm)
PUBLISHER: Galerie h, Hannover
PRINTER: Osterwald, Hannover
EDITION: 50

The Museum of Modern Art, New York.
Gift of the Cosmopolitan Arts Foundation, 1978

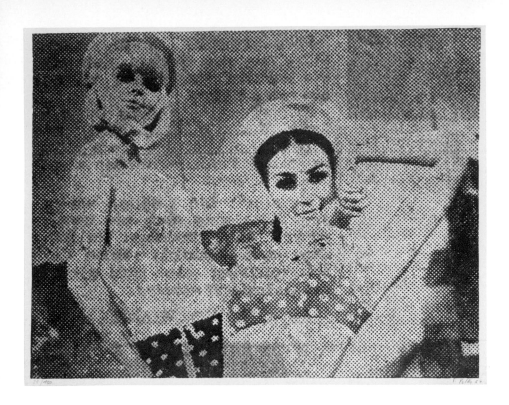

Sigmar Polke

[GERMAN, born 1941]

Freundinnen I (Girlfriends I), 1967
Offset

SHEET: 18 1/2 x 23 7/8" (47 x 60.7 cm)
PUBLISHER: Galerie h, Hannover
PRINTER: Freimann and Fuchs, Hannover
EDITION: 150

The Museum of Modern Art, New York.
Richard A. Epstein Fund, 1984

Wochenendhaus (Weekend House) from
**Grafik des Kapitalistischen Realismus
(Graphics of Capitalist Realism)**, 1967
Screenprint from a portfolio by various
artists

SHEET: 23 5/16 x 33 1/16" (59 x 83.9 cm)
PUBLISHER: René Block for Stolpe Verlag, Berlin
PRINTER: Birkle, Thomer, & Co., Berlin
EDITION: 80

The Museum of Modern Art, New York.
Linda Barth Goldstein Fund, 1995

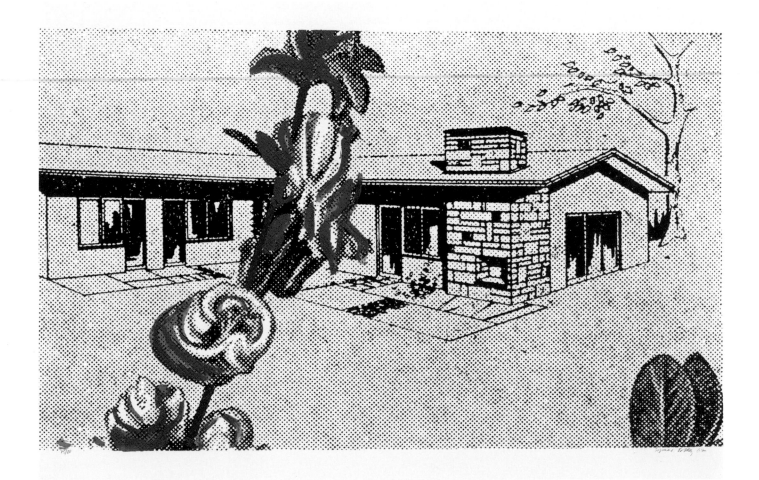

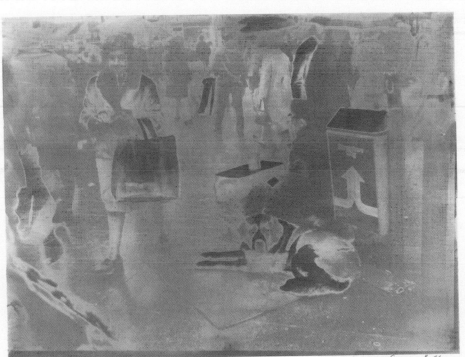

Kölner Bettler I (Cologne Beggars I) and
Kölner Bettler III (Cologne Beggars III),
1972
Two from a series of four offsets
COMP. (APPROX.): 13 X 17 5/16" (33 X 44 cm)
PUBLISHER: Edition Staeck, Heidelberg
PRINTER: Gerhard Steidl, Göttingen, Germany
EDITION: 100
The Museum of Modern Art, New York.
Walter Bareiss Fund, 1988

Sigmar Polke

[GERMAN, born 1941]

Fernsehbild (Kicker) I
(TV Picture [Kicker] I), 1971
Two from a series of four offsets

SHEET: 25 3/16 x 32 13/16" (64 x 83.3 cm)
PUBLISHER: Griffelkunst-Vereinigung, Hamburg
PRINTER: Ferdinand Baruth, Reinbek, Germany
EDITION: 120 on green paper; 141 on
yellow paper

The Museum of Modern Art, New York.
Walter Bareiss Fund, 1988 (top)
Collection Walker Art Center, Minneapolis.
T. B. Walker Acquisition Fund, 1994 (bottom)

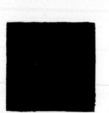

Blinky Palermo
[GERMAN, 1943–1977]

4 Prototypen (4 Prototypes), 1970
Four screenprints

SHEET (EACH): 23 1/2 x 23 9/16" (59.7 x 59.9 cm)
PUBLISHER: Edition der Galerie Heiner Friedrich
and Edition X, Munich
PRINTER: Atelier Laube, Munich
EDITION: 90

The Museum of Modern Art, New York.
Gift of the Cosmopolitan Arts Foundation, 1974

Daniel Buren

[FRENCH, born 1938]

Untitled, 1969–74
Series of double-sided posters/
exhibition announcements
(1973 verso shown bottom right)

SHEET: 20 1/2 x 30 3/16" (52.1 x 76.7 cm)
PUBLISHER: Wide White Space Gallery, Antwerp
EDITION: as needed for mailing and installation

The Museum of Modern Art, New York.
The Associates Fund, 2006

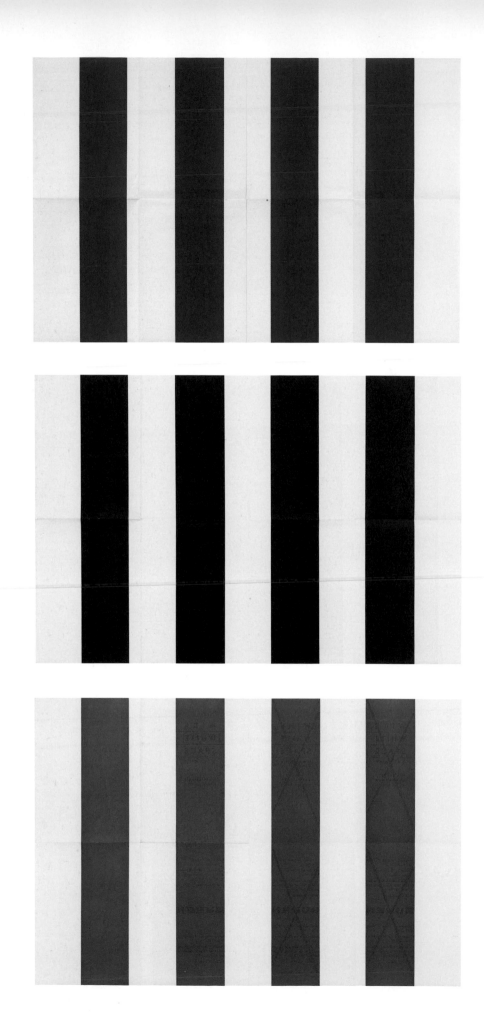

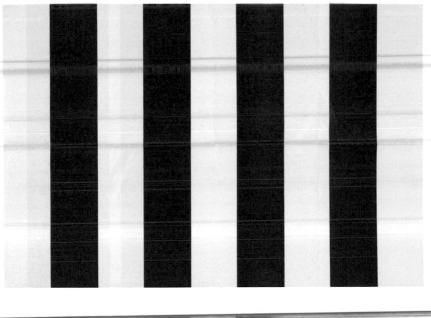

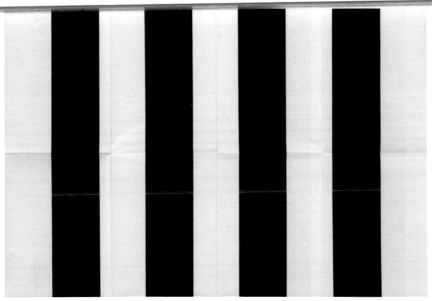

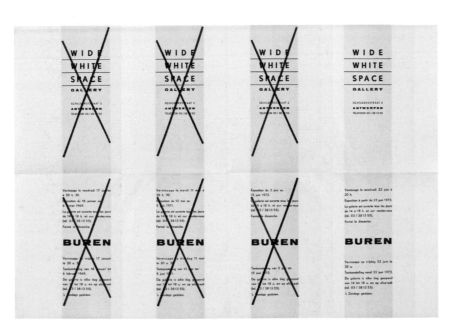

François Morellet

[FRENCH, born 1926]

8 Trames 0°90° (**8 Wefts 0°90°**), 1974
Four from a portfolio of eight
double-sided screenprints

SHEET: 23⁵/₈ X 23⁵/₈" (60 x 60 cm)
PUBLISHER: Éditions Média, Neuchâtel,
Switzerland
PRINTER: seri-m.h., Neuchâtel, Switzerland
EDITION: 100

The Museum of Modern Art, New York.
Blanchette Hooker Rockefeller Fund, 1990

language

Letters, numbers, dates, musical notes. Symbols, systems,

sounds, sequences. These were raw material for a wide range of art in the 1960s and 1970s—art that was cerebral rather than sensuous. Often referred to as Conceptual, particularly by its youngest practitioners, this art encompasses a range of strategies and approaches employed by artists who spanned generations. Certain older figures also garnered attention because their work fit this mode, which bypassed traditional painting and sculpture. All these artists experimented with language in literal or invented forms, realizing its potency as a tool for visual and intellectual contemplation.

Art in printed formats was a natural outcome of these developments, not only individual sheets framed for the wall but also books, journals, exhibition catalogues, mailers, and ephemera, from postcards to record jackets. Commercial offset was the technique most often incorporated to make language-based concepts tangible. While letterpress, screenprint, and lithography were also employed, the more tactile processes of etching and woodcut generally were not. Similarly, the traditional workshop and publisher saw rivals in the production of printed formats from the likes of museums and galleries, which supported artists they exhibited by issuing a range of materials that was relatively easy to create and distribute. Publishers specializing in the new artist's book format arose as well, and artists realized

that they could work with commercial printers directly and generate projects on their own.

Conceptual Practices

The terms Conceptualism and Conceptual art came into broad currency as new forms appeared that dematerialized the art object and focused instead on ideas. Some artists were responding to what they considered an empty formalism in painting, or rejecting the commodity status of art aimed at the upper realms of a consumer society. Conceptual art aimed to foil such developments with sober texts, or performances and environmental works that could not be purchased. An exhibition opening in Bern in 1969 captured the new artistic sensibility with its fitting title, *Live in Your Head: When Attitudes Become Form*.

While the challenges set forth by the work of Marcel Duchamp earlier in the century certainly carried over to this new art, there were other artists working from the 1940s to the 1960s whose concerns can be seen as precursors to these language-based manifestations. Some of this text-based work follows in a long tradition of what can be generally termed "visual poetry," perhaps extending as far back as Egyptian hieroglyphics. But in the modern period there was a particular preoccupation with how text looked on a page, fueled by a belief that the visual composition of words was integral to their

overall meaning. Poets like Stéphane Mallarmé in the late nineteenth century and Guillaume Apollinaire in the early twentieth century demonstrated their sensitivity to such issues, and Italian and Russian Futurists continued these explorations. Cubist and Dada collage also gave elements of language a role in their overall schema. In addition, the Dadaists, with their antics, served as a model for public performances by the *Lettriste* group in France in the 1940s and 1950s. Founded by Isidore Isou, *Lettrisme* sought to reduce poetry to letters, signs, and sounds, with no concern for coherent thought. This focus eventually led to paintings, drawings, books, and films, all formed from configurations of letters. Guy Debord, an early member of the *Lettristes*, splintered off from that group to constitute another, called Situationist International. Most active in the late 1950s and early 1960s but continuing for more than a decade, the Situationists fostered investigations of the urban environment and encouraged direct interventions in daily life. Their subversion of traditional art practices and critique of consumer society further nourished artistic strategies in the years that followed.

More closely linked to a traditional vocabulary of the visual arts was the movement of Concrete poetry, founded in the mid-1950s and still practiced today. These poets generate meaning from words and word fragments built out of typographical fonts with stripped-down, abstract shapes. They seek a universal clarity that relates their work to that of the renowned Bauhaus school of the 1920s and 1930s in Germany, where utopian goals and geometric abstraction prevailed. The poet, publisher, and typographer Hansjörg Mayer has said of the elements found in Concrete poetry: "I am only concerned with the use of the 26 lower case letters of the alphabet and ten numerals....It is necessary to get away from personal taste and style, the constructed letter based on line and circle is my material."[1] Mayer published the journal *futura* (P. 91) from 1965 to 1968, each issue of which, by an individual poet-artist, was a folded sheet of the same dimensions, featuring abstracted poetic compositions set in the Futura font. Robert Filliou broke rank with a sheet meant to be folded into one of his signature hats.

Poetics

In its engagement with language and ideas, Conceptual art embraced certain figures who had previously been involved with poetry, playwriting, or other literary pursuits. Some, like Belgian Marcel Broodthaers, were in their forties by the time their work was recognized in a visual arts context. Born in 1924, Broodthaers had been a published poet, bookseller, and even a museum docent before he decided to turn decisively to art in 1964. It was with a book of his poetry, *Pense-Bête*, that he made this step: gathering together fifty unsold copies, he immobilized them in a clump of plaster and displayed them on a base as sculpture. He also collaged a number of these books with squares and rectangles of monochrome colored papers, obliterating parts of the text (P. 83). Both gestures stifled poetic expression as the verbal morphed into the visual. A few years later Broodthaers would similarly "silence" Mallarmé by altering his celebrated text, *Un Coup de dés jamais n'abolira le hasard* (P. 83). He substituted black lines of varying length and thickness for Mallarmé's eccentrically laid-out poetry of different font sizes. In both of these works Broodthaers employs a minimalist vocabulary of geometric shapes that can be seen as a latter-day outgrowth of Kazimir Malevich's abstract compositions of the early twentieth century.

Broodthaers's practice also included sculpture and installation, often critiquing art's institutional framework and its commodity status. About the latter he said: "In reality I do not believe it is legitimate to seriously define Art other than in light of one constant factor—namely the transformation of Art into merchandise."[2] This sentiment is embodied in the diptych *Gedicht–Poem–Poème/Change–Exchange–Wechsel* (P. 82), in which Broodthaers conflates the poetic, the artistic, and the economic in a commentary on the status conferred simply by an artist's initials. Broodthaers presents his own "M.B." in groups, as if they were numbers, and totals their worth in German marks, French francs, British pounds, and American dollars.

In Spain, Joan Brossa, a poet and playwright, had, like Broodthaers, been influenced by Surrealist thinking early on. While Broodthaers befriended René Magritte, a fellow Belgian whose paintings coupled provocative texts with images, Brossa found inspiration in the friendship and work of Joan Miró. Like many other Surrealists, Miró employed written words as elements of his compositions. His attention to the visual properties of language and the playful irrationality of his themes were clearly an influence on the younger Brossa.

Brossa was integral to Spanish avant-garde circles that remained intact but basically underground during the rule of Francisco Franco. He experimented with words

and letters throughout the 1950s and 1960s in a practice that echoed Concrete poetry. In fact, it may have been his increasingly reductive use of words that eventually led to the addition of pictures to complete his poetic structures.[3] Brossa also began to give his poetry three-dimensional sculptural form, creating what he called "object-poems" that would eventually bring his work to the attention of the Conceptual art generation and give it a firm place in the realm of the visual arts. These works were made up of commonplace objects either slightly altered or put in provocative juxtapositions. The artist likened the transformative effect of such couplings to magic: "I think poetry and magic are the same thing under two different names."[4] This effect is also found in Brossa's printed images, such as *Rails* and *Convoy* (P. 84), both of which employ letters in the stripped-down fonts of Concrete poetry and include pictorial references to the everyday world. The results are visual riddles, both whimsical and unsettling.

Another experimental current in Spain at this time combined language and music. Juan Hidalgo was classically trained in piano and music composition but, like others in the 1960s, became influenced by the radical theories of John Cage, whose performances included sounds from everyday life. In 1964, soon after the first Fluxus manifestations elsewhere in Europe and with Spain still under Franco's regime, Hidalgo and his friends succeeded in establishing Zaj, a Fluxus-like group of visual artists, musicians, and writers. Inserting provocative "actions" into daily routines, Zaj artists called their performances "Zaj concerts." One consisted of an artist drinking a glass of milk. Invitations to such events were printed on cards, as were brief poems, phrases, and short narratives that gave ephemera a distinctive role in the group's activities. Some printed Zaj phrases were called "etceteras," and were meant "to provoke and open up a new path of understanding for the spectators through reflection."[5] One example simply lists people admired by the group. The etceteras by Hidalgo considered here explore geopolitical themes by combining elongated versions of national flags with words or short texts referencing that country (PP. 92–93). The British flag, for example, is printed only with the word "Shakespeare."

The model of poet-as-artist was also found in Ian Hamilton Finlay of Scotland, who represented a quixotic combination of talents nourished by the Conceptual art movement. Known in the 1960s as Britain's foremost practitioner of Concrete poetry, Finlay both edited a related magazine, *Poor.Old.Tired.Horse*, and founded a publishing firm, Wild Hawthorn Press. The last issue of the periodical appeared in 1968, but the press continued up to the artist's recent death, issuing hundreds of his booklets, prints, cards, and other ephemera. Most celebrated for his innovative landscape art, Finlay had moved to the countryside in 1966, where he started a garden called Little Sparta. That environmental project now contains all kinds of sculptural elements, including temples, sundials, and stones carved with words and phrases, on themes from Greek Classicism and the French Revolution to maritime history and modern warfare. These themes also found their way into Finlay's voluminous body of printed ephemera. Such small-scale works combine imagery, often devised with collaborators, with text, some invented, some borrowed (P. 97). By the time this material was issued, Finlay was no longer bound by the fonts used in Concrete poetry and instead chose type styles that echoed his thematic concerns. His messages on these miniaturized formats become like shared secrets, invoking a childlike sense of intimacy and playfulness. One could collect these cards or trade them with friends, enjoying a sense of marvel when encountering, for example, *Women of the Revolution after Anselm Kiefer* (P. 97), in which historic figures, including Charlotte Corday, take the form of blossoming plants.

Invented Syntax

At this time, language took on visual forms that went well beyond the possibilities inherent in conventional typefaces. Some artists tinkered with meaning by using quasilegible writing, meant to be symbolic or entirely coded. One such figure, Dimitrije Bašičević of Croatia, was an art historian, curator, and critic who took the name Mangelos for his mostly private artwork. Mangelos had written poetry since the 1950s, calling his texts "no-stories" for their basis in the absurd and ironic. Among his strategies for negating meaning was the practice of combining several languages, with some words presented only in fragments suggesting sounds. His presentation formats included small painted booklets filled with cursive script written on drawn horizontal lines, giving the impression of a school penmanship notebook. The homemade qualities of these booklets, their dependence on only black, white, and red, and their hermetic texts contribute to a sense of mystery and vulnerability. Most, like *Antifona* (P. 88), are unpublished and exist in only

one example. Referring to a rare text that was published as part of the periodical *a* (P. 88), Mangelos said: "It is evident today that this is a poem, but at that time I thought I was demolishing poetry. This was anti-art, that is, anti-poetry."[6]

Mangelos was part of an artist's group in Croatia known as Gorgona, which focused on Conceptual art practices. Their often ephemeral nature meant that this new art could exist more easily in Eastern Europe than could avant-garde painting or sculpture. Gorgona was, in effect, a network of relationships among independent-minded individuals whose alternative artworks functioned outside the government-sanctioned systems for art. Its various activities included actions that the members deemed artistic, like taking walks together in the countryside or sending each other notes that contained a "thought for the month."[7] Gorgona also published a periodical meant to be an "anti-magazine" because it offered no information about art nor any illustrations but instead was a medium for individual artists to conceive and design single issues considered artworks in themselves (P. 89).

In Poland, Stanisław Fijałkowski dispensed entirely with intelligible words and letters to create coded compositions in prints that still maintain structures suggesting texts (P. 90). Though hand-drawn, the shapes of Fijałkowski's compositional elements—which resemble punctuation marks—approximate fonts utilized in Concrete poetry. It is especially telling that the artist experimented with typography in the early 1960s.[8] In addition, he used the word "semantic" when he discussed his work as an attempt to construct symbolic communication systems with universal meanings.[9] In this quest, Fijałkowski found inspiration not only in religious and ancient texts but also in mathematical theory and the archetypes of Carl Jung. His abstractions make him heir to artistic traditions in which spirituality was a prime concern. He even translated into Polish the writings of Vasily Kandinsky and Kazimir Malevich, two progenitors of the spiritual in abstract art. In describing his philosophy, Fijałkowski stated: "Since art is situated on the borderline between the material and spiritual it derives its meaning and effect from both dimensions."[10]

As has been pointed out, many of the poet-artists discussed above, born around the 1920s, received recognition for their artistic endeavors only when they were well into maturity and Conceptual practices coincided with their own interests. In contrast, artists like A. R. Penck

and Hanne Darboven were in their twenties and thirties during the formative years of Conceptualism. Penck forged his singular artistic vocabulary in the 1970s, after he had been rejected by the state academies in East Germany. It was also at this time that his work was smuggled from the East to the West to be exhibited to a broader art public. Theories of information and communication, as well as mathematics, had led Penck to a symbolic language of forms he called "Standart" (PP. 86–87). Comprised of pictographic symbols, this work can be interpreted as cryptic codes. One might even imagine them as a means of communicating in an underground network that bypassed the official systems entrenched in the East. Penck's visual language also easily segues into the realm of abstracted sound. A free jazz musician himself, he designed numerous record jackets (P. 87), some with his now familiar lexicon relating to imaginative musical scores.

Of all the artists considered here, it is Hanne Darboven who fits most squarely within the Conceptual art movement. Her numbers, scores, and cursive, rhythmic script methodically track the passage of time. She has said of her process: "I write, but describe nothing."[11] Her work can be mesmerizing and even comforting as it unfolds on sheet after sheet, often in large, all-encompassing environmental installations, which are paralleled in her printed portfolio projects (PP. 78–79). But the performative nature of her work, as it records temporal experience, can also be communicated in book format as one turns pages and creates self-regulated, rhythmic motions (P. 80). Darboven, who spent time in New York in the mid-to-late 1960s, was in contact with American Conceptual artists, such as Sol LeWitt, who were also experimenting with an art of ideas. Her hermetic systems came to be seen as emblematic of this cerebral art, with its myriad uses of language as a visual medium.

//
New Formats

The new sensibility of the period engendered several new printed formats. As early as 1962 numerous artists began to experiment with inventive approaches to the book as a vehicle for visual expression: Daniel Spoerri's verbal cataloguing of things left on a table, *Topographie anecdotée du hasard*, was released that year, and Ben Vautier began his assemblage of everyday items, *Moi, Ben je signe*.

Dieter Roth, in fact, had been working in radical book formats since the late 1950s. With Conceptual art practices gaining favor in the late 1960s and the 1970s, there was a flourish of artist's book publishing. Artists working in this mode pioneered various innovative artistic forms in their critique of the object, exploring Land art, Performance art, Process art, Body art, and video. Texts became the norm, and the value of uniqueness in art was challenged, even overturned. Social and political commentary was a constant undercurrent, and communication and dissemination were vital concerns as artists strove to bypass the normal art channels. The hegemony of painting and sculpture was fundamentally questioned. All of these factors contributed to an environment that fostered a growing fascination with the possibilities inherent in unpretentious, mass-produced printed stuff. In addition to artists' books, many artists turned to journals as venues for original printed statements. The printed page became the exhibition space. Several journals emerged that were devoted wholly to the concept of artists' projects. Other artists presented their pictorial ideas in ephemeral printed flyers sent free of charge through the mail. Even exhibition catalogues were transformed into artworks as opposed to vehicles for reproductions and criticism about art.

Artists' Books

Artists' books in these seminal years took as many forms as the artistic personalities that produced them, but their general defining characteristics—modest scale, large editions, simple printing methods, and low cost—made this portable and accessible art form a pointed assault on accepted notions of originality and value in fine art. Primarily black and white, most comprised varying degrees of photographic imagery and text. As Anne Moeglin-Delcroix, an artist's book expert, has noted, "Originality and the quality of the work must not be confused with the handmade. The industrial quality does not prevent the artist from having full control over all the stages in the realization of the book, from its conception and layout to its publication."[12]

To Land artists such as Richard Long and Hamish Fulton, whose impermanent works functioned outside the orbit of museums and galleries, artists' books became an important format both to document their ephemeral activities as well as a distinct creative medium for the expression of their poetic approach to the landscape.

Students together at London's St. Martin's School of Art in the late 1960s, Long and Fulton both turned to nature, in particular long walks in remote locales, as the foundation for their art. Long intervened in nature during his walks, rearranging stones, twigs, and leaves to create sculpture within nature's domain. The basic vocabulary of his books comprises photographs taken on his walks, texts, and maps in softbound printed pamphlets. Among his earliest examples is *From Around a Lake* (P. 95), which depicts single leaves found on a walk. Clive Phillpot, a book specialist, has described the book's motifs as "markers or moments on a walk."[13] A parallel work to the walk, this wordless book transcends the concept of mere documentation with its simple design, deadpan title, and imaginary narrative. As one historian has commented, "Documentation of the idea was sufficient, and the art object was, at first, considered irrelevant. However, the documentation of the idea, the insignificant codex book itself, soon became the art 'object.'"[14]

Fulton does not alter the landscape on his walks. The experience of the walk itself is the art. He photographs the landscape and adds descriptive, sometimes poetic captions to his images, taken from notes he writes while walking. In the 1970s Fulton began to overprint text onto his photographs. Later the text passages became more pronounced, leaving the landscape image obscured through a network of letters. With a more complex and visually assertive display of graphic design than Long, Fulton often makes colorful text works that reveal his attention to issues of typography, spacing, layout, and color, and demonstrate his interest in the visual importance of written language. In *Ajawaan: An Eight Day Wandering Walk in Central Saskatchewan Travelling by Way of Lake Ajawaan on the Night of the August Full Moon Lightning Storm 1985* (PP. 96–97) a panoramic photograph extends across five panels, each overprinted with three columns of four-letter words in red and white. In simple sans-serif type, the poetic language describes observations and sensations that occurred on this eight-day walk through Canada, enhancing the romantic sensibility that connects Fulton to the long tradition of English landscape painting.

Both Long and Fulton work with a range of printed formats, including original postcards (P. 96), which they frequently make to announce gallery exhibitions. Their interest in printed ephemera as a means to further communicate and disseminate their ideas is evidence of their lack of artistic hierarchy. Fulton's succinct text-based

postcards are as carefully composed as any of his larger wall works, and Long's similarly crafted examples are equally concise, evocative gems.

Many artists have exploited photography as a tool for making books, both for its documentary function and low production costs as well as its industrial aesthetic. Christian Boltanski and Hans-Peter Feldmann have been influenced by the profusion of photographic images in daily life. Both artists create collections that they catalogue and organize in idiosyncratic ways in book format. As Moeglin-Delcroix has pointed out, "Filing and archiving are typically conceptual procedures for which the book is a perfectly appropriate space."[15] Boltanski made his first book in 1969 and has gone on to complete more than eighty. In 1973 he began making pamphletlike books that inventory the everyday belongings of strangers who made their possessions available to him. His first, *List of exhibits belonging to a woman of Baden-Baden followed by an explanatory note* (P. 98), is an austere double-columned design of photographic depictions of ordinary household artifacts, with corresponding handwritten captions. A cross between a sales catalogue and a photo album, this modest black-and-white inventory of quotidian relics notably lacks a human presence, evoking a poignancy and lingering sense of loss.

Nearly twenty years later, in 1991, Boltanski issued *Sans-Souci* (P. 98), a reproduction of a World War II family photo album. The title of the book refers to Frederick the Great's ornate Potsdam palace, now a popular tourist attraction, the site of the book's first photo. While at first glance the book appears unremarkable, a closer look reveals that the men are wearing Nazi uniforms, and swastikas appear on every page. Boltanski dramatizes the horror of war with startling, melancholy images of the aggressor to convey his ongoing themes of memory, death, and the passage of time. Boltanski has said, "Much of my early work is about the Holocaust, but I never would have spoken about it in those terms, or pronounced that word…I could only begin talking about it much later."[16]

Feldmann's archives question the influence photographic images have on contemporary life and art, and the various functions and values these images can assume. Presented with a formal neutrality and an appearance of nonart, his modest book series *Bilder* (P. 99), which occupied him from 1968 to 1974, comprises groupings of similar everyday images—from airplanes to shoes to women's knees—taken partly by the artist and partly from commercial sources, such as postcards, posters, and newspapers. Unlike Boltanski, Feldmann strove for the ordinary and eschewed sentiment, creating new visual narratives onto which the viewer is invited to overlay his or her own personal history. In a quiet, understated manner, his *Bilder* series challenges notions of originality and authorship and made the artist a seminal figure in appropriation art of the 1980s. In the words of one curator, "It is the tension he creates between the banal origins and functions of mass-produced photographic images and their potential for fascination that gives his work its power and appeal."[17] This sensibility inspired other printed projects, including Feldmann's own postcards, posters, and newspaper and magazine inserts (P. 212).

Journals

Another outlet artists discovered as they questioned the status of the art object and sought alternative communication networks was the journal. With their large editions and unpretentious formats, journals also served these artists' goal of demystifying the aura around the art object. These artists' periodicals, which tend to appear less regularly than trade art journals, often arise in opposition to something. For many artists, working within the media itself and communicating directly with the public furthered a philosophical stance against the art world.[18] One of the earliest examples of an experimental journal appeared in Cologne in 1962. Titled *Décollage* (P. 100), it was founded by artist/provocateur Wolf Vostell, a pioneer in video art and Happenings and a founding member of Fluxus. Trained as a commercial artist and book designer, Vostell understood the graphic language of publicity and used it to promote his artistic agenda of social change. Dissemination was an integral part of Vostell's philosophy as well.

The first issue of *Décollage* was produced to coincide with a concert of experimental new music in Düsseldorf, and showcased several musical scores as well as visual art projects.[19] Typical of most Fluxus projects, the magazine was an interdisciplinary endeavor. In seven issues over the course of as many years, it documented performance works through text, photographs, and multiples by artists ranging from Fluxus regulars, such as Dick Higgins, George Maciunas, and Nam June Paik, to legendary figures, such as Joseph Beuys and Dieter Roth. There was nothing standard about *Décollage*. Original prints and multiples were sometimes loose, sometimes folded,

sometimes bound in. Its format varied, as did the paper it was printed on. Its edition size ran between 500 and 1,000, and its contributors changed from issue to issue. Beuys contributed one of his most important early multiples to issue no. 5, *Two Fräuleins with Shining Bread*, a typewritten text with an attached painted block of chocolate. With Vostell's energy and prodigious approach to art-making, *Décollage* quickly became the most influential German periodical dedicated to Fluxus events and a model for subsequent artists' publications.

Also coming out of Cologne, just as *Décollage* was nearing the end of its run, was another groundbreaking periodical, *Interfunktionen* (P. 101). Founded in 1968 by a young psychology student and close friend of Vostell's, Friedrich W. Heubach, *Interfunktionen* has several characteristics in common with its forerunner. Its issues came out sporadically—a total of twelve were released by 1975. It featured a range of original page art projects, foldouts, enclosures, and collages by the most cutting-edge artists of the period.[20] Heubach recently reminisced about the early motivations behind the journal's innovative format:

> These early issues reflected an attempt to design the journal in a way compatible with the new aesthetic agenda manifested in these contributions. The layout was what we then used to call "direct"—most of the material was facsimiled, using different papers suited to the originals.[21]

A strong editorial voice, Heubach pursued artists working outside the mainstream, and also invited musicians and filmmakers to ensure an interdisciplinary vision, an idea reinforced in the journal's name. Committed to a critically engaged art, Heubach founded the journal in direct reaction to the conservative art establishment that organized the 1968 exhibition *documenta 4*, which showcased numerous American Pop artists but little of the new experimental artwork emerging in Europe. Beuys was a frequent contributor, and generous supporter, of the journal.[22]

As it progressed, *Interfunktionen* evolved from a local journal focused on the German Rhineland into an international periodical with European and American distribution. Its modest first issue of some seventy-five pages blossomed into a hefty, luxurious 188 by issue no. 12. In a controversial move, Heubach decided to close the magazine after ten issues, by that time a successful but tremendously demanding publication. He convinced his friend and well-known critic Benjamin H. D. Buchloh to take over the reins as editor, which he did for the final two issues.[23]

A journal of a different order appeared at about the same time in England. *Art-Language* (P. 100), published from 1969 to 1985 by the British collective Art & Language, promoted the belief that all visual art is theoretically dependent on language. (Relaunched in 1994, the journal continues publication today.) Since the foremost material of art is ideas, the collective, founded by Terry Atkinson, Michael Baldwin, David Bainbridge, and Harold Hurrell, maintained that language was the most appropriate means of expression. By developing and publishing a body of discourse on the theory and meaning of art, the group hoped to transform art from the creation of objects to a theoretical output. Texts "were presented as primary bearers of artistic meanings," and viewers were thus invited to read art, not art criticism.[24] Art & Language also sought to do away with any form of artistic individuality, thereby challenging issues of authorship in an attempt to subvert what they considered materialistic modernist strategies. It famously asked the question, "Are works of art theory part of the kit of the conceptual artist, and as such can such a work, when advanced by a conceptual artist come up for the count as a work of conceptual art?"[25]

In some exceptional cases artists found their way into more mainstream media publications. In the United States, a young gallery owner and art promoter, Seth Siegelaub, spearheaded several landmark printed projects in artists' books and catalogues that transformed notions of what art could be.[26] In the summer of 1970 Siegelaub put together an exhibition in the British art journal *Studio International* (P. 80), inviting six critics to each curate eight pages of the magazine. The project encompassed a roster of leading European and American Conceptual artists, from Hanne Darboven to John Baldessari. Perhaps more than any of the journals mentioned above, Siegelaub's special issue of a mass media publication takes the most imaginative approach to magazine art, and one that speaks to the essence of the philosophy of Conceptual art. As one curator has written, "Due to the fact that the mass media are part and parcel of everyday culture and the artists' publications are based on their forms, the artist's aim to integrate the published artworks into everyday life also implied the cancellation of the distinction between art and life."[27]

Mailers

During the heady years of Conceptual art, printed art also presented a vital way for artists to pursue alternative systems of distribution. One of the longest running series of artists' publications was a printed flyer sent for free through the mail. The groundbreaking *Art & Project Bulletin* (P. 102) began in September 1968 and continued to November 1989. Organized by Adriaan van Ravesteijn and Geert van Beijeren of the progressive Art & Project gallery in Amsterdam, the mailers were conceived as both gallery announcements and original works of printed page art, meant to generate publicity and encourage visitors to seek out the gallery's off-the-beaten-path location.[28] A single sheet, folded in half and often printed on both sides, provided an innovative format for artists to explore. The simple front cover remained relatively standard, with the gallery's logo, dates of the exhibition, and the recipient's mailing address, leaving three sides for the artist's project. More than one hundred European and American Conceptual artists participated over the run of 156 bulletins, including Daniel Buren, Hanne Darboven, Gilbert & George, Sol LeWitt, and Richard Long. The popularity of the bulletin meant that artists frequently sent unsolicited proposals to the gallery.[29]

One of the purest—as well as earliest—examples of the printed page as exhibition space, *Art & Project Bulletin* was in some instances the only physical object in the gallery. As van Ravesteijn recently remarked about the bulletins, "A complete show was presented in a letter."[30] The bulletin, and Mail art in general, became an increasingly significant vehicle during this period as artists continued to look for ways to circumvent the standard gallery system. For bulletin 62 in 1972, Alighiero e Boetti chose to reproduce a grid of six envelopes mailed to him from Afghanistan, replete with decorative postage stamps, making a clever visual pun on this innovative form of disseminating printed art.

The contemporary printed broadsheet *Point d'ironie* (P. 103) can be seen as a descendant of Art & Project's bulletin.[31] Widely distributed and free of charge, this eight-page artist-designed periodical was begun in Paris in 1997 by fashion designer agnès b., with curator Hans-Ulrich Obrist in conversation with Christian Boltanski as the editorial think tank. Referred to as a hybrid—half magazine, half poster—roughly six are issued each year. Invited artists are given complete control over the content, though the format remains the same: two sheets, each approximately 17 x 24 inches (43 x 61 cm), printed on both sides, folded in half, and unbound. The nearly forty artists who have participated comprise a list of cutting-edge names in the international contemporary art scene, from Gabriel Orozco and Annette Messager to Hans-Peter Feldmann and Matthew Barney.

Point d'ironie takes the idea of dissemination to a new level. Editions between 100,000 and 300,000 are printed and then distributed through agnès b. boutiques as well as museums, galleries, and bookstores around the world. For Boltanski, this is the most remarkable feature of the publication: "The extraordinary conception is the enormous number of copies, and thanks to agnès b.'s network, the possibility to send them to countries all over the world....We tried to work in industrial quantities: It's a little evolution in the art world."[32] Inserting vanguard art into the public sphere, *Point d'ironie* embodies a still radical concept, in which the public encounters art as free, mass-produced, and readily available.

Exhibition Catalogues

The exhibition catalogue is another venue that was transformed into a vehicle for original multiple art during this period. Catalogues became more than the documentation of art; they became the art themselves. Artists contributed to and even took control of such projects as an extension of the exhibition. Among the earliest, most ambitious, and most successful examples of this phenomenon is the series begun in 1967 at the Städtisches Museum Abteiberg in Mönchengladbach, Germany. Initiated by the museum's newly hired and forward-thinking director, Johannes Cladders, *Kassettenkataloge*, or catalogue boxes, became a hallmark of the institution (P. 104). Cladders gave many artists their first solo museum exhibitions, including Joseph Beuys, whose 1967 exhibition inaugurated the revolutionary project. Cladders and Beuys designed the box format together. The museum's limited funds contributed to this innovative idea, since making a cardboard box cost less than printing a conventional book. Cladders recently remarked, "I didn't want to make only thin leaflets. I wanted something for the bookcase, something which has volume. A box has volume."[33] Seeking to supplement rather than simply document his exhibitions, he gave the artists free rein to design the boxes' contents. Everything from postcards and photographs to twine and plastic flowers can be found inside, as well as, in most cases, a text by

Cladders. Thirty-three boxes were completed from 1967 to 1978. At that point the museum moved to a new building, entering another phase, and Cladders felt it was time to end his distinctive series.[34]

A recent example of such an artist-designed project shows that this approach is still an important avenue of investigation for artists: the artists' publications that accompanied *Migrateurs*, a series of artist interventions organized by Hans-Ulrich Obrist at the ARC Musée d'Art Moderne de la Ville de Paris, which took place from 1993 to 2004 (P. 105). Prompted again by limited funding, Obrist devised an eight-page artist's booklet that took the place of a conventional catalogue. Each artist was free to design his or her own booklet within the established format, and a distinct variety exists among the thirty-two completed examples, by artists as diverse as Ugo Rondinone, Jeremy Deller, and Olafur Eliasson. Talking about *Migrateurs*, Obrist recently remarked, "The publication is the first priority. The publication is not about the work but becomes the work."[35]

Notes

1 Mayer, quoted in "Hansjörg Mayer," in *Between Poetry and Painting* (London: Institute of Contemporary Arts, 1965), p. 67.

2 Broodthaers, quoted in Todd Alden, "Marcel Broodthaers: On the Tautology of Art and Merchandise," *Print Collector's Newsletter* 23, no. 1 (March–April 1992): 5.

3 Glòria Bordons, "Joan Brossa, Constant Experiment and Surprise," *Catalònia* (March 1992): 15.

4 Brossa, quoted in Pilar Parcerisas, "Visual Poems: Joan Brossa. Down-to-Earth," in *Poesía visual: Joan Brossa* (Valencia: IVAM Centre Julio González, 1997), p. 303.

5 Inmaculada Aguilar Civera, "Juan Hidalgo: An Analysis of His Work," in *De Juan Hidalgo (1957–1997)* (Madrid: Tabapress, 1997), p. 355.

6 Mangelos, quoted in Mladen Stilinović, "Mangelos," in *Riječi i Slike/Words and Images*, ed. Branka Stipančić (Zagreb: Soros Center for Contemporary Arts, 1995), p. 63.

7 "Thoughts for the Month" is discussed in Nena Dimitrijević, "Gorgona: Art as a Way of Existence," in *Gorgona* (Zagreb: Galerije grada Zagreba, 1977). Reprinted in *Primary Documents: A Sourcebook for Eastern and Central European Art since the 1950s*, ed. Laura Hoptman and Tomáš Pospiszyl (New York: The Museum of Modern Art, 2002), pp. 138–39.

8 *Stanisław Fijałkowski: Malarstwo, Grafika, Rysunek* (Lodz, Poland: Biuro Wystaw Artystycznych w Łodzi, 1990), pp. 3, 13–14.

9 *Stanisław Fijałkowski* (Poznan, Poland: Muzeum Narodowe w Poznaniu, 2003), p. 62.

10 Stanisław Fijałkowski, "Some Timid Remarks on Transcendency," in *Sightlines: Printmaking and Image Culture*, ed. Walter Jule (Alberta: University of Alberta Press, 1997), pp. 192–93.

11 Darboven, quoted in Kai-Uwe Hemken, "Hanne Darboven," in *Deep Storage: Collecting, Storing, and Archiving Art*, ed. Ingrid Schaffner and Matthias Winzen (Munich and New York: Prestel, 1998), p. 114.

12 Anne Moeglin-Delcroix, "1962 and After: Another Idea about Art," in *Guardare, Raccontare, Pensare, Conservare: Quattro percorsi del libro d'artista dagli anni '60 ad oggi* (Mantua, Italy: Casa del Mantegna, 2004), p. 28.

13 Clive Phillpot, "Richard Long's Books and the Transmission of Sculptural Images," *Print Collector's Newsletter* 18, no. 4 (September–October 1987): 125–28.

14 Stephan Klima, *Artists Books: A Critical Survey of the Literature* (New York: Granary Books, 1998), p. 42.

15 Moeglin-Delcroix, "Thinking," in *Guardare, Raccontare, Pensare, Conservare*, p. 187.

16 Boltanski, quoted in "Christian Boltanski: A Conversation with Leslie Camhi," *Print Collector's Newsletter* 23, no. 6 (January–February 1993): 202.

17 Gary Garrels, *Photography in Contemporary German Art: 1960–Present* (Minneapolis: Walker Art Center, 1992), p. 50.

18 There is a long tradition of artists' journals in Europe. Yet as Clive Phillpot has pointed out, artists in the early decades of the twentieth century "were not consciously using the production of a magazine to question the nature of artworks, nor were they making art specifically for dissemination through a mass-communication medium." Clive Phillpot, "Art Magazines and Magazine Art," *Artforum* 18, no. 6 (February 1980): 52. For a historical overview of the modern art periodical, see Howardena Pindell, "Alternative Space: Artists' Periodicals," *Print Collector's Newsletter* 8, no. 4 (September–October 1977): 96–109, 120–21.

19 The first issue preceded the publication of George Maciunas's periodical *Fluxus I*, which apparently contributed to the rivalry between Vostell and Maciunas, who frequently competed for artists to participate in their group publications.

20 Heubach credits Vostell with introducing him to the artists of the Cologne art scene. See Friedrich W. Heubach, "Interfunktionen, 1968–1975," in *Behind the Facts: Interfunktionen, 1968–1975*, ed. Gloria Moure (Barcelona: Ediciones Polígrafa, 2004), p. 58 n. 2.

21 Ibid., p. 49.

22 Special editions of fifty to sixty signed copies provided financial support as well.

23 A conflict erupted with issue no. 12 when Buchloh published Anselm Kiefer's 1969 photo essay *Occupations*, in which the artist posed at various locations with his arm raised in the Nazi salute. The series provoked violent reactions and funding sources disappeared, causing the magazine to be discontinued amid scandal.

24 Charles Harrison, "Art Object and Artwork," in *L'Art conceptuel, une perspective* (Paris: Musée d'Art Moderne de la Ville de Paris, 1989), p. 64.

25 Art & Language, "Introduction to Art-Language," *Art-Language* 1, no. 1 (May 1969): 2.

26 For more on the progressive activities of Siegelaub, see Alexander Alberro, *Conceptual Art and the Politics of Publicity* (Cambridge, Mass.: The MIT Press, 2003).

27 Anne Thurmann-Jajes, *Buch/Medium/Fotografie* (Bremen, Germany: Neues Museum Weserburg Bremen, 2003), p. 75.

28 Adriaan van Ravesteijn, interview with Christophe Cherix, in *25th International Biennial of Graphic Arts* (Ljubljana, Slovenia: MGLC, International Centre of Graphic Arts, 2003), p. 68.

29 Ibid.

30 Ibid., p. 69.

31 *Point d'ironie* is a French term for a nineteenth-century punctuation mark, which looks somewhat like a backward question mark and suggests a level of irony in the text.

32 Christian Boltanski, "*Point d'ironie*: A Conversation with Christian Boltanski," by Hans-Ulrich Obrist, in *Point d'ironie* (Ljubljana, Slovenia: MGLC, International Centre of Graphic Arts, 2004).

33 Johannes Cladders, "Kahn man heir Ping-Pong spieled? An Interview with Johannes Cladders," by Hans-Ulrich Obrist, *Jungle World* (Berlin), no. 48 (November 24, 1999).

34 See Susanne Wischermann, *Johannes Cladders. Museumsmann und Künstler* (Frankfurt: Peter Lang, 1997), p. 83.

35 Hans-Ulrich Obrist, conversation, October 2005.

Hanne Darboven

[GERMAN, born 1941]

Weltansichten (World Views), 1990
Four from a series of fourteen offsets,
mounted on screenprints

MOUNT: 16 9/16 X 11 3/4" (42 X 29.8 cm)
PUBLISHER: Gesellschaft Kunst Edition,
Hamburg
PRINTER: Thomas Sanmann, Hamburg
EDITION: 30

The Museum of Modern Art, New York.
Gift of Gesellschaft Kunst Edition, 1991

—— 7 ——

—— 8 ——

Hanne Darboven

[GERMAN, born 1941]

Untitled for the journal *Studio International*,
vol. 180, no. 924, July–August 1970
Pages from a project by various artists

PAGE: 11 15/16 x 9 3/16" (30.3 x 23.3 cm)
PROJECT EDITOR: Seth Siegelaub
PUBLISHER: Cory, Adams & Mackay, London
EDITION: approx. 3,500–5,000

The Museum of Modern Art Library,
New York

Quartett >88<, 1990
Artist's book

PAGE: 9 x 6 3/8" (22.8 x 16.2 cm)
PUBLISHER: Portikus, Frankfurt, and Verlag der
Buchhandlung Walther König, Cologne
EDITION: 1,000

The Museum of Modern Art Library,
New York

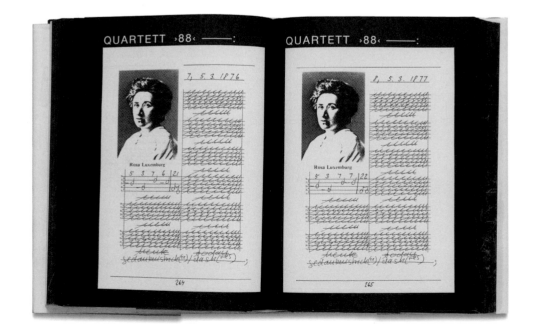

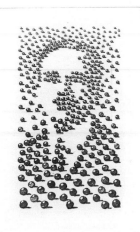

Batterien 13 Matthes & Seitz

Markus Raetz
[SWISS, born 1941]

Eindrücke aus Afrika, 1980
Illustrated book by Raymond Roussel
Cover and three of fourteen etchings

PAGE: 8 $^{11}/_{16}$ x 5 $^{1}/_{2}$" (22 x 13.9 cm)
PUBLISHER: Edition Stähli, Zurich
PRINTER: Peter Kneubühler, Zurich
EDITION: 60

The Museum of Modern Art, New York.
Monroe Wheeler Fund, 2005

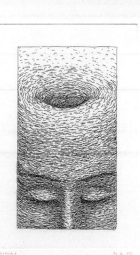

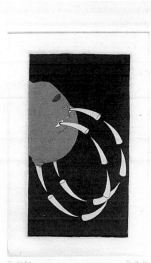

GEDICHT POEM POEME

CHANGE EXCHANGE WECHSEL

28

10

12

75

5

6

25

45

19

8

258

3

1650 F. F.

125 D. M.

98£

50$

A Teil 1 Exemplar Nr.

B

C Teil II Exemplar Nr.

Marcel Broodthaers
[BELGIAN, 1924–1976]

**Gedicht–Poem–Poème/
Change–Exchange–Wechsel**, 1973
Screenprint on two sheets

SHEET (EACH): 38 1/2 x 26 13/16" (97.8 x 68.1 cm)
PUBLISHER: Edition Staeck, Heidelberg
PRINTER: Gerhard Steidl, Göttingen, Germany
EDITION: 100

The Museum of Modern Art, New York.
Riva Castleman Endowment Fund, 2005

Pense-Bête, 1964
Artist's book with collage additions
PAGE: 10 $^{13}/_{16}$ X 8 $^{7}/_{16}$" (27.5 X 21.5 CM)
PUBLISHER: the artist, Brussels
EDITION: unknown

Collection M. Schmidt, Todenmann, in the
Research Centre for Artists' Publications/ASPC,
Neues Museum Weserburg Bremen, Germany

**Un Coup de dés jamais n'abolira
le hasard**, 1969
Artist's book based on the poem
by Stéphane Mallarmé

PAGE: 12 $^{13}/_{16}$ X 9 $^{13}/_{16}$" (32.5 X 25 cm)
PUBLISHER: Wide White Space Gallery, Antwerp,
and Galerie Michael Werner, Cologne
EDITION: 90

The Museum of Modern Art, New York.
Acquired through the generosity of Howard B.
Johnson in honor of Riva Castleman, 1994

Joan Brossa

[SPANISH, 1919–1998]

Rails, 1989
Lithograph

SHEET: 14 15/16 X 19 11/16" (38 X 50 cm)
PUBLISHER AND PRINTER: Polígrafa Obra Gráfica,
Barcelona
EDITION: 50

The Museum of Modern Art, New York.
Mary Ellen Oldenburg Fund, 2005

Comboi (Convoy), 1989
Lithograph

SHEET: 15 X 19 3/4" (38.1 X 50.2 cm)
PUBLISHER AND PRINTER: Polígrafa Obra Gráfica,
Barcelona
EDITION: 50

The Museum of Modern Art, New York.
Acquired through the generosity of
Richard Gerrig and Timothy Peterson in
honor of Bernice and Edward Gerrig, 2006

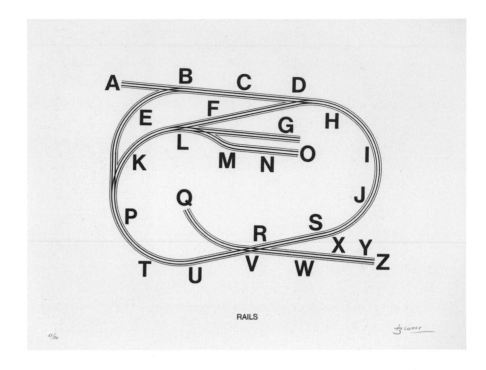

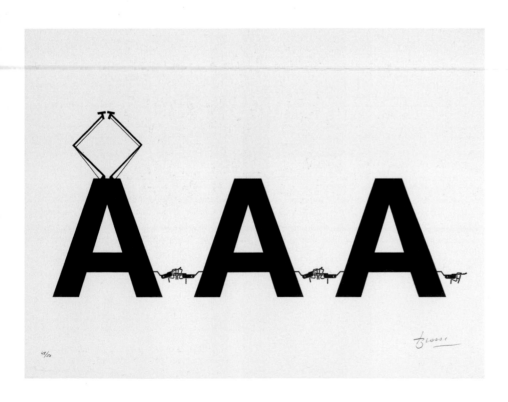

Jaume Plensa

[SPANISH, born 1955]

Twins, 1994
Lithograph

SHEET: 43 3/8 x 39 3/8" (110.2 x 100 cm)
PUBLISHER: Médecins du Monde
(Éditions de la Tempête), Paris
PRINTER: Michael Woolworth, Paris
EDITION: 50

The Museum of Modern Art, New York.
Acquired through the generosity of Martin
Nash and Jack Hennigan, 2006

A. R. Penck

[GERMAN, born 1939]

Ur End Standart, 1972
Four from a portfolio of fifteen
screenprints

SHEET: 27³/₁₆ X 27³/₁₆" (69 x 69 cm)
PUBLISHER: Fred Jahn, Munich; Galerie Michael
Werner, Cologne; Edition X, Munich; and
Edition der Galerie Heiner Friedrich, Munich
PRINTER: H.-G. Schultz and U. Streifeneder,
Munich
EDITION: 75

The Museum of Modern Art, New York.
Mrs. Gilbert W. Chapman Fund, 1979

Standarts, 1970
Artist's book
PAGE: 11⁷/₁₆ x 7¹¹/₁₆" (29 x 19.5 cm)
PUBLISHER: Galerie Michael Werner, Cologne,
and Jahn und Klüser, Munich
EDITION: 1,000

The Museum of Modern Art, New York.
Purchase, 1982

Lyrik, 1987
Illustrated book by Sarah Kirsch
One of forty-six screenprints
PAGE: 13¹/₄ x 8⁷/₈" (33 x 22.6 cm)
PUBLISHER: Edition Malerbücher, Berlin
PRINTER: Druckwerkstatt des BBK, Berlin
EDITION: 100

The Museum of Modern Art, New York.
Purchase, 1990

Piano Solo, 1985
Record jacket
SHEET: 12³/₈ x 12⁵/₁₆" (31.4 x 31.3 cm)
PUBLISHER: Music Cooperation Triple Trip
Touch, London
EDITION: 500

The Museum of Modern Art, New York.
Acquired through the generosity of Lee and
Ann Fensterstock in honor of their daughter
Jane, 2006

Mangelos
[CROATIAN, 1921–1987]

Antifona, 1964
Painted artist's book
PAGE: 7 1/8 x 7 3/16" (18.1 x 18.3 cm)
EDITION: unique
The Museum of Modern Art, New York.
Monroe Wheeler Fund, 2006

Project for *a*, no. 6, 1964
Journal
EDITOR AND PUBLISHER: Ivan Picelj, Zagreb
PAGE (FOLDED): 6 3/8 x 6 3/8" (16.1 x 16.1 cm)
EDITION: unknown
The Museum of Modern Art Library,
New York

Gorgona
Journal [1961–1966]
EDITOR AND PUBLISHER: Gorgona artist's
group, Zagreb

Victor Vasarely [FRENCH, born Hungary. 1908–1997],
project for no. 2, 1961 (top right)

Julije Knifer [CROATIAN, 1924–2004],
project for no. 4, 1961 (bottom right)

PAGE (APPROX.): 8 1/16 x 7 7/16" (20.5 x 18.9 cm)
EDITION: 65–300

The Museum of Modern Art Library,
New York

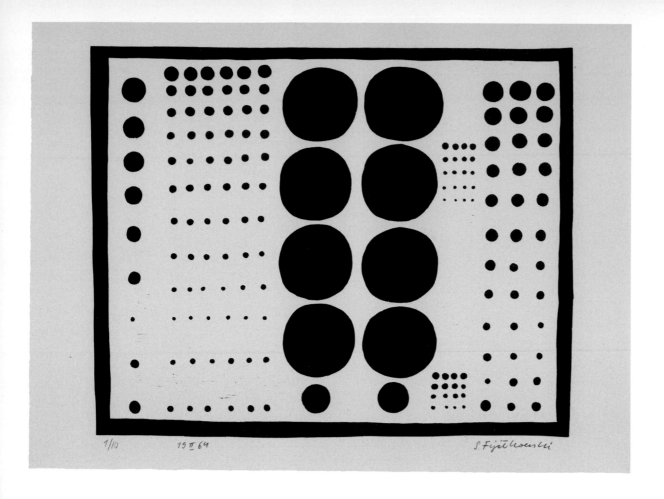

Stanisław Fijałkowski

[POLISH, born 1922]

19 II 64, 1964
Linoleum cut

SHEET: 18 7/8 x 25 9/16" (48 x 64.9 cm)
PUBLISHER AND PRINTER: the artist,
Lodz, Poland
EDITION: 10

The Museum of Modern Art, New York.
The Associates Fund, 2006

5 II 62, 1962
Linoleum cut

SHEET: 18 5/16 x 13 9/16" (46.5 x 34.4 cm)
PUBLISHER AND PRINTER: the artist, Lodz, Poland
EDITION: 10

The Museum of Modern Art, New York.
The Associates Fund, 2006

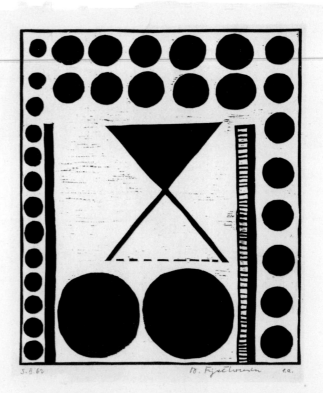

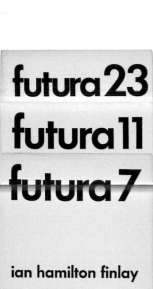

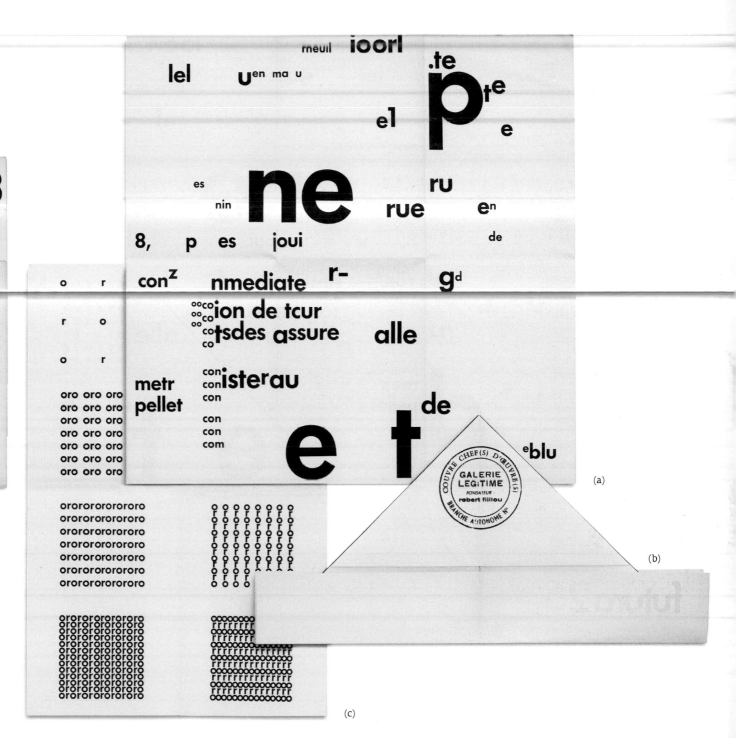

(a)

(b)

(c)

futura

Journal/broadsheet [1965–1968]
EDITOR AND PUBLISHER: Edition Hansjörg
Mayer, Stuttgart

Wolf Vostell [GERMAN, 1932–1998],
Décollage Aktions Text for no. 22, 1967 (a)

Robert Filliou [FRENCH, 1926–1987],
Galerie Légitime for no. 26, 1969 (b)

Mathias Goeritz [MEXICAN, born Germany. 1915–1990],
Die goldene Botschaft for no. 1, 1965 (c)

PAGE (FOLDED): 9⁷/₁₆ X 6⁵/₁₆" (24 X 16 cm)
EDITION: 1,200
Sackner Archive of Concrete and Visual Poetry

GUERNICA (TXALAPARTA ETA PURRUSALDA)

1895

ULISES

27/85

GRITO DE DOLORES (16.09.1810) CURA HIDALGO

27/85

27/85

BELA BARTOK

27/85

Juan Hidalgo
[SPANISH, born 1927]

Etceteras Abanderados
(**Color Guard Etcetera**), 1991
Eight from a portfolio of fifty-three
lithographs

SHEET: 3 9/16 x 26 3/4" (9 x 67.9 cm)
PUBLISHER AND PRINTER: Estampa Ediciones,
Madrid
EDITION: 85
The Museum of Modern Art, New York.
Purchase, 1993

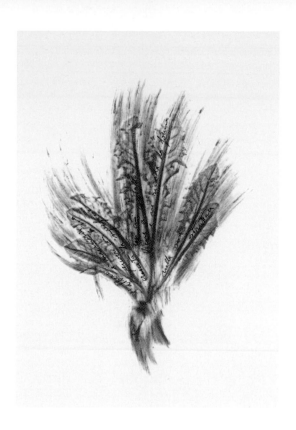

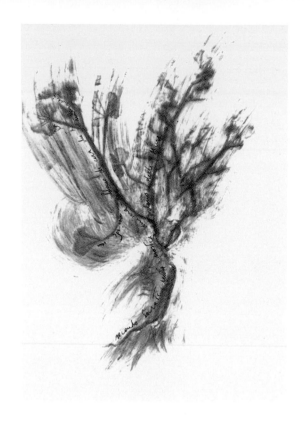

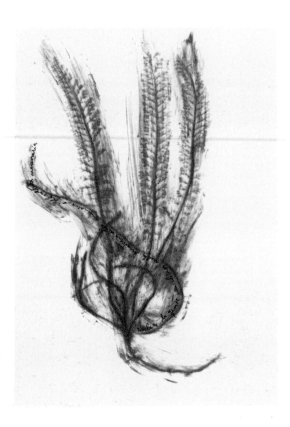

Giuseppe Penone

[ITALIAN, born 1947]

Trentatre Erbe
(**Thirty-three Herbs**), 1989
Four from a portfolio of
thirty-three lithographs

SHEET: 16 9/16 X 11 5/8" (42 X 29.6 cm)
PUBLISHER AND PRINTER: Marco Noire Editore,
Turin, Italy
EDITION: 120

The Museum of Modern Art, New York.
Frances Keech Fund, 1995

Richard Long

[BRITISH, born 1945]

A Walk Past Standing Stones, 1980
(first edition 1979)
Artist's book
PAGE (FOLDED): 3⁹/₁₆ X 2⁵/₁₆" (9 X 5.9 cm)
PUBLISHER: Coracle Press, Norfolk, England,
for Anthony d'Offay Gallery, London
EDITION: probably 500–700
The Museum of Modern Art Library,
New York

Rivers and Stones, 1978
Artist's book
PAGE: 8¹/₁₆ X 11³/₄" (20.5 X 29.9 cm)
PUBLISHER: Newlyn Orion Galleries,
Cornwall, England
EDITION: 1,500
The Museum of Modern Art Library,
New York

From Around a Lake, 1973
Artist's book
PAGE: 8¹/₄ X 3⁷/₈" (21 X 9.9 cm)
PUBLISHER: Art & Project, Amsterdam
EDITION: 300
The Museum of Modern Art Library,
New York

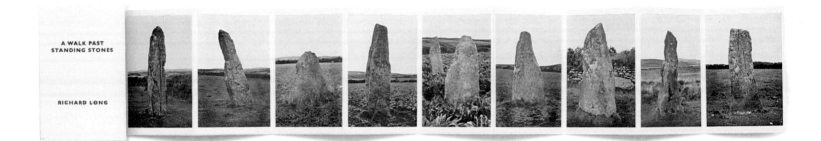

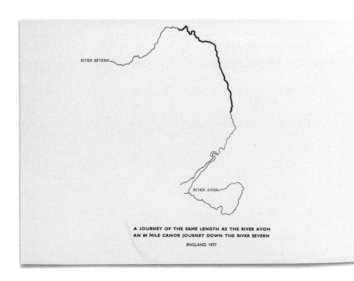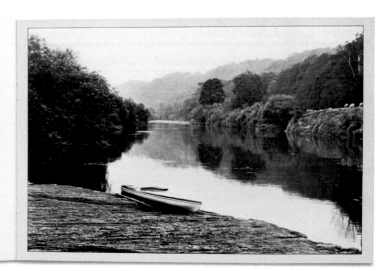

Hamish Fulton

[BRITISH, born 1946]

No Talking for Seven Days: Walking for Seven Days in a Wood February Full Moon Cairngorms Scotland 1988, 1988
Artist's book

PAGE: 8 1/2 x 6 3/4" (21.6 x 17.1 cm)
PUBLISHERS: Galerie Tanit, Munich, and Dietmar Werle, Cologne
EDITION: 300

The Museum of Modern Art Library, New York

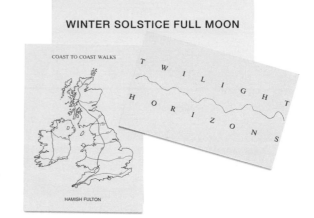

Winter Solstice Full Moon, 1992
Twilight Horizons, 1983
Coast to Coast Walks, 1987
Postcards

SHEET (APPROX.): 4 x 6" (10.2 x 15.3 cm)
PUBLISHER: John Weber Gallery, New York (top); Coracle Press, Norfolk, England (middle); Victoria Miro Gallery, London (bottom)
EDITION: probably 700 (top and bottom); probably 300 (middle)

The Museum of Modern Art Library, New York

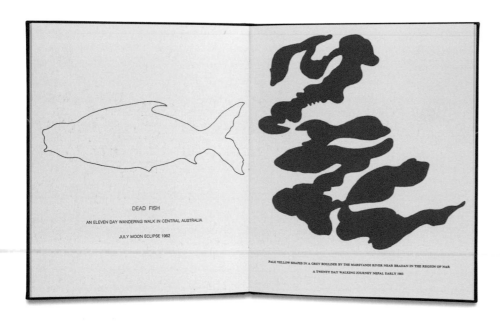

Ajawaan: An Eight Day Wandering Walk in Central Saskatchewan Travelling by Way of Lake Ajawaan on the Night of the August Full Moon Lightning Storm 1985, 1987
Artist's book

PAGE (FOLDED): 7 1/2 x 10 9/16" (19 x 26.9 cm)
PUBLISHER: Art Metropole, Toronto
EDITION: 750

The Museum of Modern Art Library, New York

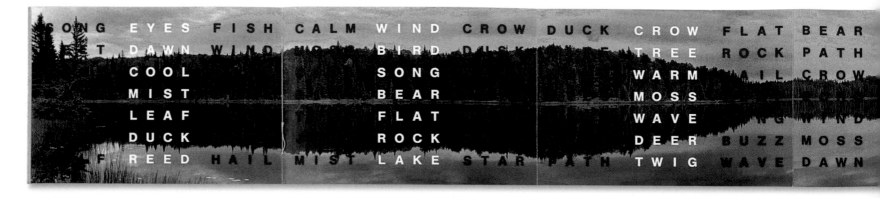

Ian Hamilton Finlay

[BRITISH, 1925–2006]

Les Femmes de la Révolution after Anselm Kiefer (**Women of the Revolution after Anselm Kiefer**), 1992
Card
SHEET: 6 5/16 x 7 15/16" (16 x 20.1 cm)
COLLABORATOR: Gary Hincks
PUBLISHER: Wild Hawthorn Press,
Little Sparta, Scotland
EDITION: unknown

The Museum of Modern Art, New York.
Walter Bareiss Fund, 1997

Three Banners, 1991
Card
SHEET (FOLDED): 7 7/8 x 2 13/16" (20 x 7.1 cm)
COLLABORATOR: Gary Hincks
PUBLISHER: Wild Hawthorn Press,
Little Sparta, Scotland
EDITION: 250

The Museum of Modern Art, New York.
Walter Bareiss Fund, 1997

Fructidor, 1992
Card
SHEET (FOLDED): 6 x 6" (15.3 x 15.3 cm)
COLLABORATOR: Kathleen Lindsley
PUBLISHER: Wild Hawthorn Press,
Little Sparta, Scotland
EDITION: unknown

The Museum of Modern Art, New York.
Walter Bareiss Fund, 1997

Christian Boltanski

[FRENCH, born 1944]

Le Club Mickey, 1991
Artist's book

PAGE: 8¼ x 5¹⁵⁄₁₆" (21 x 15.1 cm)
PUBLISHER: Imschoot, Uitgevers, Ghent, Belgium
EDITION: 500

The Museum of Modern Art, New York.
Given anonymously, 1997

List of exhibits belonging to a woman of Baden-Baden followed by an explanatory note, 1973
Artist's book

PAGE: 7¹⁄₁₆ x 4³⁄₈" (18 x 11.1 cm)
PUBLISHER: Museum of Modern Art, Oxford
EDITION: unknown

The Museum of Modern Art Library,
New York

Sans-Souci, 1991
Artist's book

PAGE: 8¹¹⁄₁₆ x 11" (22 x 28 cm)
PUBLISHER: Portikus, Frankfurt, and Verlag der
Buchhandlung Walther König, Cologne
EDITION: 2,000

The Museum of Modern Art Library,
New York

Hans-Peter Feldmann
[GERMAN, born 1941]

Bilder [1968–1974]
Artists' books

11 Bilder, 1973 (open, top left)
45 Bilder, 1971 (open, top right)

PAGE (VARIABLE): 3¹³/₁₆ X 3⁷/₈" (9.7 X 9.8 cm) to 8¹/₄ X 8¹/₄" (20.9 X 20.9 cm)
PUBLISHER: the artist, Hilden, Germany
EDITION: 1,000

The Museum of Modern Art Library, New York

Décollage

Journal [1962–1969]

EDITOR AND PUBLISHER: Wolf Vostell, Cologne

Joseph Beuys [GERMAN, 1921–1986],
Zwei Fräulein mit leuchendem Brot
(**Two Fräuleins with Shining Bread**), 1966,
for no. 5, 1967 (far right)

PAGE: 10 9/16 x 8 1/16" (26.9 x 20.4 cm)
EDITION: 500–1,000

The Museum of Modern Art Library,
New York

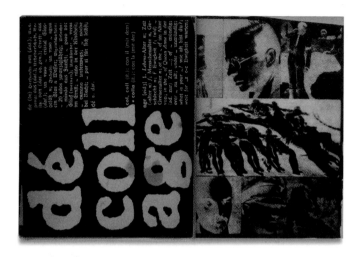

Art-Language

Journal [1969–1985; 1994–present]
EDITOR: Terry Atkinson, David Bainbridge,
Michael Baldwin, and Harold Hurrell
(nos. 1 and 2); Joseph Kosuth (no. 2)
Vol. 1, nos. 1 and 2, 1969–70

PAGE: 8 1/4 x 5 5/8" (21 x 14.3 cm)
PUBLISHER: Art & Language Press, Coventry,
England
EDITION: unknown

Lisson Gallery, London

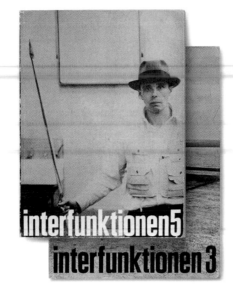

(a)

(b)

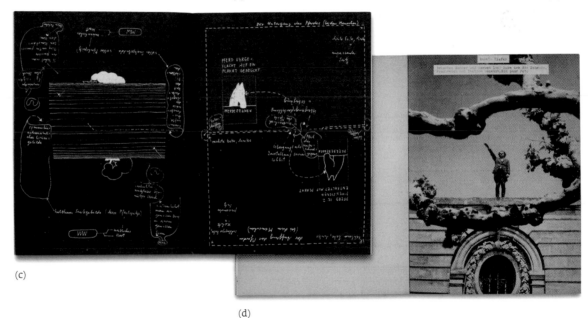

(c)

(d)

Interfunktionen

Journal [1968–1975]

EDITOR AND PUBLISHER: Friedrich W.
Heubach, Cologne, 1968–74;
Benjamin H. D. Buchloh, Cologne, 1974–75

Daniel Buren [FRENCH, born 1938],
Encre sur Papiers (Ink on Papers)
for no. 11, 1974 (a)

Marcel Broodthaers [BELGIAN, 1924–1976],
Racisme végétal (Vegetative Racism)
for no. 11, 1974 (b)

Dieter Roth [SWISS, born Germany. 1930–1998],
**Von Pferd u.a.m. (Concerning the
Horse and More, etc.)** for no. 4, 1970 (c)

Anselm Kiefer [GERMAN, born 1945],
Besetzungen (Occupations)
for no. 12, 1975 (d)

PAGE: 11 3/8 x 8 3/16" (28.9 x 20.8 cm)
EDITION: unknown

The Museum of Modern Art Library,
New York

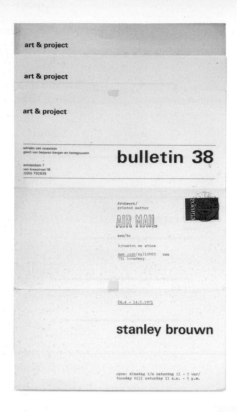

Art & Project Bulletin

Mailer [1968–1989]
EDITOR: Geert van Beijeren and
Adriaan van Ravesteijn

Jan Dibbets [DUTCH, born 1941],
project for bulletin 87, 1975 (top)

Stanley Brouwn [DUTCH, born Suriname, 1935],
project for bulletin 63, 1972 (left)

Alighiero e Boetti [ITALIAN, 1940–1994],
project for bulletin 62, 1972 (right)

PAGE: 11 5/8 x 8 1/4" (29.6 x 20.9 cm)
PUBLISHER: Art & Project, Amsterdam
EDITION: 500–800
The Museum of Modern Art Library,
New York

Point d'ironie
Broadsheet [1997–present]
EDITOR: Hans-Ulrich Obrist

clockwise from top left:

Annette Messager [FRENCH, born 1943],
project for no. 5, 1998

Gilbert & George [Gilbert Proesch,
BRITISH, born Italy, 1943] [George Passmore,
BRITISH, born 1942], project for no. 22, 2001

Christian Boltanski [FRENCH, born 1944],
L'ecole de Hamburgerstrasse
(**The School of Hamburgerstrasse**)
for no. 7, 1998

Hanne Darboven [GERMAN, born 1941],
project for no. 27, 2002

PAGE: 17 X 12" (43.2 X 30.4 cm)
PUBLISHER: agnès b., Paris
EDITION: 100,000–300,000

The Museum of Modern Art, New York.
Gift of agnès b. and Hans-Ulrich Obrist, 1999
(top left and lower right); Given anonymously,
2002 (top right), and 2003 (lower left)

Kassettenkatalog

Exhibition box/catalogue [1967–1978]
EDITOR: Johannes Cladders

Joseph Beuys [GERMAN, 1921–1986], 1967
Felt with paint additions and artist's book
(top)

Jannis Kounellis [GREEK, born 1936], 1978
Burned gunpowder, asbestos, and poem
(middle)

Panamarenko [BELGIAN, born 1940], 1969
Twine and offset cards (bottom)

BOX (APPROX.): 8 x 6¼ x 1⅛" (20.3 x 15.8 x 2.9 cm)
PUBLISHER: Städtisches Museum Abteiberg,
Mönchengladbach, Germany
EDITION: 330 (top and bottom); 440 (middle)

The Museum of Modern Art Library,
New York (top and bottom)
Spencer Collection, The New York Public
Library, Astor, Lenox, and Tilden
Foundations (middle)

(b)

(c)

(a)

(d)

(e)

Migrateurs
Exhibition catalogue/artist's book
[1993–2004]
EDITOR: Hans-Ulrich Obrist

Marie Denis [FRENCH, born 1972], 1997 (a)
Cedric Price [BRITISH, 1934–2003], 2001 (b)
Ugo Rondinone [SWISS, born 1963], 1995 (c)
Leni Hoffmann [GERMAN, born 1962], 1995 (d)
Lionel Estève [FRENCH, born 1967], 2003 (e)

PAGE: 6 3/8 x 4 3/8" (16.2 x 11.1 cm)
PUBLISHER: ARC Musée d'Art Moderne de la
Ville de Paris
EDITION: approx. 500

The Museum of Modern Art, New York.
Gift of Hans-Ulrich Obrist, 2006

105

confrontations

Arman
Atelier Populaire
Joseph Beuys
K P Brehmer
Rafael Canogar
Christo
Equipo Crónica
Öyvind Fahlström
Robert Filliou
Yves Klein
Milan Knížák
Piero Manzoni
Wolfgang Mattheuer
Otto Muehl
OHO
Pawel Petasz
Dieter Roth
Niki de Saint Phalle
Daniel Spoerri
Joe Tilson
Endre Tót
Ben Vautier
Wolf Vostell

Throughout Europe, democratic ideals permeated the new

art practices of the 1960s. As artists confronted the political upheaval that characterized the period as well as the perceived staleness of academic reiterations of abstract painting, many pursued editioned mediums as a tool to disseminate their passionate ideologies. In this spirit, a new format arose—the multiple, a three-dimensional editioned object—which embodied this progressive sensibility. Inventive artists experimented with multiples in a variety of ways, ranging from manipulating found consumer objects to printing provocative shopping bags and ephemera. The rise of the Fluxus movement during these idealistic years exemplified the attempts by numerous artists to eradicate the barriers between art and life by elevating everyday existence to an artistic experience through performances and the creation of modest objects that could be widely distributed beyond art world circles.

Joseph Beuys and Dieter Roth personified these confrontational tendencies. Beuys's entire oeuvre embodied his fervent belief that art be used as an instrument to transform society. His prolific production of multiples extended from poetic sculptural forms to politically driven postcards. Roth's maverick approach to materials engendered a body of work that is unsurpassed today in originality and inventiveness. His passion for books revolutionized a conventional, centuries-old medium into an avant-garde arena of new possibilities and discoveries. Other artists continued in the long-standing tradition of using printed art as a vehicle for social and political expression. Figures including Wolf Vostell, Rafael Canogar, and the anonymous poster brigade Atelier Populaire protested phenomena from the war in Vietnam to repressive governments to civil injustice, reaching across Europe with potent prints and posters that fused avant-garde aesthetics with the progressive beliefs of the time.

Multiples

In the late 1950s radical new voices appeared that anticipated later Conceptual practices through performance-based events, iconoclastic gestures, and an emphasis on process. France's Yves Klein was immersed in the concept of immateriality, from his renowned 1958 exhibition *The Void*, for which he left the gallery completely empty, to his attempts at levitation as a means to attain spirituality and absolute freedom. Influenced by Klein, Italy's Piero Manzoni created an eclectic body of work that revealed an altogether different obsession with an objective reality. In 1957 he remarked that he sought "images which are as absolute as possible, which cannot be valued for that which they record, explain and express, but only for that which they are to be."[1] Yet in an act of extreme negation, in 1959 Manzoni began to obscure his material objects—from lines to air to excrement—subversively encasing them in opaque containers that forced their existence to be understood only abstractly.

While neither Klein nor Manzoni produced a body of prints and editions in any conventional sense, both created groundbreaking multiple objects whose meanings are fundamentally enhanced by the fact that they exist in numerous examples and represent a dramatic new direction for editioned works of art. Theatricality also played a central role in both artists' work as they broke aesthetic boundaries. In 1960 Klein created a mythical, daylong "Theater of the Void" as his contribution to the *Festival d'Art Avant-Garde* in Paris. To accompany his imaginary spectacle he wrote, designed, and produced a four-page mock newspaper, *Dimanche—Le journal d'un seul jour* (P. 118), based on the format of the French weekly *Dimanche*. It contains his manifesto on the theater and numerous articles espousing his theories on color, space, emptiness, and immateriality as well as diagrams of positions from judo, a ritualistic sport about which Klein was passionate. The front of the newspaper included the now legendary image of Klein leaping from the rooftop of a building as if taking off in flight, the ultimate act of freedom in space.[2] Klein compounded his own mythic persona with this picture, clandestinely distributing his *Dimanche* on Paris newsstands, placing it adjacent to actual copies of the popular paper (P. 18, FIG. 6). This appropriation of the newspaper's format, materials, and distribution network signaled a new seamless fusion of art and everyday existence.

Manzoni's performative activities engendered different but equally inventive forms. Like Klein, Manzoni increasingly identified himself as the art—the individuality of his body and its byproducts acquiring an artistic value—in works that oddly counter mythic creation. In 1959 he fabricated an editioned balloon project, *Body of Air*, necessitating a person's breath. Examples filled by the artist himself were labeled "Artist's Breath." In perhaps his most notorious body-related work, in 1961 he issued an edition of ninety cans said to contain his own excrement. In *Artist's Shit* (P. 119), the notion of artistic creation is debunked with an ironic scatological gesture. Titled in four languages, each can weighed 30 grams and was priced by the artist on par with that day's price of gold, evoking the concept of artist as alchemist. In this provocative merging of life and art, Manzoni appropriates an ordinary tin can and raises it to a carrier of artistic meaning. He also parodies the art market, creating a metaphor for the fetishization and commodification surrounding works of art, here enhanced by the content's endless reproducibility.

Both Klein's and Manzoni's works anticipate the phenomenon of three-dimensional editioned objects that blossomed in the early 1960s. The irony and iconoclasm inherent in *Artist's Shit*, in particular, also harks back to Marcel Duchamp's readymades, everyday objects he elevated to works of art by the mere gesture of signing them. Duchamp was also the forebear in the field of multiples. In 1935 he completed five hundred examples of what is considered the first true multiple object, *Rotoreliefs*, a set of six rotating optical discs. It is the progenitor of Swiss artist Daniel Spoerri's 1959 publishing venture Edition MAT (*Multiplication d'Art Transformable*), which initially focused on projects with kinetic or variable elements. Duchamp, in fact, contributed a version of his *Rotoreliefs* to Edition MAT's first series, as did artists ranging from Jean Tinguely and Pol Bury to Dieter Roth and Victor Vasarely.[3]

After his first series in 1959 Spoerri issued others in 1964 and 1965, for a total of forty-eight works, always in editions of 100 and priced at less than 200 French francs. Spoerri's goal was to offer affordable art. In his landmark 1971 catalogue on multiples, John Tancock wrote: "Multiplication, as understood by Spoerri and by many of the artists who began to produce works in editions about this period, was concerned with the demythification of the artist and of the work of art."[4] Multiples appealed to many artists of the 1960s because of their challenge to the elitist status of the art object. Spoerri has acknowledged Russian Constructivists and artists of the Bauhaus as precursors to the concept of eschewing the artist's individual touch in favor of multiplicity and the dissemination of ideas.[5] As two scholars in the field have noted, "The materials of the objects are industrially manufactured and the works can by all means be repeated and made by persons other than the artist without losing their character as an original."[6] This was a prevailing sentiment of vanguard thinking in this period when multiples flourished.

Spoerri was a founding member in 1960 of the Paris-based *Nouveaux Réalistes*, a group of artists who rejected the gestural emotive work of the abstract *Informel* movement and proposed the reintroduction of the commonplace world into art. Found object assemblages and performance-based events were hallmarks of the group, whose members included Klein, Manzoni, Arman, Christo, Martial Raysse, and Niki de Saint Phalle, among others. Many *Nouveaux Réalistes* participated in Spoerri's

second and third MAT series. For the most part, when it came to editions, their assemblage-based work lent itself more to three-dimensional multiples than to prints. Arman's MAT edition of 1964, *Garbage Can* (P. 120), relates to his 1960 installation at Galerie Iris Clert in Paris for which he filled the entire space with refuse (P. 18, FIG. 5), epitomizing the *Nouveaux Réalistes'* focus on the industrialized urban environment. Arman chose to draw attention to the waste that exists in a throwaway consumer society while acknowledging a certain inherent beauty in its accumulation.

Spoerri's artistic approach to the everyday world centered on food. In 1961 he turned a gallery into a grocery store, stamping the food with "attention œuvre d'art" ("attention work of art") and selling the objects for their normal retail price.[7] The catalogues for the exhibition were small loaves of bread, in which garbage had been baked. Several years later, for his 1965 MAT project, Spoerri made *Bread* (P. 121), mounting three of these loaves in wood boxes. Influenced again by Duchamp, Spoerri played with the variable effects of chance occurrences. In discussing *Bread*, he expressed his interest in the randomness of baking and of bread as a material, with "its characteristic traits, swollen, mushy, hard-bitten, solid, etc. and which cannot be controlled exactly in its definite solid form…where so much has to be left for chance."[8]

Spoerri's performance pieces also focused around food and restaurants. In the early 1960s he organized elaborate feasts in galleries for which he would act as chef while art critics waited on tables. In 1968 he opened his own restaurant, Restaurant Spoerri, in Düsseldorf, and two years later his Eat Art Gallery opened upstairs. For all of these activities Spoerri created a variety of printed stuff, from menus to stationery to calling cards (P. 121). Fanciful documentation of short-lived events, printed in large editions, Spoerri's restaurant paraphernalia remain early markers of an artistic fascination with printed ephemera.

Christo, who arrived in Paris in 1958, drew attention to ordinary life by wrapping it—individual objects, architectural structures, and geographic configurations. While such wrapping highlights the theme of consumer packaging that was prevalent in the early 1960s, it also draws attention to the objects within. He began wrapping magazines in 1961, embalming this record of popular culture and denying the communication role of the mass media. For *Wrapped Der Spiegel*, his first multiple,

Christo chose 130 different copies of the German news magazine. The cover of the example seen here (P. 123) features industrialist Hans-Günther Sohl, chief executive of Thyssen A.G., one of Germany's largest steel manufacturers, underscoring the theme of German economic recovery in the 1960s. Several years later he wrapped three plastic flowers for *Wrapped Roses* (P. 123), again frustrating the expected function of the items within and creating a reminder of contemporary society's commodification of even beautiful objects of nature.

Fluxus

Simultaneous with the *Nouveaux Réalistes'* experimentation with the new multiple format were the activities of another loosely organized artist's group, Fluxus. Like other creative minds in the early 1960s, Fluxus artists were interested in finding a means to close the gap between art and life. Performance-based and linked to the experimental music movement, Fluxus was interdisciplinary in medium, international in scope, and utopian in outlook. Its critique of the art object epitomized "the restless energy of the 60s and the imperative to free artistic ideas and practices from their conventional frames."[9] The first Fluxus event took place in 1962 in Wiesbaden, Germany, where mastermind and organizer of the group George Maciunas lived at the time. By the mid-1960s Fluxus was also operating as a publishing house, distributing newsletters, artists' books, and multiples through mail order and an international network of Fluxshops. Fundamental to the organization was the production of modest, low-cost multiples in large editions, circulated to large numbers of people outside the normal channels of art distribution. Distinctive packaging, often designed by Maciunas, and the goal of broad dissemination of their publications were signature features of the group's aesthetic.

French artist Ben Vautier, known simply as Ben, met Maciunas and several other Fluxus artists in London when he participated in an event there known as the Festival of Misfits in 1962. He joined the group the following year and became one of the leading proponents of Fluxus activities and the group's anti-art-object ideology. Ben issued a voluminous amount of books, multiples, and ephemera covered with his provocative, short black-and-white texts. His iconoclastic approach to art and art-making reveals Fluxus's strong links to Duchamp. In questioning the role of the artist and rejecting the preciousness

Primarily through his teaching and lectures Beuys created a persona that confronted the status quo, challenging his students to take on social and political actions in search of social change. *We Are the Revolution* (P. 130) is among his most powerful and emblematic works on this theme. Based on a photograph of the artist striding out of a hotel on Capri, Italy, where he was staying during an exhibition, this commanding life-size image functions as a call to arms to the viewer to join his cause of transforming society. Beuys also made images based on actual confrontations. During his tenure at the Kunstakademie Düsseldorf, where he was professor from 1961 to 1972, Beuys's unconventional and antiauthoritarian teachings made him a controversial figure. The activism of the turbulent 1960s was interwoven into his philosophy as well. In 1972 Beuys was dismissed over his policy of open admission to his classes. He staged a sit-in for two nights, refusing to leave the building, but was finally escorted out of the school by the police with students at his side. His large screenprint poster *Democracy Is Merry* (P. 131) memorializes the event.

Student unrest deeply affected Beuys, and in the late 1960s and early 1970s he adopted several forms of political organization: in 1967 he founded the German Student's Party and in 1970 the Organization of Non-voters for Referendum, which evolved into the Organization for Direct Democracy through Referendum in 1971. These latter two sought to abolish the political party system and reorient power directly back to the individual. Beuys ran the organization from a street-front office across from the Kunstakademie and passed out information sheets on issues ranging from the environment to women's rights. He made the multiple *How the Dictatorship of the Parties Can Be Overcome* (P. 135), a plastic shopping bag printed on both sides with texts and diagrams contrasting a party system with his own "direct democracy" approach, in support of this political agenda. Containing information sheets and a felt object, this work cleverly circulated his ideas throughout the public at large. He used it as a prop in several actions and, without the felt insert, also gave it away at *documenta 5*.

When asked in a 1970 interview why he made multiples, Beuys responded, "That way I stay in touch with people... there's a real affinity to people who own such things, such vehicles. It's like an antenna which is standing somewhere."[18] With this in mind, it is not surprising that postcards figure significantly within Beuys's multiples. It was through these cards that he hoped to engage and inspire a broad public to think, act, and communicate creatively. Beginning in 1968 with a card from *documenta 4*, he issued a series of unlimited postcards that ranged from city views to those printed with his provocative short texts.[19] In 1974 he published a boxed collection of thirty-two of these cards (P. 131). Beuys often used found images for these works, integrating them into his program of social reform through the use of one of his rubber stamps—of which the most frequently seen spell out German Student's Party, Fluxus Zone West, or *Hauptstrom*, a German word for main current or flow, suggesting the cycle of life. His use of rubber stamps, a technique Beuys was undoubtedly familiar with from his Fluxus days, became an important part of his persona, acting as a marker or trace of his charismatic presence.

Several of Beuys's multiples are as subversive in design as they are in message. *Intuition* (P. 135), from 1968, is a simple box of wood, noteworthy for its unfinished appearance. To this Beuys added two barely visible horizontal pencil lines, one coming out from the left side and one slightly below it beginning on the right, suggesting antennae or an attempt at making contact. Planned as one of publisher Wolfgang Feelisch's unlimited VICE-Versand editions, approximately 12,000 boxes were produced; priced at 8 German marks when it was issued, it was one of Beuys's most widely distributed multiples (P. 21, FIG. 10). He thought of *Intuition* as a provocative container to encourage creative ideas—the ideal object to mass produce to foster social change. It has been observed that, "It is exactly the vastness of its distribution that gives this multiple its particular significance as the most successful attempt to exploit the format potential to transform a single idea into an endless network."[20]

Communication and partnership are the principal themes again in *Telephone T_____ Я* (P. 133). Here Beuys used found materials—two tin cans and some string—to construct the children's toy, marking the cans with an *S* and an *E*, referring to the German words for transmitter and receiver. The work embodies his ideas about the need for circulation and energy flow, concepts he often evoked with acoustic objects. The cans poignantly suggest the absent sound of a spoken voice, or a flow interrupted. In addition, the brown cross painted on one of the cans represents a positive pole of electrical current as well as the unity of oppositional constructs, such as intuition vs. intellect or East vs. West. All this symbolism

imbues a seemingly unpretentious object with poetic and healing potency.

Beuys's symbolic use of tactile and natural materials was a distinguishing feature of his artistic practice. His preoccupation with felt has become perhaps his most recognizable trademark. In *Felt Suit* (P. 132) he imbues this everyday material with a compelling resonance as a source of both protection and distance. Modeled after one of his own suits with the arms and legs extended, Beuys described the piece: "On the one hand it's a house, a cave that isolates a person from everybody else. On the other, it is a symbol of the isolation of human beings in our era. Felt plays the part of an insulator."[21] Beuys's legendary tale of his wartime plane crash in the mountains of Crimea and his rescue by Tartars, who wrapped him in fat and felt to nurture him back to health, infuses these comments. Elaborating on the notion of warmth as it relates to *Felt Suit*, however, he added that he did not mean physical warmth but rather "a completely different kind of warmth, namely spiritual or evolutionary warmth or the commencement of an evolution."[22] Commencing an evolution epitomizes the spirit behind Beuys's multiples. His editioned works represent a high point for this relatively new medium, one that brought about a true evolution in artistic thinking.

Dieter Roth

What is a print? A book? A multiple? The work of Dieter Roth calls into question our understanding of these formats, whether referring to centuries-old customs or even new concepts introduced in the 1960s. Roth's all-out assault on art-making resulted in a huge body of unconventional painting, drawing, prints, books, assemblage sculpture, installation, film, video, music, and poetry. The decidedly "messy" aspects of this work might surprise anyone familiar with Roth's early Constructivist compositions, with their stripped-down, geometric forms relating to Concrete art and poetry. But after meeting Swiss artist Jean Tinguely in 1961, and seeing his kinetic, self-destroying sculptural machines of junk metal, Roth changed course. His work would eventually be linked to several art movements—*Nouveau Réalisme*, Fluxus, and Conceptualism among them—but at its essence, and in its originality, it is impossible to categorize. The freedom of Roth's artistic imagination, with its exuberance, humor, and daring, and his relish for the abject have a liberating effect on the viewer. Of his art, he said, "I've tried to break

out of a pattern, rules, morality, the slavery of it all."[23] He flaunts decorum and exposes base instincts, epitomizing a "bad boy/bad girl" aesthetic in postwar art. In so doing, he has become a model for like-minded artists coming later, Martin Kippenberger (PP. 194–95), John Bock (P. 197), and Sarah Lucas (PP. 236–37) among them.

Printmaking had been integral to Roth's art since he was a teenager and scratched out a self-portrait on the cover of a tin can that he proceeded to ink and print. He remained a master of intaglio techniques, producing elegant etchings, drypoints, and aquatints that are appreciated by even the most tradition-bound connoisseur. He was also stimulated by collaboration with master printers in workshop settings, just as he enjoyed joint projects with fellow artists. His natural appetite for experimentation grew from such energizing relationships. Over the course of his prodigious and provocative career he made over five hundred prints and two hundred books, along with work in many other mediums. In addition to traditional intaglio, he worked in screenprint, woodcut, linoleum cut, and lithography. But it was his coupling of printmaking with foodstuffs that broke boundaries and redefined the medium.

It was at the Rhode Island School of Design, where Roth served as visiting professor in the mid-1960s, that he first applied chocolate to an etching, eventually sending a full box of chocolates through the printing press. He also made "pressings" and "squashings," defined as prints by Roth because they are "objects that have appeared in a series and are not thicker than 2 centimeters."[24] Slices of sausage (P. 137), cheese, vegetable juices (P. 136), mayonnaise, spices, bread, milk, and sugar replaced ink as the basis of his work. He focused on decay and the transformation and metamorphosis that comes with it. Rather than striving for permanence, Roth reveled in the transitory. He "explains" his process in a bizarre introduction to a print catalogue raisonné, saying: "Perhaps somebody comes and asks, what all this stuff was made for… I do not know!…This must have been an all encompassing sugar-bomb of the biggest width or size, with special chocopuss fillings, since otherwise it does not hang up or down like this in any way but Sugarpuss itself—Miss Neverdry or Mister Everwet."[25] Roth also used chocolate to create a series of self-portraits, defined as multiples because thirty were made for the "edition" (P. 136). Since these small busts turned moldy and began to disintegrate, by their very nature they were not identical. The artist

even helped this process along when he added birdseed and placed the works outside on small stands where birds could peck at them.

Similarly radical strategies applied to Roth's books. Among the most outrageous is his sausage series (P. 138). For these "volumes" Roth shredded popular magazines or literary works he said he "can't stand" or those by authors he wanted "to annoy."[26] He then followed sausage recipes, adding shredded pages in place of meat and mixing in spices and lard before stuffing these fillings into casings. Here again, Roth plays with the idea of an edition, since each of his fifty sausage books is in fact very different. For other "books," new ingredients came into play. In one series, *Poemetry* (P. 137), transparent plastic bags served as pages to be filled not only with printed texts but also with the likes of mutton, lamb, sauerkraut, pudding, urine, and glue. One can only imagine the unpleasant olfactory experience of these volumes when they were first made, but, as Roth explained, "Smell is an important vehicle for my memory."[27] While these books maintain certain conventions—the pages can be turned, for instance—Roth actually transforms them into sculptural objects.

In other instances, Roth made use of traditional printed pages but subverts custom in new ways. Volumes can be tiny, measuring less than 1 inch (2.5 cm) square to just over 3 inches (7.6 cm) (P. 139). Such miniaturization implies texts filled with secrets, and Roth's "stories" are, in fact, impenetrable. Pages are composed of cast-off papers like newsprint or the test sheets discarded by printers. Newspaper pages also fill larger books, as do sheets from comic books and coloring books. Some increase the sense of cacophony with die cut holes that allow the contents of underlying pages to show through. Roth made such experimental books in editions of only a few examples. But, in the late 1960s and early 1970s publisher Hansjörg Mayer, a friend and ardent supporter, set out to reprint them all, in a series to be known as Roth's *Collected Works* (P. 139). Though ultimately every volume was not included, there is great variety in this set and, with editions of 1,000, individual works can be disseminated to a relatively broad audience, spreading Roth's unique vision of what constitutes a book.

Another opportunity to spread Roth's aesthetic came with his *Rubber Stamp Box* (P. 138), a multiple object initially published by TAM THEK in an announced edition of 111. It should not be surprising that a portion of even this factory-produced multiple ended up with unique characteristics. Roth and Mayer took over part of the edition from TAM THEK and, utilizing the stamps—which feature a Roth-devised pictographic alphabet—included in each box, made "drawings" on the inside covers. Both the standard edition and these altered examples offer still further possibilities: individual owners can use the stamps themselves, extending the artist's challenge to conventional thinking far into the future.

Politics

The 1960s, which witnessed the confrontational spirit in art described here, was also a period of political upheaval. That upheaval was largely situated in the latter half of the decade, with ramifications extending into the 1970s. The catch phrase "Swinging London" and the music of the Beatles conjure up the optimism of earlier years, when television began to permeate people's lives as part of a rampant popular culture that paralleled a growing consumerism. The United States was a dominant force at this time, but disillusionment, in part due to the country's escalating involvement in the Vietnam War in the mid-1960s, ultimately led to a backlash. In fact, there was a general crisis of confidence in ruling governments, both in Europe and the United States. Some saw possibilities for change in Mao's Cultural Revolution in China, Che Guevara's resistance forces in Latin America, and other radical movements. Protests of all kind became harbingers of reform in a period known for its counterculture.

Some artists embraced mediums and messages that served social and political action, even if only in symbolic ways. In countries like Spain and East Germany, with repressive regimes, work with an undercurrent of resistance became a viable option, while outright protest was not. Rafael Canogar, of Spain, is best known for explorations of abstraction, but the fervor of this tumultuous time gave rise to a politicized subject matter in his art. In prints like *The Revolutionaries* (P. 144) and others from the portfolio *Violence*, Canogar made himself understood without specifically alluding to the Franco regime under which he lived. He reworked imagery from the press, but gave it new meaning that resonated more generally. Wolfgang Mattheuer, who functioned under East Germany's cultural dictates until the late 1980s, exploited the woodcut's potential for bold imagery and created prints with the impact of visual metaphors. The figures in *Fright* (P. 145), including one with a severed

arm, are placed against a background with no referential elements. As they respond to unknown threats, the overall message is one of pervasive fear and mankind's basic need for protection. This image, however, can also be interpreted more specifically as commentary on the effects of an authoritarian government. As Mattheuer said: "In my art I want to feel both subjective reality and the reality of the wide world, and if I'm lucky I'll achieve something universal."[28]

The Spanish artist's group Equipo Crónica chronicled social and political concerns through a satirical art.[29] While their themes referred to Spain's government and institutions, and to its great—but stifling—artistic past, the group also took aim at American imperialism and military might. In *Airplanes* (p. 146) Equipo Crónica appropriates Mickey Mouse to brand attacking planes and identify them as American. (In an earlier work it had juxtaposed the Disney character with a mushroom-shaped cloud.) By 1966, the year of this screenprint, America had begun its military escalation in Vietnam, making it a flashpoint for artists for nearly a decade to come.

Such preoccupation with the war in Vietnam is found in *Three Hairs and Shadow* (p. 143), a potent image by German artist Wolf Vostell. An ominous helicopter—the iconic symbol of military weaponry during the Vietnam era—is seen close-up in Vostell's screenprint, rendered as a monstrous flying animal. Yet the artist adorns this black-and-white newspaper image with bright pink lines in lipstick hues and collage elements of hair and cotton balls, suggesting a level of eroticism in the obscenity of war.[30] Vostell seems to indict not only war itself but also the public's appetite for it, heightened by gruesome daily television reports. Vostell said, "My art is the perpetual resistance to evil intention and violence; to everything that is antagonistic towards that principle, life!"[31]

Vietnam also provides the subject for Joe Tilson's brightly colored *Ho Chi Minh* (p. 147), which joins other depictions of world-renowned figures found in the art of this period. Tilson depicts the leader as a benign, even gentle figure despite the powerful aura created by the looming size of this screenprint. Using a collage technique he presents snapshots of the leader embracing two children and casually posing with a friend, who was also his military strategist and a master of guerrilla tactics. This sympathetic portrait flies in the face of Ho's reputation as a fierce leader, willing to accept enormous casualties in order to achieve independence for his country.

China's Mao Tse-tung was another political figure who captured the imaginations of artists. Though for many in the 1960s Mao's Cultural Revolution seemed to promise a hopeful future, it would later be discredited for its brutality. K P Brehmer depicts Mao in a postage stamp format (p. 142), one in a series of prints he made that calls attention to ways in which institutional messages are spread worldwide. He found subjects for his art in the events of the day, saying: "If an artist today is a remarkable observer of his time, then things fall again and again into his hands.... Thus one finds documents for a particular conception of this reality."[32] Between 1966 and 1972 Brehmer executed approximately fifty stamp prints, one component of a practice that brought pointed social critique to the foreground in art.

The world figure most associated with the protests of May 1968 in France was then President Charles de Gaulle. Austrian artist Otto Muehl created a garish portrayal of him (p. 140) as part of a series on major personalities of the day, which also included portraits of Ho, Mao, Konrad Adenauer of Germany, Moshe Dayan of Israel, Gamal Abdel Nasser of Egypt, and the Shah of Iran, among others. He called politicians in general "particularly abhorrent types."[33] A provocateur who landed in jail for his violent performance art, Muehl articulated his goals within a philosophy he termed "Zock." He has said, "Zock will pounce upon all statesmen and their hangmen, upon the creators of national anthems, devotional priests, state prize-winners…upon all who have accomplished something in this fucked-up society."[34]

De Gaulle and his leadership became the fulcrum of protests overrunning France in May and early June of 1968. Striking students and workers took to the streets by the millions, bringing the government to near collapse. "We are against the established order of the day," read a leaflet distributed by Atelier Populaire, a renegade print workshop established at Paris's École des Beaux-Arts to make posters in service of the cause.[35] These student artists, and others who joined in, made new images daily in response to events, posting them in the streets at night (p. 20, FIG. 9). Bold graphics covered the walls of the city, expressing widespread dissatisfaction with the capitalist system, commenting on the exploitation of workers, railing against state-run radio and television stations, and ridiculing the tactics of the French riot police known as the CRS (*Compagnies Républicaines de Sécurité*, or Republican Security Companies) (p. 141).

Beyond any single issue it was a widespread belief in the complicity of almost all ruling institutions that provided the source of much protest of the late 1960s and early 1970s. Whether the problems were economic, political, or military, they seemed to be part of the same corrupt fabric, benefiting the few to the disadvantage of many. Artists, as well as protesters from all walks of life, felt they could influence change by direct action. Öyvind Fahlström, with his series of world maps (P. 146), brought together references to many of these dissatisfactions into one teeming network of collusion, covering the entire globe. In his caustic observations, the geographic shape of continents actually expanded or contracted depending on particular spheres of influence and areas currently in revolt. One sees civil outbreaks in Northern Ireland, separatists in Spain, dissenters in the Soviet Union, military and economic exploitation in Latin America, and, of course, the war in Vietnam. Summing up his artistic stance—and that of many other artists of the day—Fahlström said: "My approach has been to orchestrate data, so people will—at best—both understand and be outraged."[36]

Notes

1 Piero Manzoni, "For the Discovery of a Zone of Images" (1957), reprinted in Kristine Stiles and Peter Selz, *Theories and Documents of Contemporary Art: A Sourcebook of Artists' Writings* (Berkeley and Los Angeles: University of California Press, 1996), p. 79.

2 Several judo masters from a nearby school were holding a tarp to catch him. The photograph was taken, and a montage made, by two photographers hired by Klein to document the event.

3 When approached by Spoerri to participate in the first Edition MAT series, Duchamp sent one hundred of his unused *Rotorelielf*. See Katerina Vatsella, *Edition MAT: Daniel Spoerri, Karl Gerstner und das Multiple. Die Entstehung einer Kunstform* (Bremen, Germany: Neues Museum Weserburg Bremen, 1998), pp. 214–15.

4 John L. Tancock, *Multiples: The First Decade* (Philadelphia: Philadelphia Museum of Art, 1971), n.p.

5 See "Daniel Spoerri: Das Multiplizierte Kunstwerk," in Vatsella, *Edition MAT*, p. 259.

6 Katerina Vatsella et al., *Product: Kunst! Wo bleibt das Original?* (Bremen, Germany: Neues Museum Weserburg Bremen, 1997), p. 8.

7 The exhibition was at Addi Kopcke's gallery in Copenhagen. For more on this exhibition, see Vatsella, *Edition MAT*, p. 168.

8 Spoerri, quoted in Vatsella, *Edition MAT*, p. 245.

9 Claudia Gould, "Art in Europe and America: The 1960s and 1970s," in *Breakthroughs: Avant-Garde Artists in Europe and America, 1950–1990* (New York: Rizzoli, 1991), p. 92.

10 Anne Moeglin-Delcroix, "1962 and After: Another Idea about Art," in *Guardare, Raccontare, Pensare, Conservare: Quattro percorsi del libro d'artista dagli anni '60 ad oggi* (Mantua, Italy: Casa del Mantegna, 2004), p. 34.

11 Peter Schmieder, *Unlimitiert: Der VICE-Versand von Wolfgang Feelisch* (Cologne: Walther König, 1998), p. 159.

12 For more on this work, see Stephen Bury, *Artists' Multiples 1935–2000* (Aldershot, England: Ashgate Publishing, 2001), p. 66.

13 Milan Knížák, printed insert from *Broken Music*. Reprinted in *Milan Knížák: Unvollständige Dokumentation, 1961–1979/Some Documentary, 1961–1979* (Berlin: Edition ARS VIVA! and Berliner Künstlerprogramm des DAAD, 1980), p. 142.

14 OHO manifesto, written by Iztok Geister and Marko Pogačnik, 1966. Reprinted in *Impossible Histories: Historical Avant-Gardes, Neo-Avant-Gardes and Post-Avant-Gardes in Yugoslavia, 1918–1991*, ed. Dubravka Djurić and Miško Šuvaković (Cambridge, Mass.: The MIT Press, 2003), p. 321. For more on OHO and other Eastern European artists' publications, see Lilijana Stepančič, "The First Line," in *Prva linija/The First Line: Raymond Pettibon. Najlepse grafike/The Most Beautiful Prints* (Ljubljana, Slovenia: MGLC, International Centre of Graphic Arts, 2006), pp. 19–28.

15 Ted Purves, *Nothing Left for Art to Say* (San Francisco: n.p., 1995), n.p.

16 Pawel Petasz, "Mailed Art in Poland," in *Eternal Network: A Mail Art Anthology*, ed. Chuck Welch (Calgary: University of Calgary Press, 1995), p. 92.

17 Beuys, quoted in Peter Nisbet, "In/Tuition: A University Museum Collects Joseph Beuys," in *Joseph Beuys: The Multiples*, ed. Jörg Schellmann (Cambridge, Mass.: Busch-Reisinger Museum, Harvard University Art Museums; Minneapolis: Walker Art Center; Munich and New York: Edition Schellmann, 1997), p. 520.

18 Joseph Beuys, "Questions to Joseph Beuys," interview by Jörg Schellmann and Bernd Klüser, in Schellmann, *Joseph Beuys: The Multiples*, p. 9.

19 For the 1968 card Beuys used an existing postcard and transformed it with stamps, including one on the back with the phrase "Documenta IV." The documenta organization tried to stop sale of the card, but eventually agreed that the card could be sold only outside the grounds of the actual exhibition. Edition Staeck, e-mail correspondence, June 2006.

20 Daniel Buchholz and Gregorio Magnani, eds., *International Index of Multiples from Duchamp to the Present* (Cologne: Walther König, 1993), p. 7.

21 Joseph Beuys, interview by Keto von Waberer, in *Eine innere Mongolei*, ed. Carl Haenlein (Hannover: Kestner-Gesellschaft, 1990), p. 206.

22 Ibid.

23 Dieter Roth, "I Only Extract the Square Root," interview by Ingólfur Margeirsson, in *Dieter Roth* (Reykjavík: Nýlistasafnid—The Living Art Museum, 1982), n.p.

24 Dieter Roth, "Introduction to *Collected Works*, Volume 20," in Dirk Dobke, *Dieter Roth: Graphic Works, Catalogue Raisonné 1947–1998* (London: Edition Hansjörg Mayer, 2003), p. 8.

25 Dieter Roth, "Introduction to *Collected Works*, Volume 40," in ibid., p. 332.

26 Thomas Kellein, "Dieter Roth – in memoriam," in Dirk Dobke, *Dieter Roth: Books + Multiples, Catalogue Raisonné* (London: Edition Hansjörg Mayer, 2004), p. 9.

27 Dirk Dobke, "Unique Pieces in Series – The Multiples," in Dobke, *Dieter Roth: Books + Multiples, Catalogue Raisonné*, p. 17.

28 Mattheuer, quoted in Eduard Beaucamp, "A Plea for Existential Art," in *Wolfgang Mattheuer Retrospektive: Gemälde, Zeichnungen, Skulpturen/Paintings, Drawings, Sculptures*, ed. Ingrid Mössinger and Kerstin Drechsel (Leipzig: E. A. Seemann, 2002), p. 20.

29 Equipo Crónica also participated in Estampa Popular, a Spanish printmaking group devoted to social and political issues. For more on Estampa Popular, see *Estampa Popular* (Valencia: Generalitat Valenciana and IVAM Centre Julio González, 1996).

30 The recent catalogue raisonné of Vostell's prints indicates that the title of this work refers to a victim who was left with three hairs after the atomic bombing of Hiroshima. That tragedy is thereby conflated with the war in Vietnam. *Wolf Vostell: Die Druckgrafik* (Bergisch Gladbach, Germany: Städtische Galerie Villa Zanders, 2005), p. 40.

31 Vostell, quoted in "The Artists and the Graphics: Wolf Vostell," in Hubertus Butin, *Grafik des Kapitalistischen Realismus/Graphics of the Capitalistic Realism: Klaus Peter Brehmer, Karl Horst Hödicke, Konrad Lueg, Wolf Vostell, Sigmar Polke, Gerhard Richter*, (Frankfurt: Galerie Bernd Slutzky, 1992), p. 39.

32 Brehmer, quoted in Georg Jappe, "K P Brehmer," *Studio International*, vol. 191 (March 1976): 142.

33 Muehl, quoted in Hans-Werner Schmidt, "Chinesen am Rhein," in Marie Louise Syring, *Um 1968: Konkrete Utopien in Kunst und Gesellschaft* (Cologne: Du Mont, 1990), p. 139.

34 Muehl, quoted in "Otto Mühl: Biography and Action Chronology," in *Wiener Aktionismus, Wien 1960–1971: Der zertrümmerte Spiegel/Viennese Aktionism, Vienna 1960–1971: The Shattered Mirror. Günter Brus, Otto Mühl, Hermann Nitsch, Rudolf Schwarzkogler*, vol. 2, ed. Hubert Klocker (Klagenfurt, Austria: Ritter Verlag, 1989), p. 211.

35 *Text and Posters by Atelier Populaire: Posters from the Revolution, Paris, May 1968* (London: Dobson, 1969), n.p.

36 Öyvind Fahlström, *Garden: A World Model, 1973* (Cologne: Aurel Scheibler, 1991), n.p.

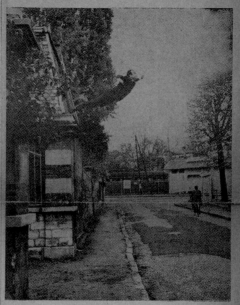

Yves Klein

[FRENCH, 1928–1962]

Dimanche—Le journal d'un seul jour,
November 27, 1960
Newspaper

SHEET: 22 x 15" (55.9 x 38.1 cm)
PUBLISHER: the artist, Paris
EDITION: unknown

The Museum of Modern Art Library,
New York

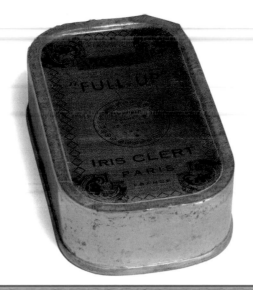
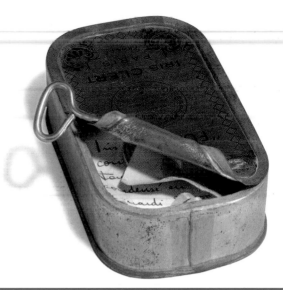

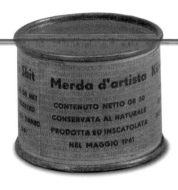

Piero Manzoni

[ITALIAN, 1933–1963]

Merda d'artista
(**Artist's Shit**), 1961
Multiple of can, printed label, and
"artist's shit"

OVERALL: $1^7/_8$ X $2^1/_2$" (4.8 x 6.4 cm)
PUBLISHER AND FABRICATOR: the artist, Milan
EDITION: 90

The Museum of Modern Art, New York.
Gift of Jo Carole and Ronald S. Lauder, 1999

Arman

[AMERICAN, born France. 1928–2005]

Le Plein (**Full Up**), 1960
Two multiples of sardine can filled with
trash and exhibition invitation

OVERALL: $4^1/_8$ X $2^1/_2$ X $1^1/_8$" (10.5 x 6.4 x 2.9 cm)
PUBLISHER: Galerie Iris Clert, Paris
FABRICATOR: the artist and Galerie Iris Clert, Paris
EDITION: 1,500; plus 500 signed and numbered

The Museum of Modern Art, New York.
The Associates Fund, 2006

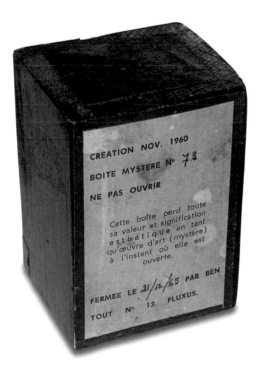

Ben Vautier

[FRENCH, born Italy, 1935]

Boîte mystère (**Mystery Box**), 1960–65
Multiple of cardboard and printed label

OVERALL: $3^{15}/_{16}$ X $2^{15}/_{16}$ X $2^3/_8$" (10 x 7.5 x 6 cm)
PUBLISHER AND FABRICATOR: the artist, Nice
EDITION: unlimited

The Gilbert and Lila Silverman Fluxus
Collection, Detroit

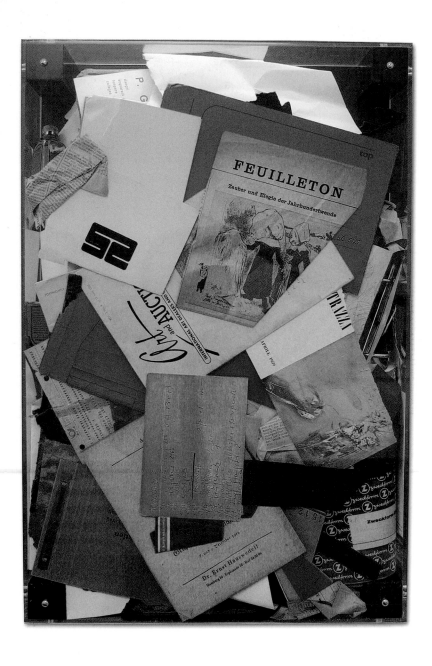

Arman

[AMERICAN, born France. 1928–2005]

Accumulation, 1973
Multiple of rubber stamps and paper in wooden box with Plexiglas lid

OVERALL: 18¹⁄₂ x 12⁵⁄₈ x 3⁵⁄₁₆" (47 x 32 x 8.4 cm)
PUBLISHER: Edition Schellmann, Munich, and John Gibson Gallery, New York
FABRICATOR: Edition Schellmann, Munich
EDITION: 100

The Museum of Modern Art, New York. Gift of Mary Ellen Oldenburg, 2006

Poubelle (Garbage Can), 1964
Multiple of trash and Plexiglas box

OVERALL: 28³⁄₈ x 20¹⁄₁₆ x 4³⁄₄" (72 x 51 x 12 cm)
PUBLISHER: Edition MAT/Galerie Der Spiegel, Cologne
FABRICATOR: the artist and Edition MAT/Galerie Der Spiegel, Cologne
EDITION: 100

Galerie Der Spiegel, Cologne

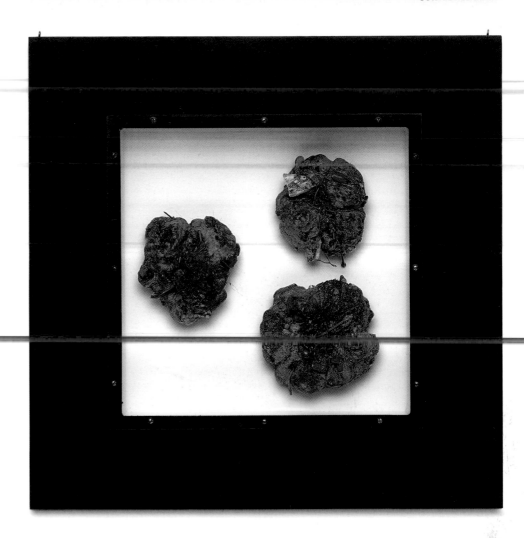

Daniel Spoerri

[SWISS, born Romania, 1930]

Brote (Bread), 1965
Multiple of bread and trash in wood and
Plexiglas frame

OVERALL: 19 $^{11}/_{16}$ x 19 $^{11}/_{16}$ x 3 $^1/_8$" (50 x 50 x 8 cm)
PUBLISHER: Edition MAT/Galerie Der Spiegel,
Cologne
FABRICATOR: the artist and Edition MAT/Galerie
Der Spiegel, Cologne
EDITION: 100

Staatsgalerie Stuttgart, Archiv Sohm

Calling card and stationery from Eat Art
Gallery, Düsseldorf, 1970–72

SHEET: various
PUBLISHER: the artist, Düsseldorf
EDITION: unknown

Staatsgalerie Stuttgart, Archiv Sohm

Menu for Restaurant de la Galerie J, 1963

SHEET: 10 $^9/_{16}$ x 8 $^1/_4$" (26.9 x 21 cm)
PUBLISHER: probably the artist, Paris
EDITION: unknown

The Museum of Modern Art Library, New York

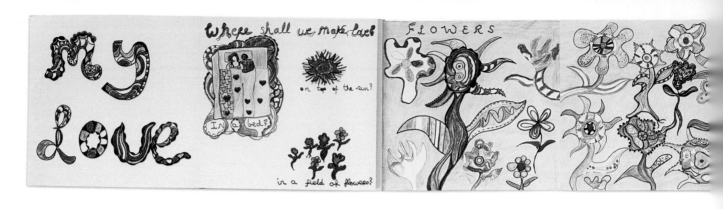

My Love, 1971
Artist's book

PAGE: 6 ¹¹/₁₆ x 7 ¹/₁₆" (17 x 18 cm)
PUBLISHER: Moderna Museet, Stockholm
PRINTER: Skaneoffset and Litografik,
Malmö, Sweden
EDITION: unknown

The Museum of Modern Art, New York.
Gift of Kynaston McShine, 1981

Niki de Saint Phalle

[FRENCH, 1930–2002]

Untitled, 1974–present
Stickers

DIMENSIONS: variable (approx. 3 ¹/₈ x 2 ³/₄" [8 x 7 cm])
PUBLISHER: various
PRINTER: various
EDITION: various

The Museum of Modern Art, New York.
Gift of the Niki Charitable Art Foundation, 2006

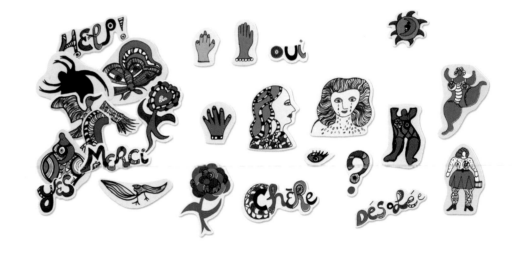

Nana de Berlin
(**Nana of Berlin**), 1968
Multiple of painted plaster

OVERALL: 10 ¹/₂ x 11 ³/₄ x 9 ³/₄" (26.6 x 29.8 x 24.7 cm)
PUBLISHER: Zeit Magazin, Hamburg
FABRICATOR: Kunstwerkstatt Kevelaer, Germany
EDITION: 500

Collection John Sayegh-Belchatowski, Paris

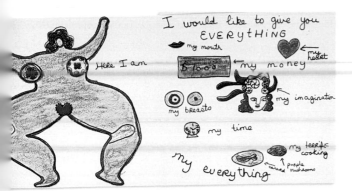

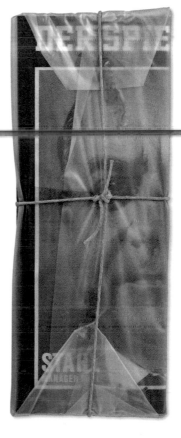

Christo
[AMERICAN, born Bulgaria, 1935]

Wrapped Der Spiegel, 1963
Multiple of magazine, polyethylene,
and string
OVERALL: 11¹³/₁₆ X 5¹/₈ X 1" (30 X 13 X 2.5 cm)
PUBLISHER: HofhausPresse, Düsseldorf
FABRICATOR: the artist, Paris
EDITION: 130

Private collection, New York

Wrapped Roses, 1968
Multiple of plastic roses, polyethylene,
and plastic string
OVERALL: 2³/₈ X 23¹/₂ X 5¹/₄" (6 X 59.7 X 13.3 cm)
PUBLISHER: Institute of Contemporary Art,
University of Pennsylvania, Philadelphia
FABRICATOR: the artist, New York
EDITION: 75

The Museum of Modern Art, New York.
Carol and Morton H. Rapp Fund, 2005

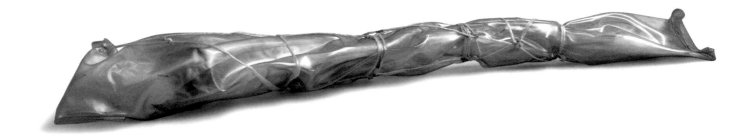

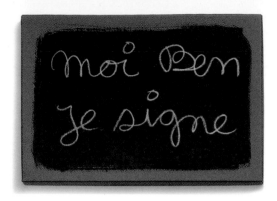

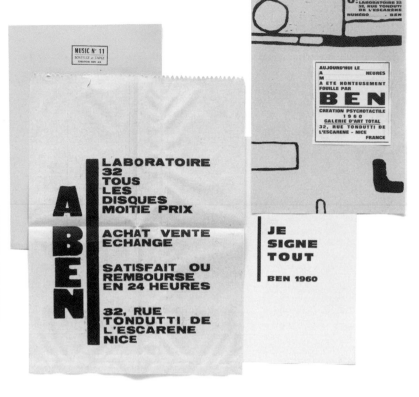

Ben Vautier
[FRENCH, born Italy, 1935]

Moi, Ben je signe, 1975
(first edition 1962–63)
Artist's book with object and
collage additions
PAGE: 12 1/4 x 8 5/16" (31 x 21.2 cm)
PUBLISHER: Lebeer Hossmann Éditeurs,
Brussels and Hamburg
(first edition, the artist, Nice)
EDITION: 375
The Museum of Modern Art, New York.
Joanne M. Stern Fund, 1975

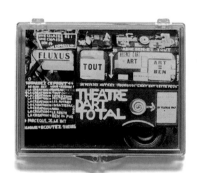

Théatre d'art total (Total Art Theater)
from **Fluxkit**, 1964
Plastic box and cards from a multiple
by various artists
OVERALL: 3 11/16 x 4 3/4 x 9/16" (9.4 x 12 x 1.4 cm)
PUBLISHER: Fluxus Editions, New York
EDITION: 30
The Museum of Modern Art, New York.
Gift of Ken Friedman, 1982

Art does not exist, 1989
Take your time, 1998
Postcards
SHEET (APPROX.): 4 x 6" (10.2 x 15.2 cm)
PUBLISHER: Emily Harvey Gallery, New York (left);
John Gibson Gallery, New York (right)
EDITION: unknown
The Museum of Modern Art Library,
New York

Robert Filliou

[FRENCH, 1926–1987]

The Frozen Exhibition, 1972
Multiple of felt-covered paper hat,
photographs, and facsimilies of
press clippings

HAT: 7 7/8 x 12 5/8" (20 x 32 cm)
PUBLISHER AND FABRICATOR:
Edition VICE-Versand, Remscheid, Germany
EDITION: 100

Collection ASPC in the Research Centre for
Artists' Publications/ASPC, Neues Museum
Weserburg Bremen, Germany

Optimistic Boxes 1–5, 1968–81
Multiple of three wooden boxes,
ceramic pig, stone, and printed labels

DIMENSIONS: from 1 1/8 x 4 11/16 x 2 5/16"
(2.9 x 11.9 x 5.9 cm) to 4 1/8 x 4 5/16 x 4 1/4"
(10.5 x 11 x 10.8 cm)
PUBLISHER AND FABRICATOR: Edition VICE-
Versand, Remscheid, Germany
EDITION: unlimited

The Museum of Modern Art, New York.
General Print Fund, 2005

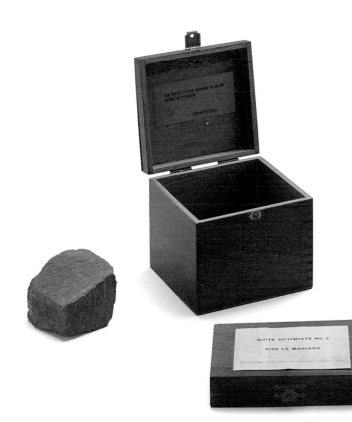

Endre Tót

[HUNGARIAN, born 1937]

Incomplete Information/ Verbal & Visual, 1972
Artist's book
PAGE: 7⁷⁄₈ X 5¹⁄₂" (20 X 14 cm)
PUBLISHER: Edition I.A.C., Oldenburg, Germany
EDITION: 100

The Museum of Modern Art Library, New York

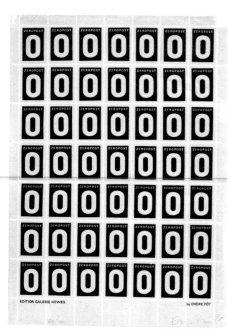

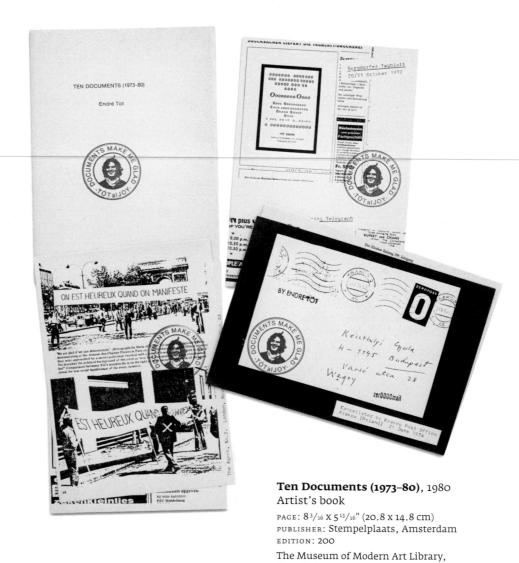

Zeropost, 1970
Postage stamps
SHEET: 11⁹⁄₁₆ X 8¹⁄₈" (29.4 X 20.7 cm)
PUBLISHER: Galerie Howeg, Zurich
EDITION: 100

The Museum of Modern Art, New York. Linda Barth Goldstein Fund, 2006

Ten Documents (1973–80), 1980
Artist's book
PAGE: 8³⁄₁₆ X 5¹³⁄₁₆" (20.8 X 14.8 cm)
PUBLISHER: Stempelplaats, Amsterdam
EDITION: 200

The Museum of Modern Art Library, New York

Milan Knížák

[CZECH, born 1940]

Necklace, 1968
Multiple of iron and scissors
OVERALL: 16¹/₄ X 11⁷/₈" (41.3 X 30.2 cm)
PUBLISHER AND FABRICATOR: Edition VICE-
Versand, Remscheid, Germany
EDITION: 2,000

The Museum of Modern Art, New York.
General Print Fund, 2005

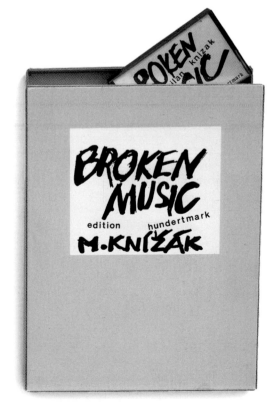

Zerstörte Musik (**Broken Music**), 1983
Multiple of melted record, cassette,
and texts in box

BOX: 10¹¹/₁₆ X 8¹/₄ X ⁷/₈" (27.1 X 21 X 2.2 cm)
PUBLISHER: Galerie and Edition Hundertmark,
Cologne
FABRICATOR: the artist and Galerie and
Edition Hundertmark, Cologne
EDITION: 40

The Museum of Modern Art, New York.
Acquired through the generosity of
Lee and Ann Fensterstock in honor of their
daughter Jane, 2006

OHO

[SLOVENIAN ARTIST'S GROUP, active 1966–1971]

Marko Pogačnik [SLOVENIAN, born 1944]
Iztok Geister [SLOVENIAN, born 1945]
Knjiga z obročkom (Book with Ringlet),
c. 1966–71
Artist's book
PAGE: 6 15/16 X 5 5/16" (17.6 X 13.5 cm)
PUBLISHER: the artists, Ljubljana, Slovenia
EDITION: unknown
Museum of Modern Art Ljubljana, Slovenia

Marko Pogačnik
Pegam in Lambergar
(Pegam and Lambergar), 1968
Artist's book
PAGE: 7 7/8 X 4 5/16" (20 X 11 cm)
PUBLISHER: the artists, Ljubljana, Slovenia
EDITION: unknown
MGLC, International Centre of Graphic Arts,
Ljubljana, Slovenia

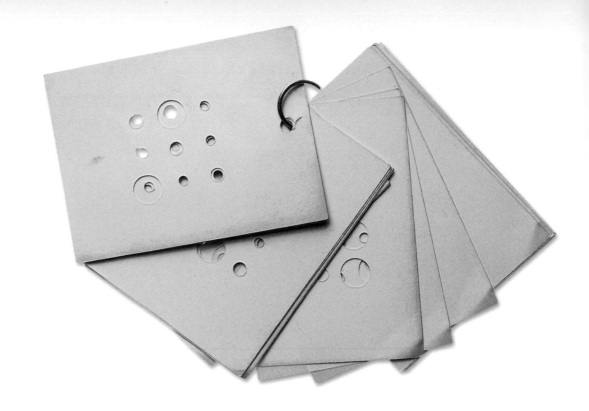

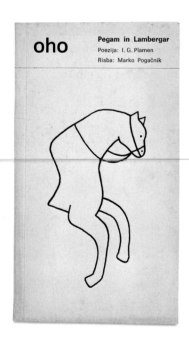

Marko Pogačnik
Iztok Geister
Gobe v knjigi (Mushrooms in a Book),
1968
Artist's book
PAGE: 3 9/16 X 8 9/16" (9 X 21.7 cm)
PUBLISHER: the artists, Ljubljana, Slovenia
EDITION: unknown
MGLC, International Centre of Graphic Arts,
Ljubljana, Slovenia

Pawel Petasz

[POLISH, born 1951]

Sealsale, 1979
Artist's book of rubber stamps
PAGE: 8 1/16 x 5 3/4" (20.5 x 14.6 cm)
PUBLISHER: Arrière-Garde, Elblag, Poland
EDITION: 20

The Museum of Modern Art Library,
New York

**Obsolete Rubberstamps
vol. 3 & 4**, 1980
Artist's book of rubber stamps
PAGE: 7 15/16 x 5 7/16" (20.2 x 13.8 cm)
PUBLISHER: the artist, Elblag, Poland
EDITION: 31
The Museum of Modern Art Library,
New York

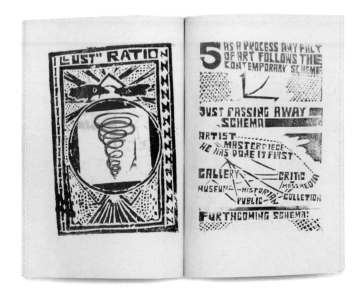

Rubber Condom vol. 3, 1980
Artist's book of rubber stamps
PAGE: 6 3/4 x 4 11/16" (17.2 x 11.9 cm)
PUBLISHER: Arrière-Garde, Elblag, Poland
EDITION: 20–30

The Museum of Modern Art Library,
New York

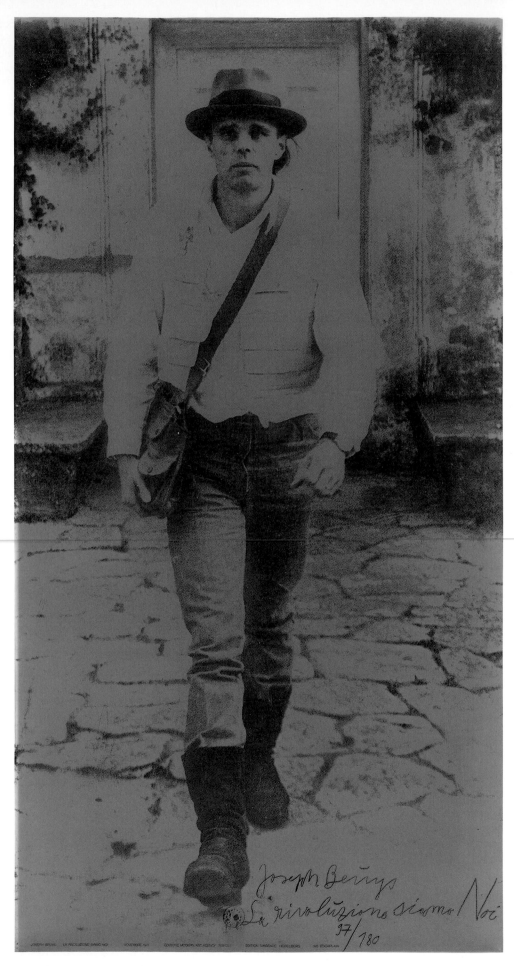

Joseph Beuys

[GERMAN, 1921–1986]

**La rivoluzione siamo Noi
(We Are the Revolution)**, 1972
Diazotype and rubber stamp on polyester

SHEET: 6' 3³/₈" x 39⁵/₈" (191.5 x 100.7 cm)
PUBLISHER: Edizione Modern Art Agency,
Naples, and Edition Tangente, Heidelberg
PRINTER: unknown
EDITION: 180 on paper; few examples
on polyester

The Museum of Modern Art, New York.
Gift of Lily Auchincloss, 1991

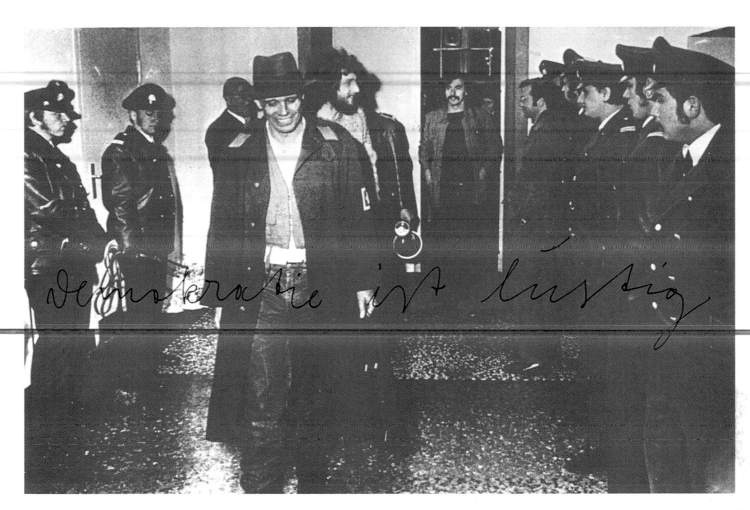

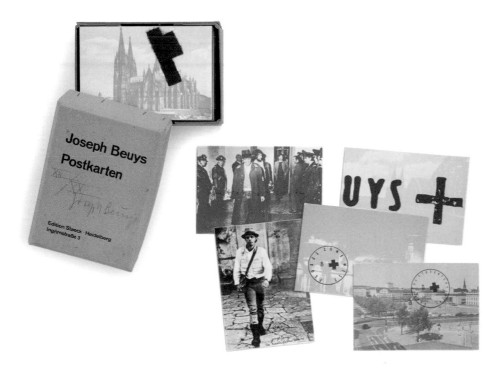

**Demokratie ist lustig
(Democracy Is Merry)**, 1973
Screenprint with ink additions

SHEET: 29 1/2 X 45 1/16" (75 X 114.5 cm)
PUBLISHER: Edition Staeck, Heidelberg
PRINTER: Gerhard Steidl, Göttingen, Germany
EDITION: 80

The Museum of Modern Art, New York.
Walter Bareiss Fund, 2001

Postcards 1968–1974, 1974
Box of thirty-two postcards

SHEET (EACH): 5 13/16 X 4 1/8" (14.8 X 10.5 cm)
PUBLISHER: Edition Staeck, Heidelberg
PRINTER: Gerhard Steidl, Göttingen, Germany
EDITION: 120

The Museum of Modern Art, New York.
Acquired through the generosity of
Richard Gerrig and Timothy Peterson in
memory of Thor Peterson, 2006

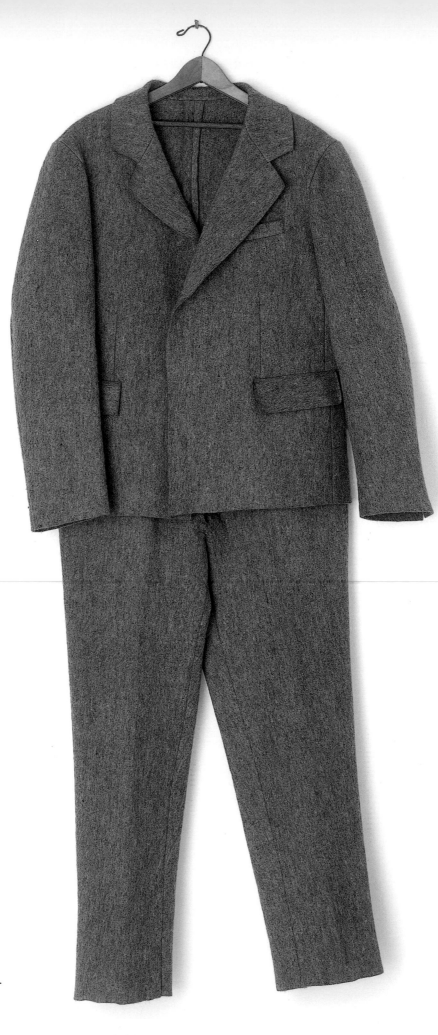

Joseph Beuys

[GERMAN, 1921–1986]

Filzanzug (Felt Suit), 1970
Multiple of felt

OVERALL: 69⁷/₈ x 28¹/₈ x 5⁵/₁₆"
(177.5 x 71.5 x 13.5 cm)
PUBLISHER: Edition René Block, Berlin
FABRICATOR: unknown
EDITION: 100

The Museum of Modern Art, New York.
The Associates Fund, 1993

Evervess II 1, 1968
Multiple of two bottles, one with felt,
in wooden box with rubber stamp
additions

BOX: 10¹³/₁₆ x 6⁷/₁₆ x 3⁷/₁₆" (27.4 x 16.3 x 8.7 cm)
PUBLISHER AND FABRICATOR: Edition René Block,
Berlin
EDITION: variant outside the edition of 40

The Museum of Modern Art, New York.
Riva Castleman Endowment Fund,
Donald B. Marron Fund, and
Harvey S. Shipley Miller Fund, 2005

Telefon S_____Ǝ
(**Telephone T_____Я**), 1974
Multiple of two tin cans with paint
additions and string

CAN: 4³/₄ x 3¹⁵/₁₆" (12 x 10 cm)
PUBLISHER AND FABRICATOR: Edition Schellmann,
Munich
EDITION: 24

The Museum of Modern Art, New York.
Riva Castleman Endowment Fund, 2005

Joseph Beuys

[GERMAN, 1921–1986]

**Phosphor-Kreuzschlitten
(Phosphorus-Cross Sled)**, 1972/1977
Multiple of phosphorus between vinyl
sheets and metal clamp

OVERALL: 19⁵/₁₆ X 17¹/₈ X 1³/₈"
(49.1 X 43.5 X 3.5 cm)
PUBLISHER: Kunstverein Braunschweig,
Brunswick, Germany
FABRICATOR: Edition Merian, Krefeld, Germany
EDITION: 100

The Museum of Modern Art, New York.
Jacqueline Brody Fund, 2005

**Samurai-Schwert
(Samurai Sword)**, 1983
Multiple of felt and steel

OVERALL: 2¹¹/₁₆ X 21 X 3⁹/₁₆" (6.9 X 53.4 X 9 cm)
PUBLISHER: Edition VICE-Versand,
Remscheid, Germany
FABRICATOR: the artist and Edition VICE-
Versand, Remscheid, Germany
EDITION: 30

The Museum of Modern Art, New York.
The Associates Fund, 2006

Intuition, 1968
Multiple of wooden box with
pencil additions

OVERALL: 11¹³/₁₆ x 8¹/₄ x 2⁵/₁₆" (30 x 21 x 5.8 cm)
PUBLISHER AND FABRICATOR: Edition VICE-
Versand, Remscheid, Germany
EDITION: unlimited; approx. 12,000 made

The Museum of Modern Art, New York.
Jacqueline Brody Fund, 2001

**How the Dictatorship of the Parties
Can Be Overcome**, 1971
Multiple of plastic shopping bag
containing printed sheets, some with
rubber stamp additions, and felt object

BAG: 29¹/₈ x 20³/₁₆" (74 x 51.3 cm)
PUBLISHER: art intermedia, Cologne
EDITION: 10,000 announced; approx. 500 made
with felt object

The Museum of Modern Art, New York.
The Ralph E. Shikes Fund, 2003

Dieter Roth

[SWISS, born Germany. 1930–1998]

Thomkinspatent, 1968
Screenprint and vegetable juice
on card in plastic cover

SHEET: 28³/₈ X 40¹/₈" (72.1 X 101.9 cm)
PUBLISHER: the artist, Düsseldorf
PRINTER: Hartmut Kaminski, Düsseldorf
EDITION: 50

The Museum of Modern Art, New York.
Ann and Lee Fensterstock Fund, 2003

P.o.TH.A.A.VFB
(**Portrait of the Artist as**
Vogelfutterbüste), 1968
Multiple of chocolate and birdseed

OVERALL: 7⁷/₈ X 5¹/₂ X 4⁵/₁₆" (20 X 14 X 11 cm)
PUBLISHER: the artist, Düsseldorf
FABRICATOR: Rudolf Rieser, Cologne
EDITION: 30

Dieter Roth Foundation, Hamburg

Poemetry (deluxe edition), 1967–68
Book of plastic bags, letterpress,
and minced mutton

OVERALL: 33⁷/₈ x 11" (86 x 28 cm)
PUBLISHER: Divers Press, Cologne
PRINTER: Gustav Adolf Höhm, Cologne
FABRICATOR: Rudolf Rieser, Cologne
EDITION: 50

Dieter Roth Foundation, Hamburg

Big Sunset, 1968 (published 1970)
Sausage on card in plastic cover

SHEET: 37³/₈ x 25⁹/₁₆" (95 x 65 cm)
PUBLISHER: the artist, Düsseldorf
PRINTER: Rudolf Rieser, Cologne
EDITION: 25

The Museum of Modern Art, New York.
Riva Castleman Endowment Fund and
Alexandra Herzan Fund, 2003

expressionist impulse

Georg Baselitz
Günter Brus
Carlfriedrich Claus
Francesco Clemente
Jörg Immendorff
Anselm Kiefer
Per Kirkeby
Krater und Wolke
Maria Lassnig
Markus Lüpertz
Hermann Nitsch
Arnulf Rainer

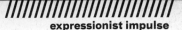
A preoccupation with popular culture and a breakdown of

boundaries between art and life characterize many of the artistic developments from 1960 on. A detached irony, found in a variety of new mediums, displaced the emotional impact of *Informel* painting. Except for passions arising from political and social events that imbued the work of certain artists, the mood of this art was cool and sardonic—from Pop imagery to the cerebral content of Conceptualism and the actions and multiples of the Fluxus group. Art that smacked of the subjective was out of place in the context of this agenda.

Yet by the late 1970s and the 1980s a Neo-Expressionist movement had gathered momentum. Whether simply a reaction to art coming before it or evidence of deeply humanistic impulses, it spearheaded a "new spirit in painting" and refocused the critical debate.[1] These engaging works were representational, replete with figures, landscapes, or simply highly suggestive forms. Some had specific content pertaining to history or myth; other examples were more ambiguous, conjuring up existential doubt or unconscious realms of hidden anxiety. The overriding meaning implied by this work was introspective, dealing with inner truths and basic instincts. It constituted a contemporary manifestation of a Romantic vision extending back to such artists as Vincent van Gogh and Edvard Munch in the modern period, and to earlier figures of Romanticism

in the late eighteenth and early nineteenth centuries. This Expressionist phenomenon was found not only in Europe but also in the United States and elsewhere. In some cases, older artists who had long worked in this vein garnered attention, while younger adherents brought a renewed vigor to these age-old concerns.

A Germanic Tradition

An outpouring of this new work appeared in Germany, where Expressionism has a strong tradition.[2] Early in the twentieth century, artists of the *Brücke* movement, beginning in Dresden and later moving to Berlin, broke away from accepted artistic practices, looking to tribal art for the primal emotion and symbolism it displayed. They also communed with nature, casting off inhibition and exploring a free sexuality, all to rid themselves of the artificial strictures of the establishment. This earlier movement was seen as a precedent for the new generation. Artists like Georg Baselitz, Jörg Immendorff, Anselm Kiefer, Markus Lüpertz, and A. R. Penck brought similar thematic issues to their painting, raising fundamental questions about mankind and society through their work. This was not an art that celebrated the mundane or provided an ironic critique of everyday life. Instead it probed emotional depths and touched on universal aspects of human experience,

and this emphasis struck a chord with the contemporary art public.

Georg Baselitz grew up in what had become East Germany, and emigrated to West Berlin when he was eighteen. His early art experiences had been under the influence of officially sanctioned Socialist Realism, but his training in the West focused on *Informel* painting. Ultimately, he rebelled against this abstract style, sensing that its formalism had left it empty of essential content. Instead he turned to an abject figuration, sometimes displaying a crude sexuality that caused a scandal when his paintings were first exhibited. During this period Baselitz also conceived of figures he called "new types" or "heroes," which populate a series of his etchings (P. 156). These hefty figures call to mind the Socialist Realist style of the East, but here they emanate a sense of the mythic or existential rather than the propagandistic. When his men stand near a tree, they appear to garner a primordial strength from nature; when depicted as wounded soldiers or lonely individuals, they project the most basic human vulnerability.

Soon after inventing these heroes, Baselitz made the decisive step of turning his painted figures on their heads. With this gesture, which would become a signature artistic device, he sought to discourage specific readings of his work, believing that "this method leaves no possible room for literary interpretation."[3] But interpretation is inevitable. A figural motif subjected to such violent disorientation bespeaks alienation, and Baselitz's rough handling of paint adds to the perception of disharmony between mankind and the world at large. Even the artist himself contributes to this understanding of his art when he says: "It is not a process of analysis but an act of aggression. That is the basis of the work."[4]

In printed art, Baselitz exploits the tactile effects of woodcut, linoleum cut, and etching, again with an aggressive attack on his blocks and plates. The autographic touch that results from carving, slashing, digging, and scratching is well suited to his Expressionist style. His process is hands-on and experimental, as his imagery evolves most often in the confines of his own studio, where his wife, Elke, serves as assistant, rather than in a workshop setting. Rarely producing standard editions, Baselitz prefers instead to continually recarve and reprint, sometimes adding hand additions. His experimentation can sometimes lead to compositions in which the figure becomes barely discernable, as seen here

in two stages of *Woman at the Window* (P. 158), where the continuum of creation to destruction seems to be the primary theme.

Baselitz exhibited his work at Galerie Michael Werner in Cologne, where he was joined by other artists of Neo-Expressionist temperament. A loose circle evolved around these like-minded painters, and their friendships of the early 1980s are reflected in *Krater und Wolke* (P. 157), a periodical edited by Ralf Winkler (better known as A. R. Penck), an artist who came from East to West Germany and whose language-based artistic vocabulary had Expressionist overtones. This adventurous journal was published by Michael Werner, with five issues appearing from 1982 to 1985 and two final ones in 1990. All but one were dedicated to an individual artist—including Baselitz, Jörg Immendorff, Markus Lüpertz, and Per Kirkeby—but also contained work of the others.[5] These figures can be seen in snapshots that make *Krater und Wolke* feel like a cross between a scrapbook and an artist's book. A layout might include, for example, monochromatic colored pages sequenced together with texts and poetry, as well as photographs and illustrations of paintings. In addition, numerous etchings, woodcuts, and vinyl records by the artists are tucked in throughout. The result is an exhilarating example of the possibilities inherent in such a medium when put into the hands of gifted artists.

Of the artists in this circle, it was Jörg Immendorff who tackled the most specifically political content in his work. For him, painting has a purpose. He has said, "Art is the only way for me to clarify and to manifest my political viewpoint."[6] This attitude was influenced by experiences Immendorff had early on, as a student of Joseph Beuys in Düsseldorf and also as part of protests of the late 1960s. His series *Café Deutschland*, created from 1978 to 1983 and encompassing nineteen paintings and ten prints, clearly attests to this position, while also laying out the sort of program that would preoccupy him throughout his career. As he has said, "Ideological and political determination run like a red thread through my art and my life."[7]

For prints in this series, such as *Futurology* (P. 160), from 1983, Immendorff chose the simplicity of linoleum cut because it is easy to work with at a large scale and does not require master printers or even a printing press. Working in his studio, he made editions of ten color variations, using the same linoleum block. The mood is generally dark, suggesting night, and occasionally Immendorff

incorporates an overall bloodred tone to give the scene a violent cast. The individual motifs have been widely interpreted, particularly as they relate to the division of postwar Germany, still a harsh reality when this work was created. Such references include the Brandenburg Gate, a helmeted form, an eagle, and a figure climbing a ladder. Yet the overall effect of the print, in some measure due to its enveloping scale, is more universal; this teeming, claustrophobic scene emanates a foreboding that might refer to any place or time.

From political and existential content, one turns to elemental forces of nature in the work of Per Kirkeby, who trained as a geologist and whose background in science permeates his paintings and prints (p. 163). When describing the effects of his layered surfaces, Kirkeby refers to "a sort of geology…in a constant process, sedimentation and erosion."[8] With a devotion to the Romantic tradition of painting and its visual dramas, he attempts to capture the metamorphosis that takes place in the domain of plants, rocks, mountains, and skies. Even though his abstracted imagery barely hints at a specific subject, it evokes a primordial sense of evolution and transformation. In particular, the way Kirkeby incorporates light in these compositions, by allowing the blank sheet of paper to show through, gives nature an overall glow, emphasizing its fecundity and bountifulness.

In contrast, in *Landscape (#2)* (p. 163), an etching and lithograph depicting the natural world, Markus Lüpertz emphasizes mystery and apprehension, as if the outer world of nature is somehow linked to the inner life of human anxiety. Lüpertz pulls us into a netherworld, though one conjured by a specific time and place—in this case, a snapshot the artist took in the region along Germany's Rhine River, where he grew up. His dramatic interpretation can be related to the awe-inspiring explorations of nineteenth-century German Romantic landscape painters, as Lüpertz believes that artists "should make visible the divine, the uncommon, the exception."[9]

The mighty Rhine, a brooding symbol of Germany, is also the subject of a monumental book of woodcuts by Anselm Kiefer (p. 163), among the most celebrated artists of his generation. Kiefer began his artistic career with photography and performance, influenced, as were many others, by Joseph Beuys. Yet even his early work explores German themes. For example, in one series of photographs, titled *Occupations*, the artist posed in what looks like military garb, giving the Nazi salute and standing in set-

tings that refer to Hitler's expansionist ambitions. When this series was reproduced in the journal *Interfunktionen* (p. 101) in 1975, it was met with outrage by many who were offended by its confrontational subject matter and confused by the artist's goals.

Kiefer eventually turned primarily to painting, incorporating thick, tactile surfaces collaged with materials like sand, leaves, and lead. Woodcut on paper was also among his collage elements, and in some works it dominates. *Ways of Worldly Wisdom: Arminius's Battle* (p. 161) is one example, and is part of a series that includes over thirty thematically related works. Here, Kiefer presents portraits of figures from German culture's distant past and recent history. Through woodcut he not only references a technique with its own distinguished tradition in German art since the Renaissance but also gives himself the opportunity to make multiple examples of each portrait. This repertoire of individual faces could be used again in different contexts and combinations. In this particular work, the ancient battle referred to in the title was fought in Teutoburg Forest in 9 AD between Germans and invading Romans. Arminius, the victorious German leader of that siege, became a symbol of national pride. While such legendary themes are common for Kiefer, it is clear that this work and others have significance beyond specific references. The faces we see here, in fact, seem generic, as if they could be portraits of any number of distinguished figures of the type revered in Western culture. In probing a shared past, Kiefer creates an art that explores basic human questions of history, memory, and myth.

Surrealist Approaches

Many artists at this time also drew on Surrealist notions of the irrational and the grotesque for their expressions of primal forces. A number of artists in Vienna in the 1960s, including Arnulf Rainer, Hermann Nitsch, Günter Brus, and Maria Lassnig, had their roots in Surrealism and found the fantastic imagery of the earlier movement to be a rich source for art exploring the absurdities of postwar life in Austria. Speaking of Rainer's experience, art historian John T. Paoletti has written, "Given the horrors of the war years in Austria during his youth, it is not surprising that Rainer found in Surrealism's fascination with madness, the perverse, and the threatening unconscious an avenue to express the inexplicable in the world he had witnessed."[10] Rainer and Brus, in particular, also

found inspiration in a more contemporary voice—the writings of visionary playwright Antonin Artaud and his aims of purification through his Theater of Cruelty, characterized by its violence and disturbing physical expression. Rainer's work embodied a virulent attack on the complacency of bourgeois society in paintings and also in performances that confronted the limits of the human psyche. In fact, physical manipulations and distortions of the human body itself, as well as depictions of it, became a pivotal strategy among many Austrian artists of this period.

In his existential search for primary states of consciousness, Rainer found an ideal match for his mark-making in the mediums of etching and drypoint. The action of scratching into copperplates paralleled his performative approach in other mediums. Discussing his process, Rainer has remarked, "Similar to the principle developed in my overpainting, my etchings develop. These gradual coverings take place slowly over several years…these stages have many states behind them like people and insects in their metamorphoses. These stages are allowed by the drypoint technique, thus it has always been most important in my graphic work."[11]

Throughout his career Rainer has alternated between abstraction and figuration, at times allowing hives of marks to stand on their own, at others using them to obscure photographic faces and figures beneath. In his earliest etchings, beginning in the late 1950s, his assured black strokes evoke a visceral violence with their rapid, frenzied gestures. In his more recent works, such as *Blue Nest* and *Greens* (P. 165), color contributes an uplifting and poetic effect. As was his frequent practice, Rainer reworked old plates for these prints, relishing the history of each image.[12] The colors and titles suggest forms from nature: the aggressive, tactile marks in *Greens* remind us of a thorny bush or tree, and the spikiness of the drypoint lines in *Blue Nest* recall loosely intertwined twigs. The slightly tinted backgrounds create illusionistic spaces that further the images' hints at organic forms. Despite the beauty and elegance of the colors, however, Rainer's incised networks remain palpable depictions of cathartic emotional expression and physical process.

Hermann Nitsch exploited Surrealism's emphasis on the unconscious to develop artistic strategies that reconnect with humanity's primitive instincts. In the early 1960s, along with Brus, Otto Muehl, and Rudolph Schwarzkogler, he founded the controversial

Austrian movement known as Viennese Actionism. The group's provocative actions included ritualistic performances involving blood and animal sacrifice in symbolic references to purification, redemption, and the release of repressed energy. In 1957 Nitsch conceived the idea of the Orgies Mystery Theater, an all-consuming *Gesamtkunstwerk*—a total synthesis of the arts—which encompassed art, theater, and music. The O.M. Theater, as it was known, engendered paintings, drawings, and prints as well as a succession of marathon Happenings. In a prolonged series of diagrammatic prints beginning in 1984, Nitsch envisioned six floors for his theater's structure. In an etched interpretation of this space, *O.M. Theater* (P. 164), he added a performative aspect to printmaking, hand painting each sheet with pig's blood in aggressive gestures that echoed his practice of splattering blood and animal entrails on his actors during performances.[13] He then printed an etched linear complex of compartmentalized, organic structures suggestive of an eerie architectural plan-cum-anatomical cross section. This unexpected juxtaposition of the vigorous, painterly staining against the sinuous Jugendstil-like design of the theater floor plan imbues the work with a drama and an immediacy similar to that evoked by Rainer's visceral scratching.

Günter Brus created equally brutal and disturbing performances in the late 1960s, many of which bordered on self-mutilation in their expression of human concerns of death and sexuality. In 1970, after his most extreme performance to date, he abruptly changed course and returned to the more conventional modes of drawing, painting, and writing that he had adamantly rejected in the early 1960s. Like Rainer, Brus preferred drypoint when it came to prints. Its hard, scratchy line enhanced his edgy, unreal images. But Brus also created an extensive body of artists' books, derived from his series of *Bild-Dichtungen*, or image-poems. Begun in the early 1970s, these works combined his Surrealist texts with fluidly drawn images alternating between the grotesque and the fanciful. Though skeptical of taking up two-dimensional mediums again, Brus felt that balancing the pictorial and literary meant fresh potential for the genre. He has commented, "One way or another, we've explored all the possibilities, from empty sheets to ones covered completely.…This ceases to be a problem if writing accompanies the imagery. It doesn't really matter which areas are opened up in

formal terms, because, together, image and writing produce something new."[14]

By the late 1970s books with fairy tale themes had become a significant part of Brus's oeuvre, his violent Expressionism evolving into a more Romantic, lyrical approach. Francisco de Goya, William Blake, and Artaud, who also made drawings, were important influences on Brus in this genre. Brus's visionary images and texts integrating biography with fiction reveal his link to Surrealism. One Brus scholar has remarked on these connections: "In adopting elements derived from the world of fairy tales, Brus uses writing to gain access to unconscious realms."[15] In one elaborate example, *Die Gärten in der Exosphäre* (P. 161), Brus's title echoes his imaginary setting. The text begins with a harrowing tale of a colossal tree that crushed the men who chopped it down, absorbing them into its rings while they danced on its stump. Several additional story lines emerge and intertwine. Graceful, sinuous, and slightly exaggerated imagery evokes a somewhat sinister sentiment as one turns the pages of this sophisticated encounter between the fantastic and the enchanted. Contemporary artists of the next generation have continued to work in this vein in masterful books that combine the surreal, the painterly, and the literary. In a particularly deluxe example, Francesco Clemente's *The Departure of the Argonaut* (P. 166) reveals a similar sentiment of lavish decadence in its poetic story, written by Alberto Savinio, and beautifully drawn and richly colored printed spreads. Savinio penned this wartime diary-travelogue in 1918, which was translated into English for the first time with this publication.

Maria Lassnig is another Austrian artist who has plied Surrealism for aesthetic strategies in her exploration of Expressionist forces. Like Rainer and Brus, Lassnig has focused on the body in her prolonged self-questioning. Her "body awareness" images, as they are known, study the expressive potential of physical and psychological sensation through bizarre figural distortions reminiscent of Surrealist dreamlike exaggerations. In the 1960s Lassnig also began to juxtapose animals with her warped human figures as a means of enhancing her search for the fundamental essence of human existence.

While her printmaking has been sporadic, Lassnig has been attracted to the austere linear capabilities of etching and drypoint, both in her early attempts in the mid-1960s when she was living in Paris and her more recent prints since returning to Vienna in 1980. Lassnig is preoccupied with self-portraiture, depicting herself in every possible emotional and physical state. She has commented on the links to mythology that occur in her human/animal hybrids, finding in mythology readymade images for concepts that surface from her own unconscious.[16] Her sketchy figures appear ethereal and phantomlike, highlighting the otherworldly sensibility of this vision. One of her most compelling examples is an etching titled *The Training* (P. 168), from 1966, based on a painting of the previous year and one of her first works to merge human and animal imagery. In it we see Lassnig's head on the body of a sphinxlike dog. Atop her is a nude figure with the body of a woman but the head of a man. In the translation from the painting to the etching, Lassnig changed the head of the figure sitting on the dog from female to male. She also changed her own face from smiling and contented to sober and questioning. What physical sensation is she exploring by transforming herself into a sphinx? What psychological attributes have brought about this fusion of genders? Lassnig leaves these and other questions for the viewer to unravel.

The work of East German artist Carlfriedrich Claus also probes the human psyche. Reminiscent again of Artaud's unique drawing style, Claus has achieved an expressive vocabulary that is singular among European artists of his generation. Interests in philosophy, history, psychology, and philology inform his enigmatic, calligraphic work. In the mid-1940s he began making automatic drawings and soon began writing experimental poetry. After 1960 his linguistic studies began to incorporate abstract signs, schematic patterns, and other visual elements in compositions of expressive floating landscapes and faces. Working on the borderline between poetry and art, Claus termed these works *Sprachblätter*, or language sheets. About this time he also began experimenting with transparent papers, drawing on both sides to explore the effects of seeing two or more images simultaneously.

Claus took up this idea in his prints, and in 1972 completed a haunting series of double-sided offsets on translucent vellum titled *Psychological Improvisation I–IV* (P. 169). Conceived in a specific order, one can view these works stacked on top of each other, creating a layering of spontaneously drawn fragmented forms.[17] Claus refers to the series as a "combination," encouraging the creation of new images and new meanings when viewed as a composite of sheets.[18] The viewer is encouraged to look at the works from either side, hold them up to the

light, and interact to promote further "improvisations." In *Psychological Improvisation IV*, titled *Vigilance*, a coiling snakelike form and floating eyes are surrounded by similarly circular text, which makes oblique references to sight and internal anxieties. The darkening vortex in the center suggests an open, screaming mouth in an existential expression of angst. Fusing partly legible, partly abstract calligraphic signs with his cryptic, often hallucinatory texts, these works comprise Claus's probing of psychological states.

Notes

1 The phrase comes from one of the most talked-about exhibitions of the period. See Christos M. Joachimides, Norman Rosenthal, and Nicholas Serota, eds., *A New Spirit in Painting* (London: Royal Academy of Arts, 1981).

2 For an indication of the persistence of German figuration and the ongoing debate with abstraction in the postwar period, see Nina Zimmer, "From *l'art non-figuratif* to New Figuration: Connecting Traditions in the Figurative Strategies of German Art Since 1945," in *Two and One: Printmaking in Germany 1945–1990* (Wellesley, Mass.: Davis Museum and Cultural Center, Wellesley College, 2003), pp. 36–49.

3 Georg Baselitz, "An Interview with Georg Baselitz," by Jean-Louis Froment and Jean-Marc Poinsot, in *Georg Baselitz: Sculpture and Early Woodcuts* (London:

Anthony d'Offay Gallery, 1987), n.p.

4 Ibid.

5 *Krater und Wolke* issue no. 5, in 1985, was dedicated to James Lee Byars, an American artist living mostly in Europe and exhibiting at the Michael Werner Gallery. The final issue, no. 7, in 1990, was dedicated to Penck, rather than edited by him. It was edited by Baselitz.

6 Immendorff, quoted in Rainer Crone, "Jörg Immendorff," in *Images and Impressions: Painters Who Print* (Minneapolis: Walker Art Center, 1984), p. 34.

7 Ibid.

8 Per Kirkeby, excerpt from *Bravura*, reprinted in *Theories and Documents of Contemporary Art: A Sourcebook of Artists' Writings*, ed. Kristine Stiles and Peter Selz (Berkeley and Los Angeles: University of California Press, 1996), p. 60.

9 Lüpertz, quoted in Dorothea

Dietrich, "A Conversation with Markus Lüpertz," *Print Collector's Newsletter* 14, no. 1 (March–April 1983): 12.

10 John T. Paoletti, "Arnulf Rainer: Prints as Encounter and Event," *Print Collector's Newsletter* 18, no. 1 (March–April 1987): 1.

11 Arnulf Rainer, text with the portfolio *Stirnstrandwand* (1970). Reprinted in *Arnulf Rainer: Die Radierungen* (Bonn: Kunstmuseum, 1997), p. 9.

12 Kurt Zein, Vienna, the master printer with whom Rainer worked, e-mail correspondence, May 2006.

13 Ibid.

14 Brus, quoted in Johanna Schwanberg, "'It's not me that's alive—it's my art.' Gunter Brüs: From Actionist to Image-Poet," in Monika Faber, *Günter Brus: Nervous Stillness on the Horizon* (Barcelona: Museu d'Art Contemporani de Barcelona and Actar, 2005), p. 70.

15 Ibid., p. 75.

16 For more on Lassnig's relationship to mythology, see Thomas Döring and Claus Kemmer, *Neue Ansichten vom Ich: Graphische Selbstbildnisse des 20. und 21. Jahrhunderts* (Munich: Hirmer Verlag, 2004), p. 80.

17 For more on Claus's unique working process, see Klaus Werner, *Carlfriedrich Claus: Erwachen am Augenblick, Sprachblätter* (Karl-Marx-Stadt, Germany: Städtische Museen Karl-Marx-Stadt; Münster, Germany: Westfälisches Landesmuseum für Kunst und Kulturgeschichte, 1990), p. 70.

18 For more on Claus's layering process in printmaking, see Klaus Werner and Gabrielle Juppe, *Carlfriedrich Claus: Das Druckgraphische Werk* (Altenburg, Germany: Lindenau-Museum, 2000), p. 16.

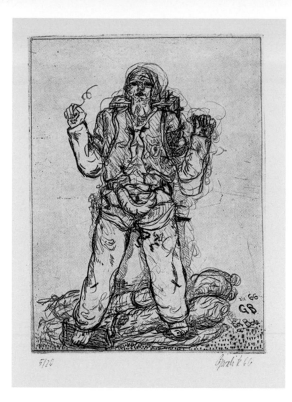
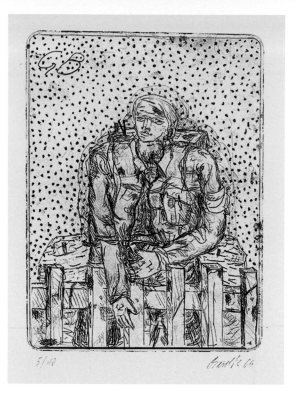

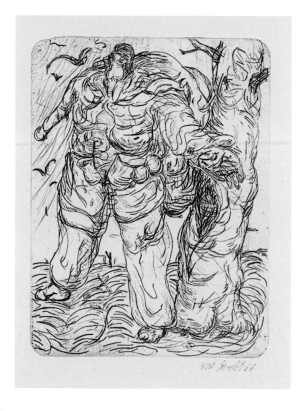

Georg Baselitz

[GERMAN, born 1938]

clockwise from top left:

Grün-Roter (Green-Red One), 1966
(published 1974)
Untitled, 1966
**Typ/Grüner am Baum (Type/Green
One at the Tree)**, 1965 (dated 1966,
published 1974)
Zwei Soldaten (Two Soldiers), 1967
(published 1974)
Etching and drypoint

PLATE (APPROX.): 12 ⁵/₈ X 9¹/₄" (32 X 23.5 cm)
PUBLISHER: Edition der Galerie Heiner
Friedrich, Munich
PRINTER: the artist, Osthofen, Germany
EDITION: 10; 20 (top left)

The Museum of Modern Art, New York.
Acquired in honor of Anna Marie Shapiro by
the Committee on Prints and Illustrated Books
in recognition of her tenure as Committee
Chair, 2006

Krater und Wolke
Journal [1982–1990]
EDITOR: A. R. Penck (Ralf Winkler), 1982–90;
Georg Baselitz, 1990

A. R. Penck [GERMAN, born 1939],
cover (a) and project (e) for no. 2, 1982

Jörg Immendorff [GERMAN, born 1945],
project for no. 3, 1983 (b) and no. 2, 1982 (c)

Georg Baselitz [GERMAN, born 1938],
project for no. 1, 1982 (d)

PAGE: 12 x 9¼" (30.5 x 23.5 cm)
PUBLISHER: Galerie Michael Werner, Cologne
EDITION: unknown

The Museum of Modern Art, New York.
Transferred from Museum Library, 1993

(a)

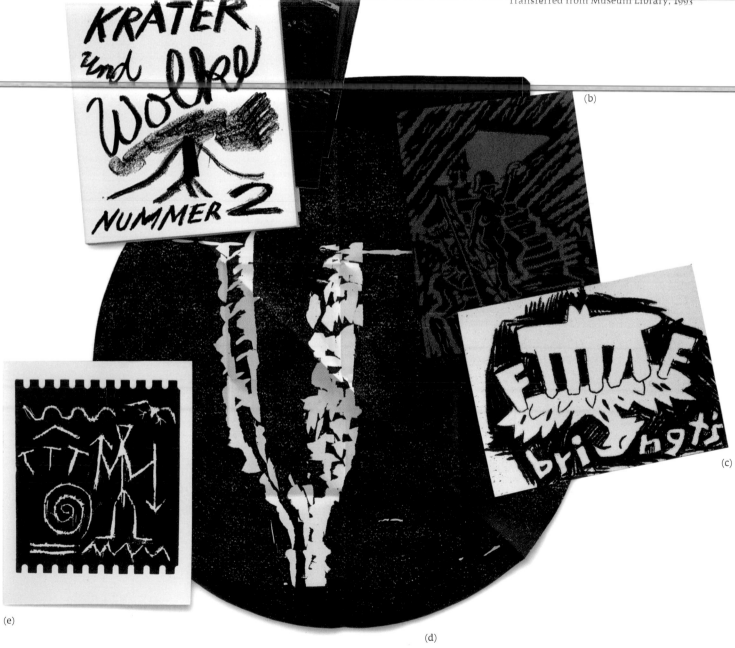

(b)

(c)

(e)

(d)

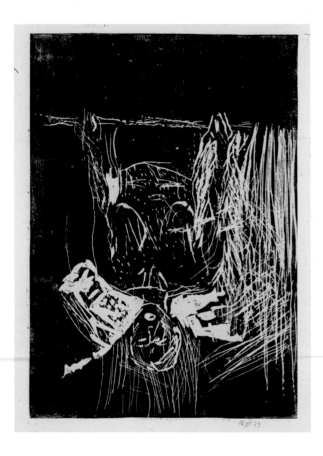

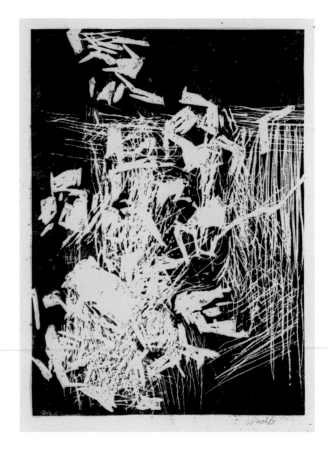

Georg Baselitz

[GERMAN, born 1938]

Frau am Fenster (Woman at the Window),
states I and IV, 1979
Linoleum cut

SHEET: 34 X 24 1/8" (86.3 X 61.3 cm)
PUBLISHER: unpublished
PRINTER: the artist, Derneburg, Germany
EDITION: unique

The Museum of Modern Art, New York. Blanchette
Hooker Rockefeller Fund, 1982

**Akt mit drei Armen
(Nude with Three Arms),** 1977
Linoleum cut with oil paint additions

SHEET: 8' 7 9/16" X 61 13/16" (263 X 157 cm)
PUBLISHER: unpublished
PRINTER: the artist and Michael Krebber,
Derneburg, Germany
EDITION: 1 of 4 variants

The Museum of Modern Art, New York.
Jeanne C. Thayer Fund and Purchase Fund,
1984

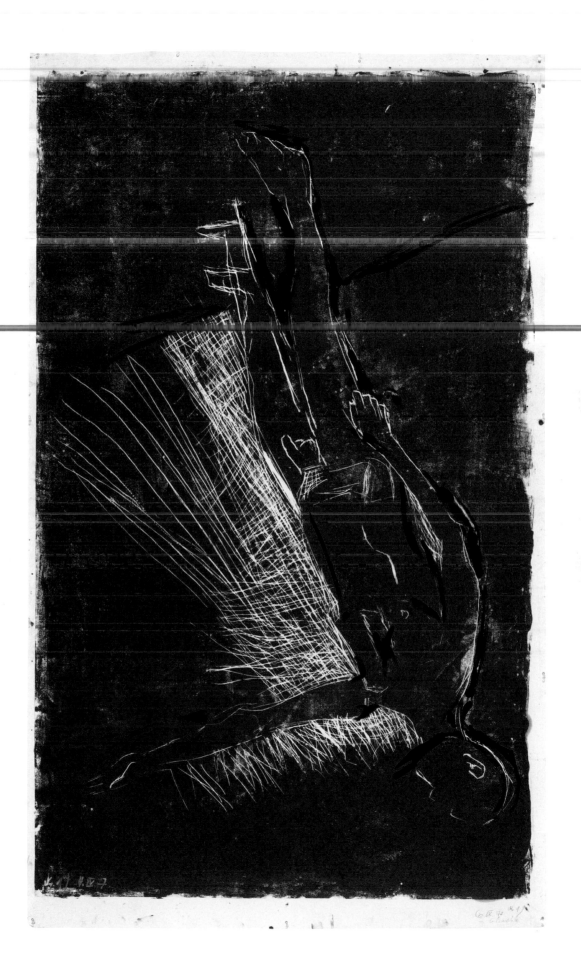

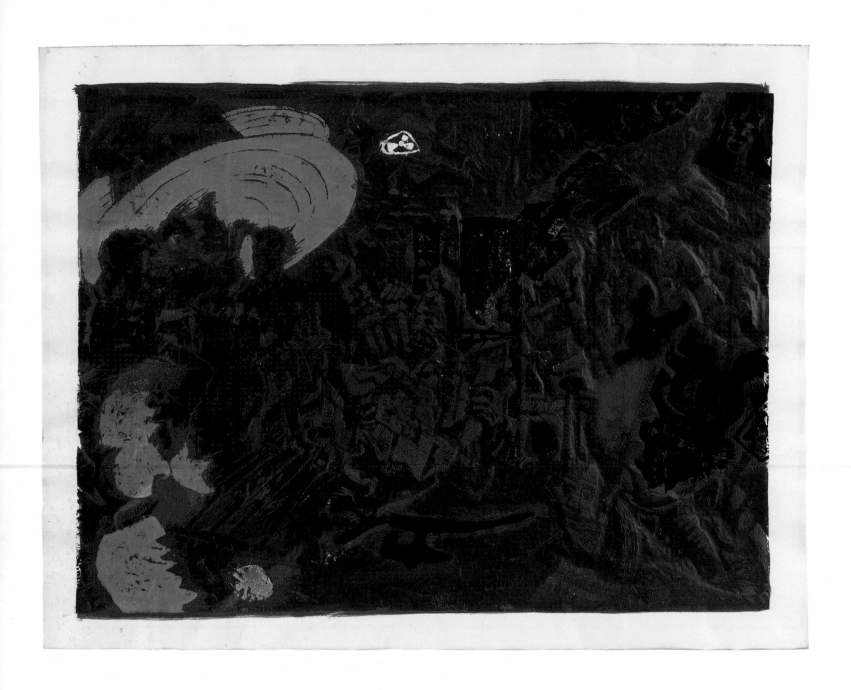

Jörg Immendorff

[GERMAN, born 1945]

Futurologe (**Futurology**) from the series
Café Deutschland, 1983
Linoleum cut

SHEET: 70⅞" x 7' 6¹/₁₆" (180 x 228.7 cm)
PUBLISHER: Sabine Knust•Maximilian Verlag,
Munich
PRINTER: the artist, Düsseldorf
EDITION: 10

The Museum of Modern Art, New York.
Gift of Nelson Blitz, Jr., 1984

Anselm Kiefer

[GERMAN, born 1945]

**Wege der Weltweisheit:
Die Hermannsschlacht
(Ways of Worldly Wisdom:
Arminius's Battle)**, 1978
Woodcut mounted on canvas with oil
paint additions

SHEET: 6′ 5¼″ x 7′ 10¼″ (196.2 x 239.4 cm)
PUBLISHER: unpublished
PRINTER: the artist, Hornbach, Germany
EDITION: unique

The Museum of Modern Art, New York.
Partial and promised gift of UBS, 2002

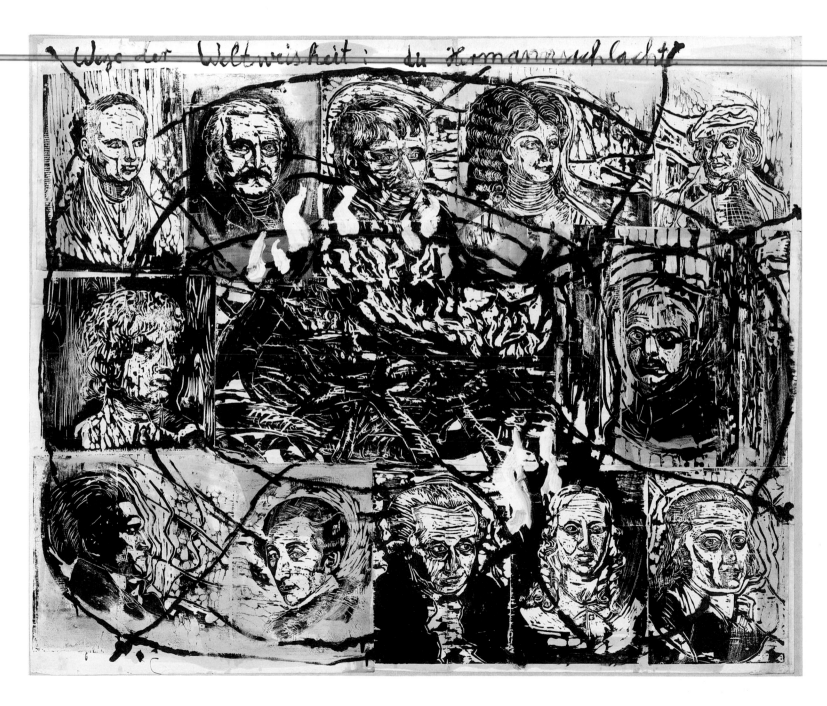

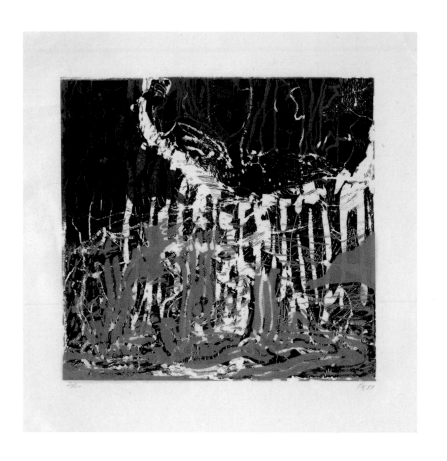

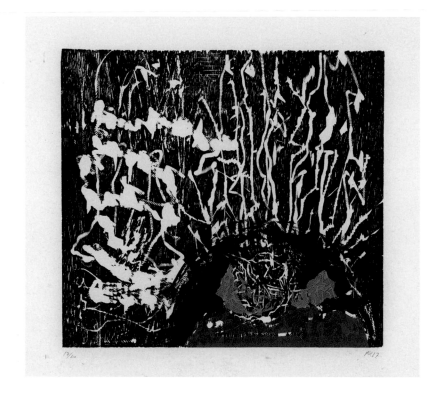

Per Kirkeby

[DANISH, born 1938]

Untitled, 1987
Two from a series of six woodcuts

SHEET: 27 9/16 X 25 3/8" (70 x 64.5 cm)
PUBLISHER: Sabine Knust•Maximilian Verlag,
Munich
PRINTER: Niels Borch Jensen, Copenhagen
EDITION: 20

The Museum of Modern Art, New York.
Walter Bareiss Fund, 1988 (top)
Tate, Purchase 1989 (bottom)

Markus Lüpertz

[GERMAN, born Bohemia
(now Czech Republic), 1941]

Landschaft (#2)
(**Landscape [#2]**), 1998
Etching and lithograph

SHEET: 31¹/₂ x 42³/₁₆" (80 x 107.1 cm)
PUBLISHER: Sabine Knust•Maximilian
Verlag, Munich
PRINTER: Kurt Zein, Vienna
EDITION: 25

The Museum of Modern Art, New York.
Walter Bareiss Fund, 1999

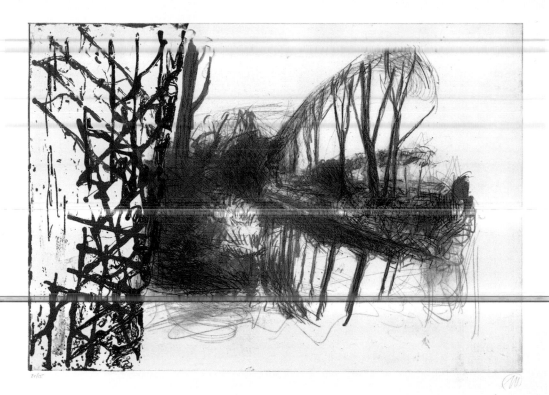

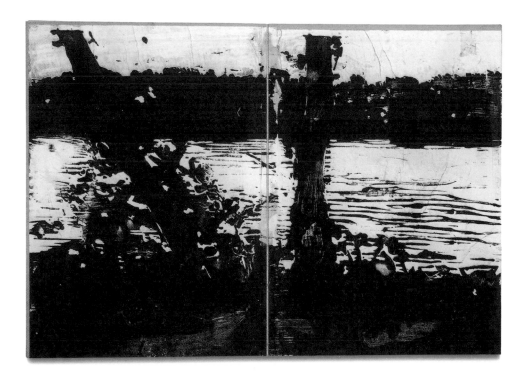

Anselm Kiefer

[GERMAN, born 1945]

Der Rhein, 1983
Illustrated book with
twenty-one woodcuts

PAGE: 23¹/₄ x 16¹/₂" (59 x 42 cm)
PUBLISHER AND PRINTER: the artist,
Hornbach, Germany
EDITION: 10

The Museum of Modern Art, New York.
Purchase, 1984

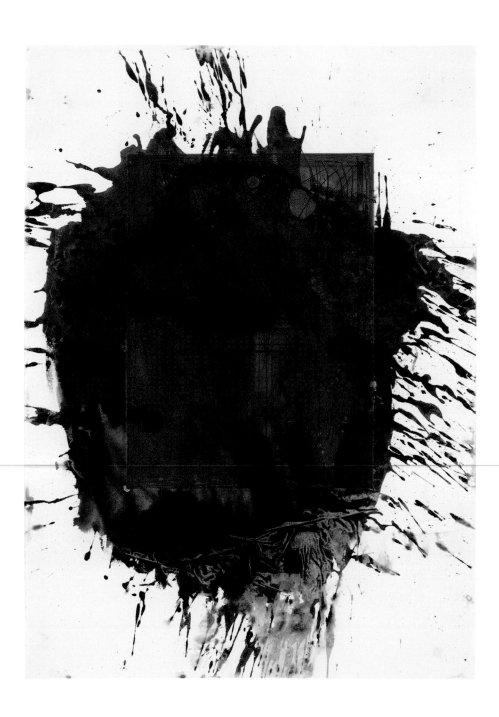

Hermann Nitsch

[AUSTRIAN, born 1938]

O.M. Theater, 1991
Etching with pig blood additions

SHEET: 29^{11}/$_{16}$ X 21^{3}/$_{16}$" (75.4 X 53.8 cm)
PUBLISHER: Edition Krinzinger, Vienna
PRINTER: Kurt Zein, Vienna
EDITION: 50

The Museum of Modern Art, New York.
The Philip and Lynn Straus Foundation
Fund, 1993

Arnulf Rainer

[AUSTRIAN, born 1929]

Grünzeug (Greens), 1997
Etching and drypoint
SHEET: 25 1/2 x 19 5/8" (64.8 x 49.9 cm)
PUBLISHER: Sabine Knust•Maximilian Verlag,
Munich
PRINTER: Kurt Zein, Vienna
EDITION: 35
The Museum of Modern Art, New York.
Gilbert Kaplan Fund, 1997

Blaues Nest (Blue Nest), 1997
Etching and drypoint
SHEET: 25 7/16 x 19 9/16" (64.6 x 49.7 cm)
PUBLISHER: Sabine Knust•Maximilian Verlag,
Munich
PRINTER: Kurt Zein, Vienna
EDITION: 35
The Museum of Modern Art, New York.
Purchase, 1997

Francesco Clemente

[ITALIAN, born 1952]

The Departure of the Argonaut, 1986
Illustrated book by Alberto Savinio
One of forty-nine offsets

PAGE: 25 9/16 x 19 11/16" (65 x 50 cm)
PUBLISHER: Petersburg Press, London and
New York
PRINTER: Rolf Neumann, Stuttgart
EDITION: 200

The Museum of Modern Art, New York.
Gift of Petersburg Press, 1986

Günter Brus

[AUSTRIAN, born 1938]

Eisblut, Blauer Frost, 1984
Artist's book

PAGE: 8 3/8 X 5 13/16" (21.2 X 14.8 cm)
PUBLISHER: Galerie and Edition
Hundertmark, Cologne
EDITION: 500

The Museum of Modern Art Library,
New York

Die Ruine, 1985
Artist's book

PAGE: 8 1/4 X 5 13/16" (21 X 14.8 cm)
PUBLISHER: Daniel Lelong, Éditeur, Paris
EDITION: 1,000

The Museum of Modern Art Library,
New York

Die Gärten in der Exosphäre, 1979
Artist's book

PAGE: 11 13/16 X 16 1/16" (30 X 40.8 cm)
PUBLISHER: Das Hohe Gebrechen,
Altona and Hohengebraching, Germany
EDITION: 600

The Museum of Modern Art Library,
New York

Die Dressur (The Training), 1966
(published 1981)
Etching and drypoint
SHEET: 12⁵/₁₆ x 10¹/₂" (31.2 x 26.6 cm)
PUBLISHER: the artist, Paris
PRINTER: Manfred Maly, Vienna
EDITION: 30

The Museum of Modern Art, New York.
Purchase, 1990

Maria Lassnig

[AUSTRIAN, born 1919]

Untitled, 1985
Etching and drypoint
SHEET: 9 x 12¹/₂" (22.8 x 31.8 cm)
PUBLISHER: Galerie and Edition
Hundertmark, Cologne
PRINTER: Martin Kätelhön, Cologne
EDITION: 50

The Museum of Modern Art, New York.
Acquired through the generosity of Richard Gerrig
and Timothy Peterson in honor of Bernice and
Edward Gerrig

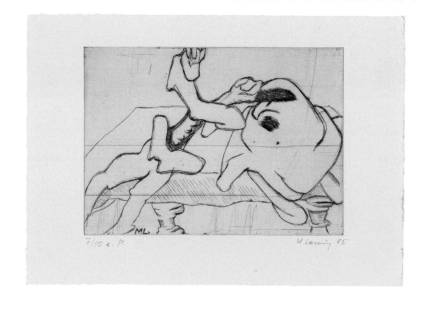

Carlfriedrich Claus

[GERMAN, 1930–1998]

Psychologische Improvisation II: Begegnung (Psychological Improvisation II: Encounter) (left) and **Psychologische Improvisation IV: Vigilanz (Psychological Improvisation IV: Vigilance)** (right), 1972
Two from a series of four double-sided offsets

SHEET: 19 1/4 x 14 1/4" (48.9 x 36.2 cm)
PUBLISHER: the artist, Berlin
PRINTER: Wolfgang Arnoldi, Berlin
EDITION: 40

The Museum of Modern Art, New York.
Gift of Staatliche Kunstsammlungen Dresden
(by exchange), 1979

recent projects

John Armleder
Christiane Baumgartner
Carole Benzaken
Jean-Charles Blais
John Bock
Claude Closky
Tacita Dean
Olafur Eliasson
Sylvie Fleury
Katharina Fritsch
Damien Hirst
IRWIN
Ivana Keser
Martin Kippenberger
Peter Kogler
Annette Messager
Paul Morrison
Antoni Muntadas
Museum in Progress
Olaf Nicolai
Parkett
Dan Perjovschi
Leonid Tishkov
Rosemarie Trockel
Franz West

Encountering the postmodern period we are confronted with

a network of artistic practices that reveals both connections and ruptures with the dominant aesthetic concerns since the 1960s. Resonant with ironic attitudes that question previously held truths, the art of the last fifteen years or so is distinguished by its embrace of contradictions and its rejection of traditional hierarchies between art forms. French philosopher Jean-François Lyotard characterized postmodernism for its lack of an overarching "meta-narrative," totalizing explanation, or dominant mode of thought, promoting instead a breakdown or fragmentation of beliefs and values.[1]

In its endorsement of a multiplicity of approaches, mediums, and messages, postmodernism championed appropriated imagery and techniques that challenged issues of originality, authenticity, and reproduction—ideas inherent to editioned mediums, in particular. The work of artists such as Martin Kippenberger and Franz West, for example, in their subversion of the poster, as well as Peter Kogler, with his computer-generated wallpaper, directly addresses these concepts. The related tenet of simulation, positing a new processed reality engendered by the mass media, is reflected throughout this period—in the recycling that characterizes Sylvie Fleury's ironic multiples, and Katharina Fritsch's and Olaf Nicolai's play on prefabicated aesthetic models. Many artists have used found photography to these ends, reinterpreting images in new contexts as seen, for example, in the work of Rosemarie Trockel and Jean-Charles Blais, as well as that of younger artists, including Tacita Dean and Christiane Baumgartner. The artist's book has also flourished, as artists such as Leonid Tishkov and Ivana Keser have usurped commercial models from comic books to newspapers. But perhaps the multifarious approaches of Kippenberger and Damien Hirst best exemplify the eclecticism of the postmodern approach, and these ambitious figures' prodigious range of statements regarding the present human condition characterize much of the European vanguard's contemporary aesthetic.

Subverting the Poster

As artists ignored the barriers between mediums and high and low forms of art, several appropriated the format of the poster—and its expected communicative function—to propose their own agendas. Using photographic imagery and text, Martin Kippenberger, Franz West, and the Slovenian collective IRWIN, among others, inventively twisted the format's conventional role as a mass-produced tool of disseminating information. To greater or lesser extent, all three used the poster as a document or relic of performance pieces, reminiscent of Dada and Fluxus antics and their desire to undermine artistic traditions. Dispensing with hierarchical notions about art, they believed their posters to be an integral part of their overall oeuvre. Kippenberger and West, in particular,

embody an irreverent, "provocateur" sensibility, which follows the pied piper persona of Joseph Beuys, who also ignored hierarchical distinctions between mediums and worked extensively in posters.

Like Beuys, Kippenberger was a master of marketing and self-promotion, and used his posters to that end. As a virtuoso appropriator, he made repetition and recycling of material inherent to his underlying strategy, an approach that fueled a passion for the multiplied image. Ringleader of a Berlin "bad boy" group, which included Albert Oehlen and Georg Herold, Kippenberger had a charismatic, often raucous personality. He generated a constant maelstrom of activity that included art-making, organizing exhibitions, and playing in a rock band—with a Kippenberger poster frequently accompanying these events. Beginning in 1977 he created more than 175 posters, ranking him among the most prolific contemporary artists in the medium. Well versed in graphic design and the techniques of commercial printing from an apprenticeship at a printing plant in his youth, he preferred screenprint, which allowed him to experiment with variation of color, the combination of existing and newly made screens, and the photographic and the hand drawn. In 1986 Kippenberger began making portfolios of his posters, for which he reissued recent examples. Editioned in relatively small numbers, these portfolios have become retrospectives of his career and those of his friends, and the diversity of styles represented indicates the far-reaching scope of his practice.

By far the most common motif in Kippenberger's posters is the self-portrait, an image often seen in his paintings and drawings as well. He has positioned himself in seemingly every possible site and situation, singly and in groups, photographed or drawn. In *Ce Calor 2* (P. 194), he pictures himself as an embarrassing middle-class tourist vacationing on the beach in Spain, where he moved in 1988. Staring directly at the viewer, he replaces the anticipated glamorous rendering with an unflattering flaccid-bellied depiction, creating an ironic send-up of the conventional advertising poster and the vanity typical of the self-portrait. It is this tension between provocation and vulnerability that typifies his singular and subversive approach to the medium. Artist Jutta Koether, who conducted a series of interviews with Kippenberger in the early 1990s, recently commented that the posters "best represent him and sum up the range of his ability: the humor, the social critique, the clever combination of provocative images and allusions. They were critical and politicised, perfectly expressing his ideas and his personality."[2]

In 1983 Kippenberger met Franz West, a sculptor from Vienna whose work evokes an equally subversive human vulnerability and humor. In a radical, participatory approach beginning in the mid-1970s, West made sculptures that viewers were invited to touch, try on, and cavort around in. Known as "Adaptives," these awkwardly elegant papier-mâché objects occasionally inspired crudely formed multiples, such as the recent commissions for Whitechapel Art Gallery in London (P. 197), designed as portable art to be handled and passed around.

In the mid-1970s West's interest in collage also expanded and, inspired by Dada examples by Kurt Schwitters and Hannah Höch, he began clipping glossy advertisements and racy photographs from popular magazines. Cropping and isolating human figures in fields of crude painting, the resulting compositions exuded a casual messiness equal to that of his amorphous sculptures. The collages, in turn, inspired poster designs, which portray people in contorted poses wearing his Adaptives. He even staged performances with his friends posing with the sculptures in order to film or photograph them for use in later projects.[3] In 1990 he issued his first set of screenprints, a series of six posters that unite all these elements of his work (P. 196). Figures adorned with his sculptures appear in bizarre poses, some strewn across his own wire furniture designs. In one of these, the central figure is a waiter whom West met in a restaurant, handed a sculpture, and photographed holding it aloft.[4] Images of scantily clad women, clipped from the media, form part of the mix in these printed collages. West does not use these posters to announce an upcoming exhibition but rather compiles them, like Kippenberger in his portfolios, after the fact. He transforms the typically quick conveyor of advertising into a process piece to be slowly contemplated.

IRWIN, a collective of five artists from Slovenia established in 1983, is preoccupied with reenacting the ruptures and traumas of history—totalitarianism in particular—and borrowing from radical art historical movements to undermine dangerous dogmas of the present. They subvert totalitarian ideology by both integrating and imitating its symbols, formats, and methods in works that attempt to expose the inadequacies of all systems of belief while also exploring art's role within political systems. Communication is at the heart of IRWIN's strategy,

extending Beuys's concept of social sculpture with an even more pointed political edge.

IRWIN is part of a larger organization known as NSK (*Neue Slowenische Kunst*), which also encompasses a rock band, a theater troupe, a philosophical lecture group, and a design collective. NSK's efforts have been described as "attempts to...bring about a more rapid disintegration of obsolete ethical and aesthetical standards for the understanding of culture and one's own identity. The work of NSK is characterized by a radical questioning of the realization, presentation, and circulation of works of art."[5] To this end, in 1992 IRWIN began one of their most adventurous and long-term projects, *NSK State in Time*. Predicated on the idea of statehood without territory or borders, it formed an itinerant, illusory nation to which anyone can apply for citizenship. The group produced all the vestiges of a state—NSK passports, flags, staged embassies, and consulates.

The project entails an ongoing series of performances, lectures, and discussions in cities around the globe. To document the NSK embassies, IRWIN made a series of nine posters (P. 214)—relics of performances in which it collaborated with actual members of a country's army. It asked them to pose holding the NSK flag, which bears a black cross in reference to Kazimir Malevich's Suprematism, and to wear armbands with the same image. Miran Mohar, a member of IRWIN, has explained the motivation behind the project, saying, "Art society and army society are social structures that are usually totally opposite to each other....With this action Irwin organizes this encounter. Its foundation was connected with the autonomy of art. It was established soon after the collapse of the old political systems in Eastern Europe."[6] The posters, which themselves appropriate a tool of propaganda, were also issued as inserts in the Austrian newspaper *Der Standard*, under the auspices of the association Museum in Progress. Mohar has noted that publishing these images in a mass media format enhanced the project's meaning: "In this work we put the photo of the public performance into a public medium and we get out a multiple with the help of a public media/newspaper."[7]

A Twist on Abstraction

Numerous artists working today have explored abstract modes as part of an overall artistic vocabulary that may include figurative and conceptual approaches as well. Ideas and conundrums resonate in the nonrepresen-

tational forms of artists from Damien Hirst to Olafur Eliasson, eclipsing the formal issues of their work. While Hirst may have catapulted to fame with his sculptural vitrines housing dead animals, he also works extensively with abstraction in an ongoing series of gridded dot paintings and expressionist spin paintings. Made by pouring paint onto rotating canvases attached to a spin machine in his studio, these works embody issues of chance and randomness while referencing not only the formal gesture of Abstract Expressionism but also the booths of county fairs and the popular children's toy.

When Hirst turned to etching, he transformed this traditionally laborious process into an extemporaneous and performative experience, creating *In a Spin, the Action of the World on Things* (PP. 186–87), a tour-de-force project of twenty-three prints. To make these prints Hirst screwed copperplates to his spin machine and, resting on a platform above, drew onto the spinning plates with tools ranging from needles to screwdrivers. He so enjoyed drawing on the spinning plates that he continued this performative process for several days, resulting in this expansive series.[8] These works were inspired by a long-exposure photograph of the night sky in which the stars appeared as concentric white circles on a field of black.[9] One can also associate their concentric incised markings with LP records, since pop music plays an important role in Hirst's life. In fact, one of Hirst's DJ friends was with him in the studio while he made these prints, and inspired the use of pop lyrics that appear etched into some of the plates.

In the last few years Olafur Eliasson, who was born in Denmark but lives in Iceland and Berlin, has shown an extraordinary interest in printmaking, especially photogravure, completing eight large projects in less than five years. Some appear diagrammatic and chartlike while others pursue a more sensory approach to natural phenomena. Generally, his work explores means to harness transient experiences of intangible forms, such as light, color, temperature, and pressure. Rainbows, in particular, have been a preoccupation for over a decade. While preparing a light installation for the Venice Biennale in 2005 he came upon the idea of printing a rainbow. An extremely elaborate project ensued, in collaboration with printer Niels Borch Jensen in Copenhagen, which resulted in a sublime evocation of a spectrum across forty-eight richly colored photogravures (PP. 188–89). *The Colour Spectrum Series* functions as an installation itself, which is typical of Eliasson's approach to printmaking.

Stressing the interactivity that is at the core of his environmental installations, Eliasson allows the collector several installation choices for this monumental work. He has remarked that Felix Gonzalez-Torres's work taught him that art can be "minimal yet completely dense...active, generous, and not formalistic."[10] This characterization could also easily describe his own eloquent approach to the manipulation of minimalist, nonobjective strategies.

John Armleder has explored abstract forms as representative of the concept of high modernism, with borrowings from Russian Constructivism to Abstract Expressionism. Since the late 1960s and the 1970s, when he founded Groupe Écart, a Swiss offshoot of Fluxus, his work has also involved various attempts at the integration of art and life. Armleder's irreverent, antiformalist attitude developed during this Conceptual period and fostered his ongoing questions about art's authenticity and its contemporary contexts. Prints, books, and multiples have been at the heart of his oeuvre since he established Écart's publishing network. Most recently he completed *Supernova* (PP. 190–91), a dazzling portfolio of lithographs that exemplifies his philosophy of modernism with an interactive format. Representing nonobjective modes, from dizzying Op art spirals to expressive mutating patterns, the title refers to the massive explosion and spectacular release of energy that accompanies the death of a star. The work functions as an installation piece when all nineteen components are shown, though Armleder leaves much to the viewer's discretion. Not only can the images be presented singly, in groups, or together as a series but, in an approach reminiscent of Fluxus antics, the artist does not specify the individual images' orientation—they may be viewed vertically, horizontally, or upside down in a sabotage of modernist principles.

Olaf Nicolai also involves the viewer in the installation of his art. His work examines the relationship between nature and artifice, and he has employed abstract forms as markers or signifiers in this study, exploring the intersection between art, design, and public accessibility. He also invests his work with a participatory element that emphasizes the performative quality of everyday life. *30 Colors* (P. 193) is an exemplary case in point. First conceived as a large, temporary room installation, this project looks at contemporary society's standardized and mass-produced comprehension of the fundamental phenomenon of color.[11] Unlike Eliasson's attempt to reproduce a naturally occurring form, Nicolai stresses a man-made and processed understanding of color by selecting thirty choices from a Pantone sample book. Five years after his initial project he made a portfolio-cum-installation in a box that included the thirty colors, now printed on large sheets of paper, as well as a set of instructions and a possible installation diagram.[12] To foster the viewer's own experience of sampling, like Armleder, Nicolai leaves the ultimate installation of the sheets to the owner, simultaneously critiquing a paint-by-numbers approach to creativity epitomized by Pantone and engendering a dynamic involvement with aesthetic issues. The artist has said, "I seek to give the observer the opportunity of experiencing and gaining insight into the material reality of the products I make. I want to invest the products I make with a particular quality enabling the viewer to ask why they are the way they are."[13]

In a similar conceptual approach, French artist Claude Closky invests critical ideas into seemingly abstract models he samples from everyday life. He makes lists of all sorts, frequently compiling them into artist's book formats. Often evoking a sense of the absurd, Closky's works exaggerate and distort the signs and codes that characterize contemporary communication, taking commonplace logical systems—from popularity polls to economic charts—to their illogical extremes. In mediums including Web site design, collage, photography, artists' books, wallpaper, and ephemeral paper products, Closky distills systems from contemporary media into abstract, often unintelligible patterns in order to alter perceptions of our routines and lifestyles.

Since the late 1990s Closky has designed several wallpaper projects based on regular newspaper features, from NASDAQ quotes to supermarket advertisements. In *Up and Down* (P. 192) he creates a chartlike comparison table but omits the headings that would indicate what exactly is being compared, leaving only the graphic pattern of colored boxes, arrows, *x*'s, and stars. Now rendered meaningless, this assortment of abstract signs and minimal colored bars operates only on a formalist level, underscoring the absurdity of the media's overload of visual clutter. Closky refers to wallpaper as a "non-contextual work of art,"[14] and here uses it to highlight ideas of communication systems run amok. Typical of his recycling of motifs in various mediums, Closky used this pattern again for ephemeral projects, from refrigerator magnets to the entrance ticket at Paris's Centre Pompidou, where the wallpaper also adorns the walls of some administrative offices.

Dystopic Nature

As contemporary artists continue to examine the human condition, some have turned to images of natural forms gone awry to express a certain edgy discomfort. Such depictions of systems out of control exemplify perhaps a sense of fin-de-siècle anxiety that characterized much of the 1990s and the first years of the twenty-first century. Austrian Peter Kogler's work exudes this tension, transforming representational motifs through sequential repetition into nonobjective forms that resonate with Conceptual underpinnings. Kogler has used wallpaper since the 1980s as one of his primary tools, exploiting its potential to create expansive environments that envelop the viewer in a stimulating, and often disorienting, total atmosphere. His talent resides in the way he combines strategies of repetition, borrowed from Viennese Jugendstil decoration as well as more recent Minimalist practices, with unsettling computer-generated imagery to keep his viewers off-balance as he strives to harmonize art, architecture, and design.

Kogler has limited his vocabulary of motifs, focusing on ants, brains, and tubing, arranging them into massive labyrinthine networks that stretch and crawl across walls, ceilings, and floors and over chairs, tables, and curtains. Kogler first used ants in 1991 for a gallery installation in Munich, and in 1992 he gained international recognition for an elaborate installation of his ant-covered wallpaper at *documenta 9* (PP. 182–83). He found this particular ant motif in a natural history book.[15] Simple in design and lacking in detail, it was ideal for printing and reprinting. He scanned it into a computer, enlarged it to its current scale of nearly two feet in length, and repeatedly cloned it. In addition to wallpaper, his ants have appeared in formats ranging from screenprints on canvas to projections on building facades.

Kogler's streaming army of ants embodies a plethora of contemporary ideas. The subservience of the individual to the greater good of the community and alienation within modern society perhaps resonate most clearly. In his use of wallpaper, Kogler ignores distinctions between high and low art forms, another facet of his interest in the Jugendstil tradition as well as a hallmark of postmodern aesthetic practice. His anxiety-ridden, often threatening environments arouse ambivalent sensibilities characterized by a fascination with their visual impact and an unease at the critical vision embodied in their provocative motif.

Rosemarie Trockel's study of nature is equally disturbing. Her portfolio of eight photogravures *What it is like to be what you are not* (P. 185) exemplifies her rigorous, if cryptic, approach to the examination of patterns of thought and behavior in Western society. Trockel has often used animals in her work, and is fascinated by the systems they live by. She has also been interested in animal testing and its relevance to humans. The images in this portfolio are based on photographs of spider webs created during experiments done at the University of Bern with spiders on various narcotics. The study proved that spiders fed hashish, LSD, and other drugs would spin imperfect webs—making them unusable to secure food—and thereby perish. Trockel emphasized the misshapen forms by cropping and enlarging the images, exaggerating their irregular and distorted appearances while also creating beautiful abstract visions of asymmetry.

This disturbing view of nature is taken up by a younger generation of artists as well. Like Kogler, Briton Paul Morrison rigidly limits his vocabulary, working exclusively in black and white to create landscapes that are eerily devoid not only of color but also of human presence. His sources range from Disney to Albrecht Dürer to Victorian botanical books, and he cites mentors in Pop figures Patrick Caulfield and John Wesley, who famously streamline their forms, as well as nineteenth-century designer William Morris for his fascination with nature. Morrison mixes the scientifically accurate with the cartoon-like, distorting scale and perspective at will. His silhouetted graphic forms are a natural for printmaking, and he recently began to explore screenprint. The medium's potential for crisp edges, dense color, and slick, anonymous surfaces enhance his imagery's cartoonishly threatening impact. The three blossoms in one of the works from the series *Black Dahlias* (P. 184, TOP) appear foreboding and anthropomorphized in their oversize scale, bursting against the top of the sheet. In another work from the same series (P. 184, BOTTOM), Morrison depicts his landscape in the negative with white, spidery forms against a black background, imbuing these more detailed representations with an irradiated, otherworldly glow.

A Dialogue with Photography

The recycling of processed imagery has been an ongoing practice since Pop strategies of the 1960s, but recent art has witnessed a resurgence of this approach as artists routinely mine magazines and newspapers for potent imagery to manipulate. Several artists discussed above, such as Peter Kogler and Rosemarie Trockel, depend on

photographic depictions for their printed work. As technologies have advanced, photographic and digital capabilities have become so intertwined that it is often hard to detect with the naked eye what processes are used.

Jean-Charles Blais provides an interesting example of this integration of mediums. He gained recognition in the 1980s for his Expressionist, earthy figures, drawn or painted on unusual surfaces, including torn billboard posters and printed fabric and wood. Blais then shifted gears, streamlining his figures into silhouettes of eerie, faceless heads and fragmented bodies. Most recently he has begun using found photography to further these haunting, surrealist effects.

His series *Panoply* (P. 209), which depicts photographically rendered female garments overlaid with disembodied heads, exudes a palpable sentiment of alienation and anxiety. The title, which refers to a ceremonial attire or suit of armor, intensifies the work's interpretation as a modern-day facade for the vulnerable and unstable. To enhance his otherworldly sensibility, and in keeping with his experimental approach to printmaking, Blais chose to print these images on rubber, enjoying the material's skinlike affinities. He then cut the rubber to conform to the outline of the garments, allowing the shapes to hang loosely against the wall, provocatively suggesting anonymous flayed figures.[16] Discussing the process involved in making this series, Blais has written, "I used pictures from magazines and played with them, as if cutting them out and using them for collage. After that, I distorted them digitally so that they became shadows. Because in my mind, they have the same relationship with reality as an object does with its shadow."[17] Blais intuitively exploited the processed nature of photography, and the computer's ability to distort it, to advance the evolution of his art from rough hewn, big-footed males in the 1980s to these svelte surrogate females, from the tangible and powerful to the immaterial and ghostlike.

Christiane Baumgartner weds photography and video to the centuries-old tradition of woodcut. Based in Leipzig, and steeped in that city's long history of printing, Baumgartner integrates the slow and laborious technique of carving into a block of wood with the expediency of new technologies. This tension between speed and stillness is at the center of her work, and dominates her choice of imagery as well, specifically her focus on moving machines such as cars, airplanes, and wind turbines. For her most monumental woodcut, *Transall* (PP. 202–03), she began with

a newspaper photograph, transforming a 2 by 3 inch (5.1 by 7.6 cm) image of aircraft on a runway into a huge and threatening scene of military machines.[18] She traced the outlines of the magnified image onto an enormous woodblock, which she then carved over a period of ten months. Rigorously limiting herself to black and white, she carves horizontal lines into the block through which her images mysteriously emerge. This linear approach harks back to her work in video and the motion lines that result when shooting out the window of a moving car. These lines also reinstate a kind of degraded, processed appearance indicative of her photographic source. By executing *Transall* in this painstaking, time-consuming manner, Baumgartner not only attempts to slow down, freeze, and enfeeble the warplane but effectively fuses her medium and her message.

With a similar strategy, Tacita Dean composes wall-size works from small found photographs and postcards. For her most recent print project, *T&I* (PP. 204–05), she began with such a photograph and, collaborating with master printer Niels Borch Jensen in Copenhagen, transformed a small coastal landscape shot into a grand Romantic vision.[19] Dean is arguably best known for her films of enigmatic, incomplete narratives in which past and present, fact and fiction are combined to explore time and memory. The sea and other maritime themes—symbols of man's struggle against powerful natural forces—play central roles in her poetic works.[20]

Since 1996 Dean has been obsessed with the tragic tale of a lost yachtsman, using his story as the foundation of several films, drawings, and books. The sailor, Donald Crowhurst, took off in 1968 from the English coast, frightened and ill-prepared, in a solo, round-the-world yacht race, never to return. In her 1997 film *Disappearance at Sea II (Journey of Healing)* Dean fuses reality and narrative and metaphorically relates Crowhurst's plight to the medieval romance of Tristan and Isolde. Dying, Tristan also wafted idly at sea, although, unlike Dean's yachtsman, he is rescued and nurtured back to life by his beloved princess Isolde and her mother.

Dean interweaves these tales again in *T&I*, short for Tristan and Isolde, and presents a majestic image of a barren rocky coastline facing out to sea, evoking the longing and memory for those who have not yet returned. Broken into twenty-five sheets, the composition suggests a narrative sequence but, unlike her prior print series, which typically depict a cycle of different photographic

images, here Dean creates a single monumental image from the individual components, generating a breathtaking, visionary effect. The rich velvety texture of the photogravure medium conveys a nineteenth-century patina that is ideally suited to the intensity and foreboding melancholy of its subject.

Dean often scribbles cryptic notes in white over her prints and drawings. In *T&I* words such as "start" and "stage 4" appear as clear theatrical directions; others, such as "dispute," or "uncommon solvent," seem to refer to the doomed legend of the title, with its love triangle and magic potions. She also incorporates bits of a favorite poem,[21] about a painter killed in an accident, somehow fitting to the subject of this lyric tragedy. The poem alludes to lighthouses off the coast of Cornwall, which is the site Dean imagined was pictured in this found photograph.[22] The artist manipulates one's expectations of veracity in her photographic images, making that perceptual confusion part of the content of her work. Like Blais and Baumgartner, and many others, Dean seamlessly synthesizes the photographic and the printed for rich, emotive meaning and haunting visual impact.

//
New Formats as Accepted Practice

While the artist's book and the multiple were "born" in the idealistic period of the 1960s, by the 1990s they had become a standard outlet for new ideas and were widely produced and appreciated. Earlier on, artists had hoped to bypass the gallery system with these inexpensive formats, bringing art directly to a broad public. There was missionary zeal, for example, in Joseph Beuys's aspirations to transform society through art, particularly through the vehicle of the edition. In a more lighthearted vein, Fluxus artists, too, sought to break down barriers between art and life, with the distribution of multiples a fundamental component of their program.

Contemporary artists are now as familiar with these formats as they are with the myriad of other art forms that are part of today's pluralistic scene. The artistic hierarchy that privileged painting and sculpture was dismantled long ago, and now the same artist often practices in a range of mediums. In addition, the period dominated by signature styles and singular trends is over. A new atmosphere of openness has nurtured the creation of books, multiples, and ephemeral artworks, often integral to an artist's overall work, sometimes simply a welcome foray when an opportunity arises.

A Cartoon Language

In striking contrast to the bold, emotion-laden gestures found in the paintings and prints of the Neo-Expressionists, a comic mode of drawing now characterizes the work of a number of artists in Europe, as well as in United States and elsewhere. Such work can be whimsical or absurd, but often grapples with content that is more serious than first appears. Leonid Tishkov, whose work captures this sensibility within the context of art and life in Eastern Europe, has said: "Caricature is a philosophy, and the people who do it think amazingly strangely."[23]

Born in the Ural Mountains and now living in Moscow, Tishkov creates not only artists' books but also drawings, paintings, prints, sculptural objects, performances, and videos, all populated by a family of related characters. In their likeness to bodily organs and appendages, such characters hark back to Tishkov's earlier study of medicine, which he abandoned in the late 1970s to pursue art. Even before taking this decisive step, however, Tishkov was always drawing and even had his cartoons published in newspapers and magazines. By the mid-1980s he had joined the Artists' Union, and later began to craft artists' books. He eventually established Dablus Press to publish these books, and also titles by other artists. In fact, in the late 1980s there was a general revival of this format in Russia, often compared to the "golden age" of the avant-garde book there in the 1910s and 1920s.[24]

A character called "Dabloid" is Tishkov's main protagonist, as seen in an artist's book of 1997 (P. 198) and in a page project adaptation created by the artist especially for this volume. Shaped like a foot, with what looks like a tiny head bent forward to lead the way, Dabloid is both grotesque and poignant. It is the subject of complicated, surrealist narratives, functioning as part pet, part protector, and part tormentor. "Each of us has his own Dabloid," states the artist in this book. Dabloid is everywhere, whether one is aware of it or not. It can drop from one's eye as a tear, or be pulled out of a nostril. In Tishkov's fantasy universe, such base gestures are decidedly humorous, as are his stories as a whole. But at the same time, there is room for commentary on Russian society of the past, with references to comrades, committees, and collectives, and to party optimism and the proletariat.

Well-known figures also make appearances—from Karl Marx to Andrey Sakharov and Yuri Gagarin.

Political realities take center stage in the doodles of Dan Perjovschi of Romania. A cartoon contributor to opposition newspapers, Perjovschi also functions within the art world, bringing his graffiti-like imagery to the pages of numerous artists' books and also to the walls of room-size installations. His spontaneous drawing style resembles what one finds scribbled on the most banal of surfaces—whether public walls or private notepads (P. 200). Yet his individual sketches and texts serve as elements of an overall system of biting commentary and critique, comprising a satiric vision that makes his observations comic and even absurd. For example, the casually penned words "pro" and "anti" are applied equally to war and peace and to smoking. Sometimes his works are site-specific, like a book issued in Sweden that references the store Ikea and the Nobel Prize. Relations between Eastern Europe and the West are constant rallying points, as well. His witty drawings and sly annotations bring the long tradition of political cartoons into the world of fine art, where low meets high without skipping a beat.

The Private Performance

Multiples set new meanings in motion, particularly when those who own them decide where they will be placed or how they will be used. The network of actions generated by these small, inert, three-dimensional artworks can be seen as performative, especially in an artistic milieu in which performance art and installation are prevalent. A multiple may occupy a shelf in the home of a friend, or sit on the desk of a coworker. As family, friends, and acquaintances involve themselves with this object—picking it up, passing it around, or even trying it on—they become participants in a theatrical enterprise. Their actions then become part of a larger event, as those in other settings improvise with other examples of that multiple. An unusual artistic community is formed, consisting of related "performers" in different places.

Katharina Fritsch launches countless narratives through her multiples issued in large editions (P. 210). With a strategy that combines elements of both Pop art and Conceptual art, she generally chooses commonplace subjects and remakes them in different materials, giving them the status of icons. Fritsch's *Mouse* is both repulsive and endearing. While the placement of her bright yellow *Madonna Figure* in the context of contemporary art might be offensive to some, it is also reminiscent of the many such figures sold in souvenir shops, including the plastic versions that seem more kitsch than religious symbol. Fritsch has said: "My Madonna figures…are banal objects, and at the same time they aren't….every individual plaster figure does retain a certain aura."[25]

Parkett, a journal of art and ideas now more than twenty years old, has been a prime initiator of art in editioned formats by collaborating with artists it features on its pages. Bice Curiger, one of the founding editors, has said, "It was extremely important for us to make a publication that views the artist as a partner."[26] This partnership involves the production of a print, photograph, drawing, painting, multiple, video, DVD, sound piece, or another format that is made available to subscribers. Prints predominated in the 1980s, but multiples soon outpaced them (P. 211). Franz West's colorful pouch is particularly interactive and in keeping with this artist's overall strategy of audience participation. The pouches, each in a different African fabric, are just the right size to carry around an issue of *Parkett*, making it easily available for reading or sharing with others.

John Bock's knit multiple (P. 197), which relates to his elaborate performance pieces, is also a production of *Parkett*. In his staged spectacles, Bock invariably includes costumed participants as well as music and film. When such stagings are part of an extended exhibition, he leaves behind the costumes and other props to constitute a kind of "set" where the drama unfolded. Sometimes viewers can rummage through these artifacts, trying on costumes and extending the life of the production. Bock's editioned works function in much the same way. The *Parkett* multiple, for example, can be worn as a pair of underpants, tail and other appendages not withstanding. Another example of Bock's multiples also prompts participation. He presents us with what appears to be a used and discarded pizza box (P. 197). Upon opening it, however, one finds two personal scrapbooks, filled with imagery culled from magazines and collaged together. Remembering childhood hours spent cutting and pasting, we regain that early sense of wonder and freedom. Bock's goal, as he explains it, is "to give a direction to the viewer so that he/she can feel, smell, or eat something in a different way."[27]

Other multiples in the form of clothing, such as those by Rosemarie Trockel and Sylvie Fleury, take on feminist implications. The works Trockel became known for in the late 1980s were made of knitted wool, stretched as if they

were paintings on canvas. Even though the knitting was accomplished by machine and the patterns designed by computer, these works call to mind the fact that weaving and knitting have long been considered "women's work." Other knitted garments by Trockel, such as leg warmers and a sweater with two neck openings, became sculptural objects, sometimes with strange or sinister connotations. Instead of suggesting cozy warmth, for example, the hats of her *Balaklava* series (P. 206), are frightening. Is their purpose to stifle expression? What is the meaning of patterning that includes both a swastika and a Playboy bunny? In an era of terrorism, these masks have further negative associations. But Trockel focuses on their feminist subtext when she says that "women have historically been left out....The masks...consist not only of what they say or intend to say, but also of what they exclude. They have absence as their subject."[28]

Sylvie Fleury's multiples, presenting glamorous accoutrements of fashion, occupy another aspect of feminist critique. Following in a long tradition extending from Marcel Duchamp's urinal to Andy Warhol's Brillo boxes, Fleury plucks objects from the everyday world and places them in an art context. For *His Mistress' Toy* (P. 208) she chose an iconic shoe style from a designer collection, highlighting the eroticism associated with women's footwear, particularly high-heeled pumps. This rubberized multiple—which squeaks when bent—also has a comic dimension, since it can be used as a dog's plaything. A related work in the form of a shoe box with faux fur lining (P. 208) exaggerates the slick, seductive packaging of couture items, itself an element of allure. Fleury makes note of the transformation that takes place when she chooses these commonplace objects: "Just re-contextualizing something that's very superficial will give it a new depth.... Sometimes just being a woman and showing something like a pair of shoes...gives it another dimension."[29] The bright, cheerful boxes reproduced in *Slim-Fast* (P. 208), a multiple that takes its inspiration from a weight-loss supplement, suggests the dark side of the pursuit of glamour and preoccupation with weight loss. Such negative behavior is also emphasized in the work of Annette Messager, whose artist's book *Les Tortures volontaires* (P. 207) portrays all manner of strange treatments, procedures, and products geared to women's goal of idealized bodily perfection.

Interventions

Antoni Muntadas, from Spain, is of the generation that first began exploring alternative artistic practices in the late 1960s and the 1970s, and to this day his work situates itself not only in gallery and museum settings but also in the midst of everyday life. His subjects include social, political, and economic issues as they relate to structures of power, particularly those revealed in manipulations by the mass media. His artistic means include photography, printed materials, installation, video, and the Internet, and his projects are often adapted to the particular locale in which they are presented.

In the mid-1990s Muntadas began a series called *On Translation*, which now comprises over thirty-five projects. One example, *On Translation: Warning*, was launched in Geneva and includes printed interventions in newspapers, on postcards and stickers, and in window displays. It has been presented in numerous cities, among them Montevideo, Florence, and Tokyo, all with the goal of capturing the public's attention and prompting new awareness. Muntadas's mass-produced printed materials, featuring white letters on a red background, say "Warning: Perception Requires Involvement," and the stickers forming part of this campaign crop up in many unexpected places (P. 215).[30] By adopting strategies of mass media and advertising and subverting them for his own messages, Muntadas reaches out to a population that has learned to absorb and interpret the ubiquitous printed materials around it. His goal is to break through the numbing effect of information overload, providing new insight into the ways and means of media manipulation and calling for active involvement in the world at large.

Croatian-born Ivana Keser, more than twenty-five years younger than Muntadas, is part of a generation for whom alternative practices are standard artistic strategies. After some traditional art training, Keser took a job in a small newspaper office, learning the basics of layout design, editorial writing, and advertising. She soon adopted a newspaper format for her own work, noting, "I was looking for a type of media in which I could express all my ideas, a surface able to receive very different things."[31] By now Keser has devised over a dozen newspapers, often submitting them as her contributions to group exhibitions (P. 201). Stacks of them are presented for the taking.

Reading a Keser newspaper project involves the usual random scanning one typically associates with the daily news. Items catch one's attention enough to read a few lines or sometimes finish an article. Included are Keser's commentaries on social and political issues as well as

random personal musings. In addition she provides cartoons and photographs of everyday motifs, like cigarettes, ice cream, and trash, or even the faces of individuals sitting in a park. Her newspapers become a collage of the visual and the textual, replete with poetic associations between words and images. Printed in editions of some 1,500 to 2,500 examples, these personal newspapers go out into the world and set into motion further thoughts and actions, even if they simply find their way into a wastebasket. As Keser says, "No paper gets thrown away without having made some impression."[32]

Arguably the most all-encompassing intervention project of recent times has been the activities undertaken by Museum in Progress, an Austrian association founded in 1990. Partnering with government, business, and the media, Museum in Progress brings art to an enormously broad public. Using innovative means that provide an "open discourse in society,"[33] Museum in Progress challenges the conventional concept of the museum as an institution in a physical setting, as well as the normal delivery systems of art. It organizes what it deems thematic "exhibitions," inviting various curators to select the participating artists. Rather than existing in the galleries of an institution, these exhibitions occupy such venues as billboards and the pages of newspapers and magazines. In more than fifty such exhibition projects, Museum in Progress has worked with over four hundred artists, representing various generations and countries around the world.

The pages of *Der Standard,* an Austrian newspaper, have been among Museum in Progress's foremost venues. One exhibition there, *Interventions*, has been ongoing since 1995. Most often, artists are invited to submit imagery to fill a double-page spread of the paper. Mona Hatoum's contribution depicts a woman in profile staring down a soldier figurine balanced on her nose accompanied by the words "Over my dead body" (P. 213). Dramatizing the link between the personal and the political—this is in fact the artist, who has suffered from displacements brought on by conflict and war in the Middle East—the work is an image of one individual's defiance. Hatoum joins vulnerability and resistance, presenting someone who refuses to become a nameless casualty of any war in any place.

Thomas Locher created a double-page spread as part of a Museum in Progress exhibition called *The Message as Medium*,

which made use of two venues: *Der Standard* and the business magazine *Cash Flow*. Locher's artistic practice, in general, explores the inherent limitations of language, and for this project he created a work that was meant to analyze a controversial and widely discussed statement made on a German television talk show to the effect that "all soldiers are potential murderers."[34] But when representatives of *Der Standard* and *Cash Flow* objected to the attention he was giving to this controversy, and worried about possible legal actions stemming from it, Locher responded by blacking out the text and resubmitting a "censored" version. In the context of a financial magazine, this design resembled a chart tracking economic data. In contrast, seen in the newspaper format, it becomes an intriguing abstraction with no obvious content (P. 213). However, in both venues a provocative text was added at the bottom stating that this work by Locher hides another work by Locher.

The Austrian weekly news magazine *Profil* has also been a partner in Museum in Progress exhibitions. In one, titled *Travelling Eye*, artists were invited to create photographic narratives that would appear as double-page spreads in four consecutive issues of the magazine. For his contribution, Gerhard Richter reproduced four details of one of his paintings, using a conceptual strategy that he has explored in other formats (P. 212). When seen together, Richter's pages give the sense that the paint is actually shifting and coagulating before one's eyes.

Hans-Peter Feldmann's project for *Profil* closely relates to work he has done in the past, presenting found photographic images with no explanatory texts (P. 212). Here, he maintains the pictorial layout of a regular issue of the magazine but removes all the text. Many viewers will recognize political figures that remain in the pictures, and perhaps piece together the events that bind them. Without explanatory captions or story, however, a certain disequilibrium sets in and readers begin to substitute their own narratives, literally filling in the blanks. Focusing on just the visual aspects of an article—the fact that some pictures are small and others large, that some are more prominently placed than others—illustrates how power is communicated through hierarchical presentations in the media. Approximately five hundred to six hundred magazines altered by Feldmann were distributed. The "normal" edition was issued as well.

Notes

1 For more on the idea of postmodernism, see Jean-François Lyotard, *The Postmodern Condition: A Report on Knowledge*, trans. Geoff Bennington and Brian Massumi (Minneapolis: University of Minnesota Press, 1984).

2 Jutta Koether, "Martin Kippenberger: A Cacophony for a Formidable Iconoclast," *Tate Etc.*, no. 6 (Spring 2006).

3 For more on this practice, see Robert Storr, *Franz West Projects 61* (exhibition brochure) (New York: The Museum of Modern Art, 1997).

4 For a reproduction of this photograph, see *Fama & Fortune*, issue 4 (Vienna: Verlag Pakesch & Schlebrügge, October 1990): n.p. This entire issue was devoted to West.

5 Marina Gržinić, "Neue Slowenische Kunst (NSK): The Art Groups Laibach, Irwin, and Noordung Cosmokinetical Theater Cabinet – New Strategies in the Nineties," in *Irwin: Interior of the Planit* (Ljubljana, Slovenia: Museum of Modern Art, 1996), p. 55.

6 Miran Mohar, e-mail correspondence, May 2006. Mohar has also stated that "it is always extremely difficult to negotiate with any army to get their permission to make the action. We got positive answers in about half of the cases. It is also important that we never stage fake armies" (e-mail correspondence, October 2005).

Thus far IRWIN has carried out these actions with armies in Bishkek, Kyrgyzstan; Cetinje, Montenegro; Graz, Austria; Kyoto; Prague; Priština, Serbia; Rome; Sarajevo; Tirana, Albania; and Zagreb.

7 Miran Mohar, e-mail correspondence, October 2005.

8 E-mail correspondence from the publisher Charles Booth-Clibborn of The Paragon Press, May 2003. At the same time Hirst also completed the second volume of the series, which encompasses fourteen larger color etchings.

9 Ibid.

10 Eliasson, quoted in Carol Diehl, "Northern Lights," *Art in America* 92, no. 9 (October 2004): 111.

11 The installation took place at the Bonner Kunstverein in 2000. Nicolai also produced an accompanying catalogue in the form of an artist's book on the same theme.

12 Each box actually includes three sets of the thirty colors, increasing installation possibilities.

13 Nicolai, quoted in Zdenka Badovinac, ed., *Form Specific ArtEast Exhibition* (Ljubljana, Slovenia: Museum of Modern Art, 2003), p. 102.

14 Claude Closky, telephone conversation, June 2006.

15 Susanne Modelsee, *The Art of Peter Kogler: Came out of the Computer* (Bonn: Artothek in the Bonner Kunstverein, 1996), n.p.

16 Printer Franck Bordas, e-mail correspondence, August 2005.

17 Jean-Charles Blais, "Working Proof," interview by Faye Hirsch, *Art on Paper* 5, no. 1 (September–October 2000): 70.

18 Transall is the name of a military cargo aircraft.

19 Niels Borch Jensen Galerie, e-mail correspondence, May 2006.

20 Dean also spent her student years on the English coast.

21 The poem, *The Thermal Stair*, is by Scottish neo-Romantic poet W. S. Graham, whose initials "WSG" Dean legibly writes at least twice on the composition.

22 Tacita Dean, e-mail correspondence, June 2006.

23 Tishkov, quoted in Ludmila Lunina, "The Mythology of Leonid Tishkov: Sources, Heroes, Actions, Traditions," in *Leonid Tishkov: Creatures* (Durham, N.C.: Duke University Museum of Art, 1993), p. 14.

24 For a discussion of the revival of the artist's book in Russia at this time, see Mikhail Karasik, *The Book Garden: Contemporary Russian Artists' Books* (Bristol, England: Off-Centre Gallery, 1995).

25 Katharina Fritsch, "In Conversation with Katharina Fritsch," by Matthias Winzen, in Gary Garrels, *Katharina Fritsch* (San Francisco: Museum of Modern Art; Basel: Museum für Gegenwartskunst Basel, 1996), p. 80.

26 Curiger, quoted in Mirjam Varadinis, "Parkett Backstage: Mirjam Varadinis in conversation with Bice Curiger, Jacqueline Burckhardt, and Dieter von Graffenried," in *Parkett: 20 Years of Artists' Collaborations*, ed. Mirjam Varadinis (Zurich and New York: Parkett, 2004), p. 127.

27 Bock, quoted in Michele Robecchi, "John Bock: A Man in Space," *Flash Art International* 38 (January–February 2005): 92.

28 Trockel, quoted in Cornelia Lauf, "Multiples/Balaclava," in *Rosemarie Trockel*, ed. Sidra Stich (Munich: Prestel Verlag, 1991), p. 114.

29 Sylvie Fleury, interview by Peter Halley, *index*, no. 33 (April–May 2002): 88.

30 A set of stickers in three languages—English, Spanish, and Chinese—was produced for this project and is included in this book. These languages were chosen by the artist, based on his research that they are the most commonly spoken in New York City.

31 Ivana Keser, interview with Christophe Cherix, in *25th International Biennial of Graphic Arts* (Ljubljana, Slovenia: MGLC, International Centre of Graphic Arts, 2003), p. 174.

32 Ibid.

33 Museum in Progress website, http://www.mip.at.

34 Information about Locher's project comes from telephone conversations and e-mail correspondence with Roman Berka, Curatorial Assistant and Project Manager, Museum in Progress, Vienna, May–June 2006.

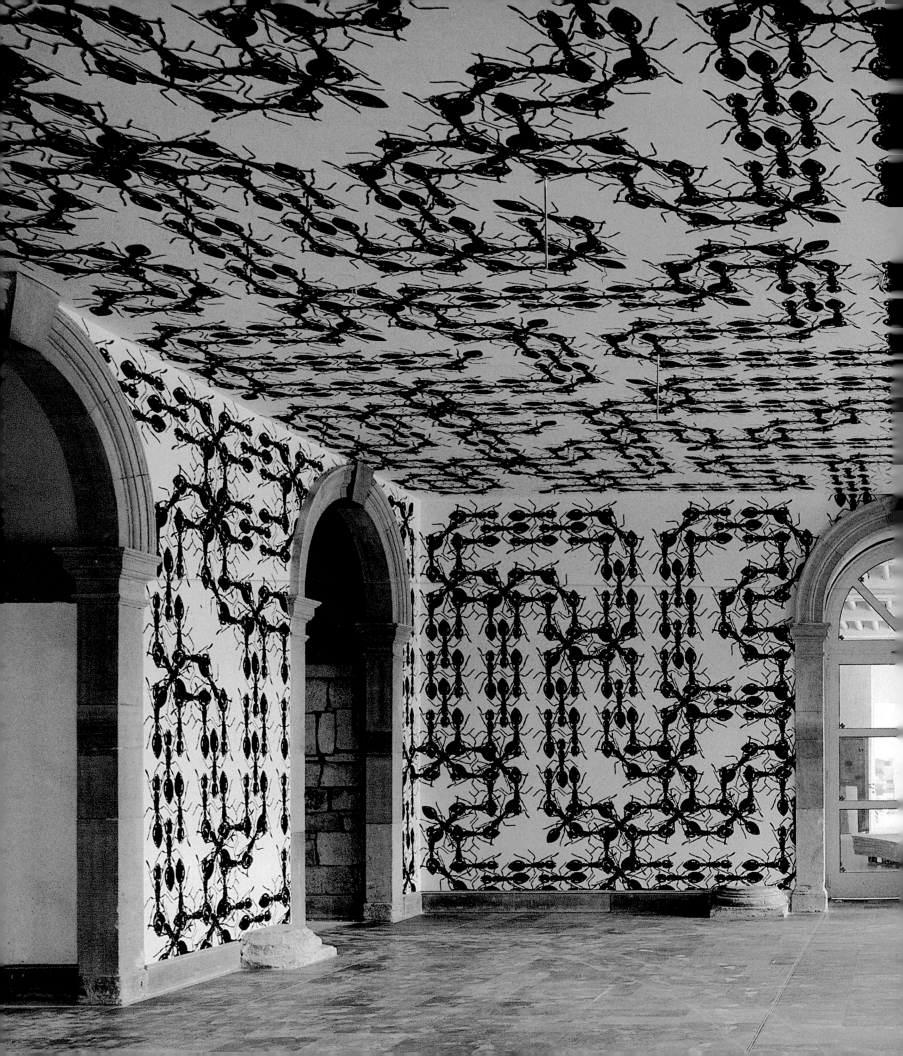

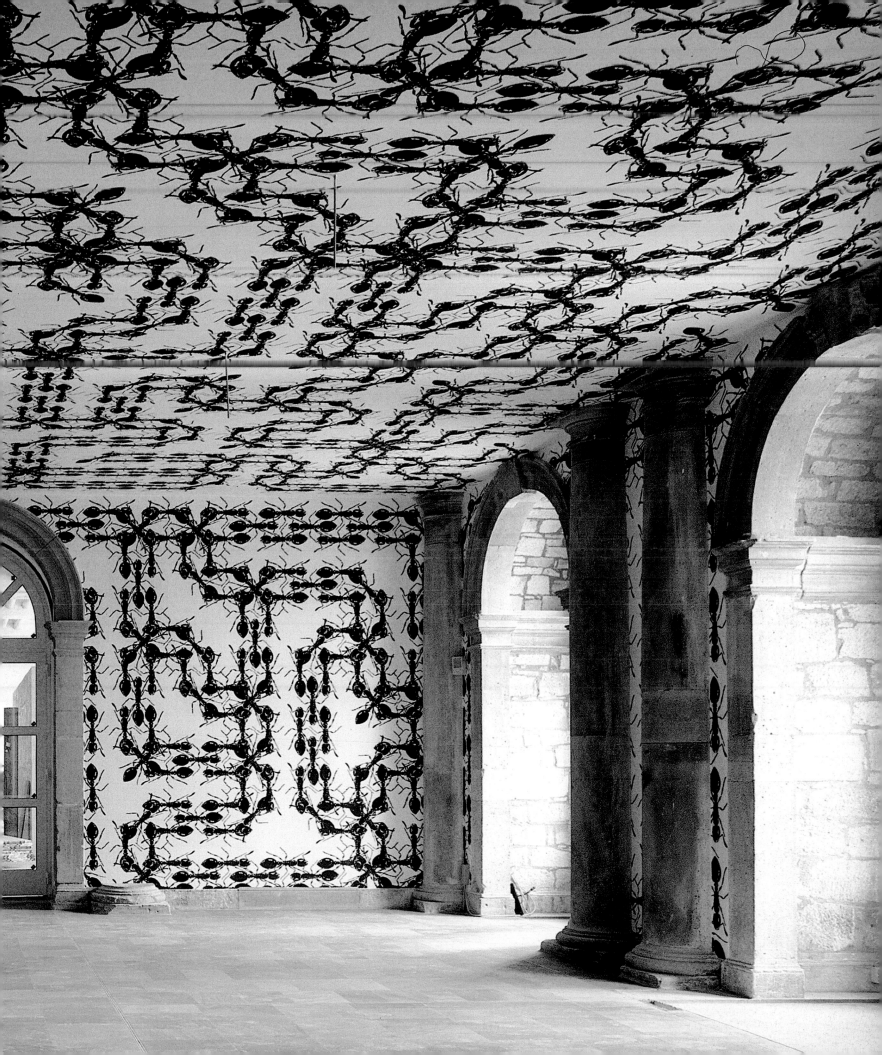

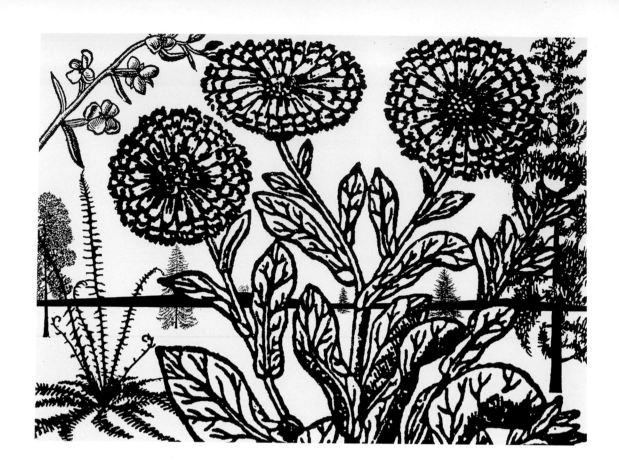

Paul Morrison
[BRITISH, born 1966]

Black Dahlias, 2002
Two from a portfolio of twelve
screenprints

SHEET: 28⁷/₈ x 38³/₄" (73.3 x 98.5 cm)
PUBLISHER: The Paragon Press, London
PRINTER: Coriander Studio Ltd., London
EDITION: 45

The Museum of Modern Art, New York.
Gift of Charles Booth-Clibborn and
The Paragon Press, 2006

previous spread

Peter Kogler
[AUSTRIAN, born 1959]

Untitled, 1992
Installation, *documenta 9*,
Kassel, Germany
Screenprinted wallpaper

DIMENSIONS: variable
PUBLISHER: unpublished
PRINTER: Galerie and Edition Artelier,
Graz, Austria
EDITION: not editioned

Courtesy the artist

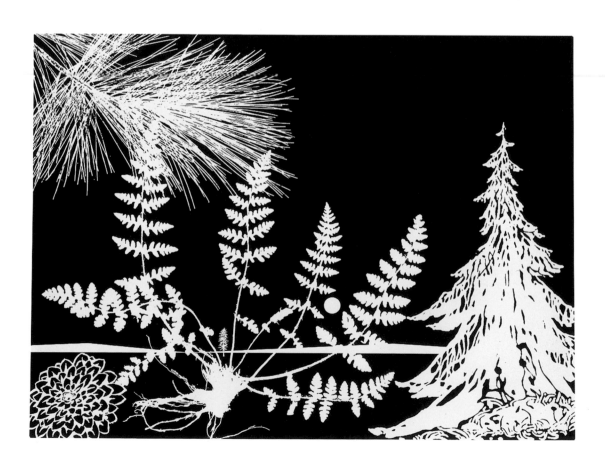

Rosemarie Trockel

[GERMAN, born 1952]

**What it is like to be what
you are not**, 1993
Four from a portfolio of
eight photogravures and
one screenprint
SHEET: 22⅝ x 17½" (57.5 x 44.5 cm)
PUBLISHER: Helga Maria Klosterfelde
Edition, Hamburg
PRINTER: Niels Borch Jensen,
Copenhagen
EDITION: 9

The Museum of Modern Art,
New York. Carol O. Selle Fund
(by exchange), 1995

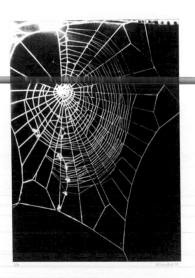

John Armleder

[SWISS, born 1948]

Supernova, 2003
Four from a portfolio of nineteen
lithographs and one monoprint

SHEET: 22 X 30" (55.9 X 76.2 cm)
PUBLISHER: Edition Copenhagen, Copenhagen,
and World House Editions, South Orange,
New Jersey
PRINTER: Edition Copenhagen, Copenhagen
EDITION: 33

The Museum of Modern Art, New York.
General Print Fund, 2003

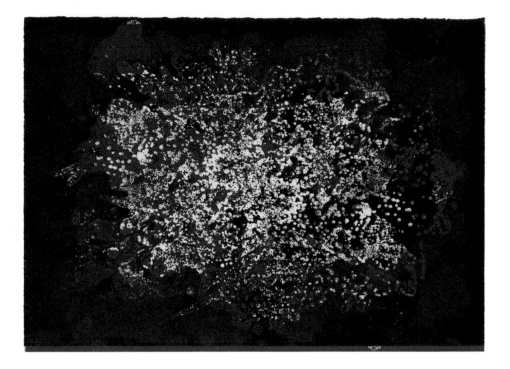

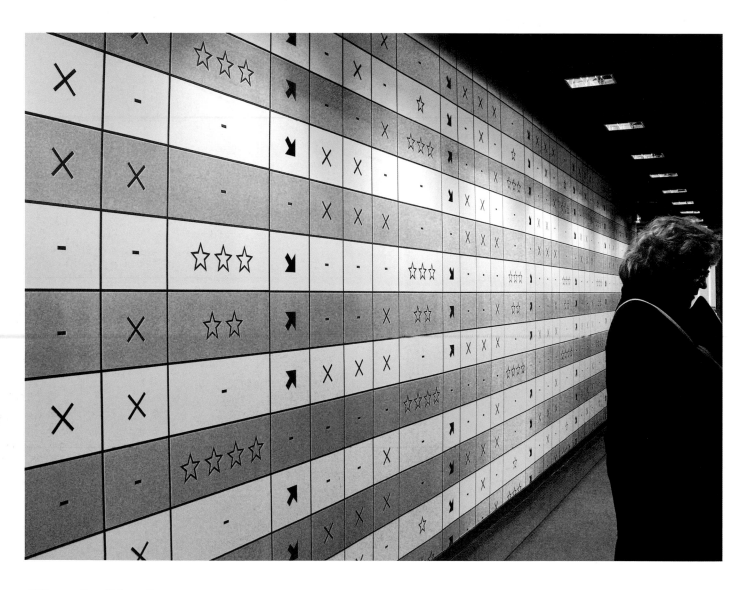

Claude Closky

[FRENCH, born 1963]

**Augmentation et réduction
(Up and Down)**, 2005
Wallpaper, installation at Centre Pompidou
administrative offices, Paris

DIMENSIONS: variable
PUBLISHER: Centre Pompidou, Paris
EDITION: mass produced

The Museum of Modern Art, New York.
General Print Fund, 2006

Olaf Nicolai

[GERMAN, born 1962]

30 Farben (**30 Colors**), 2000–05
Installation of eighteen from a portfolio
of ninety offsets and CD

SHEET (EACH): 40 x 12" (101.6 x 30.5 cm)
PUBLISHER: Carolina Nitsch Editions, New York
PRINTER: Druckhaus Steinmeier, Nördlingen,
Germany
EDITION: 3

The Museum of Modern Art, New York.
The Associates Fund, 2006

193

Martin Kippenberger

[GERMAN, 1953–1997]

left to right:

Ce Calor 2, **Angst**, **Stefan Mattes**,
and **VIT 89** from **Mut zum Druck**
(**Courage to Print**), 1990
Four screenprints from a portfolio
of twenty-three screenprinted,
one Xeroxed, and four offset posters

SHEET (APPROX.): 33 ³/₁₆ x 23⁷/₈" (84.3 x 59.5 cm);
46¹⁵/₁₆ x 33¹/₄" (119.2 x 84.4 cm) (far right)
PUBLISHER: the artist, Cologne
PRINTER: various
EDITION: 25

The Museum of Modern Art, New York.
The Associates Fund, 2001

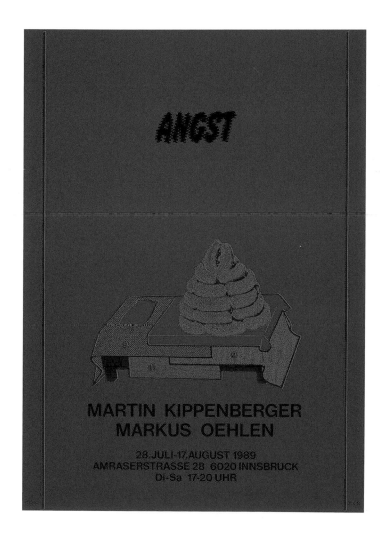

Martin Kippenberger

VIT 89

17. November – 23. Dezember '89

Galerie Max Hetzler, Köln

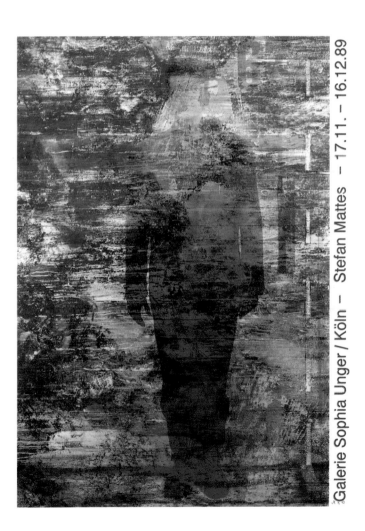

Galerie Sophia Unger / Köln – Stefan Mattes – 17.11. – 16.12.89

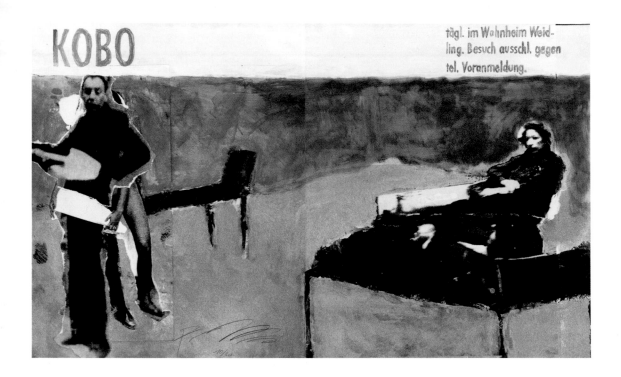

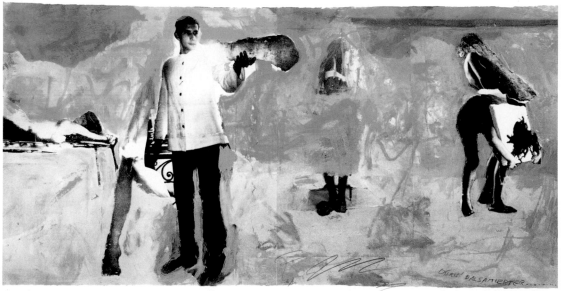

Franz West
[AUSTRIAN, born 1947]

Konventionelle Dichotomie
(**Conventional Dichotomy**), 1990
Two from a portfolio of six
double-sided screenprints

SHEET: 24 1/2 x 40 15/16" (62.2 x 104 cm) (top);
30 3/16 x 40 15/16" (76.6 x 104 cm) (bottom)
PUBLISHER: Galerie and Edition Artelier,
Graz, Austria, and Jänner Galerie, Vienna
PRINTER: Galerie and Edition Artelier,
Graz, Austria
EDITION: 30

The Museum of Modern Art, New York.
Mary Ellen Oldenburg Fund, 2005

Franz West

Adaptive, 2003
Three multiples of polyurethane resin
and acrylic enamel
EACH: 1³/₁₆ x 1¹³/₁₆ x 8¹¹/₁₆" (3 x 3 x 22 cm)
PUBLISHER: Whitechapel Art Gallery, London
EDITION: 300

The Museum of Modern Art, New York.
The Associates Fund, 2006

John Bock

[GERMAN, born 1965]

**Geometrischer Ort der 2 Mio.
$ Knödel-knickerbockermigränehitshit-
bitssoufflévisage, drin strohmulmige
Isoquante touchiert goldene Bilanzregel
+ Insolvenzsnob** for the journal *Parkett*,
no. 67, 2003

Multiple of wool, gold sequins, straw,
silicone, rabbit droppings, and pill
OVERALL: 5⁷/₈ x 21¹/₄ x 13" (15 x 54 x 33 cm)
PUBLISHER: Parkett, Zurich and New York
FABRICATOR: Atelier John Bock, Berlin
EDITION: 60 variants

The Museum of Modern Art, New York.
Purchase, 2003

Untitled, 1998
Multiple of cardboard box with gold
marker and tape additions, containing
two artists' books with cut-and-pasted
paper, pencil, ink, and gold marker
additions
PAGE: 11¹/₄ x 8⁷/₁₆" (28.6 x 21.5 cm);
BOX: 11¹/₈ x 11¹⁵/₁₆" x 2¹⁵/₁₆"(28.2 x 30.4 x 5.8 cm)
PUBLISHER: Helga Maria Klosterfelde
Edition, Hamburg
FABRICATOR: Atelier John Bock, Berlin
EDITION: 8 variants

The Museum of Modern Art, New York.
Purchased with proceeds from the 2000 "Clue"
event sponsored by The Junior Associates
of The Museum of Modern Art, 2001

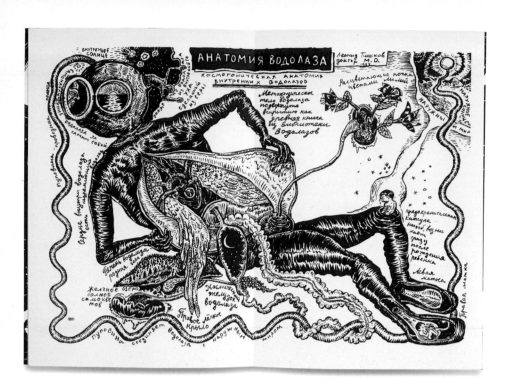

insert

Dabloids, 2006
Page project for *Eye on Europe*
based on **Dabloids**, 1997

Leonid Tishkov

[RUSSIAN, born 1953]

**Kosmogonia Vodolazov
(Cosmogony of the Deep Sea Divers)**,
2004
Artist's book with ink additions
PAGE: 13⁷/₁₆ x 9¹/₄" (34.1 x 23.5 cm)
PUBLISHER: Alcool, Moscow and Dirizhabl,
Nizhniy Novgorod, Russia
PRINTER: Dirizhabl, Nizhniy Novgorod, Russia
EDITION: 200

The Museum of Modern Art, New York.
Acquired through the generosity of
Richard Gerrig and Timothy Peterson in
memory of Thor Peterson, 2006

Dabloids, 1997
Artist's book
PAGE: 18⁵/₈ x 12¹/₂" (47.3 x 31.8 cm)
PUBLISHER AND PRINTER: Hand Print Workshop
International, Alexandria, Virginia
EDITION: 100

The Museum of Modern Art, New York.
Acquired through the generosity of
Richard Gerrig and Timothy Peterson in
memory of Thor Peterson, 2006

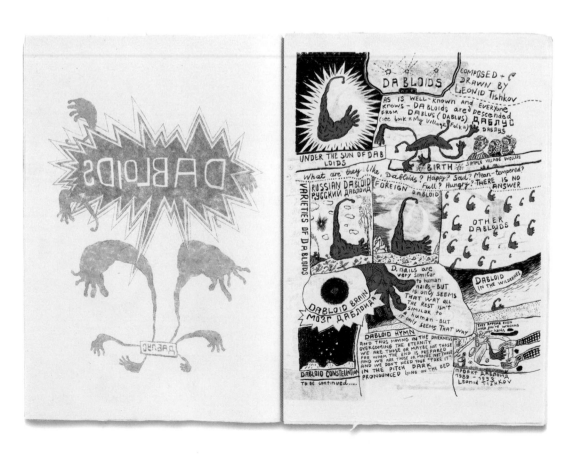

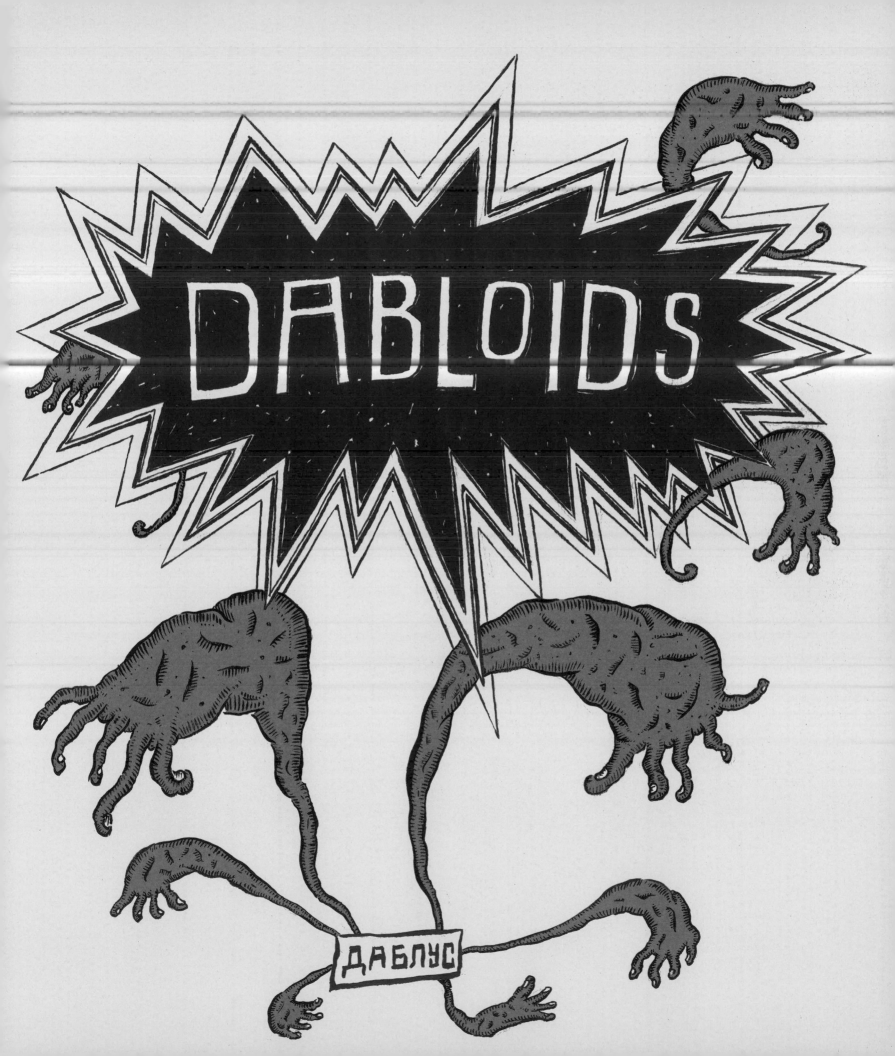

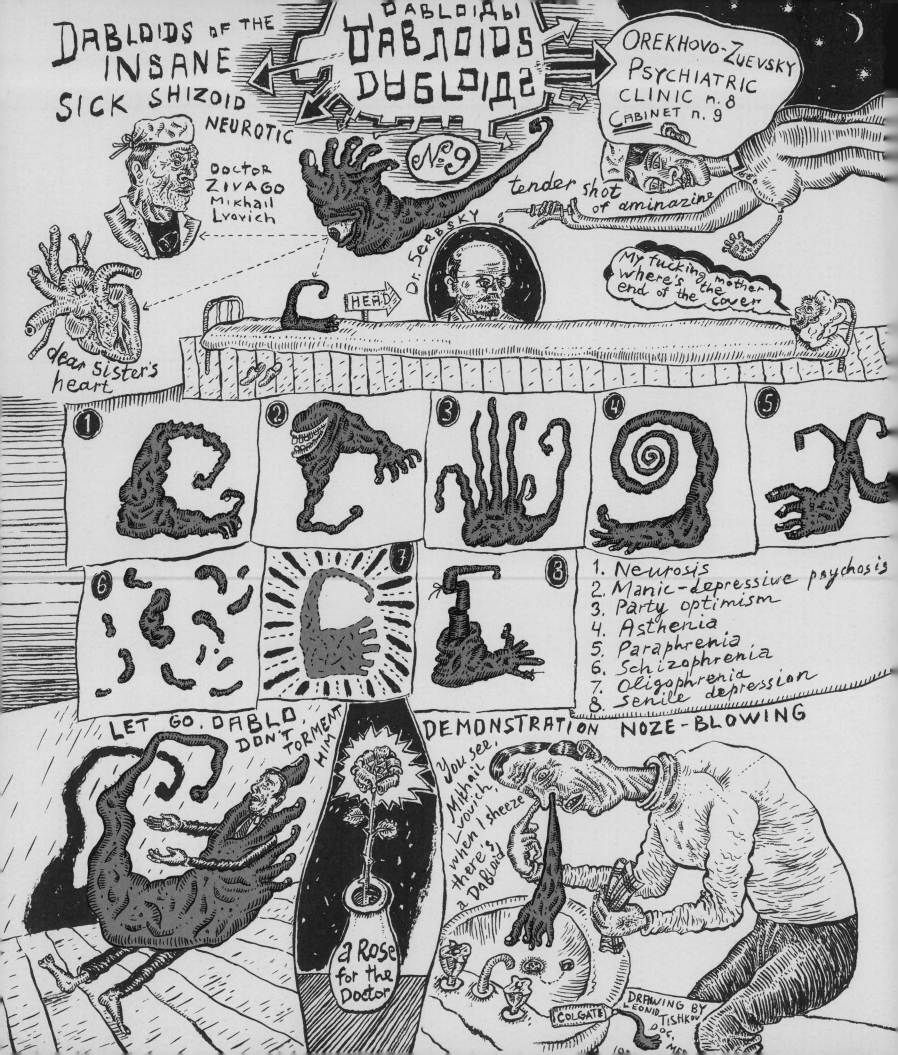

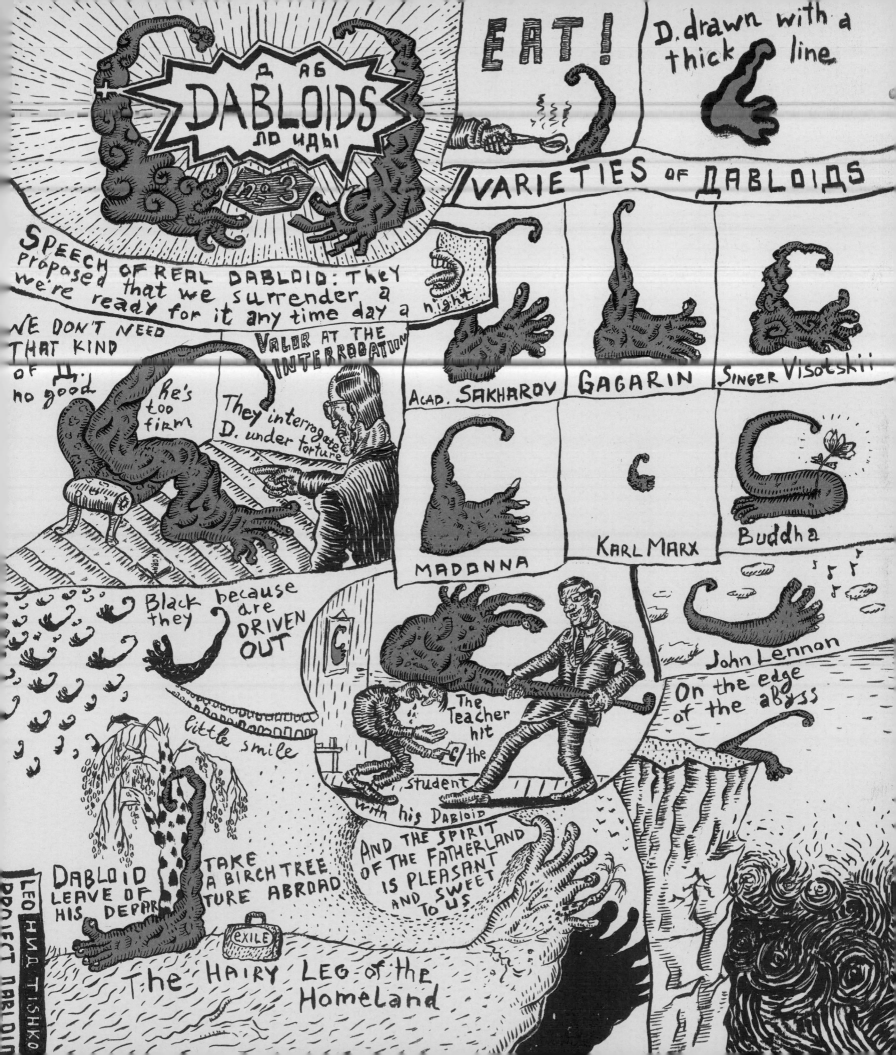

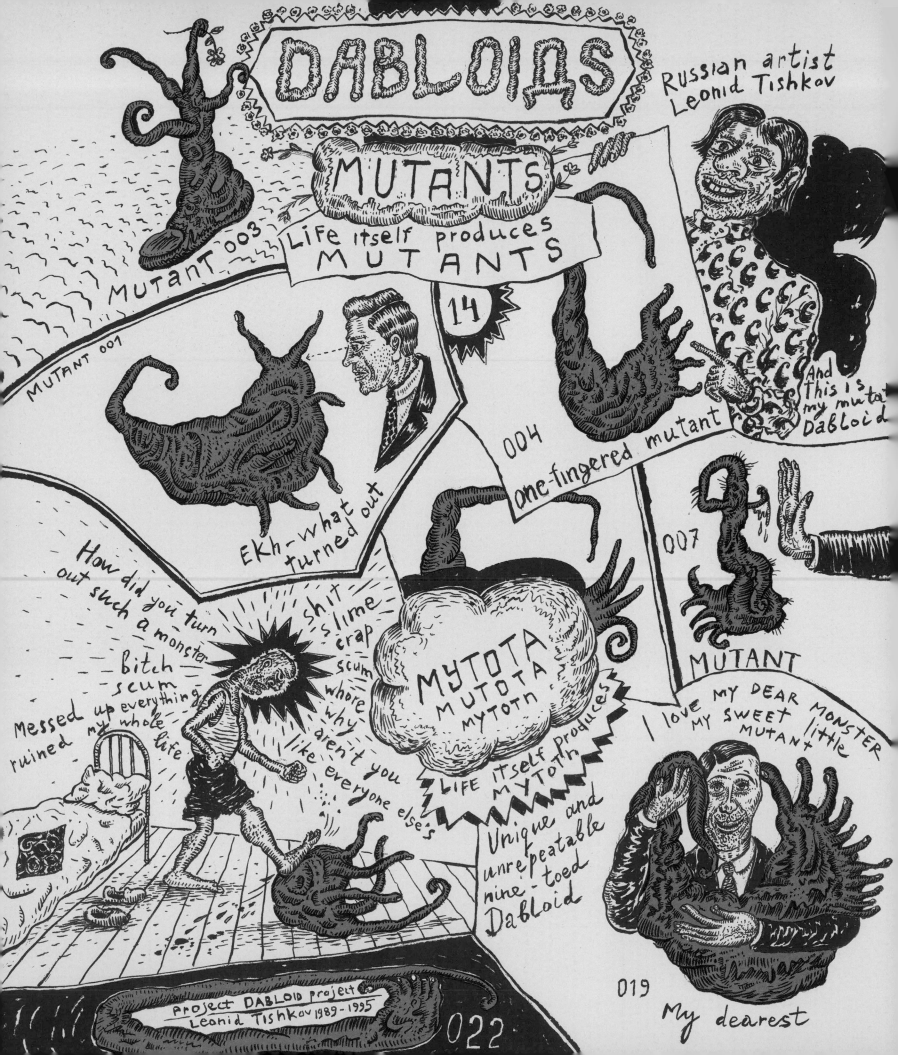

Ryba (Fish), **Kartofel (Potatoes)**, and
Dabloid from **Natiur Morty (Still Lifes)**,
1992
Three from a portfolio of sixteen
lithographs
SHEET: 24 x 16⁷/₈" (61 x 42.9 cm)
PUBLISHER: Dablus Press and Moscow Palette
Gallery, Moscow
PRINTER: Valery Bezkrovny, Moscow
EDITION: 10
The Museum of Modern Art, New York.
The Associates Fund, 2006

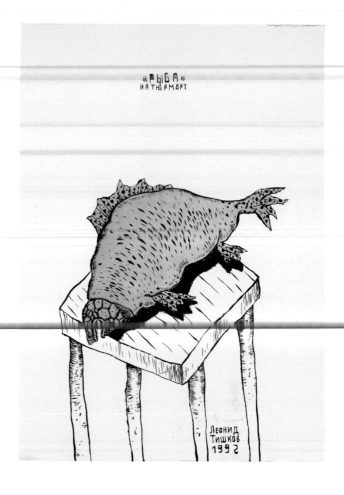

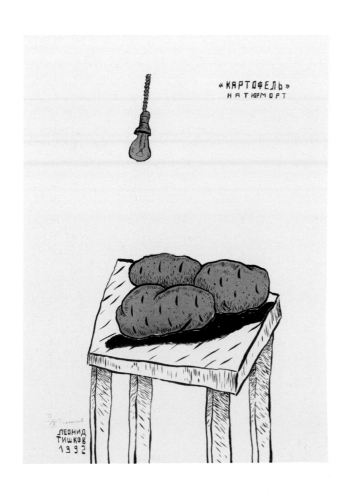

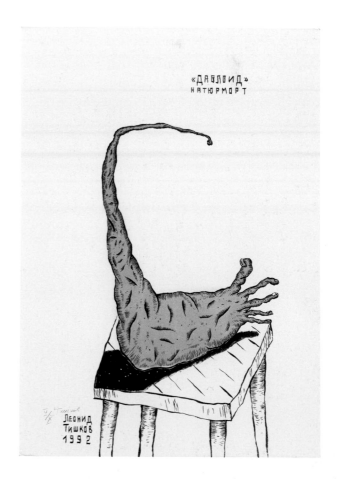

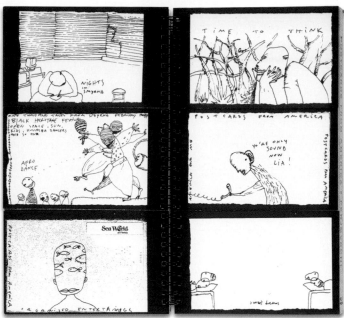

Dan Perjovschi

[ROMANIAN, born 1961]

Postcards from America, 1995
Artist's book
PAGE: 10⁷/₈ x 5⁷/₈" (27.6 x 15 cm)
PUBLISHER: Pont La Vue Press, New York
EDITION: 500

The Museum of Modern Art Library,
New York

Autodrawings, 2003
Artist's book
PAGE: 9⁷/₁₆ x 6³/₈" (24 x 16.2 cm)
PUBLISHER: Kunsthalle Göppingen,
Germany, and Verlag der
Buchhandlung Walther König,
Cologne
EDITION: 830

The Museum of Modern Art, New York.
Gift of the artist, 2006

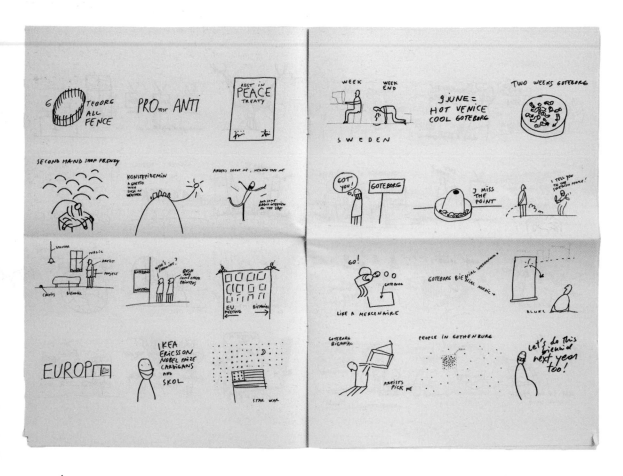

Flow, 2001
Broadsheet for Göteborg
International Biennial
PAGE: 16¹/₈ x 11" (41 x 28 cm)
PUBLISHER: Kunsthalle Göteborg,
Sweden
EDITION: unknown

The Museum of Modern Art, New York.
Gift of the artist, 2006

Ivana Keser

[CROATIAN, born 1967]

Local-Global, 1995
Local Newspapers, 1997
Nothing Personal, 1997
Private Copy, 2000
Strangers in the City, 2000
Newspaper/broadsheet

PAGE (APPROX.): 16 9/16 X 11 11/16" (42 X 29.7 cm)
PUBLISHER: various exhibition venues
EDITION: approx. 1,500–2,500

The Museum of Modern Art Library,
New York

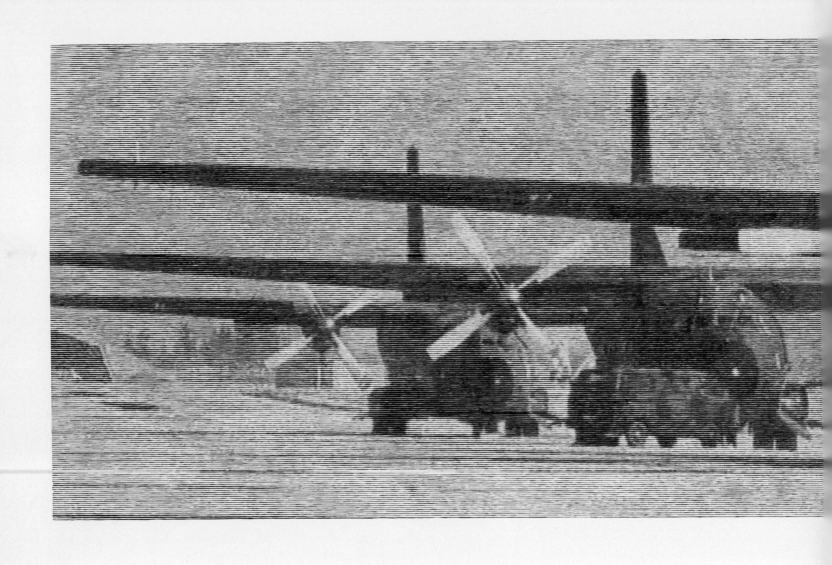

Christiane Baumgartner

[GERMAN, born 1967]

Transall, 2002–04
Woodcut

SHEET: 61" x 14' 3 ¹/₄" (154.9 x 435 cm)
PUBLISHER AND PRINTER: the artist, Leipzig
EDITION: 6

The Museum of Modern Art, New York.
Fund for the Twenty-First Century, 2005

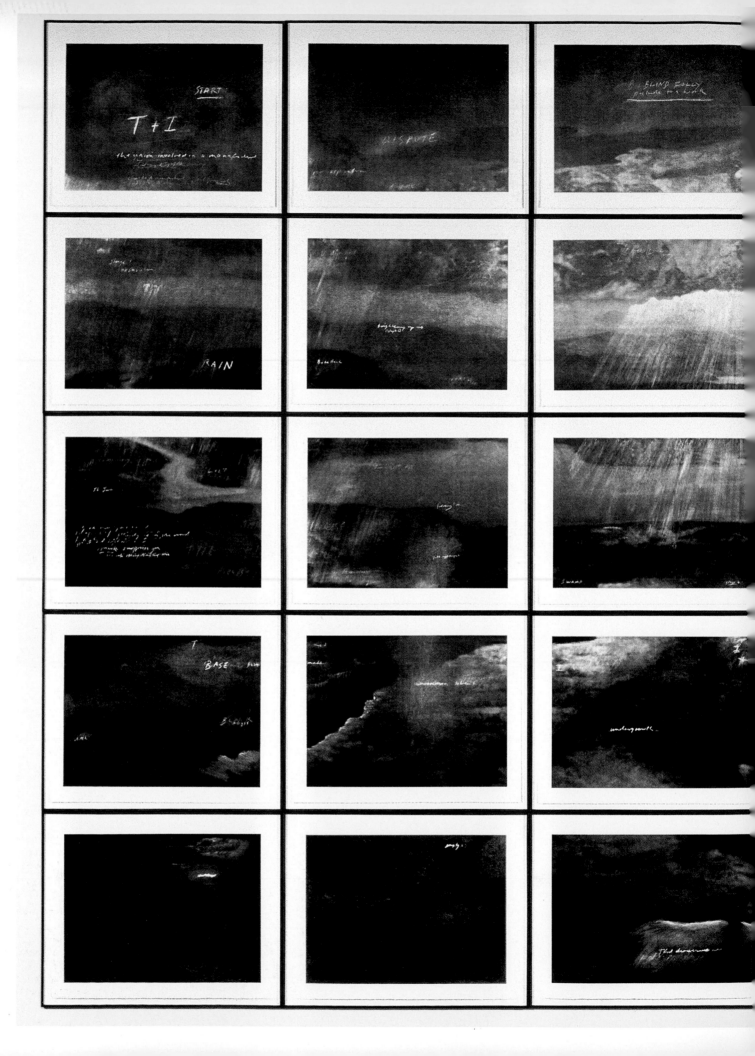

Tacita Dean

[BRITISH, born 1965]

T&I, 2006
Photogravure on twenty-five sheets

SHEET (EACH): 26 3/4 x 33 7/8" (68 x 86 cm)
PUBLISHER AND PRINTER: Niels Borch Jensen
Gallery and Edition, Berlin and Copenhagen
EDITION: 8

Courtesy Niels Borch Jensen Gallery and
Edition, Berlin and Copenhagen, and the artist

Rosemarie Trockel

[GERMAN, born 1952]

Balaklava, 1986
Multiple of five knitted masks

EACH: 11 $^{13}/_{16}$ X 8 $^{1}/_{16}$ X 1 $^{9}/_{16}$" (30 X 20.5 X 4 cm)
PUBLISHER: Esther Schipper, Cologne
FABRICATOR: various
EDITION: 10

Hamburger Kunsthalle

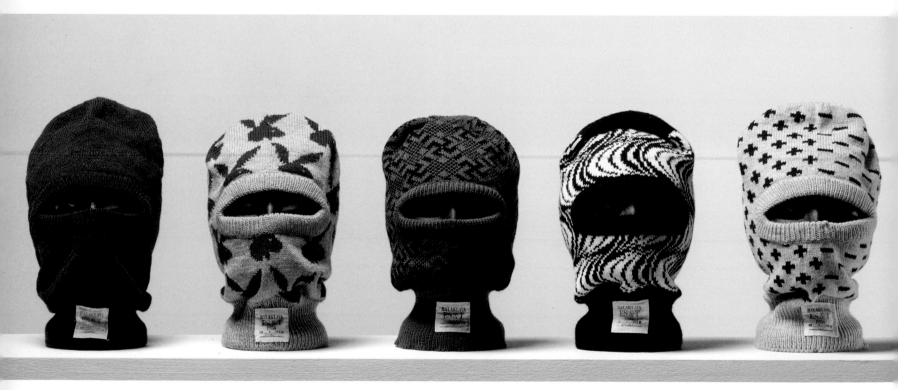

Annette Messager
[FRENCH, born 1943]

Mes ouvrages, 1989
Artist's book

PAGE: 7¹/₂ x 3¹⁵/₁₆" (19 x 10 cm)
PUBLISHER: Actes sud, Arles
EDITION: 1,500

The Museum of Modern Art Library,
New York

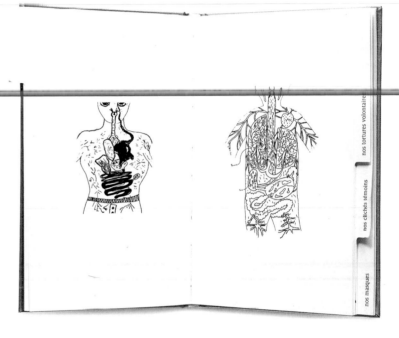

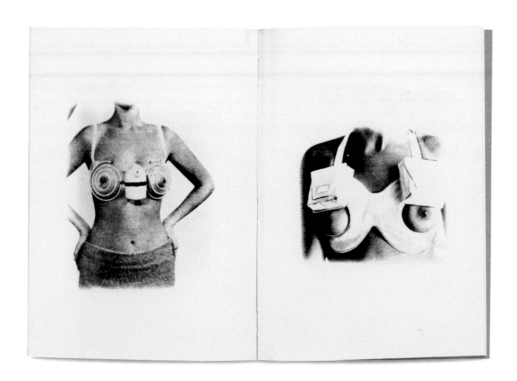

Nos témoinages, 1995
Artist's book

PAGE: 6⁵/₁₆ x 4¹/₈" (16 x 10.4 cm)
PUBLISHER: Oktagon Verlag, Stuttgart
EDITION: 900

The Museum of Modern Art, New York.
Transferred from Museum Library, 2001

Les Tortures volontaires, 1974
Artist's book

PAGE: 8¹/₄ x 5⁵/₈" (21 x 14.3 cm)
PUBLISHER: H. M. Bergs Forlag and
Daner Galleriet, Copenhagen
EDITION: 600

The Museum of Modern Art Library,
New York

Sylvie Fleury

[SWISS, born 1961]

His Mistress' Toy for the journal
Parkett, no. 58, 2000
Multiple of polyurethane shoe with
integrated noisemaker

OVERALL: 4⁷/₁₆ x 3³/₄ x 7¹¹/₁₆" (11.2 x 9.5 x 19.5 cm)
PUBLISHER: Parkett, Zurich and New York
EDITION: 99

The Museum of Modern Art, New York.
Roxanne H. Frank Fund, 2000

Vital Perfection, 1993
Multiple of faux fur-lined
cardboard shoebox

OVERALL: 3³/₄ x 10¹⁵/₁₆ x 6⁵/₈"
(9.5 x 27.8 x 16.8 cm)
PUBLISHER: Edition Hervé Mikaeloff, Paris
EDITION: 100

The Museum of Modern Art, New York.
Mary Ellen Oldenburg Fund, 2005

Slim-Fast: Délice de Fraise and
Slim-Fast: Délice de Vanille, 1993
Multiple of screenprint on wood

BOX: 5⁷/₈ x 7¹/₁₆ x 3¹⁵/₁₆" (15 x 18 x 10 cm)
PUBLISHER: Art & Public, Geneva
PRINTER: Staudhammer, Bière, Switzerland
EDITION: 250

The Museum of Modern Art, New York.
General Print Fund, 2005

Jean-Charles Blais

[FRENCH, born 1956]

Panoply #3, 2000
Lithograph on rubber

SHEET: 57³/₄ x 22" (146.7 x 55.9 cm)
PUBLISHER AND PRINTER: Atelier Bordas, Paris
EDITION: 8

The Museum of Modern Art, New York.
The Associates Fund, 2006

Katharina Fritsch

[GERMAN, born 1956]

Maus (**Mouse**), 1998
Multiple of painted resin
OVERALL: 7⁵/₁₆ x 2³/₈ x 9¹/₄" (18.5 x 6 x 23.5 cm)
PUBLISHER AND FABRICATOR: the artist, Düsseldorf
EDITION: 240

Courtesy Matthew Marks Gallery, New York

Madonnenfigur (**Madonna Figure**), 1982
Multiple of plaster with pigment
OVERALL: 11¹³/₁₆ x 3¹/₈ x 2³/₈" (30 x 8 x 6 cm)
PUBLISHER AND FABRICATOR: the artist, Düsseldorf
EDITION: unlimited

The Museum of Modern Art, New York.
Acquired through the generosity of
Linda Barth Goldstein, 1995

Carole Benzaken

[FRENCH, born 1964]

Candide, 2004
Lithograph
SHEET: 2" x 66' 8" (5.1 cm x 20.3 m)
PUBLISHER AND PRINTER: Item Éditions, Paris
EDITION: 30

The Museum of Modern Art, New York.
Lily Auchincloss Fund, 2005

Parkett

Journal [1984–present]
EDITOR-IN-CHIEF: Bice Curiger

clockwise from top right:

Daniel Buren [FRENCH, born 1938]
De la Broderie à la dentelle: Travail in situ, encres de couleur et découpes en hommage à Madame Livia Curiger (From Embroidery to Lace: Work in Situ, Colored Inks and Cutout in Hommage to Mrs. Livia Curiger)
Insert for no. 66, 2002
PAGE: 9 15/16 X 8" (25 X 20.3 cm)

Roman Signer [SWISS, born 1938]
Feuerwehrhandschuh mit Photo (Fireman's Glove with Photograph)
for no. 45, 1995
Multiple of fireman's glove
OVERALL: 7 3/16 X 13 5/16 X 9/16" (18.3 X 33.8 X 1.4 cm)
EDITION: 80

Rebecca Horn [GERMAN, born 1944]
Der Doppelgänger (The Double)
for no. 13, 1987
Multiple of silver-plated brass double-headed hammer
OVERALL: 10 X 3 1/8 X 1/2" (25.4 X 7.9 X 1.2 cm)
EDITION: 99

Franz West [AUSTRIAN, born 1947]
Etui für diese Ausgabe von Parkett (Pouch for This Edition of Parkett)
for no. 37, 1993
Multiple of fabric bag with metal chain
OVERALL: 10 7/16 X 9 1/4" (26.5 X 23.5 cm)
FABRICATOR: Franz West Studio, Vienna
EDITION: 180 variants
PUBLISHER: Parkett, Zurich and New York

The Museum of Modern Art, New York.
Riva Castleman Endowment Fund,
Lily Auchincloss Fund, and Gift of Parkett, 1998

Museum in Progress

[AUSTRIAN ARTS ASSOCIATION, 1990–present]
Magazine and newspaper inserts
PUBLISHER: Museum in Progress, Vienna
The Museum of Modern Art, New York.
Linda Barth Goldstein Fund, 2006

Hans-Peter Feldmann [GERMAN, born 1941]
Without Words, page project for the
magazine *Profil*, 2000
PAGE: 11$^{1}/_{8}$ x 8$^{1}/_{4}$" (28.2 x 21 cm)

Gerhard Richter [GERMAN, born 1932]
Page project for the series *Travelling Eye*,
in the magazine *Profil*, 1996
PAGE: 11$^{1}/_{8}$ x 8$^{1}/_{4}$" (28.2 x 21 cm)

Mona Hatoum [BRITISH OF PALESTINIAN ORIGIN, born Lebanon, 1952]

Page project for the series *Interventions*, in the newspaper *Der Standard*, 1998

PAGE: 18¼ x 12" (46.4 x 30.5 cm)

Thomas Locher [GERMAN, born 1956]

Page project for the series *The Message as Medium*, in the newspaper *Der Standard*, 1991

PAGE: 18¼ x 12" (46.4 x 30.5 cm)

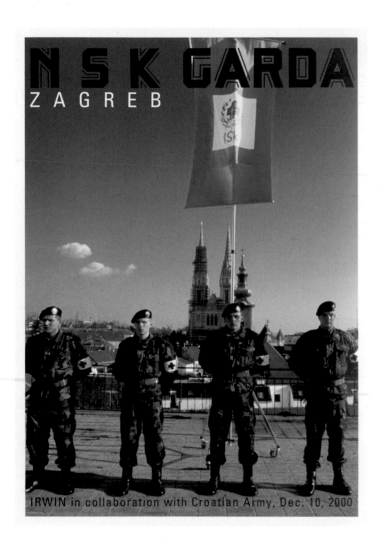

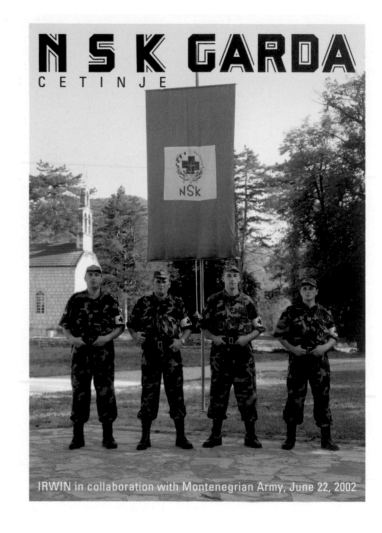

IRWIN

[SLOVENIAN ARTIST'S GROUP, active 1983–present]

NSK Garda Zagreb, 2002 (printed 2006) and
NSK Garda Cetinje, 2002 (printed 2006)
Digital print

SHEET: 27 9/16 x 19 11/16" (70 x 50 cm)
PUBLISHER: Galerija Gregor Podnar,
Ljubljana, Slovenia
PRINTER: Matformat, Ljubljana, Slovenia
EDITION: 6

The Museum of Modern Art, New York.
The Associates Fund, 2006

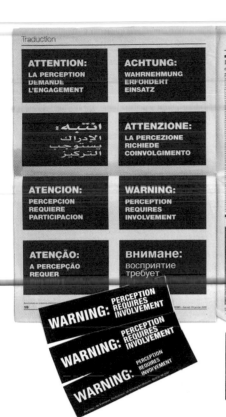

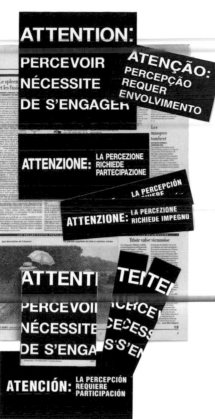

Antoni Muntadas
[SPANISH, born 1942]

On Translation: Warning, 1999–present
Ephemera, including newspaper insert,
exhibition announcements, stickers,
bookmarks, and artist's book (left);
sticker in situ, Venice (below)

DIMENSIONS: variable
PUBLISHER: various exhibition venues
EDITION: various

The Museum of Modern Art, New York.
The Associates Fund, 2006

loose insert

On Translation: Warning, 1999–present
Stickers
Project for *Eye on Europe*

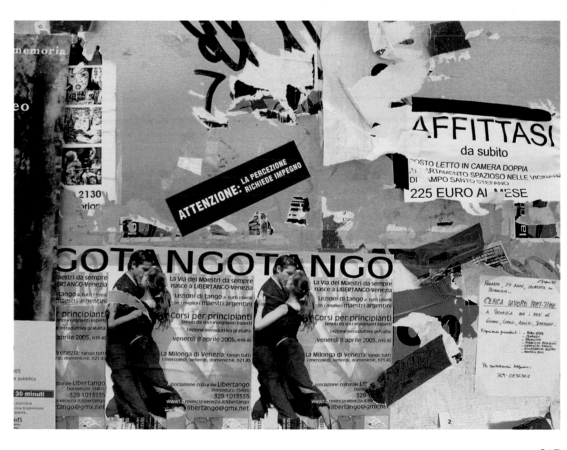

british focus

Fiona Banner
Jake and Dinos Chapman
Michael Craig-Martin
Adam Dant
Peter Doig
Helen Douglas
Lucian Freud
Gilbert & George
Liam Gillick
Richard Hamilton
Mona Hatoum
Damien Hirst
David Hockney
Peter Howson
Langlands & Bell
Paul Etienne Lincoln
Sarah Lucas
Chad McCail
Jonathan Monk
Paul Noble
Julian Opie
Simon Patterson
Grayson Perry
David Shrigley
Telfer Stokes
Gillian Wearing
Rachel Whiteread

As we have seen with examples from Richard Hamilton to

Richard Long, artists in Britain actively participated in developments across Europe in the period under discussion. But two decades—the 1960s and the 1990s—gave rise to singular bursts of creativity and excitement there. This excitement extended to the field of prints, books, and multiples as well. The turn to screenprint, for example, was a phenomenon integral to the Pop aesthetic of Swinging London in that earlier time. Artists like Hamilton, Eduardo Paolozzi, Patrick Caulfield, and Bridget Riley took advantage of the potential of this relatively new technique and are featured in the section Mass Mediums. British artists are also discussed elsewhere in this volume, but a particular focus on the generation of the 1990s to now will be introduced here, with a few precedents furnishing context.

In the 1990s passions arose around a group known as YBAs, or Young British Artists.[1] Attention would be showered on British art in general because of this group. The first inkling of a new sensibility came in 1988 with *Freeze*, an exhibition organized by a young Damien Hirst, and advertising mogul Charles Saatchi surely courted the media when he began to collect this art and promote it through his own gallery space. In 1997 London's Royal Academy showed Saatchi's collection in an exhibition that lived up to its name, *Sensation*. The provocative nature of the work on view generated controversy—and great crowds. The show traveled to the Brooklyn Museum of Art in New York, and its notoriety only grew as then Mayor Rudolph Giuliani expressed outrage and threatened to close the publicly supported museum. Thanks to developments such as these, it seemed everyone had an opinion on the new British art. When the Tate Modern opened in 2000 it appeared to be the crowning achievement for art in London. As Grayson Perry has said, "As an artist who has worked in London in this period I've seen a huge change in the art world and Tate Modern is a kind of physical manifestation of that."[2] The Tate's Turner Prize, which in 1984 began to be awarded annually to encourage wider interest in contemporary art, became one of the most watched events of the 1990s, and remains so today.

The artists presented here were, for the most part, born in the 1950s and 1960s. Although some were producing mature work before 1990, all received special notice in the years following. Also included are artists whose work served as precursors or who are noteworthy for the renewed consideration they garnered at this time. Areas of concentration are etching, which has proved an appropriate vehicle for an enduring figurative tradition; a new Pop sensibility that privileges both screenprint and digital technology; a compositional strategy of mapping that charts exterior and interior worlds; and, finally, provocative new books, multiples, and ephemera.

A Figurative Tradition in Etching

It is the mark of a pluralistic period in art when various traditions coexist comfortably. Painting or drawing the figure, or using it as a motif for an etching, for example, may seem conservative in the realm of contemporary artistic investigation, but such explorations have proved continually relevant for devising new narratives. With figural motifs, David Hockney, who came to attention in the 1960s, demonstrates that Pop art was more nuanced than simply representing mass culture. Likewise, Richard Hamilton shows figural studies encompassing complex subjects in examples of his work from the 1980s.

Hockney's *A Rake's Progress* (P. 228), a portfolio of etchings created in the early 1960s, seems particularly fresh today in its disjointed storytelling and casual drawing style. Here, the artist exploits the technique's potential to produce scratchy, brittle lines that give his tale an edginess that approximates the tensions purportedly felt by the protagonist—Hockney himself venturing out into the world by making a trip to New York. But one hardly needs to know the specific subject, or the fact that the series is based on one issued by William Hogarth in the eighteenth century, to enter Hockney's world.[3] These etchings capture the immediacy of sketchbook impressions, almost as if the artist had quickly jotted down daily events on a notepad kept in his pocket. For the plate called *The Start of the Spending Spree and the Door Opening for a Blonde*, it is amusing to know that Hockney dyed his hair blonde on this trip. A bottle of Lady Clairol bleach sits on the head of the bespectacled young artist as he approaches the door to his future. Also, if one were to study the Hogarth series on which this is based, one would learn that the earlier protagonist is an adventurer who squanders his inheritance and eventually ends up in Bedlam, the notorious London asylum. For the final scene in Hockney's series, titled *Bedlam*, the institution is clearly referenced. In addition to the asylum's name being spelled out in the background, the artist seems to imply a kind of insanity in the actions of a robotic line of young men, numbed by the recorded music plugged into their ears.

Richard Hamilton similarly bases a series of etchings on an earlier work, James Joyce's *Ulysses*, a milestone of modernist literature that has occupied him since the late 1940s. At that time Hamilton drew a series of illustrations that would eventually serve as models for prints on this subject made since 1982. The artist has explained that "Joyce...was the exemplar that later gave me confidence

to try some unlikely associations in paint."[4] These "associations" were also made in aquatint, one of the intaglio processes more commonly called etching, under the tutelage of master printer Aldo Crommelynck. In *The transmogrifications of Bloom* (P. 229), Hamilton creates an introspective mindscape, which contrasts dramatically with the brash mediascapes he made in screenprint in the 1960s. Using his familiar collagelike aesthetic, Hamilton combines fragments to conjure up the main character's visit to a brothel, where he undergoes multiple transformations of role and even gender.[5] Soft, velvety aquatint surfaces, in shades of gray, create a mood of indeterminate space where actions fade in and out of cognition. While those familiar with Joyce's work will recognize similarities between Hamilton's structure and the experience of the writer's prose, one can also respond more generally to a sense of ongoing fragmentation likened to modern experience as a whole.

Lucian Freud, of the same generation as Hamilton, was broadly recognized outside Britain only in the 1980s and 1990s, even though he has been active since the late 1940s. Here, his etchings are related to those of Peter Howson, more than thirty-five years his junior and an artist who gained prominence as part of the international phenomenon of Neo-Expressionism. Both artists maintain a commitment to figural motifs and to portraiture, though for the most part outside the honorific conventions long established for this genre.

Etching is the only printmaking technique practiced by Freud. He worked with it early in his career, abandoned it for nearly forty years, and then returned to it in 1982. Since then he has employed the medium extensively, creating wiry, bristling lines that crisscross into mesmerizing webs to define his forms. As with his paintings, Freud's intricate etchings demand countless sittings from his subjects. Describing his method, he has said, "I take readings from a number of positions because I don't want to miss anything that could be of use to me."[6] In both *Large Head* and *Woman with an Arm Tattoo* (P. 230) the sitters appear to be sleeping, evidence of this long and arduous process. But their closed eyes also give the viewer a kind of permission to stare at these unusual people, to study their every curve and bulge. The artist dramatizes their startling presences by eliminating background details and emphasizing their silhouettes through bold, curving outlines. These examples, in fact, portray two of Freud's favorite models—Leigh Bowery, a performance artist who later died

of AIDS, and Sue Tilley, a benefits supervisor and friend of Bowery's. In both instances, it was their unusual body types that attracted the artist to them.

Howson gives specific titles to the etchings seen here, acknowledging the individuals who inspired them—*Bob*, *Ned*, and *Amanda* (P. 231). These are salty characters the artist observed at Saracen Head, a pub located in a run-down area of Glasgow, and drew from memory rather than from the long sittings Freud requires. Like Freud, however, Howson dramatizes his forms against backgrounds of little or no narrative detail. He captures essence by focusing on characteristic gestures and details: the proud thrust of a neck or tilt of a head, the ravages revealed in sunken cheeks, or the pugnacious profile that might have come from a broken nose. Howson's etched lines describe emaciated features, deeply wrinkled skin, or missing teeth that evoke old age or dissipation, but he also captures pride and dignity. He has said of the customers at the pub, "These are real people... I met some brilliant people there...I discovered you could make something heroic."[7] Going on to acknowledge a "tremendous energy" that attracted him, he says: "I always think these people are nearer to *salvation* than the suburban middle class...because they're *desperate*, they *want it*, you know?"[8]

Although of the same generation as Howson, Peter Doig, a painter, and Jake and Dinos Chapman, sculptors, tap into Surrealism and represent very different approaches in their art. For etchings, Doig chooses the aquatint technique for its ability to create tone rather than line, and for the way it can approximate the flow of painted surfaces. Aquatint also has a soft, blurry quality and a glow, particularly suited to the mysterious, dreamy effects he conjures in his strange narratives. Photographic sources may serve as Doig's compositional tools, but in *House of Pictures*, *Carrera*, and *Guest House* (P. 233) there is little to guide the viewer through specific story lines. Instead, we experience a vague sense of instability and are left to rely on our own imaginations and memories, set in motion by his ambiguous motifs.

The Chapman brothers are among the most notorious of the YBAs. Their work, usually taking the form of installations, is often a blatant affront to conventional taste and decorum. While Doig's Surrealist aesthetic creates an atmosphere of dreams, the Chapmans' work is decidedly in the realm of nightmares. Their frightening vision falls within a tradition established by Georges Bataille, a

Surrealist writer and theorist who reveled in negativity and transgression and focused his gaze on taboo subjects. The Chapmans follow suit with gruesome, nihilistic tableaux. Yet some details are also reminiscent of adolescent jokes, like the nose that becomes a penis on some of their figures. Describing their work, Jake Chapman has said: "It is not offering beneficence to the world. It is not claiming to make the world nicer."[9]

Many of the Chapmans' most celebrated sculptural works are based on a set of etchings by Francisco de Goya, *Disasters of War*. Comprising some of the most powerful and grotesque images in the history of art, Goya's series seems to have awakened in the Chapmans an interest in etching, a medium that now occupies a good deal of their time. In the print cycle *Exquisite Corpse* (P. 232) they exploit the technique's ability to create obsessive details from myriad tiny lines and scratches. The title refers to a Surrealist game of chance in which several people pass around a piece of paper, each drawing one part of what will ultimately be a complete figure. After the first person has drawn a head the paper is folded over to conceal it, with the next person drawing a chest that will be attached to a head he or she has not seen. Drawing and folding continues until the figure is complete. When the paper is unfolded, something entirely imaginary appears, representing, the Surrealists believed, unconscious thought revealed.

Using a similar process for their series, one Chapman brother drew a section of a body on an etching plate, then covered that section and turned the plate over to the other, and so on. The results are mutilated figures reminiscent of their sculptural works and taking the form of frightening underwater creatures or nightmarish monsters—hybrids of nature gone awry. The intoxicating detail in these works mesmerizes the viewer. Of the concentrated effects achieved with this medium, Dinos Chapman has said, "Etching is a very neurotic form. It allows for an incredible intensity."[10]

Legacy of Pop

Among the plethora of approaches to art in the contemporary period is one that immediately suggests the bold, brash iconography of Pop art. Michael Craig-Martin and Julian Opie, two artists whose work embodies this sensibility, often work in screenprint, as did many of the Pop generation. But they also turn to digital technology, representing yet another adaptation of a new medium for artistic expression. In a further twist recalling the 1960s,

Craig-Martin and Opie are both connected to publisher and gallery owner Alan Cristea, who also took part in the printmaking boom of the earlier period.

Craig-Martin was a teacher at Goldsmiths College, where Opie and many of the YBAs studied. Since Craig-Martin, a generation older than the YBAs, was trained in the 1960s, it is not surprising that he would be influenced by Pop art, and he also derived inspiration from Minimalism and Conceptualism. It was only in the late 1970s that he turned to the roster of images for which he is now well known and from which he creates drawings, murals, projections, and digital animations. He devises this imagery through computer manipulation of his own photographs and keeps a database of these everyday objects as a ready source for his art.

The series *Folio* (P. 238) depicts a typical array of Craig-Martin's objects in the clean, pared-down style and bright, opaque colors that give his work the eye-catching qualities of advertising. Craig-Martin likens these simplified images to those one might find in a children's book: "I think that the drawings of ordinary objects.... are just like primers. A for apple, B for book, T for table."[11] Devising these works, according to the artist, was like "creating a vocabulary, like you were learning to speak."[12] Here, he pairs designer products, like a fancy sneaker or a modernist lamp, with generic items. The pairings are usually puzzling and, with their arbitrary color combinations and dramatic shifts in scale, make for unsettling effects in what is otherwise a clear and precise vocabulary of forms. It is as if riddles are being laid out before us, tempting the viewer to find hidden subtexts.

Julian Opie adopts a similar aesthetic strategy in his simplified forms made up of precise lines and bold, flat colors. An artist who works in sculpture and installation, also adapting his imagery to billboards, CD covers, T-shirts, and other surfaces, Opie wholeheartedly embraces a visual language that emphasizes its digital simulation and celebrates a virtual reality that was barely known ten or so years ago. His stylized, immaculate world of landscapes, highways, people, and animals still seems like a futuristic dream of some brave new world. Is this a utopian ideal? Are we happy? Or is this a frightening manifestation of some kind of global alienation? Opie's work poses such questions while delivering its message in a language of quickly absorbed, logo-like signs.

Opie now completely depends on the computer to generate his art—ranging from printouts to animations—

keeping a database archive of available images. He has said, "Before, I used to think, draw and then make something. But now I can think and draw on the computer, continue to work it through....it can just stay in the computer and be outputted when I've decided what to do with it."[13] In fact, he says, "I do not actually physically make anything anymore, I just juggle with stuff on the telephone and the computer."[14]

Portraits make up one genre of imagery within Opie's overall practice. While they appear in any number of formats and contexts, at first glance they seem blandly identical, with their button eyes, and dots and dashes for nostrils and lips (PP. 240–41). While each manages to maintain some sense of individuality, enhanced by a title referring to the sitter's name and occupation, these portraits still seem as if they portray people who are related, members of a vast extended family. And, while this might be a somewhat sinister commentary on life in the computer age, Opie's faces are actually quite touching, and his work, overall, emits a sense of pleasure and fun.

Mapping

Maps, charts, diagrams, patterns, systems—these are all means of ordering the world, whether that world means tangible places or imaginary realms. By devising intricate structures, inventing complex scenarios, and developing overlapping narratives, artists allow us to lose and then find ourselves through their mapping strategies. They exploit an inherently abstract form with its own visual beauty and imbue it with messages that can both subvert expectations and expand upon them.

Digital technology provides Chad McCail with a tool to create scientific-looking charts that, at first glance, are reminiscent of those found in a doctor's office or a biology textbook. They are clear and easy to navigate, with bright but sanitized colors. While his overall vision is utopian—mankind in harmonious balance through love—McCail acknowledges the constant battle between such aspirations and the normal tensions and traumas of life. His messages in some works may be bleak, but in *Love is rooted in sharing and trust* (P. 239), the good triumphs over the bad. Here, McCail's faceless, futuristic, hieroglyphiclike creatures are endearing as they go about their routines of daily life: working, eating, having sex, emptying the garbage, etc.

In contrast, Paul Noble's minutely detailed creatures in *nobnest zed* (PP. 234–35), a wallpaper project, are hand-drawn

without the aid of a computer. They populate a fairy tale universe, involving everything from dragons to elephants to humanoids of diverse shape and form. The tale unfolds in storyboard format and, when the wallpaper is mounted, can fill an entire room. This environmental effect is similar to what Noble achieves with monumental drawings he has made for several years. Taken together, these drawings constitute a map charting a place Noble calls "Nobson Newtown"—a setting that is part utopian planning and part dystopic satire. Noble has explained that the imagery for *nobnest zed* came about in response to an invitation he received from *Nest*, an interior design magazine.[15] When asked to design a wallpaper product, he wanted to think about a particular room, and decided on a bedroom. The title of this piece refers to himself ("nob" for Noble), the magazine ("*Nest*"), and the letter z ("zed"), which conjures up sleep in cartoon language. Up close, Noble's dreamlike story is actually rather nightmarish, containing obscene acts and terrible predicaments, like being boiled alive. Dripping, oozing formations create the perfect backdrop for such goings-on, all of which fall within a fantasy tradition that extends from Hieronymus Bosch to the Surrealists.

Grayson Perry employs a similar strategy of revealing unexpected subjects when one examines his works carefully. Primarily a ceramist, Perry fashions classically shaped vases and urns and then decorates their surfaces with unconventional designs. His provocative subjects, which often have a critical edge, include sexuality, politics, and cultural mores. To this confrontational art he adds a personal style that also courts notoriety. For example, he likes to dress in women's clothes, and even accepted the vaunted Turner Prize wearing a fancy frock, with his wife and daughter smiling beside him. Despite his eccentricities, the artist has noted that it is difficult to shock people these days: "I think the art world had more trouble coming to terms with me being a potter than my choice of frocks."[16]

Perry's etched *Map of an Englishman* (P. 245) appears at first to be a charming antique map filled with tiny details that illuminate the distant past. As with his pots, a conventional armature onto which the artist slips his subversive messages, attentive inspection reveals instead that the map's seas and inlets, towns and castles bear highly unexpected names. In fact, Perry is following a seventeenth-century precedent called the Map of Tenderness.[17] While the earlier example charms us with

bays and hamlets called "Indifference," "Indiscretion," "Negligence," and "Mischief," Perry's twenty-first-century version reveals the contemporary condition. It locates waters named "Bipolar Disorder," "Anorexia Nervosa," and "Paranoia" and towns called "Machismo" and "Political Correctness," while still other locales are referred to as "Nose-Jobs" and "Botox."

Simon Patterson and the team of Langlands & Bell stay closer than Perry to geographic and celestial realities in projects seen here. Patterson's work generally explores systems of classification—from subway maps to periodic tables. In *Cosmic Wallpaper* (PP. 242–43) he chooses the constellations as a topic of inquiry, and continues his practice of dissecting the kinds of information we all take for granted without ever questioning their authoritative stances. This project fills the foyer of a university building, where one expects to be greeted by traditional subjects of learning designed for the edification of the student population. Instead, Patterson has superimposed a different body of knowledge over the well-known constellations. He gives us the history of Deep Purple, a pioneering British heavy metal band that emerged in the 1970s and became a "star" in its own right. The names of the band's members, records, and record labels populate Hydra, Pyxis, and Caelum, areas familiar to those who study the heavenly bodies. The beauty of the abstract patterns formed by Patterson's stars and demarcations of hemispheric areas, as well as by blue seas and pale land masses, speaks not only to those who love maps but also to those who are familiar with the abstract languages of Color Field painting and Minimalism.

The team of Langlands & Bell also takes full advantage of formal properties with their studies of architectural plans and aviation routes. They have said of their approach, "One's first encounter with a piece is with its physical nature, its formal and aesthetic characteristics....We don't start from a socio-political standpoint, maybe it's more socio-esthetic."[18] With their elegance, the webs and skeins of *Air Routes of the World (Day & Night)* (P. 244) are transporting in themselves, reconfiguring the messy world of reality into orderly patterns. Langlands & Bell adopt the strategies of Minimalism and infuse them with a Conceptualist program that offers a subtext to the initial experience of austere beauty. While the pair often explore the relationship of physical surroundings to behavior, here they fashion a more symbolic membrane

that becomes a defining apparatus as it ushers people around the globe.

Abstraction of a decidedly eerie sort resides in the patterning found in series by Rachel Whiteread and Mona Hatoum. Both produce compositions that contrast sharply with an idealized, geometric abstraction championed by early modernists, who sought harmony and order through their art. In their work we witness the disorderly and the imperfect aspects of life, expressed in evocative networks that become a kind of mapping, either by charting memories or recording moods.

In *Untitled (Nets)* (P. 248), Whiteread turns the fragility of old lace into the stiff rigidity of shiny metal by incorporating the etching plate as the basis of her composition. After drawing lace patterns onto their surfaces, she employed an industrial etching process to cut through the plates and make holes between the threads depicted in her drawings. She then matted these metal lace patterns as if they were conventional prints, creating works that "disorient the viewer by making what is familiar slightly strange."[19] The imperfections evident in these fragments declare their history but also suggest an inherent beauty in the vulnerabilities that are evidence of aging. One responds to these works as one would to an old garment found in an attic, discarded but still evocative.

Mona Hatoum's series of etchings *hair there and everywhere* (P. 249) seems at first to be made up of automatic drawings of the kind the Surrealists made to delineate their moods and reveal unconscious thoughts and desires. Such drawings are not unlike the casual doodles one makes while sitting in a meeting or talking on the phone. Some of Hatoum's compositions indicate a churned up anger, while others suggest a quiet restfulness. The title, however, reveals that these "drawings" actually derive from bunches of hair. That knowledge sets into motion a series of associations, like itchiness when strands of hair touch skin or the gagging sensation of hair caught in one's throat, that make this aesthetic abstraction vividly tangible. In addition, the feminine ideal embodied in one's crowning glory of hair is thoroughly dissipated.

Provocateurs

A provocative "bad boy" sensibility has been promoted by a string of artists in the contemporary period, beginning with shamanistic characters such as Yves Klein and Joseph Beuys and the transgressive Dieter Roth through to the audacious Martin Kippenberger. Artworks presenting confrontational content and made from unexpected materials, often coupled with an extravagant artistic personality, fostered these reputations. There is a particular British variation characterized by a sly humor and an attraction to taboo subjects that harks back to the political satire and critique of manners by figures such as William Hogarth and James Gillray. The team of Gilbert & George has carried on this subversive tradition since the 1970s, followed by artists such as David Shrigley and Adam Dant. These artists also share a passion for printed formats, often ephemeral in nature, as a means to communicate their droll, off-color sentiments.

Gilbert & George's beginnings were radical in a number of ways. Their collaborative approach, their uniform of conservative gray suits, and their open homosexuality were all subsumed in their art. In a complete fusion of art and life they attempted to make art for everyone; "Art for All" was an overarching concept they assigned to their merged home and studio, as well as the work they produced there. Their democratic approach extended to the artistic formats they chose, and editioned art—from magazine inserts to artists' books—played an important role in their overall aesthetic. In the late 1960s and early 1970s they were part of a growing trend among artists to bypass the gallery system and take charge of the distribution of their own work. They used Britain's Royal Mail as their communication network and, beginning in 1969, made printed works in small editions they called "postal sculptures." These were inspired by their keen interest in postcards, and comprised printed images and poetic texts on smallish pieces of thick paper, usually folded, signed, and mailed out to friends. Several, such as *The Limericks* (P. 252) from 1971, were issued in series.

The underbelly of human experience became the subject of much of their work, and in the early 1970s that focus resulted in imagery relating to the revelry and debauchery of drunkenness. A series of eight note cards, and their collective title, *The Pink Elephants* (P. 252), address this theme. ("Pink elephants" refer to the hallucinations that accompany alcohol abuse.) Individual captions such as *Bristol Cream*, *Dom Perignon*, and *London Dry* further allude to the artists' frequent state of inebriation. The accompanying short texts seem to spout from minds "under the influence" as well, reflecting authors in a state of bewilderment. In some, tender lines seem to point to despair and meaninglessness, while others are comical in their descriptions.

The work of David Shrigley also spits in the face of society's niceties and addresses taboo topics, including foul language, bathroom references, God, death, and other subjects not typically found on the walls of fine art galleries. His often hilarious books comprise comic book–style compilations of casual drawings and straightforward, witty texts, pinpointing the bleakness of one's current state of affairs or the disasters waiting around the corner. Referring to his texts, Shrigley has said, "It's a voice that lets me say a lot of things I can't say in real life."[20] Shrigley's messy handwriting, crossed out words, and awkwardly drawn figures conspire to create an endearing picture of the foibles and vulnerabilities, cruelties and injustices that populate everyday existence. Where Gilbert & George used limericks, Shrigley makes lists, diagrams, puzzles, and maps. In one of his early classic books, Err (P. 254), he highlights the idea that mistakes are inevitable, beginning with a list of complaints made about one of his prior books. His absurd observations of things that come in threes include "Old women from another planet" and "Water from the public baths bottled & sold." Other illustrated lists include different kinds of ashtrays and bodies of water, such as a "reservoir of dust."

Again reminiscent of Gilbert & George, Shrigley has consistently exploited the dissemination inherent in printed ephemera. After graduating from art school in the early 1990s, he made photocopied books. Now his many ephemeral projects include a London Underground map and newspaper inserts for the Guardian. Shrigley values these widely distributed formats because he can reach a large number of people. He said recently, "I like the democracy of it. Hopefully it means my work is accessible, which pleases me."[21] Recently he has begun to make more conventional prints as well, completing several etching portfolios and, in 2005, a boldly graphic series of woodcuts that poignantly communicates both humor and vulnerability (P. 255). The resistance offered by the woodcut medium appealed to him: "I liked the physicality of cutting the plates....It was very brutal and slightly haphazard, perhaps a little crude, which I think makes the images sit comfortably alongside my drawings."[22]

Adam Dant created an alter ego who embarks on various nonsensical and occasionally shady escapades in his photocopied pamphlet Donald Parsnips Daily Journal (P. 253). In this modest, eight-page publication the title character, depicted in glasses and striped hat, relates satirical scenarios, such as "How to Make a Failed Coup Attempt."

Bogus advertisements for sundry products occasionally appear as well. Alternately presented in comic book–style frames and larger full-page illustrations, the compositions are usually hand drawn with childlike script. The overall eccentricity and anarchist nature of the project, which lasted from 1995 to 1999, recall Elizabethan pamphlets of the sixteenth century—satirical, usually sensationalistic handouts that were distributed to pedestrians on the streets of London and elsewhere. Dant's pamphlets, which were similarly handed out but free of charge and came out daily, also appeared weekly in the London newspaper the Independent. His humorous, subversive publications raise questions about the systems of contemporary communication and the infrastructure of the art world while also spoofing the tradition of incendiary British tabloid journalism.

Damien Hirst, whose sculptures of dead and decaying animals of the early 1990s shocked the art world and public alike, is perhaps best known among contemporary British provocateurs. Unsavory subjects, such as death, drugs, and cigarettes, have been among Hirst's main preoccupations, and he has explored all of them in editioned mediums from multiples to books to wallpaper. The cover of his elaborate hybrid artist's book-cum-monograph, I Want to Spend the Rest of My Life Everywhere, with Everyone, One to One, Always, Forever, Now (P. 258), pictures a hospital X-ray room, followed by endpapers displaying the interior of an ambulance. The theme continues throughout the book, with images that include a morgue and a list of suicide instructions interspersed between chapters chronicling Hirst's major bodies of work. One section, devoted to his many artworks on the theme of cigarettes, opens with his remark, "The whole smoking thing is like a mini life cycle. For me the cigarette can stand for life. The packet with its possible cigarettes stands for birth. The lighter can signify God, which gives life to the whole situation. The ashtray represents death."[23] This theme has preoccupied him since the early 1990s and engendered several related multiples. Among these are a pack for Camel cigarettes and a 1996 plate screenprinted to look like a dirty ashtray by the luxury goods producer Swid Powell, and similar to his monumental ashtray sculpture of the prior year (P. 258).

Perhaps most dazzling of Hirst's printed works are his wallpaper projects. Related to his fixation on death is a keen interest in medical paraphernalia and pharmacology. He named his short-lived Notting Hill

restaurant Pharmacy and designed most of its decor, including barstools, matchbooks, and wallpaper (PP. 260–61), on that theme. Exploiting the decorative appeal of abstract shapes and color, Hirst patterned his wallpaper with minimalist rows of tablets, capsules, and bottles—similar to the structure of his numerous medicine cabinet sculptures—now printed on silver or bronze backgrounds. Like much of Hirst's art, the wallpaper has a strong graphic punch from a distance and a startling surprise up close when you discover the unsettling motif.

Hirst's fascination with themes of death and medical science helped to launch his career as the ringleader of the YBAs, many of whom exhibited work with equally disturbing imagery surrounding distorted and fragmented bodies. Sarah Lucas's sculpture challenges gender stereotypes with humorous and defiant juxtapositions of furniture and food, making crude references to sex and genitalia.[24] In 2000 she had an exhibition titled *The Fag Show* in which she displayed her own obsession with cigarettes, making various sculptures assembled from and adorned with row upon row of them. In certain works she has explored working class associations with smoking; in others, it is cigarettes' connection with sexual activity that particularly inspired Lucas. In her wallpaper *Tits in Space* (PP. 236–37), made for the same exhibition, Lucas transforms her everyday source material into a confrontational, if amusing, feminist jibe and exemplifies her fusion of bawdy humor, edgy commentary, and decorative strategies.

Vanguard Books and Multiples

In recent years the impact of artists' books has grown immeasurably as artists have broadened the definition of artists' publications in general. As editor and book historian Cornelia Lauf has pointed out, "The number of projects published by artists is at an all-time high.... whether it is a 'conventional' artist's book, a hybrid catalogue, or fashion collections book designed by an artist, the book format is arguably the most useful device to chart the changes in artistic intention over the last fifteen years."[25] Artists' books have a particularly long tradition in England, distinguished by the work of brilliant innovators such as William Blake in the eighteenth century and William Morris in the nineteenth century, among many others. In the contemporary period, alongside the experimental approaches of Conceptual figures, such as Richard Long and Hamish Fulton discussed earlier

in this volume, several artists have explored the sequential format of the book to create visual narratives with strong cinematic impact. Most notable in this field are Telfer Stokes and Helen Douglas, who worked together as well as individually for many years under their own imprint, Weproductions, established by Stokes in 1971. (Douglas joined him in 1974.) Self-publishing has gained in popularity in the contemporary period as artists have sought to retain control of their productions and bypass the market-driven system. Other British ventures, from Ian Hamilton Finlay's Wild Hawthorn Press to David Shrigley's Armpit Press and Fiona Banner's Vanity Press, have followed a similar approach.

The majority of Stokes's and Douglas's books are photographic and offset printed as large-edition paperbacks. Stokes's first book, *Passage* (P. 250), exemplifies his early filmic approach. In his early books he typically chose everyday items whose scale fit appropriately on the page; in this case, one of his images is a piece of bread. Spreads of the book depict an open face sandwich. In a brilliant use of the codex format, the sandwich appears to be spread with jam, shut, and pried open again for respreading as the reader turns the pages. In a recent example by Douglas from 1999, titled *Wild Wood* (P. 251), photographs of the woods from around her Scottish home appear in beautiful allover spreads of tangled branches and underbrush. Imbued with a magical sense of enchantment, the book conjures up the historic legacy of the woods where the artist's ancestors from the fourteenth and fifteenth centuries once lived. Turning the pages simulates a journey through this romantic wild landscape. Clive Phillpot succinctly summarized Stokes's and Douglas's cinematic style, describing their work as "a virtually new genre of book, in which the mechanics of the codex form have been analysed and put into service to structure extended visual and verbal experiences that become the equivalent of filmic poetry."[26]

Many of Fiona Banner's books come quite literally from film. In her monumental book *The Nam* (P. 246) she describes in her own words the plots of six films based on the Vietnam War: *Apocalypse Now*, *Born on the Fourth of July*, *Full Metal Jacket*, *Platoon*, *Hamburger Hill*, and *The Deer Hunter*. With no paragraph breaks, page numbers, or chapter divisions, the 1,000-page book becomes a narrated mantra on violence and the media's interpretation of it. The dense, hefty work has a distinct sculptural quality as well, and Banner has often displayed it in stacks,

its vibrant red on blue cover serving as graphic entice-ment into an incomprehensible and unreadable deadpan description of horror. Similarly, in her print *Break Point* (P. 247) Banner describes the car chase scene in the cult film *Point Break*. She metaphorically composes the red wordscape, as these works are known, positioning the words and lines closer and closer together until the words virtually run into each other in sync with the final crash of the film's climax.

Other artists have followed more Conceptual approaches to bookmaking, and the medium has expanded to include the artist-designed exhibition catalogue, a phenom-enon begun with the inventive series of boxes known as *Kassettenkatalog* (P. 104). Lauf recently discussed this development, commenting that "contemporary art-ists are usurping the traditional role of the art histo-rian by taking an active role in the construction of their own histories."[27] The artist-designed catalogue has blossomed into an entire subgenre of artists' books, including those by Liam Gillick. Gillick's work encom-passes a variety of book formats, from novels to deluxe *livres d'artistes*. Several, including *The Book of the 3rd of June* (P. 257), function as catalogues. Accompanying an exhibi-tion of his work in Japan, this artful paperback presents a retrospective of sorts, with pages depicting proposals for various installations and public art projects from Kalmar, Sweden, to Leipzig. Interspersed with graphic texts, ranging from suggestive political commentaries such as "espionage and subversion in an industrial soci-ety" to cryptic descriptive settings such as "a person alone in a room with Coca-Cola colored walls," the book alter-nates between a catalogue of reproductions and an inte-grated conception of text and images. The book also pre-views a new text of Gillick's called *Literally No Place*, which spawned a multiple of the same name in 2001 (P. 257) as well as an artist's book project in 2002 and several sculp-tures. Speaking of his books, Gillick recently commented, "I consider all of these to be artworks that have equal weight with any other object I might produce. The key is their different 'exchange value' and the fact that they can be easily distributed."[28]

Jonathan Monk sees himself as a second-generation Conceptual artist, adding a personal touch to the rigor of the systemic approaches followed by figures such as Sol LeWitt and Robert Morris. And, like LeWitt, he is a book enthusiast, counting a substantial collection of LeWitt's artists' books among his considerable holdings.[29] But Monk inflects his books with a sense of humor as he models his work on the older artists he admires. In the book 2 (P. 257), for example, he attempts to organize a rigid photographic inventory, much like the classic art-ists' books of the 1960s by Edward Ruscha and Christian Boltanski. Monk gave cameras to two of his uncles, one in Leicester and one in Stuttgart, instructing them to photo-graph their respective dogs during the course of their daily routines. Pages of abrupt juxtapositions from these two series of images comprise this amusing book. Monk has worked with some of the most progressive artist's book publishers, including Revolver Books in Frankfurt and Book Works in London.

Book Works, a nonprofit organization dedicated for nearly twenty years to publishing inexpensive artists' books and writings, has issued works by some of Britain's most interesting vanguard artists, including Tacita Dean, David Shrigley, Gillick, and Monk. It has also collaborated with the visionary sculptor Paul Etienne Lincoln. His unusual artist's book *The World and Its Inhabitants* (P. 256), comprises a boxed set of twenty-four cards, each bearing a photographic depiction of a strange, hybrid mechani-cal "character." Mostly named for historical figures, each character's card includes a biographical description on the back. This fantastic collection,[30] is based on a series of actual miniature moving sculptures that Lincoln has been working on since 1981. Describing the inspi-ration behind the project in an accompanying booklet, Lincoln has written, "It was always intended as a very intimate, ritualistic form of 18th-century parlour activ-ity....The assembled personalities form an idealised world where history has been plucked from its source and re-presented...with a wit and sarcasm thrown into a cauldron fit for the likes of Gillray and Cruikshank,"[31] The card set functions as a rearrangeable catalogue of these absurd, circus-like inventions. Lincoln also works in multiples, crafting poetic relics from some of his more elaborate installations, such as his romantic *In Tribute to Madame de Pompadour and the Court of Louis XV (Perfume Set)* (P. 256). This box contains glass vials of perfume and honey and a cascading flow chart illustrating the complex chain reactions of the installation's performance, during which live bees and snails produced the queen's actual perfume in this mock-up of royal Versailles.

Several other artists of Lincoln's generation have cre-ated haunting multiples that evoke issues of history and memory. Gillian Wearing and Rachel Whiteread are

both associated with the provocative YBAs. Wearing is primarily a photographer and video artist whose work examines the social behavior of ordinary people. Among her most compelling works are vignettes of some of society's offbeat and forgotten—alcoholics, the homeless, children. Masks play an important role in Wearing's work, providing a false persona, which ironically allows people to reveal more about their true selves. Wearing also makes riveting self-portraits, which aim to expose the facades we construct to protect ourselves against the emotional confusions of everyday life. In a project for the journal *Parkett* in 2004, *Sleeping Mask* (P. 259), Wearing created a wax and resin multiple of her own face, presented with an idealized, blank expression, composed in a seemingly restful sleep.[32] In spite of its title, however, the piece resembles a death mask, with eyes and lips tightly sealed, and conveys an eerie and poignant sense of a tragically young memento mori.

Similarly, Rachel Whiteread's casts of the empty spaces inside and around buildings, rooms, and everyday domestic objects seek to memorialize the mundane. Her negative imprints function as fossil-like reminders of past events and forgotten sites. Her multiples, like Wearing's and Lincoln's, embody jewellike memories that emit a mysterious and magical aura. *Doorknob* (P. 259) relates to a commission Whiteread made for the Deutsche Guggenheim in Berlin, which included two casts from her new London home and studio. Intrigued by the generic architecture that characterized much of the rapidly built housing of the immediate postwar years in Europe, Whiteread bought a languishing warehouse building that had previously housed a synagogue. Commenting on the building's varying history, she has remarked, "I'm interested in the layering in buildings, and the traces that are left behind by the change of use of places. My work is really about the strange kind of architecture that cropped up during the postwar years."[33] *Doorknob* was also cast from this new studio, and its unadorned shape reflects the building's nondescript architecture.

The Deutsche Guggenheim has published a series of multiples in conjunction with their exhibitions, numbering thirty-five to date, and represents one of several imaginative initiatives in the contemporary publishing of multiples. In England, several fostered a lively interest in contemporary multiples, including Sarah Lucas's and Tracey Emin's short-lived The Shop, and Sarah Staton's Supastore. One of the more established organizations is The Multiple Store, a nonprofit venture set up in 1998 that actively commissions work by contemporary British artists. Recent studies surveying this field have also focused on the British contribution to this medium, invented in the 1960s and continuing to thrive in contemporary artistic thinking.

Notes

1 For further information on the new British art, see Richard Flood, *Brilliant! New Art from London* (Minneapolis: Walker Art Center, 1996); and Laurence Bossé and Hans-Ulrich Obrist, *Life/Live: La Scène artistique au Royaume-Uni en 1996, de nouvelles aventures*, 2 vols. (Paris: Musée d'Art Moderne de la Ville de Paris, 1996).

2 Grayson Perry, "Grayson Perry: Joseph Beuys," *Times Online*, April 29, 2006, http://entertainment.timesonline.co.uk/article/0,,29269-2154650.html.

3 For a detailed discussion that compares and contrasts Hogarth's tale with Hockney's series, see James A. W. Heffernan, "Hockney Rewrites Hogarth: A Gay Rake Progresses to America," *Art on Paper* 4, no. 2 (November–December 1999): 56–61, 103.

4 Richard Hamilton, *In Horne's House: An illustration for the 'Oxen in the Sun' episode of James Joyce's* Ulysses (London: Waddington Galleries, n.d.), n.p.

5 For a thorough discussion of Hamilton's prints based on *Ulysses*, see Stephen Coppel, *Richard Hamilton: Imaging James Joyce's* Ulysses (London: The British Council, 2001).

6 Freud, quoted in Scott Wilcox, "Between Fact and Truth: Lucian Freud's Printmaking," in *Lucian Freud: Etchings from the Paine Webber Art Collection* (New Haven, Conn.: Yale Center for British Art, 1999), p. 58.

7 Howson, quoted in Steven Berkoff, "Profile Peter Howson: The Best of Times, the Worst of Times," *State of Art* (Winter 2005): 15.

8 Ibid. Artist's emphasis.

9 Jake Chapman, quoted in Ana Finel Honigman, "Difficulty Is Good: A Conversation with Dinos and Jake Chapman," *Sculpture* 22, no. 6 (July–August 2003): 42.

10 Dinos Chapman, quoted in Patrick Elliott, "Jake and Dinos Chapman Exquisite Corpse, 2000," in *Contemporary Art in Print: the Publications of Charles Booth-Clibborn and His Imprint The Paragon Press 1995–2000*, ed. Patrick Elliott (London: Booth-Clibborn Editions, 2001), p. 329.

11 Craig-Martin, quoted in Marco Livingstone, "Deconstructing Michael: Making Connections," in *Michael Craig-Martin: Prints* (London: Alan Cristea Gallery, 2004), p. 5.

12 Ibid.

13 Opie, quoted in Mary Horlock, *JO: Julian Opie* (London: Tate Publishing, 2004), p. 87.

14 Opie, quoted in Louisa Buck, "Logo People," *Art Newspaper* 12, no. 111 (February 2001): 37.

15 Paul Noble, telephone conversation, May 2006.

16 Perry, quoted in "Transvestite potter wins Turner" *BBC News*, December 7, 2003, http://news.bbc.co.uk/1/hi/entertainment/arts/3298707.stm.

17 See *The Map of Tenderness*, frontispiece to Madeleine de Scudéry's novel *Clelia, an Excellent New Romance*, 1654–60 (English edition published in London, 1678), illustrated in Robert Storr, *Mapping* (New York: The Museum of Modern Art, 1994), p. 13.

18 Langlands & Bell, "Interview with the Artists," in *Langlands & Bell*, ed. Hans-Michael Herzog, et al. (London: Serpentine Gallery, 1996), p. 132.

19 Whiteread, quoted in Beryl Wright, *Options 46: Rachel Whiteread* (Chicago: Museum of Contemporary Art, 1993), n.p.

20 Shrigley, quoted in Jim Medway, "Words," *Flux*, no. 20 (August–September 2000): 86.

21 David Shrigley, e-mail correspondence, May 2006.

22 Ibid.

23 Damien Hirst, *I Want to Spend the Rest of My Life Everywhere, with Everyone, One to One, Always, Forever, Now* (London: Booth-Clibborn Editions; New York: The Monacelli Press, 1997), p. 102.

24 Among Lucas's most inventive multiple projects is a series of editioned cakes, published in 2001 by Counter Editions, London. Counter Editions, which arose with the outburst of activity in contemporary British art, started as an online publisher of relatively inexpensive prints and multiples, aimed at a broad audience. It now includes a gallery location.

25 Cornelia Lauf, "Cracked Spines and Slipped Disks," in Cornelia Lauf and Clive Phillpot, *Artist/Author: Contemporary Artists' Books* (New York: D.A.P./Distributed Art Publishers, 1998), p. 67.

26 Clive Phillpot, "Weproductions," *0.6 Weproductions* (exhibition brochure) (Dundee, Scotland: VRC Centre for Artists' Books, 2000). For a full reprint of this text, see www.vrc.dundee.ac.uk/CAB/pdf/Weproductions_essay.pdf.

27 Lauf, "Cracked Spines and Slipped Disks," p. 69.

28 Liam Gillick, e-mail correspondence, May 2006.

29 Telephone conversation with Clare Coombes, Lisson Gallery, London, May 2006.

30 For a discussion of this collection in relationship to Surrealist Raymond Roussel, see Claudia Banz, "Why Is the Bear Being Milked? Metaphysical Tricks and Artful Science," in Claudia Banz, Katy Siegel, and Paul Etienne Lincoln, *The Metropolis of Metaphorical Intimations* (Berlin: Staatliche Museen zu Berlin; Cologne: Walther König, 2003), pp. 5–21.

31 Paul Etienne Lincoln, "The World and Its Inhabitants 1981–1997," in *The World and Its Inhabitants* (London: Book Works, 1997), n.p.

32 Wearing cast her face at London's Madame Tussauds wax museum. Telephone conversation with Monika Condrea, Parkett, New York, June 2006.

33 Rachel Whiteread, "If Walls Could Talk: An Interview with Rachel Whiteread," by Craig Houser, in *Rachel Whiteread Transient Spaces* (New York: The Solomon R. Guggenheim Foundation, 2001), p. 48.

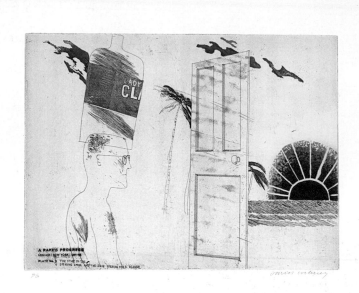

David Hockney

[BRITISH, born 1937]

**The Start of the Spending Spree and
the Door Opening for a Blonde** and
Bedlam from **A Rake's Progress**, 1963
Two from a portfolio of sixteen etching
and aquatints

SHEET: 19 11/16 x 24 5/8" (50 x 62.5 cm)
PUBLISHER: Editions Alecto, London,
in association with The Royal College of Art,
London
PRINTER: C. H. Welch, London
EDITION: 50

The Museum of Modern Art, New York.
Mr. and Mrs. Ralph F. Colin Fund,
Leon A. Mnuchin Fund, and Joanne M. Stern
Fund, 1964

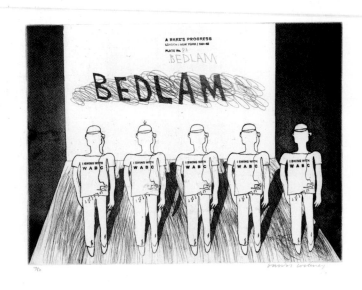

Richard Hamilton

[BRITISH, born 1922]

The transmogrifications of Bloom,
1984–85
Etching and aquatint

SHEET: 29 15/16 X 22 5/16" (76 x 56.7 cm)
PUBLISHER: Waddington Graphics, London
PRINTER: Atelier Crommelynck, Paris
EDITION: 120

The Museum of Modern Art, New York.
Riva Castleman Fund, 1993

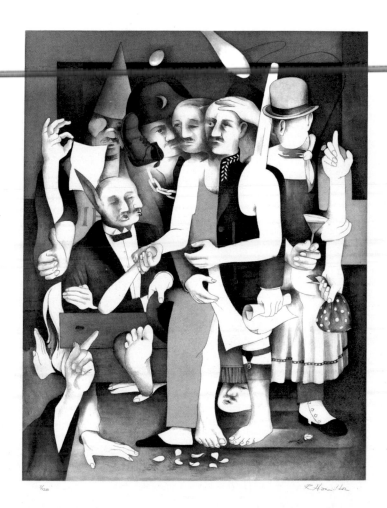

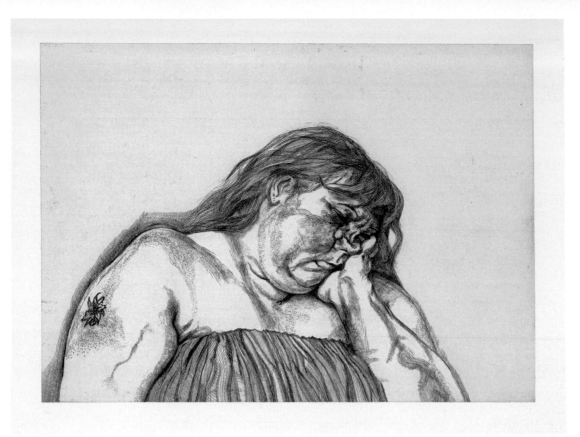

Lucian Freud

[BRITISH, born Germany, 1922]

Woman with an Arm Tattoo, 1996
Etching

SHEET: 27 9/16 x 36 1/8" (70 x 91.7 cm)
PUBLISHER: Matthew Marks Gallery, New York
PRINTER: Studio Prints, London
EDITION: 40

The Museum of Modern Art, New York.
Jacqueline Brody Fund, Scott Sassa Fund,
and Roxanne H. Frank Fund, 2002

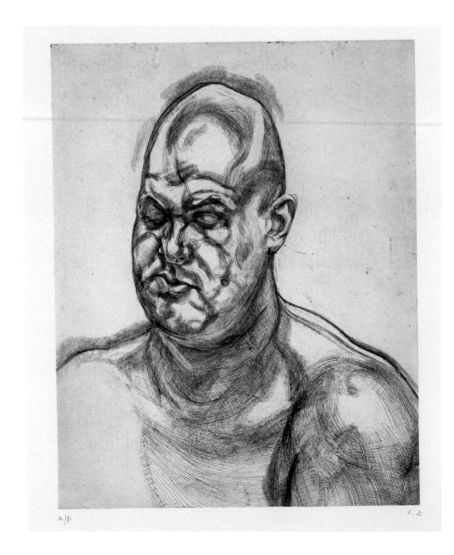

Large Head, 1993
Etching

SHEET: 31 1/4 x 25" (79.4 x 63.5 cm)
PUBLISHER: Matthew Marks Gallery, New York
PRINTER: Studio Prints, London
EDITION: 40

The Museum of Modern Art, New York.
Mrs. Akio Morita Fund, 1995

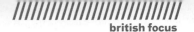

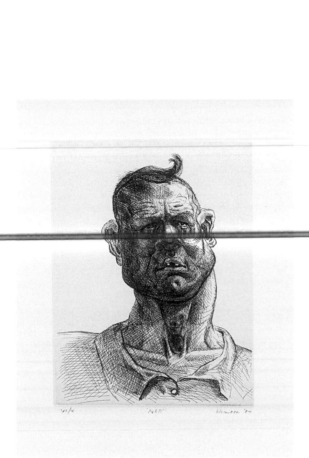

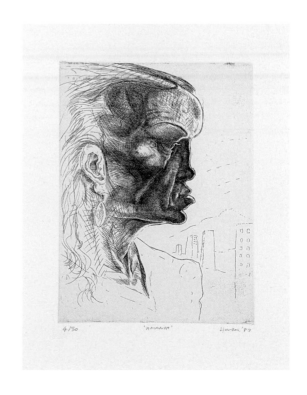

Peter Howson
[BRITISH, born 1958]

top to bottom:

Bob, **Ned**, and **Amanda** from
Saracen Heads, 1987 (published 1988)
Three from a series of twenty-five
etchings

PLATE (APPROX.): 13 x 9 5/8" (33 x 24.5 cm)
PUBLISHER: Flowers Graphics, London
PRINTER: Printmakers Workshop, Edinburgh
EDITION: 30

Courtesy Flowers Graphics, London

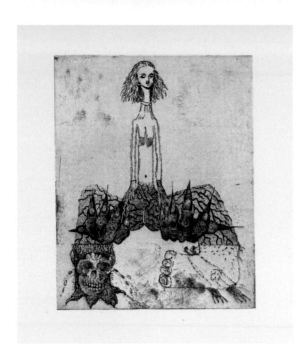

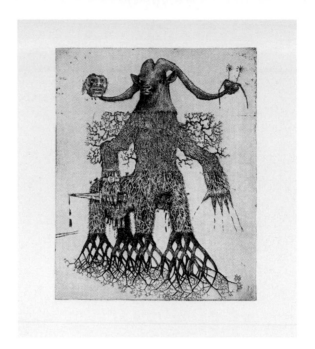

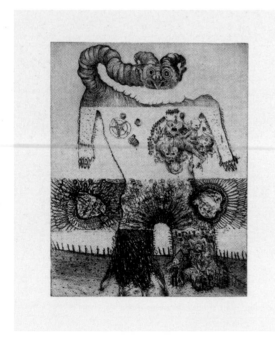

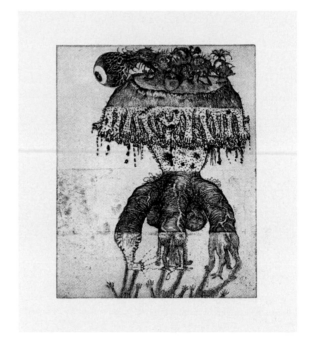

Jake and Dinos Chapman
Jake Chapman [BRITISH, born 1966]
Dinos Chapman [BRITISH, born 1962]

Exquisite Corpse, 2000
Four from a portfolio of twenty etchings

PLATE: 9^1/$_{16}$ x 7^1/$_{16}$" (23 x 18 cm)
PUBLISHER: The Paragon Press, London
PRINTER: Hope (Sufferance) Press, London
EDITION: 30

The Museum of Modern Art, New York.
Roxanne H. Frank Fund, 2000

Peter Doig

[BRITISH, born 1959]

House of Pictures, 2002
Aquatint and drypoint
PLATE: 9 1/2 X 14 1/2" (24.1 X 36.8 cm)
PUBLISHER AND PRINTER: Crown Point Press,
San Francisco
EDITION: 25

Fine Arts Museums of San Francisco,
Crown Point Press Archive, gift of
Crown Point Press

Carrera, 2002
Aquatint and etching
PLATE: 9 1/2 X 14 1/2" (24.1 X 36.8 cm)
PUBLISHER AND PRINTER: Crown Point Press,
San Francisco
EDITION: 25

Fine Arts Museums of San Francisco,
Crown Point Press Archive, gift of
Crown Point Press

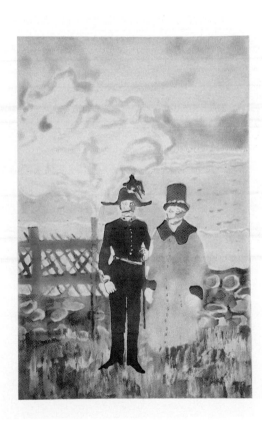

Guest House, 2002
Aquatint and drypoint
PLATE: 15 1/2 X 10" (39.4 X 25.4 cm)
PUBLISHER AND PRINTER:
Crown Point Press, San Francisco
EDITION: 25
Fine Arts Museums of San Francisco,
Crown Point Press Archive, gift of
Crown Point Press

following spread

Paul Noble

[BRITISH, born 1963]

nobnest zed, 2002
Wallpaper for the journal *nest*
DIMENSIONS: variable
PUBLISHER: Nest, New York
EDITION: mass produced

The Museum of Modern Art, New York.
Linda Barth Goldstein Fund, 2003

233

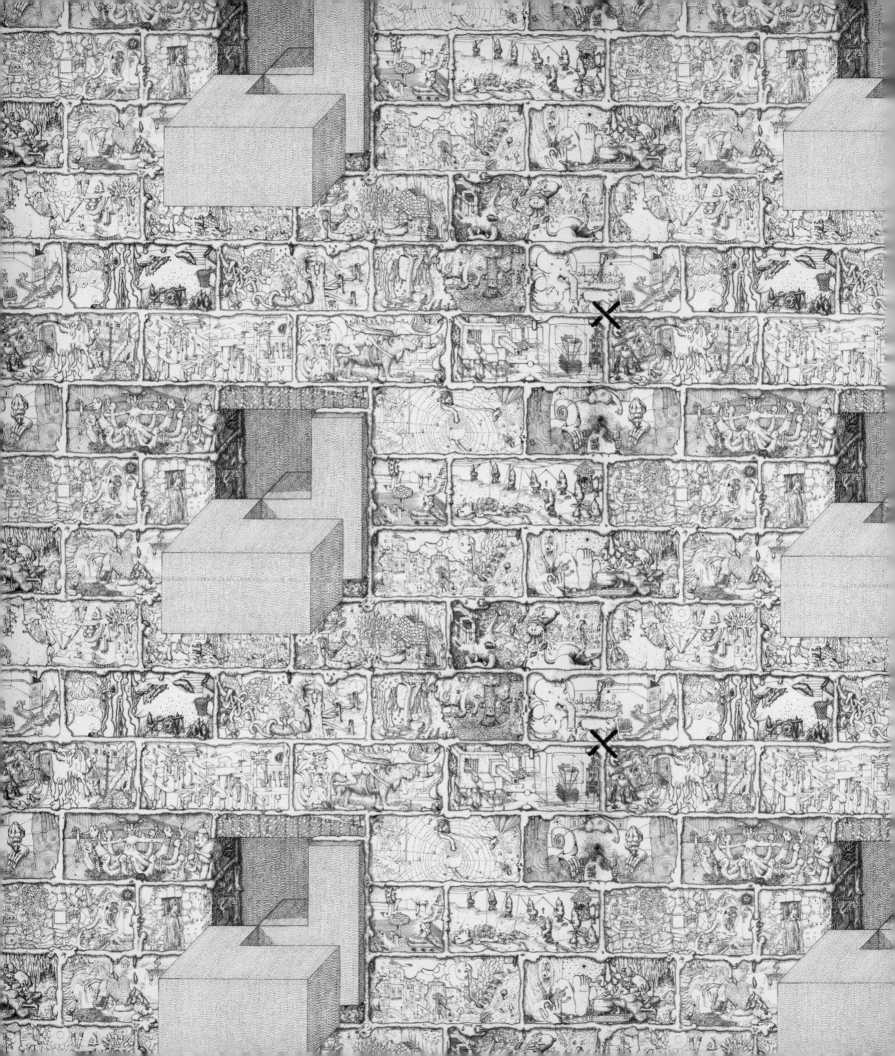

previous spread

Sarah Lucas
[BRITISH, born 1962]

Tits in Space, 2000
Wallpaper

DIMENSIONS: variable
PUBLISHER: Gladstone Gallery, New York,
and Sadie Coles HQ, London
EDITION: not editioned

Courtesy the artist, Gladstone Gallery,
New York, and Sadie Coles HQ, London

Michael Craig-Martin
[BRITISH, born 1941]

Folio, 2004
Four from a portfolio of twelve
screenprints

SHEET: 12⁷/₈ X 39³/₈" (32.7 X 100 cm)
PUBLISHER: Alan Cristea Gallery, London
PRINTER: Advanced Graphics London
EDITION: 40

The Museum of Modern Art, New York.
Virginia Cowles Schroth Fund, 2006

Chad McCail

[BRITISH, born 1961]

Love is rooted in sharing and trust
from **Life is driven by the desire for pleasure**, 2001–02
One from a series of twenty-one
digital prints

SHEET: 6' 2³/₈" x 50¹/₄" (188.9 x 127.7 cm)
PUBLISHER: the artist, Thankerton, England
PRINTER: Cova DPI, Edinburgh
EDITION: 3

The Museum of Modern Art, New York.
The Associates Fund, 2006

following spread

Julian Opie
[BRITISH, born 1958]

**Elena, schoolgirl
(with lotus blossom)**, 2002
Wallpaper

DIMENSIONS: variable
PUBLISHER: the artist, London
EDITION: unique

Courtesy the artist, Lisson Gallery, and
Alan Cristea Gallery, London

Untitled, 1996–present
Ephemera, including T-shirts, stickers,
shopping bag, postcards, magnets, book
covers, CD covers, artist's book, and LP
cover

DIMENSIONS: variable
PUBLISHER: various
EDITION: various

The Museum of Modern Art, New York.
Gift of the artist and Alan Cristea Gallery,
London, 2006

Simon Patterson
[BRITISH, born 1967]

Cosmic Wallpaper, 2002
Wallpaper, installation at the University
of Warwick, England

DIMENSIONS: 21' 7 13/16" x 61' 8 1/8" (6.6 x 18.8 m)
EDITION: not editioned

Commissioned by The Contemporary Art Society,
special collection scheme with funds from the Arts
Council Lottery Fund on behalf of Mead Gallery,
University of Warwick, England.

Courtesy the artist

opposite page

Langlands & Bell

Ben Langlands [BRITISH, born 1955]
Nikki Bell [BRITISH, born 1959]

Air Routes of the World (Day & Night), 2001
Two screenprints
SHEET (EACH): 33 1/16 x 56 9/16" (83.9 x 143.7 cm)
PUBLISHER: Alan Cristea Gallery, London
PRINTER: Advanced Graphics London
EDITION: 45

The Museum of Modern Art, New York.
Miranda Kaiser Fund, 2005

Grayson Perry

[BRITISH, born 1960]

Map of an Englishman, 2004
Etching
SHEET: 44 1/8 x 59 1/16" (112.1 x 150 cm)
PUBLISHER: The Paragon Press, London
PRINTER: Stoneman Graphics, Cornwall, England
EDITION: 50

The Museum of Modern Art, New York.
Patricia P. Irgens Larsen Foundation Fund, 2005

245

Fiona Banner

[BRITISH, born 1966]

The Nam, 1997
Artist's book

PAGE: 11 x 7 15/16" (27.9 x 20.2 cm)
PUBLISHER: Frith Street Books, London
EDITION: 1,000

The Museum of Modern Art, New York.
Linda Barth Goldstein Fund, 1999

Table Stops, 2000
Multiple of glazed ceramic

OVERALL: 11 13/16 x 11 13/16 x 6 5/16" (30 x 30 x 16 cm)
PUBLISHER: The Multiple Store, London
EDITION: 100

The Museum of Modern Art, New York.
Mary Ellen Oldenburg Fund, 2006

All the World's Fighter Planes, 2004
Artist's book

PAGE: 8 7/16 x 6 5/16" (21.5 x 16 cm)
PUBLISHER: The Vanity Press, London
EDITION: 500

The Museum of Modern Art, New York.
Mary Ellen Oldenburg Fund, 2006

Break Point, 1998
Screenprint

SHEET: 71⁵/₈" x 8' 1¹/₈" (182 x 246.7 cm)
PUBLISHER: Frith Street Gallery, London
PRINTER: Wallis Screenprint, Kent, England
EDITION: 10

The Museum of Modern Art, New York.
Linda Barth Goldstein Fund, 1999

Rachel Whiteread

[BRITISH, born 1963]

Untitled (Nets), 2002
Two from a series of five etched
metal sheets

MOUNT (APPROX.): 25⁹/₁₆ X 20¹/₂" (65 X 52.1 cm)
PUBLISHER: Edition Schellmann, Munich
and New York
EDITION: 36

The Museum of Modern Art, New York.
General Print Fund, 2003

Mona Hatoum

[BRITISH OF PALESTINIAN ORIGIN, born Lebanon, 1952]

hair there and every where, 2004
Four from a portfolio of ten etchings

SHEET: 16 x 14" (40.6 x 35.6 cm)
PUBLISHER AND PRINTER: Edition Jacob Samuel,
Santa Monica
EDITION: 20

The Museum of Modern Art, New York.
Carol and Morton H. Rapp Fund, 2004

249

Telfer Stokes

[BRITISH, born 1940]

BECOME, 2000
Artist's book
PAGE: 7 9/16 x 5 9/16" (19.2 x 14.2 cm)
PUBLISHER: Weproductions, Yarrow, Scotland
EDITION: 1,000
The Museum of Modern Art Library,
New York

Passage, 1972
Artist's book
PAGE: 7 x 4 3/16" (17.8 x 10.7 cm)
PUBLISHER: Weproductions, London
EDITION: 1,000
The Museum of Modern Art Library,
New York

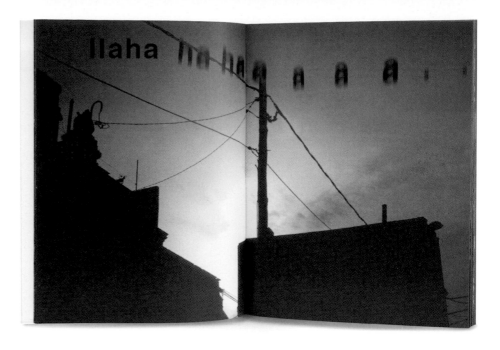

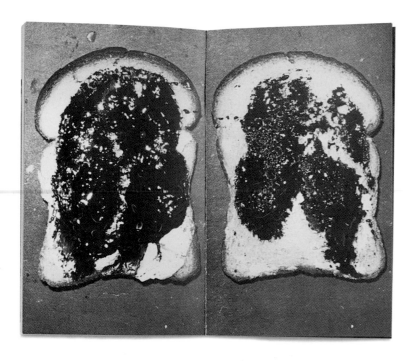

Helen Douglas and Telfer Stokes

Loophole, 1975
Artist's book
PAGE: 7 x 4 1/8" (17.8 x 10.4 cm)
PUBLISHER: Weproductions, London
EDITION: 1,000
The Museum of Modern Art Library,
New York

Helen Douglas

[BRITISH, born 1952]

Wild Wood, 1999
Artist's book
PAGE: 6 1/16 X 4 3/8" (15.4 X 11.1 cm)
PUBLISHER: Weproductions, Yarrow, Scotland
EDITION: 1,000

The Museum of Modern Art Library,
New York

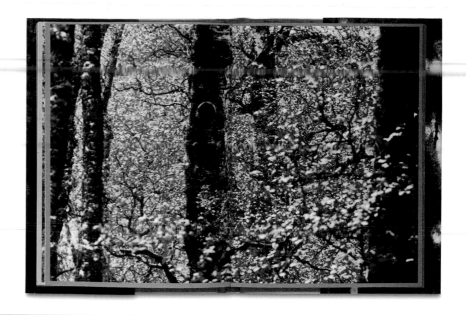

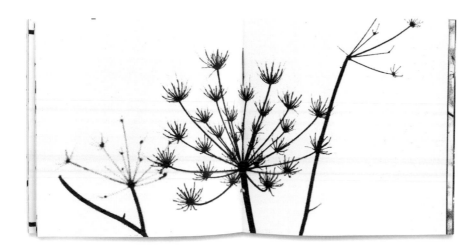

Between the Two, 1997
Artist's book
PAGE: 5 1/4 X 5 3/16" (13.3 X 13.2 cm)
PUBLISHER: Weproductions, Yarrow, Scotland
EDITION: 1,000

The Museum of Modern Art Library,
New York

Unravelling the Ripple, 2001
Artist's book
PAGE: 6 11/16 X 4 11/16" (17 X 11.9 cm)
PUBLISHER: Pocketbooks, Edinburgh
EDITION: 2,750

The Museum of Modern Art Library,
New York

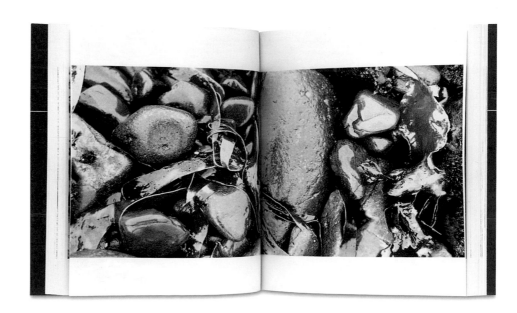

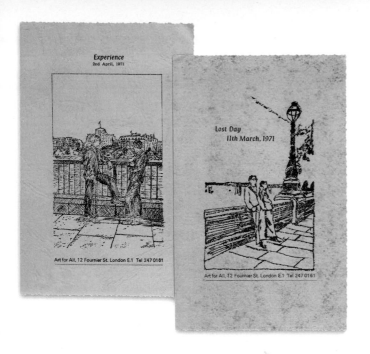

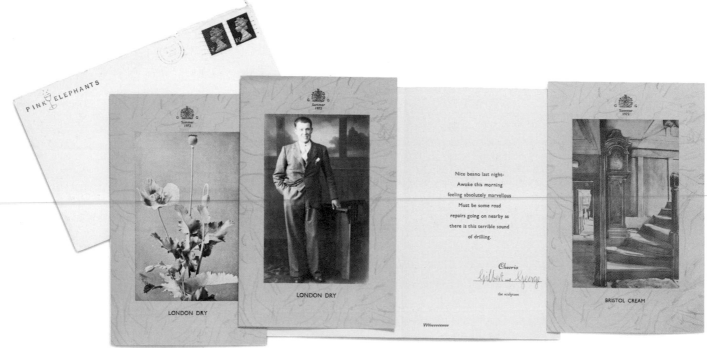

Gilbert & George

Gilbert Proesch [BRITISH, born Italy, 1943]
George Passmore [BRITISH, born 1942]

Experience: 2nd April, 1971 and
Lost day: 11th March, 1971 from the
series **The Limericks**, 1971
Mailer

SHEET: 7¹⁵/₁₆ x 5" (20.2 x 12.7 cm)

**May we describe to you with picture
and words a sculpture which began on
the last Saterday [sic] in November of
'69...**, 1970
Mailer

SHEET: 7¹⁵/₁₆ x 6¹¹/₁₆" (20.2 x 17 cm)

**London Dry ("Felt a trifle queer last
night..."), London Dry ("We dropped
by..."), Bristol Cream ("Nice beano
last night..."),** and **Bristol Cream
("Went up to the bar..."),** from the
series **The Pink Elephants**, 1973
Mailer

SHEET: 8 x 4¹³/₁₆" (20.3 x 12.2 cm)
PUBLISHER: Art for All, London
EDITION: unknown

The Museum of Modern Art Library,
New York

Adam Dant

[BRITISH, born 1967]

Donald Parsnips Daily Journal, 1995–99
Pamphlet

PAGE (APPROX.): 5⁷/₈ x 4¹/₈" (14.9 x 10.4 cm)
PUBLISHER: the artist, London
EDITION: approx. 50

The Museum of Modern Art, New York.
Gift of the artist and Adam Baumgold Gallery,
2006

253

TO MAKE MERINGUE YOU MUST BEAT THE EGG WHITES UNTIL THEY LOOK LIKE THIS;

opposite page

Untitled, 2005
Four from a portfolio of twenty-two woodcuts
SHEET: 23 9/16 X 15 11/16" (59.8 x 39.9 cm)
PUBLISHER: Galleri Nicolai Wallner, Copenhagen
PRINTER: Schaefer Grafiske Vaerksted, Copenhagen
EDITION: 20
The Museum of Modern Art, New York. The Associates Fund, 2006

David Shrigley

[BRITISH, born 1968]

To Make Meringue You Must Beat the Egg Whites Until They Look Like This, 1998
Artist's book

PAGE: 9 7/16 X 8 1/8" (24 x 20.7 cm)
PUBLISHER: Galleri Nicolai Wallner, Copenhagen
EDITION: 2,000
The Museum of Modern Art, New York. Anonymously given, 2002

Leotard, 2003
Artist's book
PAGE: 11 11/16 X 8 7/16" (29.7 x 21.5 cm)
PUBLISHER: BQ, Cologne
EDITION: 500
The Museum of Modern Art Library, New York

Err, 1996
Artist's book
PAGE: 8 1/2 X 5 3/4" (21.6 x 14.6 cm)
PUBLISHER: Book Works, London
EDITION: 1,000
The Museum of Modern Art Library, New York

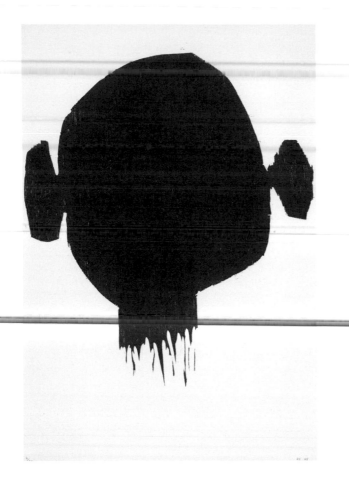

Paul Etienne Lincoln

[BRITISH, born 1959]

**In Tribute to Madame de Pompadour and
the Court of Louis XV (Perfume Set)**, 1985
Multiple of glass vials, perfume, honey,
offsets, and box

OVERALL: 3¹/₂ x 6¹/₈ x 3³/₈" (8.9 x 15.6 x 8.6 cm)
PUBLISHER: the artist, London
EDITION: 30

The Museum of Modern Art, New York.
Linda Barth Goldstein Fund, 2002

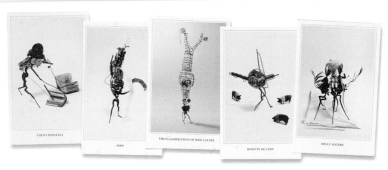

The World and Its Inhabitants, 1997
Artist's book

PAGE: 4¹¹/₁₆ x 3" (11.9 x 7.6 cm)
PUBLISHER: Book Works, London
EDITION: 1,000

The Museum of Modern Art, New York.
Gift of the artist and Alexander and Bonin Gallery,
2002

A la Tour Eiffel, le 13

Jonathan Monk
Meeting #13

Liam Gillick
[BRITISH, born 1964]

The Book of the 3rd of June, 2000
Artist's book
PAGE: 8 1/4 x 6" (21 x 15.3 cm)
PUBLISHER: CCA Kitakyushu, Japan
EDITION: 1,000
The Museum of Modern Art Library,
New York

Literally No Place for the journal
Parkett, no. 61, 2001
Multiple of Plexiglas and aluminum
OVERALL (AS SHOWN): 22 7/16 x 10 x 10" (57 x 25.4 x 25.4 cm)
PUBLISHER: Parkett, Zurich and New York
EDITION: 70
The Museum of Modern Art, New York.
Alexandra Herzan Fund, 2001

Jonathan Monk
[BRITISH, born 1969]

Meeting #13, 2000
Artist's book
PAGE (FOLDED): 4 15/16 x 3 15/16" (12.5 x 10 cm)
PUBLISHER: Book Works, London, and
Yvon Lambert, Paris
EDITION: 10,000
The Museum of Modern Art Library,
New York

2, 1999
Artist's book
PAGE: 8 1/16 x 5 15/16" (20.5 x 15.1 cm)
PUBLISHER: Revolver, Frankfurt
EDITION: 500
The Museum of Modern Art Library,
New York

257

Damien Hirst

[BRITISH, born 1965]

**I Want to Spend the Rest of My Life
Everywhere, with Everyone,
One to One, Always, Forever, Now**, 1997
(printed 1997–98)
Artist's book

PAGE: 12 ¹⁵/₁₆ X 11 ⁵/₁₆" (33 X 28.7 cm)
BOOK DESIGNER: Jonathan Barnbook
PUBLISHER: Booth-Clibborn Editions, London,
with The Monacelli Press, New York
EDITION: 24,000

The Museum of Modern Art, New York.
Linda Barth Goldstein Fund, 2000

Home Sweet Home, 1996
Multiple of screenprint on porcelain

OVERALL: 8 ¹/₄ X 8 ¹/₄" (21 X 21 cm)
PUBLISHER: Gagosian Gallery, New York
PRINTER: Swid Powell, New York
EDITION: 1,500

The Museum of Modern Art, New York.
The Associates Fund, 2006

**I Want to Spend the Rest of My Life
Everywhere, with Everyone,
One to One, Always, Forever, Now**, 1999
Multiple of pack of cigarettes

OVERALL: 3 ³/₈ X 2 ³/₁₆ X ⁷/₈" (8.5 X 5.5 X 2.2 cm)
PUBLISHER: the artist, London, Gagosian Gallery,
New York, and R. J. Reynolds Tobacco Co.,
Winston-Salem, North Carolina
EDITION: mass produced

The Museum of Modern Art, New York.
Anonymously given, 2000

Gillian Wearing

[BRITISH, born 1963]

Sleeping Mask for the journal *Parkett*, no. 70, 2004
Multiple of wax and polymer resin, with oil paint additions

OVERALL: 8 ¹/₄ X 5 ⁵/₁₆" (21 X 13.5 cm)
PUBLISHER: Parkett, Zurich and New York
EDITION: 60

The Museum of Modern Art, New York.
Linda Barth Goldstein Fund, 2005

Rachel Whiteread

[BRITISH, born 1963]

Doorknob, 2001
Multiple of Technogel

OVERALL: 2 ¹/₂ X 5 X 2 ¹/₄" (6.4 X 12.7 X 5.7 cm)
PUBLISHER: Deutsche Guggenheim, Berlin
EDITION: 300

The Museum of Modern Art, New York.
Acquired through the generosity of Coco Kim
and Richard Schetman, 2006

Switch for the journal *Parkett*, no. 42, 1994
Multiple of plaster and brass

OVERALL: 3 ⁹/₁₆ X 3 ⁹/₁₆ X 1 ³/₁₆" (9 X 9 X 3 cm)
PUBLISHER: Parkett, Zurich and New York
EDITION: 60

The Museum of Modern Art, New York.
Riva Castleman Endowment Fund,
Lily Auchincloss Fund, and Gift of Parkett, 1998

following spread

Damien Hirst

[BRITISH, born 1965]

Pharmacy Wallpaper, 1998
Wallpaper for the restaurant
Pharmacy, London

DIMENSIONS: variable
PUBLISHER: the artist, London
EDITION: not editioned

Courtesy the artist, London

259

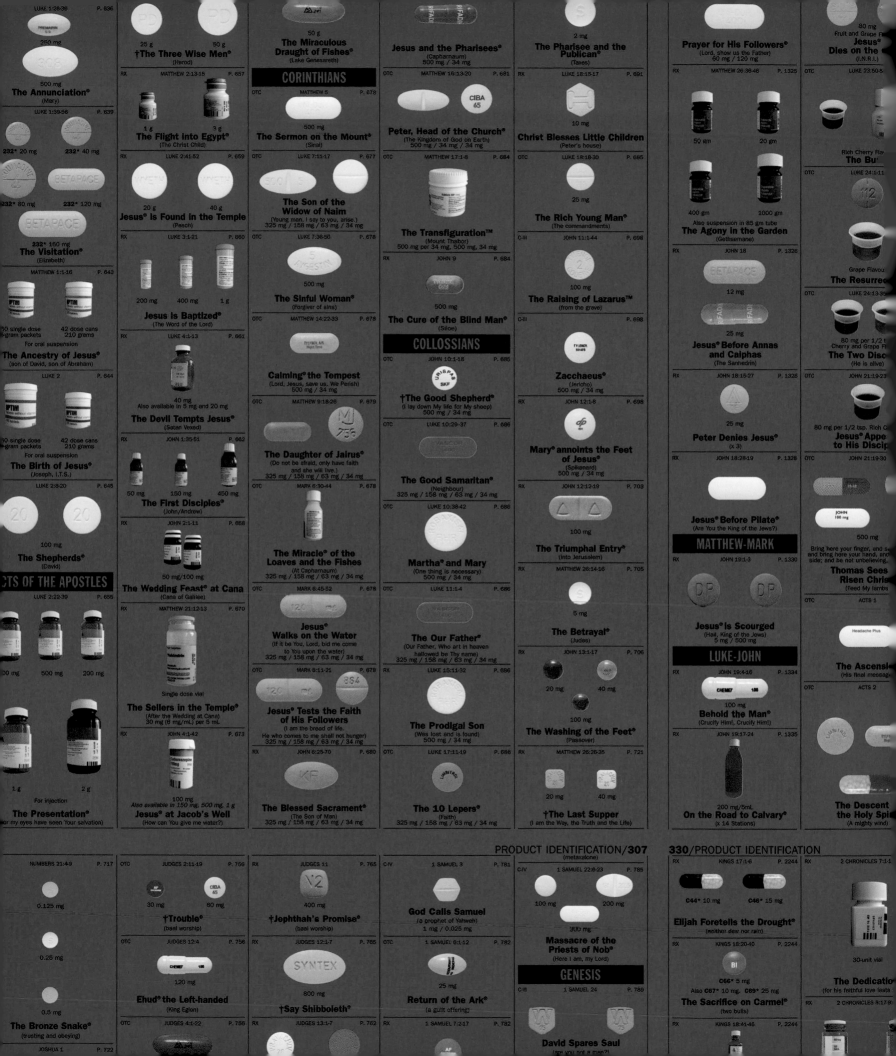

notes on the artists

Compiled by Starr Figura, Amy Gordon, Judith Hecker, Anjuli Lebowitz, Sarah Suzuki, and Gretchen Wagner

These notes refer to artists, collectives, and journals featured in the Essays & Plates section of this volume. The information compiled here focuses on these artists' work in prints, books, and multiples. When artists or their representatives have maintained extensive Web sites, they are cited.

///

Arman (Armand P. Arman)

Born in Nice in 1928. Died in New York in 2005. Sculptor and founding member of the *Nouveaux Réalistes* in Paris in 1960, a group of artists who incorporated everyday objects into their work, challenging artistic conventions and commenting ironically on contemporary life. Eschewing the personal mark, began in 1955 to make works based on the repetitive, haphazard imprinting of rubber stamps, or of everyday items dipped in paint. By 1959 began making signature "accumulations," inventive sculptures constructed from vast quantities of a single manufactured good, such as violins, guns, or car parts, sometimes encased in Plexiglas boxes. Sometimes smashed, sliced, or burned objects in performance pieces that reflected, in part, political tensions in France at the time. As an outgrowth of his interest in repetition and accumulation, produced nearly 300 prints from 1960 to the 1990s, working in lithography, screenprint, and etching. Also from 1960 was among the pioneers of the multiple object, creating numerous inventive examples as an extension of his accumulations, working with various publishers, including Edition MAT/Galerie Der Spiegel, Cologne, and Edition Schellmann, Munich and New York. *SF*

Otmezguine, Jane, Marc Moreau, and Corice Arman. *Arman Estampes: Catalogue raisonné*. Paris: Marval, 1990.

///

John Armleder

Born in Geneva in 1948. Lives in Geneva and New York. Painter, sculptor, and installation and performance artist who emerged on international scene with the Geneva-based Fluxus collective and exhibition space Écart, which he cofounded with Patrick Lucchini and Claude Rychner in 1969. With irreverent attitude toward artistic mediums and practices, became known for combining abstract painting and found furniture in works that question authenticity and contextualization in art, as well as the relationship between art and design. With appropriated motifs, work often makes ironic allusions to classic modernist traditions. Promoted work of experimental artists through Écart, which published around twenty-five artists' books and special exhibition catalogues, and its bookshop. During the 1980s and 1990s completed nearly forty multiples and printed projects, often using screenprint and serial formats. Has also made wallpaper and rubber stamps. Has collaborated recently with Wiener Secession, Vienna; Édition Sollertis, Toulouse; and Parkett, Zurich and New York, among many others. In 2004 cofounded Hard Hat, a nonprofit venture in Geneva whose many goals include publishing multiples, organizing contemporary art events, and promoting Écart publications. *AL*

Bovier, Lionel, ed. *John Armleder*. Paris: Flammarion, 2005.
Bovier, Lionel, and Christophe Cherix, eds. *L'Irrésolution commune d'un engagement equivoque: Écart, Genève 1969–1982*. Geneva: Museé d'Art Moderne et Contemporain and Cabinet des Estampes, Museé d'Art et d'Histoire, 1997.

///

Art-Language

Journal published by influential Conceptual art collective Art & Language, established in Coventry, England, in 1968 by Terry Atkinson, David Bainbridge, Michael Baldwin, and Harold Hurrell. Others in England, the United States, and elsewhere became associated with the group for varying periods of time. Made radical effort to subvert the commodity-based nature of art and to redefine art in relation to language and the workings of the human mind. From 1969 to 1985 published journal, which was edited by critic Charles Harrison and others. Joseph Kosuth briefly became their American editor in 1970. Relaunched in 1994 and continues to publish sporadically. Group also utilized other language-based mediums such as artists' books, posters, philosophical texts, musical scores, and transcripts of informal conversations. In 1979 the New York sector fell apart, and many other members left to pursue individual careers. The group continues with Baldwin and American Mel Ramsden, who have made paintings examining the relationship between style and content, and Harrison, who continues with literary efforts. *SF*

Art & Language. Paris: Galerie Nationale du Jeu de Paume, 1993.
Maenz, Paul, and Gerd de Vries, eds. *Art & Language*. Cologne: M. DuMont Schauberg, 1972.

///

Art & Project Bulletin

Conceptual artist's publication issued by gallery and publisher *Art & Project*, founded in Amsterdam in 1968 by Geert van Beijeren and Adriaan van Ravesteijn. A pioneer of the page-art/mailer in Europe, this bulletin was conceived of as both a work of art and exhibition

invitation. Bulletins, 156 in total, issued on a regular basis from September 1968 to November 1989, sent free to a mailing list of about 800 people. Gallery invited an artist to design each issue, maintaining the same scale and format of a folded, single sheet, printed on both sides. More than 100 international artists participated, including Stanley Brouwn and Richard Long, each of whom conceived seven issues, as well as Alighiero e Boetti, Marcel Broodthaers, Hanne Darboven, Gilbert & George, and Sol LeWitt. In 1990 the gallery moved to a rural area in northern Holland; ceased operations in 2001. *AL*

Cherix, Christophe. "Art & Project Bulletin." In *25th International Biennial of Graphic Arts*. Ljubljana, Slovenia: MGLC, International Centre of Graphic Arts, 2003.

///

Atelier Populaire

Poster group set up at the École des Beaux-Arts in Paris when student protestors occupied that institution during the period of public rioting, strikes, and protests in May and June 1968. Produced hundreds of boldly graphic posters, mostly in screenprint, exploiting the print medium as an inexpensive, provocative, and prolific means of public communication. New posters, responding to the day's events, were printed around-the-clock and posted throughout the streets. Individual designers remained anonymous in keeping with the posters' function as "street weapons" rather than art. Reflecting the demand for a new social order in France, principal themes included poor conditions for workers and students; criticism of the leadership of President Charles de Gaulle; and contempt for the CRS (Compagnies Républicaines de Sécurité), or French riot police. *SF*

Dreyfus-Armand, Geneviève, and Laurent Gervereau. *Mai 68: Les Mouvements étudiants en France et dans le monde*. Nanterre, France: Bibliothèque de Documentation Internationale Contemporaine, 1988.
Perussaux, Charles. *Les Affiches de mai 68, ou L'Imagination graphique*. Paris: Bibliothèque Nationale de France, 1982.

///

Fiona Banner

Born in Merseyside, England, in 1966. Lives in London. Works in sculpture, drawing, prints, and books. First came to prominence with her wordscapes, or "still films"—large-scale, continuous text pieces that document her retelling of often violent or pornographic films. Translates movies, such as *Platoon*, *Top Gun*, *Full Metal Jacket*, and *Apocalypse Now*, into uninterrupted streams of words, obliterating the notion that language of any kind can accurately communicate history. Also investigates the structure of language by focusing on punctuation and syntax through periods, in various typefaces, to emphasize the shifting and adaptable nature of language. Has produced several artists' books, multiples, and screenprints to date, publishing under her own imprint, The Vanity Press, London, established in 2003, as well as with Frith Street Gallery, Laure Genillard Gallery, and The Multiple Store, all in London. *AL*

Brown, Katrina M., and Susanne Titz, eds. *Banner*. Aachen, Germany: Neuer Aachener Kunstverein; Dundee, Scotland: Dundee Contemporary Arts; Frankfurt: Revolver Archiv für aktuelle Kunst, 2002.

///

Georg Baselitz

Born Georg Kern in Deutschbaselitz, Germany, in 1938. Lives in Derneburg, Germany. Painter, printmaker, and sculptor who grew up in East Germany, emigrating in 1957 to West Berlin, where he reacted against the dominance of abstract painting. Created a vigorously expressive art, devising figure types that included heroes, rebels, and shepherds, rich in mythical, spiritual, and historical overtones. Began fragmenting his subjects and, in 1969, depicting them upside-down in a move that would become his signature motif. A prolific printmaker, began working in intaglio in 1963 and woodcut in 1966, mediums that would suit his aggressive drawing style and physical engagement with process. His intense experimentation, often undertaken on his own press, has yielded numerous states and color variants of his images, many with hand additions. In 1979 began creating crudely carved wooden figurative sculptures that relate to his monumental woodcuts and linoleum cuts. Has completed nearly 1,000 prints to date, including around twenty books, working with a handful of German publishers, mainly Edition der Galerie Heiner Friedrich, Fred Jahn, and Sabine Knust•Maximilian Verlag, all in Munich, and Galerie Michael Werner, Cologne. Has also self-published many editions. *JH*

Jahn, Fred, and Johannes Gachnang. *Baselitz: Peintre-Graveur*. Bern and Berlin: Gachnang & Springer, 1983.

Mason, Rainer Michael, and Jeremy Lewison. *Georg Baselitz: Grabados/Gravures/Prints 1964–1990*. Valencia: IVAM Centre Julio González; Geneva: Cabinet des Estampes, Musée d'Art et d'Histoire; London: Tate Gallery, 1991.

///

Christiane Baumgartner

Born in Leipzig in 1967. Lives in Leipzig. Printmaker and video artist steeped in German tradition of woodcuts. Transfers stills from video to a woodblock, then carves and prints images on handmade paper. Projects, up to 14 feet (4.3 m) long, take up to ten months to complete. Subject matter frequently features industrial and military technologies known for high energy, force, and speed, such as wind turbines, cars, and planes, reflecting her interest in the passage of time and movement through space. Has also experimented with print techniques on aluminum and glass, as well as screenprint and offset. Completed approximately twenty print projects and twenty-five artists' books from 1998 to 2005. Works primarily with Editions & Artists' Books Johan Deumens, near Amsterdam, and the Carivari Artists Press, Leipzig, which she cofounded with Sabine Golde in 1992. *AL*

Blume, Julia, and Anne Hamlyn. *Christiane Baumgartner: Speed/Standstill*. Leipzig: Carivari, 2003.
Prince, Nigel, ed. *Christiane Baumgartner*. Birmingham, England: Ikon Gallery, 2005.

///

Carole Benzaken

Born in Grenoble in 1964. Lives in Paris. Painter, photographer, and video artist who first captured international attention in the mid-1990s with vivid realist paintings. Emphasizes immediacy of contemporary life by appropriating fleeting imagery from soap operas, family snapshots, and news events derived from mass-media sources, including television, movies, posters, advertisements, and newspapers. Has filmed cities and suburbs of Southern California and France, relating geography of urban sprawl to horizontal format of her canvases. Adapts mechanisms of filmmaking, such as long shots and close-ups, as well as techniques of the editing process, to juxtapose imagery in paintings, drawings, projections, and video. Made first print in 1993, but considers *Candide*, from 2004, her first significant printed project. Has made several other prints working with Item Éditions, Paris; has also collaborated with Imprimerie Clot, Paris, and Alain Buyse, Lille. *AL*

Bordaz, Jean-Pierre, et al. *Carole Benzaken: Search for the New Land*. Paris: Centre Pompidou, 2004.

Hindry, Ann. *Carole Benzaken*. Nice: Villa Arson, 1995.

Joseph Beuys

Born in Krefeld, Germany, in 1921. Died in Düsseldorf in 1986. Sculptor, draftsman, performance and installation artist, printmaker, and teacher. Studied and taught at the Kunstakademie Düsseldorf, later bringing his ideas to larger audiences through public lectures and ritualistic theatrical performances. Influenced by Dada and Fluxus, his radical approach abolished boundaries between art and life, creating an "expanded concept of art" that included art as a conduit for social revolution and the notion that any person could activate his or her creative powers. Recurring themes include unifying diametric aspects of the universe, such as man and nature, East and West, and intuition and intellect, as well as means of communication and the search for healing. Devoted to the broad dissemination of his ideas, editions were critical to his practice. Created first edition in 1965, completing more than 600 prints and multiples, including found objects and organic materials, photographic and hand-drawn prints, and mass-produced ephemera related to his performances and published in limited and unlimited editions. Worked with a variety of European publishers, mainly in Germany, including Edition René Block, Berlin; Edition Staeck, Heidelberg; and Edition Schellmann, Munich and New York. *JH*

Schellmann, Jörg, ed. *Joseph Beuys: The Multiples, Catalogue Raisonné of Multiples and Prints*. Cambridge, Mass.: Busch-Reisinger Museum, Harvard University Art Museums; Minneapolis: Walker Art Center; Munich and New York: Edition Schellmann, 1997.

Jean-Charles Blais

Born in Nantes, France, in 1956. Lives in Paris and Arcueil, France. Painter and printmaker. Developed figurative imagery during the 1980s, often working in the *affichistes* or *décollage* mode, in which successive layers of glued paper are ripped and separated. Known for monumental paintings of abstracted and fragmented figures, often executed on layers of torn billboard posters or other found supports, including newspaper, metal, and rubber. Suggests states of alienation and instability with silhouettes of headless bodies, empty clothing, and blank faces. Began printmaking in 1983 and has created well over 100 printed works, usually in series and small editions. Collaborators have included Peter Kneubühler, Zurich, for engraving and etching, and Franck Bordas, Paris, for lithography. *AL*

Faber, Monika, and Alain Mousseigne. *Jean-Charles Blais, Grafik*. Vienna: Museum Moderner Kunst, Palais Liechtenstein, 1989.

Piguet, Philippe, and Alain Mousseigne. *Jean-Charles Blais, Estampes*. Toulouse: Musée d'Art Moderne, 1986.

John Bock

Born in Gribbohm, Germany, in 1965. Lives in Berlin. Performance and installation artist who constructs complex environments to stage his carnivalesque actions that address the absurdity of everyday life. Cites Joseph Beuys, Paul McCarthy, the Viennese Actionists, and the experimental theater of Bertolt Brecht and Samuel Beckett as his influences. Developed his first "lectures" during the early 1990s, giving faux lessons in economic matters, replete with chalkboard diagrams and overhead projections. Also produced his "suitcase performances" at this time, traveling to locations with a carryall of props to aid his improvised monologues, exaggerated gesticulation, and audience provocation. Around 1998 began constructing elaborately messy sets for his performances using cheap materials such as plywood, duct tape, rags, obsolete electronics, and produce. Films his actions and meticulously edits the footage, leaving the recording and the installation as traces of his activities. Has editioned a handful of objects and produced artists' books, some of which double as catalogues for his exhibitions. Has collaborated with Parkett, Zurich and New York, and Helga Maria Klosterfelde Edition, Hamburg. *GW*

Hoffman, Jens. *John Bock: Koppel*. Ishøj, Denmark: Arken Museum for Moderne Kunst; Cologne: Walther König, 2004.

Christian Boltanski

Born in Paris in 1944. Lives in Paris. Conceptual artist whose works explore emotional issues relating to childhood and memory, loss and death, and the passage of time. Self-taught, began painting in 1958 but by 1968 switched to photography and film, using a strategy of combining fact and fiction from his own and others' lives. In 1972/73 began making assemblages from found family or school photographs. Those including Jewish schoolchildren of the 1930s made implicit reference to the Holocaust. In 1986 began making signature installations from metal boxes, photographs of children, and naked light bulbs in haunting, altarlike arrangements. Made his first artist's book in 1969, which purported to document his life up to age six. Since then has made more than seventy-five artists' books as well as mail art and other printed ephemera, sometimes related to installation projects. These are often presented as inventory- or scrapbook-style sequences of photographs that reflect the need to organize, examine, and reconstruct the past. Since 1991 has also made a few print projects, usually working in serial formats with photo-based techniques. *SF*

Flay, Jennifer, ed. *Christian Boltanski, Catalogue: Books, Printed Matter, Ephemera, 1966–1991*. Cologne: Walther König; Frankfurt: Portikus, 1992.

Rainwater, Robert. *Christian Boltanski: Books, Prints, Printed Matter, Ephemera*. Exhibition brochure. New York: The New York Public Library, 1993.

KP (Klaus Peter) Brehmer

Born in Berlin in 1938. Died in Hamburg in 1997. Painter, printmaker, and filmmaker who borrowed images and themes from popular culture as a means of social critique and political resistance. Focused on printmaking throughout his career, considering the medium's capacity for duplication a conceptual counter to the exclusivity and preciousness of "high art." Completed more than 150 printed works, and for many projects from the 1960s employed commercial photo-based processes commonly used for newspaper illustrations. Appropriated advertisements for housewares and beauty products to produce three-dimensional object-prints parodying store displays and packaging. Between 1966 and 1972 developed major series of approximately fifty "postage stamp" works, often customizing each impression with a unique array of stamped ink additions. Also experimented with etching and linoleum cut during these years. Concentrated on drawing and painting during the last twenty-five years of his life, creating provocative map and chart projects of bold color and sizable scale. Collaborated with publishers Griffelkunst-Vereinigung, Hamburg, and Edition René Block, Berlin, among others. See www.kpbs.de. *GW*

Block, René, et al. *KP Brehmer: Alle Künstler lügen.*
Kassel, Germany: Museum Fridericianum, 1998.
Butin, Hubertus. *KP Brehmer: Briefmarken 1966–1972.*
Frankfurt: Galerie Bernd Slutzky, 1994.

Marcel Broodthaers

Born in Brussels in 1924. Died in Cologne in 1976.
A poet who became, in the 1960s, an avant-garde
maker of sculpture, paintings, prints, books, films,
performances, and installations that challenged the
traditional definitions of art and critiqued the systems
that support it. Influenced by Surrealism and his
long-standing interest in words and their meanings,
confounded the boundary between the visual and
the literary, creating ironic juxtapositions of images
and text. Produced large-scale installations that
simulated museum exhibitions to confront the art
world's preoccupation with authorship, display and
classification, and the art market. Began issuing
books in 1957 and prints in 1964. His most elaborate
installation, *Museum of Modern Art, Department of
Eagles*, presented in various venues from 1968 to
1972, incorporated numerous related works on paper.
Completed nearly fifty prints, books, and multiples
with galleries, museums, and publishers, mainly in
Germany, Brussels, and New York. *JH*

Marcel Broodthaers: Complete Graphic Work and Books.
Knokke-Duinbergen, Belgium: Galerie Jos Jamar, 1989.
Nobis, Norbert. *Marcel Broodthaers: Catalogue of the
Editions Prints and Books.* Hannover: Cantz, 1996.

Joan Brossa

Born in Barcelona in 1919. Died in Barcelona in
1998. Poet, playwright, and visual artist whose works
often blur the boundaries between theater, poetry,
performance, and visual art. Cofounder of review *Dau
al Set* in 1948 and leading figure in Catalan poetry.
Created first poem-object in 1943, but fully realized
concept with *Poema Visual* of 1951. Combined elements
of the magical and the surreal in witty, ironic sculptures
made from everyday objects. Works sometimes include
critical dimension, subtly denouncing sociopolitical
conditions in Spain while reflecting upon the nature of
language. In more than 100 lithographs and screenprints
translated poem-objects into minimalist, geometric,
graphic style and combined with letters of the alphabet.
Produced many celebrated poster projects and
lithographic series in the 1970s and 1980s, and nearly
fifty illustrated book projects, including collaborations
with Joan Miró and Antoni Tàpies. Worked with some
of the best-known publishers in Barcelona, including
Polígrafa Obra Gráfica, Galeria Carles Taché, and
Galeria Joan Prats. See www.joanbrossa.org. *AL*

Salvador, Josep, et al. *Poesía visual: Joan Brossa.*
Valencia: IVAM Centre Julio González, 1997.

Günter Brus

Born in Ardning, Austria, in 1938. Lives in Graz, Austria.
Performance artist, painter, draftsman, writer, filmmaker,
and musician. Cofounded Viennese Actionism and
staged performances using his own body as primary
medium, first painting it, and then, in a radical
confrontation of social taboos and the limits of art, by
incorporating processes such as self-wounding and
defecating. Was convicted of "offending decency and
public morals" in 1968; lived in exile in Berlin from 1969
to 1979. Staged last performance in 1970, then turned
to *Bild-Dichtungen* (image-poems), fairy tale–like works
combining drawing and writing in cyclical series that
are at once tragic, grotesque, and whimsical. Started
printmaking in 1972, working primarily in etching and
drypoint and occasionally in screenprint and lithography.
Has completed more than 150 prints, published by
Galerie Heike Curtze, Vienna and Berlin, and Sabine
Knust•Maximilian Verlag, Munich, among others.
Has also created numerous image-poems as artists'
books, issued by various galleries and book publishers,
including Edition Hundertmark, Berlin and Cologne.
From 1969 to 1977 published the periodical
Die Schastrommel as a forum for members of the
Austrian avant-garde living in Berlin. *SF*

Faber, Monika. *Günter Brus: Werkumkreisungen.*
Cologne: Walther König, 2003.
Faber, Monika, et al. *Günter Brus: Nervous Stillness on
the Horizon.* Barcelona: Museu d'Art Contemporani
de Barcelona and Actar, 2005.

Daniel Buren

Born in Boulogne-Billancourt, France, in 1938. Lives
in Paris. Conceptual artist known for site-specific
installations of colored stripes—either painted, cut from
paper, or printed on paper or cloth—in a width of 8.7 cm
(about 3 1/2 inches), a standard width for awning stripes.
Often installed temporarily in urban settings, they
counter notions of art as object, commodity, or personal
expression, and shift focus to the viewer's perception of
the surrounding architectural and social spaces. From
1965 to 1970 exhibited with the group BMPT (including
Buren, Olivier Mosset, Michel Parmentier, and Niele
Toroni), each member of which chose to work repeatedly
with just one geometric form. Since then has continued
independently with the stripe motif. To circumvent the
traditional gallery system, has consistently made page-
art interventions in books and magazines as well as
printed ephemera, such as posters and announcements,
an integral aspect of his oeuvre. Usually prints these
via commercial offset but sometimes uses screenprint.
Since 1970, working with various European and American
publishers, has also issued occasional print series,
often devising creative solutions, such as special hanging
instructions, to make them site-specific in any given
location. See www.danielburen.com. *SF*

Buren, Daniel, et al. *The Eye of the Storm: Works in situ by
Daniel Buren.* New York: Guggenheim Museum, 2005.
Schraenen, Guy. *Daniel Buren: Farbige und vielfache
Eindrücke/Impressions colorées et multiples.* Bremen,
Germany: Neues Museum Weserburg Bremen, 1999.

Rafael Canogar

Born in Toledo, Spain, in 1935. Lives in Madrid. Painter
and printmaker who gained recognition in the mid-1950s
with an expressive and spontaneous mode of abstract
painting. In 1957 cofounded the influential group *El Paso*
with other leading Spanish artists and intellectuals
interested in gestural painting. In the 1960s introduced
figurative imagery to his work, often incorporating
fragments of news photographs and three-dimensional
collage elements. A majority of his work from this time
addressed topical themes of violence and protest.
Completed his first major print projects in the 1960s,
favoring lithography and screenprint techniques. Invited
to work at the Tamarind Lithography Workshop in
Los Angeles during 1969, where he produced two major
series of lithographs portraying politically charged
subject matter. In the mid-1970s turned again to
abstraction, which he continues to explore to the present
day, combining a geometric vocabulary with textural
surfaces. Intaglio mediums gained prominence in his
prolific abstract printmaking of the past twenty-five
years. Has completed more than 150 prints to date.
In addition to Tamarind, has also published projects with

Carlson, Prudence. *Ian Hamilton Finlay: Prints*. Exhibition brochure. New York: UBS Art Gallery, 2004.

Pahlke, Rosemarie E., and Pia Simig, eds. *Ian Hamilton Finlay: Prints, 1963–1997*. Ostfildern-Ruit, Germany: Hatje Cantz, 1997.

///

Sylvie Fleury

Born in Geneva in 1961. Lives in Geneva. Sculptor and video and installation artist who, in a twist on Pop art, appropriates signs and products of commerce to address issues of class, desire, and feminism. Evokes gender ambivalence by forming traditionally masculine subject matter—rocket ships, automobiles, and wildlife scenes—from traditionally feminine materials—fake fur, lipstick colors, and feather boas. Throughout the 1990s installations often incorporated her personal passion for fashion, and consisted of shopping bags from luxury brands haphazardly arranged, recreations of shopping environments, and enlarged and altered fashion magazine covers. Prompted by ongoing debates about consumption and gender representation, has created numerous multiples depicting cosmetics, shoes, hair clips, and diet foods to demonstrate similarities between artistic and commercial systems. Use of multiples also emphasizes parity in modes of production of high and low culture. Has collaborated with publishers Art & Public, Geneva; Parkett, Zurich and New York; Écart, Geneva; and Edition Schellmann, Munich and New York, among others. *AL*

Bovier, Lionel, and Christophe Cherix, et al. *Sylvie Fleury: First Spaceship on Venus and Other Vehicles*. Baden, Switzerland: Lars Müller; Bern: Swiss Federal Office of Culture, 1998.

///

Lucian Freud

Born in Berlin in 1922. Moved to London in 1933; became British national in 1939. Lives in London. Preeminent painter of portraits and nudes. First emerged in London in the mid-1940s with small paintings in a Magic Realist style. In 1956 began working in his characteristically expressive style, using thick brushstrokes to depict family and friends in portraits that redefine the genre. Fascinated by the awkward and anti-ideal and, taking a dispassionate approach, usually presents nudes in seemingly graceless or unflattering positions. In printmaking works only in etching, which has become extremely important within his oeuvre.

Made his first etchings in 1946, then abandoned the medium until 1982. Has since completed nearly eighty examples, working in a painstaking manner to build up the linear webs that define his forms. Often depicts the same subjects as in his paintings but, by isolating them against blank backgrounds rather than placing them in identifiable settings, introduces new sense of abstraction and dislocation. Since 1988 has worked with the same London printer, Mark Balakjian at the Studio Prints workshop. *SF*

Cohen, David, and Scott Wilcox. *Lucian Freud: Etchings from the Paine Webber Art Collection*. New Haven, Conn.: Yale Center for British Art, 1999.

Hartley, Craig. *The Etchings of Lucian Freud: A Catalogue Raisonné, 1946–1995*; and supplement, *Lucian Freud: Recent Etchings, 1995–1999*. London and New York: Marlborough Graphics, 1995–99.

///

Katharina Fritsch

Born in Essen, Germany, in 1956. Lives in Düsseldorf. Sculptor, known for precise representational objects and elaborate installations, who blends Conceptual art with elements of Pop art. Alters scale and proportion of subjects to tap subconscious fears and anxieties embedded in contemporary culture, folklore, myth, personal memories, dreams, and experiences. Forms objects, such as brains, religious souvenirs, poodles, cats, rats, and dinner tables, from industrial materials like polyester, resin, wood, and cloth, often in bright, garish colors. Installations comprise intricately and ironically arranged repeated objects, which often suggest uncanny narratives. Made first multiple in 1979, and began issuing them in unlimited editions in the early 1980s. Produced more than fifty editioned works to date. These works often use similar themes and techniques as her sculptures and utilize commercial fabrication processes. Has self-published many of her works, and has also collaborated with publishers including Matthew Marks Gallery, New York, and Parkett, Zurich and New York. *AL*

Garrels, Gary, et al. *Katharina Fritsch*. San Francisco: San Francisco Museum of Modern Art, 1996.

///

Hamish Fulton

Born in London in 1946. Lives in Canterbury, England. Conceptual artist who began in 1971 to base work on long walks in nature, lasting from one day to several weeks, in locations all over the world. While walking, takes black-and-white photographs to record his experience of the landscape, then usually adds printed captions that concisely describe the circumstances of the walk, such as the length, duration, or weather conditions, or that poetically evoke its mood. From the beginning has made artists' books another important means of sharing his walks with the public, publishing several dozen titles to date, usually in collaboration with museums and galleries. Printed ephemera, such as postcards, announcements, and posters, are also integral to his oeuvre. Since the early 1980s, has occasionally made prints using offset, photogravure, or screenprint, working with different British and American publishers. These various printed works may feature photographic images with captions, or simply crisply designed texts, sometimes presented in a style similar to Concrete poetry. See www.hamish-fulton.com. *SF*

Tufnell, Ben, and Andrew Wilson. *Hamish Fulton: Walking Journey*. London: Tate Publishing, 2002.

///

futura

Innovative journal published in Stuttgart from 1965 to 1968 by Hansjörg Mayer, a leading poet-typographer of Concrete poetry. A publication for experimental literature, prints, and typography, included projects by internationally known visual and Concrete poets, such as Robert Filliou, Ian Hamilton Finlay, Dick Higgins, Dieter Roth, and Wolf Vostell. Printed primarily in letterpress using lowercase form of Futura typeface, one of the first sans-serif fonts and known for its stylistic neutrality. Twenty-six issues published to equal number of letters in the alphabet. Printed in editions of 1,200, of which 300 were later distributed as a set of two boxes containing thirteen issues each. Format consisted of a single sheet approximately 18 7/8 inches (48 cm) square, folded to approximately 9 3/8 by 6 5/16 inches (24 by 16 cm), with the exception of the final issue by Filliou, which, when folded following his instructions, forms a hat. Within set parameters, artists were free to create purely visual compositions based on patterns, logic systems, poetry, or symbolic languages. *AL*

Glasmeier, Michael. *Die Bücher der Künstler: Publikationen und Editionen seit den sechziger Jahren in Deutschland*. Stuttgart: Institut für Auslandsbeziehungen; Stuttgart and London: Hansjörg Mayer, 1994.

Gilbert & George

Gilbert Proesch born in Dolomites, Italy, in 1943. George Passmore born in Devon, England, in 1942. Met in London in 1967. Live in London. British Conceptual artists who have functioned as a single unit since 1968. Work in a wide variety of mediums, but consider entire output—including paintings, performances, prints, books, videos, drawings, installations, photographs, and even their daily existence as humans/artists—to be sculpture. First works in the late 1960s comprised "living sculpture" pieces in which artists' bodies were their medium. From 1969 to 1975 completed a number of "postal sculptures," cards containing images and messages sent out in editions to friends and colleagues. First photographic works, largely featuring themselves as subjects, appeared in 1971 and focused on themes of drunkenness and urban life. During the 1980s signature format became stylized photo works in grids using a range of vivid colors, which frequently focused on overtly sexual or corporeal themes. Have completed more than forty works in editions, including postal and magazine "sculptures," multiples, posters, photo albums, and booklets. Made first artist's book in 1970. Have continued with the medium consistently up through the 1990s, with approximately forty books published by a variety of galleries, the majority of which are photo- and text-based and closely related to the artists' ventures in other mediums. *AG*

Jahn, Wolf. *The Art of Gilbert & George, or An Aesthetic of Existence.* New York: Thames & Hudson, 1989.
Violette, Robert, with Hans-Ulrich Obrist. *The Words of Gilbert & George: With Portraits of the Artists from 1968 to 1997.* London: Violette Editions, 1997.

Liam Gillick

Born in Aylesbury, England, in 1964. Lives in London and New York. Conceptually-based sculptor, installation artist, and novelist best known for his fusion of art, architecture, and design strategies involving a rigorous theoretical framework for social change. Uses translucent multicolored screens of metal and Plexiglas to create metaphors for functional spaces that suggest alternatives to existing social conditions. Exploits capacity of basic materials, structures, and color to shape our environment and thereby influence behavior, underscoring systems of power that surreptitiously control everyday life.

Incorporates graphically designed texts into installations, instructions, sculptural design, and fiction writing, alternately encouraging communication and obfuscating messages. Has produced nearly twenty artists' books and novels, which he views as condensed cores of ideas important to connecting concepts amongst his various mediums. Other text-based works include scripts and project proposals. Has worked with publishers including Book Works, London; CCA Kitakyushu, Japan; and One Star Press and TwoStar Books, both in Paris. *AL*

Gaensheimer, Susanne, and Nicolaus Schafhausen, eds. *Liam Gillick.* New York: Lukas & Sternberg, 2000.

Gorgona

Journal published by artist's group of same name in Zagreb, Yugoslavia (now Croatia), from 1961 to 1966. Members of Gorgona, which began in 1959, included painters, sculptors, architects, and art historians. Name derived from a poem by member Mangelos (the pseudonym taken by Dimitrije Bašičević). Proto-Conceptual group, though it promoted no single ideology or aesthetic, standing for only "the absolute ephemeral in art." Work characterized by spiritual and intellectual freedom with a strong tendency toward nihilism and Neo-Dadaism. Exercised social and aesthetic criticism through everyday actions, such as group walks and simply "being together." Correspondence played an integral role in the group's activities, including its *Thoughts for the Month*—quotations culled from literature, philosophy, and art that members would send to each other in the mail. An "anti-review," each issue of the journal designed and produced by a single artist as a coherent work of art. With projects by international artists including Dieter Roth, Victor Vasarely, and Piero Manzoni, among others, the eleven issues, published in editions of 65 to 300, established the group's wider reputation. By using the postal service, group demonstrated that official means could be used to disseminate alternative media—an inspiration for artists living under repressive regimes. *AL*

Bek, Božo, and Nena Dimitrijević, *Gorgona.* Zagreb: Galerije Grada Zagreba, 1977.
Gattin, Marija, ed. *Gorgona: Protocol of Submitting Thoughts.* Zagreb: Museum of Contemporary Art, 2002.

Richard Hamilton

Born in London in 1922. Lives in Oxfordshire, England. Pioneer in the evolution of Pop art and ideology in London. Active member of the Independent Group of the 1950s, which organized the seminal proto-Pop exhibition *This Is Tomorrow* at Whitechapel Art Gallery, London. Painter, printmaker, and influential writer and curator whose ideas investigate the relationship between art and consumer culture, as well as complex questions of perception. Began screenprinting in 1963, allowing for the fluid recycling and layering of photographic imagery drawn from the mass media, often in combination with experiments in color. Has worked inventively in all print mediums except relief, frequently combining several techniques in one print. Began using the computer and printing with digital mediums in the 1990s, furthering his ability to manipulate photographic imagery. Has produced some 200 prints in all, collaborating with eminent and highly specialized printers throughout Europe. Has published with Editions Alecto, Petersburg Press, Waddington Graphics, and Alan Cristea Gallery, all in London. *JH*

Coppel, Stephen. *Imaging James Joyce's* Ulysses/*Richard Hamilton.* London: British Council, 2001.
Lullin, Etienne, et al. *Richard Hamilton: Prints and Multiples, 1939–2002.* Winterthur, Switzerland: Kunstmuseum Winterthur; Düsseldorf: Richter, 2003.

Mona Hatoum

Born in Beirut in 1952. Moved to London in 1975; following outbreak of civil war in Beirut, settled there. Lives in London and Berlin. After graduating from the Slade School of Fine Art, London, in 1981, began career as a performance artist. Since the mid-1980s has focused on sculpture, installations, videos, and photography. By fusing spare, elegant, or sensual forms with threatening or disturbing content creates visual and psychological tension in works exploring cultural identity, gender politics, the dynamics of power, and the vulnerability of the human body—issues that can often be related to her experience as a Palestinian in exile. Known for her exceptional sensitivity to materials, in terms of both their physical presence and metaphoric potential. Since 1992 has occasionally made multiples, and since 1996 has also made ethereal rubbings on waxed paper of graters, colanders, and knives, some unique and some in small, variant editions. Produced

handmade paper editions at Dieu Donné Papermill, New York, in 2003; a portfolio of etchings with Edition Jacob Samuel, Santa Monica, in 2004; and a few single prints since then. *SF*

Heinrich, Christoph, ed. *Mona Hatoum*. Ostfildern-Ruit, Germany: Hatje Cantz, 2004.

Juan Hidalgo

Born in the Canary Islands, Spain, in 1927. Lives and works in the Canary Islands. Enigmatic figure active in experimental music, actions and Conceptual art. In 1964 cofounded Zaj, radical Fluxus-like group of musicians, visual artists, and writers who sought to visualize music with movements, gestures, and everyday objects and their resulting sounds. After graduating from the Geneva Conservatory of Music in 1955, became increasingly involved in contemporary trends and was greatly influenced by American composer John Cage. Staged first Zaj concert in 1964 and first Zaj Festival in 1965, garnering a reputation with the Spanish government as a promoter of anarchy and as a revolutionary pioneer among fellow artists. Composed "etcéteras"—short, open-ended Concrete poems—and gradually turned more exclusively to visual art, often of an erotic nature. Has produced about ten editioned projects with Estampa Ediciones, Madrid, most notably *Etcéteras Abanderados* (1991), rearranging national symbols to highlight figures of history, literature, art, and myth. *AL*

Martín de Argila, María Luisa, and Carlos Astiárraga Sirgado, eds. *De Juan Hidalgo (1957–1997)*. Madrid: Tabapress, 1997.

Damien Hirst

Born in Bristol, England, in 1965. Lives in London. Sculptor, installation artist, painter, and printmaker who first gained recognition in 1988 when he organized *Freeze*, an exhibition of his and his fellow Goldsmiths College students' work, which marked the birth of the so-called YBAs, or Young British Artists. Became the most visible figure of the group with often confrontational works centered around themes of death and decay, the most notorious of which presented preserved animals in large glass vitrines. Also addresses relationship between disease, science, and commerce in numerous works that reference pharmaceuticals and medical environments, including metal display cabinets featuring pills and other medications. Paintings include colored dot works and spin paintings, created by pouring paint onto a rotating canvas. Has made a wide variety of editioned artworks, from prints, multiples, and artists' books to wallpaper, paint-by-numbers kits, and a special-edition cigarette package. Made first print portfolio in 1999, and has created several ambitious print cycles and individual prints to date. Has collaborated primarily with The Paragon Press, London, but has also worked with Paul Stolper, London, among others. *AG*

Burn, Gordon. *On the Way to Work/Damien Hirst*. London: Fabor, 2001.

David Hockney

Born in Bradford, England, in 1937. Lives in Los Angeles and London. Painter, printmaker, photographer, and stage designer. Following studies at the Royal College of Art, London, from 1959 to 1961, became known for flatly stylized portraits and figure studies (almost always of close friends or family), as well as still lifes and interiors. Although initially related to British Pop art, his work has always been more personal and autobiographical, rooted in his relationships, his homosexuality, and his literary and art historical interests. In late 1963 moved to Los Angeles and added images of swimming pools and other emblems of California to his repertoire. Began his prolific printmaking career in 1961. Has completed more than 500 prints, working extensively in etching and lithography, both of which complement his natural proclivity for drawing. Has also experimented with other techniques, including Xerox and paper pulp editions. Often works on serial projects to develop a narrative or elaborate on a theme. Has made several illustrated books. Has collaborated with many leading workshops, including Editions Alecto and Petersburg Press, both in London, and Gemini G.E.L., Los Angeles. *SF*

Brighton, Andrew. *David Hockney Prints, 1954–1977*. London: Petersburg for the Midland Group and the Scottish Arts Council, 1979.
Livingstone, Marco. *David Hockney: Etchings and Lithographs*. London: Thames & Hudson and Waddington Graphics, 1988.

Peter Howson

Born in London in 1958; moved to Scotland as a child. Lives in Glasgow. Painter and printmaker. Studied at The Glasgow School of Art from 1975 to 1977 and from 1979 to 1981. Became a leading figure in the New Glasgow School, which revived figurative painting in the 1980s. Reacting to the economic depression in Scotland at the time, and to the bleakness he experienced during nine months of training in the Scottish army in the late 1970s, developed a style of harsh contemporary realism. Often depicts downtrodden or unsavory characters in portraits or savage allegorical scenes rendered in vigorous brushstrokes. Went to Bosnia as the Imperial War Museum's official British war artist in 1993. Created first print in 1983 and has since completed some 180 editions, working in screenprint, woodcut, lithography, and, most prominently, etching; also makes monotypes. Often works on large thematic series. Has collaborated extensively with the Glasgow Print Studio as printer/publisher, as well as the Edinburgh Printmakers Workshop. Has also published with Flowers Graphics and The Paragon Press, both in London. *SF*

Heller, Robert. *Peter Howson*. London: Momentum, 2003.

Jörg Immendorff

Born in Bleckede an der Elbe, Germany, in 1945. Lives in Düsseldorf. Painter, sculptor, printmaker, and teacher who, after learning stage design, studied under Joseph Beuys at the Kunstakademie Düsseldorf in the 1960s. During this time created cartoonlike narrative paintings with text and political underpinnings. Frequently used babies as a motif, later adopting the childlike word *LIDL* for his program of cultural protest, including performances, political demonstrations, classes, and related works. In the 1970s began epic series of paintings titled *Café Deutschland*, a metaphor for the ideological clash between East and West Germany, combining brightly colored figures and symbolic props in turbulent compositions. An active printmaker working predominantly in linoleum cut, followed painting series with series of prints on the same subject in the early 1980s. Has experimented with color variants, also creating unique prints with hand additions. Utilizing an aggressive, jagged style and monumental scale, became associated with the German Neo-Expressionists, and helped revive the mediums of woodcut and linoleum cut. Has created some 350 prints, published mainly with Sabine Knust•Maximilian Verlag, Munich, and several artists' books. *JH*

Geuer, Dirk and Beate Reifenscheit. *Jörg Immendorff: das Grafische Werk.* Düsseldorf: Geuer & Breckner, 2006.

Hüsch, Anette, and Peter-Klaus Schuster, eds. *Jörg Immendorff: Male lago.* Cologne: Walther König, 2005.

Diederichson, Diedrich, and Ulrich Krempel. *Jörg Immendorff, Café Deutschland gut: Linolschnitte 82/83.* Munich: Sabine Knust•Maximilian Verlag, 1983.

///

Interfunktionen

Vanguard journal, based in Cologne and issued twelve times between 1968 and 1975. Founded by Friedrich W. Heubach (a young psychologist and friend of artist Wolf Vostell), who edited the first ten issues. Art critic Benjamin H. D. Buchloh edited issues 11 and 12. Launched in reaction to the conservative, antiexperimental character of the *documenta 4* exhibition in Kassel, Germany, in the summer of 1968. Early issues reflected an attitude of activist opposition to prevailing aesthetic tastes and practices, and featured works by artists related to then emerging movements of Fluxus, Happenings, Conceptual art, and Land art, including Joseph Beuys, Rebecca Horn, Anselm Kiefer, Richard Long, Sigmar Polke, and Arnulf Rainer. Conceived and designed in keeping with the artists' aesthetics as opposed to the conventional combination of reproduction and text, with specially created projects reproduced via facsimile on various papers and with original documents, foldouts, and collages sometimes bound in. *SF*

Mehring, Christine. "Continental Schrift: The Story of *Interfunktionen.*" *Artforum* 42, no. 9 (May 2004): 178–83, 233.

Moure, Gloria, ed. *Behind the Facts: Interfunktionen 1968–1975.* Barcelona: Ediciones Polígrafa, 2004.

///

IRWIN

Artist's group active in Ljubljana, Yugoslavia (now Slovenia) since 1983. Comprising five multimedia artists, originally anonymous, but now identified as Dusan Mandič, Miran Mohar, Andrej Savski, Roman Uranjek, and Borut Vogelnik. In 1984 became part of a larger collective, NSK (*Neue Slowenische Kunst*, or New Slovene Art), which consisted of groups devoted to rock music, theater, design, and philosophy. NSK collective, combining the artistic, social, and ideological, was formed at a time of changing political conditions in then-Yugoslavia after the death of Tito in 1980. NSK, including IRWIN, initially emphasized Slovene national alliance, but later stressed the conceptual space of territories without borders. Has been influenced by utopian thinking of early twentieth-century Russian avant-garde, in particular the artist Kazimir Malevich. In 2001 initiated the *East Art Map*, a chronicle of Eastern European art since 1945. See www.eastartmap.org. *AL*

Arns, Inke, ed. *IRWIN-Retroprincip, 1983–2003.* Frankfurt: Revolver, 2003.

Zabel, Igor. *IRWIN: Interior of the Planit.* Ljubljana, Slovenia: Moderna Galerija; Budapest: Ludwig Museum, 1996.

///

Kassettenkatalog

Series of combination exhibition catalogues, artists' books, and multiples published by Städtisches Museum Abteiberg, Mönchengladbach, Germany, to accompany monographic exhibitions, beginning with Joseph Beuys in 1967. Initiated by Johannes Cladders, museum director from 1967 to 1984, who sought to cultivate an exhibition space for experimentation and improvisation. Issued thirty-three boxes over eleven years with artists including Marcel Broodthaers, Hanne Darboven, Jannis Kounellis, Panamarenko, Daniel Buren, Jasper Johns, and James Lee Byers, among many others, with edition sizes ranging from fifty-five to over 600. *GW*

Wischermann, Susanne. *Johannes Cladders: Museumsmann und Künstler.* Frankfurt, Berlin, Bern, New York, Paris, Vienna: Peter Lang, 1997.

///

Ivana Keser

Born in Zagreb, Yugoslavia (now Croatia), in 1967. Lives in Zagreb. Conceptually based artist interested in dissemination of information and systems of probability. Influenced by Russian avant-garde and 1960s Croatian collective Gorgona, challenges conventional notions of art and accepted tenets of Eastern European history. Co-organized *EgoEast* exhibition in 1992, with aim to articulate current art scene in Croatia and reestablish international connections lost during Communist rule. Developed graphic design skills while working as a writer for Slovenian and Croatian art magazines and newspapers. From 1994 to 2003 designed and published about a dozen newspapers, free to the public, as contributions to group exhibitions. Inexpensive and easily produced and distributed, these contain her editorials, political cartoons, and personal journal entries. Has also created installations by piling, wrapping, and labeling daily newspapers with their subject matter and weight to comment on the ways information and truth are valued in a media-saturated world. *AL*

Cherix, Christophe. *Ivana Keser: Local News 1993–2003.* Geneva: Cabinet des Estampes, Musée d'Art et d'Histoire, 2003.

///

Anselm Kiefer

Born in Donaueschingen, Germany, in 1945. Lives in Barjac, France. Regarded as a leading exponent of Neo-Expressionism, a dominant movement in the 1980s characterized by bold gestures, grand scale, and mythic or confrontational figurative content. Studied with Joseph Beuys in 1970, and subsequently began making work referencing the troubled legacy of his country's recent past. German history, Nordic myth, and related issues of transformation and regeneration are central themes. Best known for monumental, heavily worked paintings incorporating materials such as photographs, straw, tar, lead, clay, sand, dried plants, and fragments of woodcuts. Also makes immense sculptural books whose pages are encrusted with similar elements. In printmaking uses only the woodcut technique, but eschews standard editions and the collaborative environment of the print workshop. Carves and prints himself, pasting fragments together to create unique works that rival the heroic scale of his paintings. Evokes the distinguished history of woodcut in German art, favoring a rough-hewn aesthetic, with implications of violence and destruction. *SF*

Adriani, Götz, ed. *The Books of Anselm Kiefer, 1969–1990.* New York: George Braziller, 1991.

Hyman, James. "Anselm Kiefer as Printmaker, I: A Catalogue, 1973–1993." *Print Quarterly* 14, no. 1 (March 1997): 42–67.

——. "Anselm Kiefer as Printmaker, II: Alchemy and the Woodcut, 1993–1999." *Print Quarterly* 17, no. 1 (March 2000): 26–42.

///

Martin Kippenberger

Born in Dortmund, Germany, in 1953. Died in Vienna in 1997. Influential and irreverent painter, sculptor, draftsman, and installation artist with prolific and diverse output. Known for disturbing, subversive work that evokes

chaotic energy and irrationality with a mordant humor and sense of vulnerability. Led a peripatetic life that included studying dance, appearing in films, managing an alternative exhibition space, and playing drums in a punk band. Filled paintings with imagery of consumer products, raunchy cartoons, celebrities, portraits of fellow artists, mocking phrases, and unflattering self-portraits imbued with moral undertones concerning the values of society and responsibility of the artist. Seemingly inexhaustible maker of editioned art, producing nearly 200 posters, 150 book projects, and ninety multiples between 1977 and 1997. Preferred the malleability of screenprint process, but also used offset printing for posters made to promote exhibitions as well as to announce birthdays, concerts, parties, lectures, and readings. Self-published many projects, but also collaborated with publishers, including Galerie Gisela Capitain and Galerie Max Hetzler, both in Cologne; Galerie and Edition Artelier, Graz, Austria; and Galerie Erhard Klein, Bonn, among many others. *AL*

Curiger, Bice, and Martin Kippenberger. *Martin Kippenberger: Die gesamten Plakate 1977–1997*. Zurich: Offizin; Cologne: Walther König, 1998.

Grässlin, Karola, ed. *Kippenberger Multiples*. Cologne: Walther König, 2003.

Koch, Uwe. *Annotated Catalogue Raisonné of the Books by Martin Kippenberger, 1977–1997*. Cologne: Walther König, 2002.

///

Per Kirkeby

Born in Copenhagen in 1938. Lives in Copenhagen and Frankfurt. Painter, sculptor, printmaker, filmmaker, and writer. Though trained as a geologist, began frequenting Copenhagen's Experimental Art School in 1962. Joined the Fluxus movement in the 1960s and experimented with various styles and mediums. In the mid-1970s, influenced by Abstract Expressionism, European *Informel*, and CoBrA artist Asger Jorn, developed signature style of vividly gestural abstraction with oblique references to landscape, geological strata, and figurative imagery. Has also made sculptures using bricks, bronze, or plaster as well as numerous documentary and experimental films. Has published many volumes of poetry and essays. From 1958 to 1964 self-published more than 200 etchings, linoleum cuts, and woodcuts, usually modest in scale. Although less prolific in the subsequent decade, in 1977 resumed active printmaking and by the 1980s was creating large-scale, colorful, Neo-Expressionist etchings, woodcuts,

linoleum cuts, and lithographs, many in collaboration with publisher Sabine Knust•Maximilian Verlag, Munich, and master printer Niels Borch Jensen, Copenhagen. Since 1977, has completed more than 1,000 prints, as well as monotypes, artists' books, and offset printed and screenprinted posters. *SF*

Andersen, Troels. *Per Kirkeby: Werkverzeichnis der Radierungen 1977–1998*. Bern: Gachnang & Springer, 2001.

Holler, Wolfgang. *Per Kirkeby: Holzschnitte von 1980 bis 1999*. Dresden: Staatliche Kunstsammlungen; Munich: Sabine Knust, 1999.

///

Yves Klein

Born in Nice in 1928. Died in Paris in 1962. Painter, proto-Conceptual artist, and founding member of *Nouveau Réalisme* in 1960. A charismatic, highly influential figure despite premature death at age thirty-four. Influenced by Eastern religions and mystical philosophy, began making radical monochrome paintings in the mid-1950s—many in his patented ultramarine blue known as International Klein Blue—not for formal purposes but as expressions of freedom, immateriality, and the infinite. Also made sculptures by applying blue to objects such as sponges, stones, and replicas of statuary (four of which were posthumously reproduced as multiples). Highlighted theme of immateriality in historic 1958 installation *The Void*, for which he painted a gallery white and left it empty. In 1960 began staging pioneering performances to evoke ritual and spiritual energy, most notably his *Anthropométries*, in which naked women, smeared with blue paint, imprinted their bodies on paper. Printmaking consists of occasional screenprints as well as a few artists' books and examples of ephemera, including "certificates of immateriality," blue postage stamps, and an edition of a fake issue of the newspaper *Dimanche*, displayed in Paris newsstands as if real. See www.yvesklein.com. *SF*

Berggruen, Olivier, Max Hollein, and Ingrid Pfeiffer, eds. *Yves Klein*. Ostfildern-Ruit, Germany: Hatje Cantz, 2004.

Ledeur, Jean-Paul. *Yves Klein: Catalogue of Editions and Sculptures*. Belgium: Guy Pieters, 2000.

///

Milan Knížák

Born in Pilsen, Bohemia (now Czech Republic), in

1940. Lives in Prague. Performance artist, sculptor, painter, and filmmaker associated with Fluxus and Prague's *Aktual* group, whose participants promoted radical creative engagement. Sought to unite art and everyday life by way of spontaneous action and public participation. Staged his first street performances in the early 1960s, and cofounded *Aktual* in 1964. Made assemblage works in the form of jewelry and clothing, and sculptures using objects salvaged from the trash. Jailed repeatedly for activities deemed subversive by officials. Published more than forty prints, books, and multiples from 1964 to 1980. A majority of these projects related to his performances and those of other *Aktual* artists; many contain musical references. Published several multiples with Fluxus leader George Maciunas, who included the objects in various Fluxus boxed editions. Was editor of the Czech edition of the transnational artist's journal *Schmuck*. Collaborators include Edition VICE-Versand, Remscheid, Germany; Galerie and Edition Hundertmark, Berlin and Cologne; Edition ARS VIVA!, Berlin; and Francesco Conz, Verona. Currently serves as director of the National Gallery in Prague. *GW*

Milan Knížák: Arbeiten 63/89. Cologne: Hundertmark, 1989.

Milan Knížák: Unvollständige Dokumentation/Some Documentary, 1961–1979. Berlin: Edition ARS VIVA! and Berliner Künstlerprogramm des DAAD, 1980.

///

Peter Kogler

Born in Innsbruck in 1959. Lives in Vienna. Painter and installation artist recognized for ambitious wallpaper environments and digital projections. Borrowing from Art Nouveau, Pop, and Minimalist tendencies, during the mid-1980s developed a vocabulary of computer-generated images, including the human brain, worker ants, and labyrinthine tubing, which he screenprints in repetition on canvases or weaves into tapestries. By the late 1980s began working on a monumental scale, covering entire building interiors and, later, exteriors with dizzying ant trails and tangled geometric mazes, primarily using screenprinted wallpaper and fabrics. Also embellishes furniture, curtains, and clothing with compositions using screenprint or digital technologies. Works primarily with publisher and print workshop Galerie and Edition Artelier, Graz, Austria, where he has produced approximately fifteen small-format screenprint editions since 1986 and fabricated approximately forty wallpaper installations. Has also published with Edition

Krinzinger and Galerie Edition Stalzer, both in Vienna. See www.kogler.net. *GW*

Berg, Stephan, Silvia Eiblmayr, and Noëlle Tissier, eds. *Peter Kogler*. Ostfildern-Ruit, Germany: Hatje Cantz, 2004.
Weibel, Peter, ed. *Kunst ohne Unikat: Edition Artelier, 1985–1998*. Cologne: Walther König, 1999.

///

Krater und Wolke

Translated as "Crater and Cloud," journal published by Galerie Michael Werner, Cologne, from 1982 to 1990, focusing on group of predominantly German artists represented by the gallery. Issue nos. 1–6 edited by A. R. Penck (under the name of Ralf Winkler); issue no. 7, the last one published, edited by Georg Baselitz. Comprised loose and bound prints with text, photographs, and illustrations in series of experimental volumes. First five issues are each dedicated to a different artist exhibiting at Galerie Michael Werner: Georg Baselitz, Jörg Immendorff, Markus Lüpertz, Per Kirkeby, and James Lee Byars. Some include records by either Penck or Immendorff. No. 6 contains contributions by several of these artists; no. 7 is dedicated to the work of Penck. *JH*

///

Langlands & Bell

Ben Langlands born in London in 1955. Nikki Bell born in London in 1959. Live in London. Artistic duo who have collaborated on sculptures, prints, animations, and installations since 1978. Works address the architecture, structural frameworks, and global systems that serve to define human behavior. Frequently incorporate maps, diagrams, logos, and models in works that are marked by rigorous conceptualization and a cool, detached aesthetic. Until recently worked almost exclusively in white, black, and shades of gray. For past several years have focused attention on the Internet and air travel in an investigation of global networks that connect humans to each other and to their surroundings. First major printmaking work in 1996 was a suite of ten blind-embossed prints depicting floor plans of mosques. Since then, attracted to their capacity for wide accessibility, have made editioned works an important element of their oeuvre, completing more than forty prints, including several screenprint series, artists' books, and multiples. Prefer digital or screenprint mediums to achieve pristine renderings suitable for their highly conceptualized works. See www.langlandsandbell.com. *AG*

Herzog, Hans-Michael, et al. *Langlands & Bell*. London: Serpentine Gallery; Bielefeld, Germany: Kunsthalle Bielefeld; New York: Grey Art Gallery, 1996.

///

Maria Lassnig

Born in Kappel am Krappfeld, Austria, in 1919. Lives in Vienna. Painter and draftsman. Was influenced in the early 1950s by Surrealism and the gestural expressionism of *Informel*. Soon began to create her signature "body awareness" images, exploring sensations of physical and psychological pain and pleasure in large, colorful, quasiabstract paintings as well as small, delicate drawings of bizarrely distorted or deformed bodies. Many are introspective self-portraits, sometimes incorporating animals to represent a primal state of existence. Lived in Paris in 1951 and again from 1961 to 1968, then in New York from 1968 to 1980. Has made prints sporadically throughout her career. Among the first were nine etchings printed in only a few proofs on a friend's press in Paris in 1965–66 (a few were reprinted in editions in 1981). Made fifteen screenprints at the Pratt Institute of Art in Brooklyn, New York, in 1969–70. Since 1981 has made mostly etchings and drypoints, sometimes for group portfolios, working with various European publishers, including Edition Krinzinger, Vienna; Galerie and Edition Hundertmark, Cologne; and Barbara Gross Galerie, Munich. *SF*

Gross, Barbara, ed. *Maria Lassnig: Werkverzeichnis der Druckgraphik 1949–1987*. Munich: Barbara Gross Galerie, 1988.

///

Paul Etienne Lincoln

Born in London in 1959. Lives in New York. Studied at the Royal College of Art, London, from 1983 to 1984. Creates elaborate and quirky mixed-media sculptures and installations usually composed of a vast accumulation of objects, many of them visibly mechanized. Bases his works on meticulous, erudite investigations of the scientific and artistic achievements of bygone eras, lyrically and nostalgically preserving obsolete technologies and modes of communication. Often makes an accompanying artist's book or multiple, completing some forty examples to date. These are often conceived as small booklets, similar to instruction manuals, explaining the history and function of the larger project, or as small fragments representative of the whole. Many are self-published; others have been produced in collaboration with various European and New York–based galleries and artist's book publishers, including Book Works, London, and Alexander and Bonin Gallery, New York. *SF*

Banz, Claudia, Katy Siegel, and Paul Etienne Lincoln. *The Metropolis of Metaphorical Intimations*. Berlin: Staatliche Museen zu Berlin; Cologne: Walther König, 2003.
Lincoln, Paul Etienne. *Books and Editions*. New York. Great Jones, 2006.

///

Richard Long

Born in Bristol, England, in 1945. Lives in Bristol. Sculptor and Land artist. Since the late 1960s has made walking and his personal interaction with nature the subject of his art. In addition to ephemeral sculptures made on site, makes works arranged from stones, twigs, or mud collected during these epic walks and then transported to a museum or gallery. These are usually laid out in circles or lines on the floor. Also makes drawings using mud handprints or footprints as well as photographs and text works that document his walks worldwide. Since 1970, has created more than sixty artists' books documenting his walks, usually published by galleries or museums showing his work. Most combine photographs of his environmental sculptures with strings of spare, matter-of-fact words recalling his experience, creating permanent records of otherwise ephemeral projects. Has produced an extensive body of printed ephemera, such as announcements, brochures, and postcards. Since 1984 has also made occasional lithographs and screenprints, published by various European and American print publishers. See www.richardlong.org. *SF*

Phillpot, Clive. "Richard Long's Books and the Transmission of Sculptural Images." *Print Collector's Newsletter* 18, no. 4 (September–October 1987): 125–28.
Rainwater, Robert. *Richard Long: Books Prints Printed Matter*. Exhibition brochure. New York: The New York Public Library, 1994.

///

Sarah Lucas

Born in London in 1962. Lives in London. Sculptor, photographer, and installation artist known for reassessing traditional themes of sexuality and death. In 1993 opened

The Shop in London's East End with fellow artist Tracey Emin, selling multiples. Enjoys puns and slang, and appropriates confrontational motifs from pornography and other forms of mass culture. Uses ordinary materials from second-hand shops near the working class east London neighborhood in which she was raised to force reevaluation of everyday life and gender stereotyping. Focuses on bodily functions, especially cravings and addictions. In this vein, often uses cigarettes as both subject and material, emphasizing dual roles of desire and disgust, attraction and repulsion. Has produced numerous multiples, including inexpensive key chains, mugs, and provocative T-shirts, as well as digital prints and wallpaper projects. Has worked with publishers Gladstone Gallery, New York; Parkett, Zurich and New York; and Counter Editions, London, among others. *AL*

Dziewior, Yilmaz, and Beatrix Ruf, eds. *Sarah Lucas: Exhibitions and Catalogue Raisonné, 1989–2005.* Ostfildern-Ruit, Germany: Hatje Cantz; London: Tate Publishing, 2005.

Markus Lüpertz

Born in Liberec, Bohemia (now Czech Republic) in 1941; to Rheydt, Germany, in 1948. Lives in Düsseldorf and Berlin. Painter, sculptor, and printmaker. In the 1960s developed a style of monumental painting based on frenzied gestures melding figuration with abstraction. In the early 1970s incorporated imagery from the German military and World War II, including helmets, chariot wheels, trench coats, and crosses. Since the 1980s has continued to make paintings in a boldly gestural, Neo-Expressionist manner. Has also made sculptures in painted bronze and in clay. Became an active printmaker in 1980. Has completed more than 450 prints, many printed in his own studio, others with master printers, including Peter Kneubühler, Zurich. Usually eschews woodcut but has worked extensively in other mediums, sometimes in unusual combinations, such as etching with lithography or drypoint with linoleum cut. Has made many prints for illustrated books. Has also produced numerous screenprinted posters. Has published with Fred Jahn, Edition der Galerie Heiner Friedrich, and Sabine Knust•Maximilian Verlag, all in Munich, among others in Europe and the United States. *SF*

Dietrich, Dorothea. "A Conversation with Markus Lüpertz." *Print Collector's Newsletter* 14, no. 1 (March–April 1983): 9–12.
Hofmaier, James, Siegried Gohr, and Johann-Karl Schmidt. *Markus Lüpertz, Werkverzeichnis 1960–1990: Druckgraphik.* Munich: Cantz, 1991.

Mangelos (Dimitrije Bašičević)

Born in Šid, Yugoslavia (now Serbia), in 1921. Died in Zagreb, Yugoslavia (now Croatia), in 1987. Prominent poet and curator who produced artwork under the pseudonym Mangelos, taken from the hometown of a close friend killed in World War II. Themes of loss and destruction informed much of his work. Composed poetry throughout the 1950s, while privately creating hand-painted books and globes, using red, black, white, and gold almost exclusively, never expecting to display these works publicly. Used calligraphic script to illustrate his "no-stories"—combinations of personal narratives, ironic observations, and imagined words that center on themes of nihilism and the absurd. Challenged the rationality of language by mixing Croatian, French, German, and English with Cyrillic and Glagolitic letters, layering linguistic puns and purposely negating meaning. Though a member of Gorgona, a Zagreb artist's group, he never exhibited under its auspices, and did not have his first solo exhibition until 1972. First public presentation of his work was in 1964 with the publication of "no-stories" in the artist's journal *a.* Continued his career-long engagement with the artist's book format by utilizing it for exhibition catalogues. See www.mbasicevic.net. *AL*

Stipančić, Branka, ed. *Mangelos nos. 1 to 9 1/2.* Porto, Portugal: Fundação de Serralves, 2003.

Piero Manzoni

Born in Soncino, Italy, in 1933. Died in Milan in 1963. Painter and proto-Conceptual artist who received his formal training in philosophy. Self-taught as an artist, first painted traditional landscapes before turning to more conceptual approaches for the remainder of his short life. Exchanged ideas with many Italian contemporaries, contributing to collective manifestos and the founding of the short-lived journal *Azimuth.* Also helped found avant-garde exhibition space Galleria Azimut, where in 1960 he staged the performance *Consuming Art by Devouring It,* one of the artist's many provocative actions and objects connected to the physical and mythical processes of life. Produced a handful of print projects and multiples. Screenprints and offset page projects record his fascination with his fingerprint, also found on "signed" eggs and individual sheets. His renowned multiple *Artist's Shit* consists of a small can, said to contain his feces, fabricated in an edition of 90. Also issued printed certificates as "Declarations of Authenticity," claiming models and friends as "living sculptures." See www.pieromanzoni.org. *GW*

Gualdoni, Flaminio. *Le carte di Piero Manzoni.* Milan: Charta, 1995.
Meneguzzo, Marco. *Azimuth & Azimut 1959: Castellani, Manzoni e....* Milan: Arnoldo Mondadori, 1984.

Wolfgang Mattheuer

Born in Reichenbach, Germany, in 1927. Died in Leipzig in 2004. Painter, sculptor, and printmaker; became major figure in East Germany's Leipzig School from the 1960s through the late 1970s. Apprenticed as a lithographer at age fifteen and later studied at the School for Printmaking and Book Arts, Leipzig, eventually holding a teaching position there for over twenty years. Taught himself how to paint in a figurative manner, believing only realism, not abstraction, could communicate to a broad audience. His realism, imbued with a Surrealist undercurrent, was celebrated in the official East German cultural realm. Depicted mythical figures Prometheus, Sisyphus, and Icarus and invented allegories to make oblique commentary on contemporary social conditions and humanitarian concerns. Produced more than 500 print projects, primarily lithographs, woodcuts, and linoleum cuts, over nearly sixty years. Used a vocabulary of strong linear repetition and bold, flat shapes to build his mostly black-and-white compositions. Published projects with the East German ministry of culture; Reclam Verlag, Leipzig; and Galerie Brusberg, Berlin, among others. *GW*

Gleisberg, Dieter. *Wolfgang Mattheuer: Das druckgrafische Werk 1948–1986, Sammlung Hartmut Koch, Karl-Marx-Stadt.* Leipzig: Museum der bildenden Künste, 1987.
Mössinger, Ingrid, and Kerstin Drechsel, eds. *Wolfgang Mattheuer: Retrospektive, Gemälde, Zeichnungen, Skulpturen.* Leipzig: E. A. Seemann, 2002.

Chad McCail

Born in Manchester in 1961. Lives in Thankerton,

England. Painter, draftsman, and printmaker whose frequently polemical works investigate societal and economic structures, exposing the violence, repressed sexuality, and corruption inherent to them. Early works comprised gouaches and graphite drawings dealing with themes of abuse and desire, rendered in meticulous detail and flat color to emulate a posterlike style. Since 2000 has used digital technology to the same effect. Signature works feature images in the simplistic style of children's book illustrations or generic diagrams, often with captions, panels, and narratives reminiscent of graphic novels. Such works are frequently allegorical and employ snakes, faceless humans, trees, and daggers as symbols. Long interested in print as a mass medium, began making screenprints in 1989. Has made digital prints since 2002, citing the desire for multiplicity and as large an audience as possible. Graphic works have also been translated to billboards. Has completed several major digital print cycles, and a number of individual prints and artists' books. *AG*

Schwabsky, Barry. "Drawings on the New Town: Chad McCail and Paul Noble." *Art on Paper* 4, no. 6 (July–August 2000): 34–39.

Annette Messager

Born in Berck, France, in 1943. Lives near Paris. Installation artist, photographer, sculptor, and maker of artists' books known for provocative works on issues of personal and collective identity. Since the 1970s has stressed the autobiographical and the role of women in society, incorporating traditionally undervalued themes, such as personal stories and folk religion, and media, such as knitting, embroidery, and books. Work informed by Surrealism, astrology, fairy tales, and nineteenth-century photography. Highlights subjugation of individuality to socially defined standards through recurring images of fragmented bodies. Began making books in 1971 with *Album Collections*, fifty-six handmade books that inspected, sorted, and ordered all aspects of her private life. Collecting and cataloguing remain prevalent themes. Has produced around 100 artists' books, special exhibition catalogues, and magazine projects. Has published with Actes sud, Arles; Oktagon Verlag, Stuttgart; Maeght Editeur, Paris; and Écart, Geneva, among others. *AL*

Grenier, Catherine. *Annette Messager*. Paris: Flammarion, 2001.

Princenthal, Nancy. "Annette Messager Bibliophile." *Print Collector's Newsletter* 26, no. 5 (November–December 1995): 161–65.

Migrateurs

A publication and exhibition series established and directed by Swiss curator Hans-Ulrich Obrist for ARC Musée d'Art Moderne de la Ville de Paris from 1993 to 2001. Featured a range of young international artists, many of them conceptually based or working with issues of space and viewer perception or interaction. Each artist was invited to create a site-specific intervention in a different or unusual ("migratory") space in the museum, rather than mount a conventional exhibition. Each project was accompanied by an artist's book—always in the same 6 3/8 by 4 3/8 inch (16 x 11 cm) format with four or eight pages—in place of a traditional exhibition catalogue. Twenty-five projects in total were realized. *SF*

Jouannais, Jean-Yves. "Migrants: Musée d'Art Moderne de la Ville de Paris. Exhibit and Interview with Hans-Ulrich Obrist." *Art Press*, no. 193 (July–August 1994): 64–65.

Jonathan Monk

Born in Leicester, England, in 1969. Lives in Berlin. Installation artist, photographer, filmmaker, sculptor, performance artist, and artist's book maker. Studied at the Glasgow School of Art from 1988 to 1991. Appropriates the forms and strategies of 1960s Conceptualism, especially those of Sol LeWitt, such as repetition, seriality, and a systems-based approach to art-making, but infuses that cool aesthetic with wit and warmth by using aspects of his personal experience and that of his family as the content of his art. Often appropriates found ephemera, such as photographs, postcards, or other artists' work, and manipulates or groups it according to a predetermined system. Frequently incorporates brief texts, to playful or nostalgic effect. Since 1995 has used the same strategies to make some twenty artists' books as well as other examples of editioned ephemera, including postcard sets, records, and posters, which together constitute a major aspect of his oeuvre. *SF*

Berg, Stephan, Ellen Seifermann, and Roland Wäspe, eds. *Jonathan Monk: Yesterday Today Tomorrow etc.* Frankfurt: Revolver, 2006.

Stout, Katharine. "Jonathan Monk." In *Tate Triennial 2006: New British Art*, edited by Beatrix Ruf and Clarrie Wallis. London: Tate Publishing, 2006.

François Morellet

Born in Cholet, France, in 1926. Lives in Cholet. Known for geometric work with affinities to Minimalism, Conceptualism, Kinetic art, and Op art. Began in 1952 to make canvases with gridlike linear structures, executed according to predetermined mathematical systems and banishing individual decisions or personal marks. In 1960 cofounded Groupe de Recherche d'Art Visuel (GRAV) to experiment with the optical effects of lines and of artificial light and movement. Since 1963 has also made sculptures of neon rods, sometimes allowing for spectators to participate by using switches to produce rhythmic effects. Has since 1961 consistently utilized screenprint, appreciating the medium's "cold," uniform surface, often working in sequential formats that reflect his systemic processes. Has completed some 150 examples to date, working with publishers such as Galerie Denise René, Paris, and Éditions Média, Neuchâtel, Switzerland, among others. Eschewed intaglio and woodcut techniques as too personal until 1980, but subsequently produced some seventy-five examples in collaboration with various European publishers, including Atelier-Editions Fanal, Basel, and Galerie Dorothea van der Koelen, Mainz, Germany. Has also made several artists' books and multiples. *SF*

Le Saux, Marie-Françoise. *François Morellet Gravures 1980–1999*. Vannes, France: Musée de la Cohue, 1999.
"François Morellet, de la contrainte comme stimulation. Propos recueillis." *Nouvelles de l'estampe*, no. 163 (March 1999): 52–56.

Paul Morrison

Born in Liverpool in 1966. Lives in London. Painter recognized for his eerie tableaux of schematic plant life depicted in an austere black-and-white palette. Studied at Goldsmiths College, London, during the late 1990s and first exhibited his conceptually based landscape paintings in 1996. Began making wall paintings in 1998. His varied influences include sources such as botanical handbooks, popular cartoons, William Morris's designs, and Albrecht Dürer's meticulous drawings. Titles his works *Endophyte*, *Auxin*, and *Xylem*, among

other botanical terms, revealing his quasiscientific fascination with nature. Develops acrylic maquettes of his compositions, which he scans and projects onto a wall or canvas for tracing. Although primarily a painter, has also produced films and sculptures, and has recently begun making prints. Has published screenprints—an apt technique for accomplishing his crisp lines and flat hues—with The Paragon Press, London. *GW*

Aupetitallot, Yves. *Paul Morrison: Mésophylle Mesophyll*. Grenoble: Magasin-Centre Nationale d'Art Contemporain, 2003.
Madesta, Andrea, et al. *Paul Morrison: Chloroplast*. Cologne: Walther König, 2002.

Otto Muehl

Born in Grodnau, Austria, in 1925. Lives in Moncarpacho, Portugal. Performance artist, painter, filmmaker, and writer. After serving in the German army during World War II, studied painting in Vienna. By 1963 began staging violently expressive performances, using both men and women, usually naked, in ritualistic actions reflecting the need for cathartic reconstruction of society and the self in the post-Nazi era. Many performances also confronted sexual taboos. In the early 1960s founded Viennese Actionism with Hermann Nitsch, Günter Brus, and Rudolf Schwarzkogler. Sometimes had his actions documented in photographic series or on film. Printmaking comprises a few screenprint projects, including a 1967–68 series related to paintings depicting world leaders in an unflattering, harshly colored, flatly contoured style related to Pop art; several posters advertising actions and Happenings; and a 1971 series depicting his earlier actions. In the late 1960s also issued printed ephemera under the name Zock-Press, which accompanied the political action group Zock. In the early 1970s withdrew from the art world and established the Action Analytical Commune, a utopian community uniting art and life. See www.archivesmuehl.com. *SF*

Klocker, Hubert, ed. *Wiener Aktionismus, Wien 1960–1971: Der zertrümmerte Spiegel/Viennese Aktionism, Vienna 1960–1971: The Shattered Mirror. Günter Brus, Otto Mühl, Hermann Nitsch, Rudolf Schwarzkogler*. Klagenfurt, Austria: Ritter, 1989.
Noever, Peter. *Otto Muehl: Lebel, Kunst, Werk: Aktion Utopie Malerei 1960–2004*. Cologne: Walther König, 2004.

Antoni Muntadas

Born in Barcelona in 1942. Lives in New York. Video and multimedia installation artist interested in critically intervening in modes of communication, such as the press, publicity, and television. Member of Conceptual Catalan collective *Grup de Treball* (1973–75). After brief flirtation with painting in the 1960s, pioneered video as artistic medium in the early 1970s, and fully dedicated himself to multimedia installations throughout the 1980s. In 1992 completed monumental project for public sites in twelve countries in Europe, relating design, architecture, communication, and power to the social and cultural roles of occupied spaces. Began making multiples in the late 1970s and prints in the early 1980s, working with publishers Estampa Ediciones and Arts + Prints, both in Madrid, and CNEAI, Chatou, France, among others. Has infiltrated everyday means of communication through numerous magazine and newspaper interventions worldwide. Also produces CD-ROMs, posters, billboard projects, artists' books, and a multitude of ephemera, such as stickers and postcards. See www.thefileroom.org. *AL*

Augé, Marc, et al. *Muntadas, On Translation: I Giardini*. Venice: Spanish Pavilion, 51st Venice Biennale, 2005.
Lebrero Stals, José, et al. *Muntadas: On Translation*. Barcelona: Museu d'Art Contemporani, 2002.

Museum in Progress

Arts association founded in Vienna in 1990 by Kathrin Messner and Josef Ortner that seeks to integrate contemporary art into everyday life. Forged innovative channels for cooperation among business, art, and media. Partners with the Austrian government, foreign consulates, galleries, and museums to commission artists for media-specific projects. Embraces the context-dependent and temporary nature of exhibitions organized for mass media forms, such as daily newspapers, news and business magazines, and public television, as well as for public venues, such as billboards, opera houses, theaters, and building facades. Often works in series, sometimes choosing a theme, and organizes all logistical details but exerts no editorial control over artists' final works. Hans-Ulrich Obrist has been an editor of series since 1995, and various curators are chosen for different projects. Has collaborated with more than 400 international artists, including Christian Boltanski, Richard Hamilton, Mona Hatoum, Jenny Holzer, Peter Kogler, Wolfgang Tillmans, and Kara Walker, on more than fifty projects. See www.mip.at. *AL*

Messner, Kathrin, and Josef Ortner, eds. *Museum in Progress*. Vienna: Museum in Progress, 2000.

Olaf Nicolai

Born in Halle an der Saale, Germany, in 1962. Lives in Berlin. Sculptor and environmental designer whose works often explore social conditions and the relationship between nature and artifice, particularly design's ability to affect everyday life. Has created environments such as a skateboard park, an alternative golf course, and a beauty salon that only bleaches hair blond. Editioned works also aim to transform society and alter social space through design, often necessitating audience interaction. To this end, has distributed postcards at installation sites, produced stickers, stamps, and newspaper inserts for mass distribution, created a perfume for trees, and has published his own broadsheet, *Die Gabe* (The Gift), since 1994. Has created approximately three-dozen editioned projects, including prints and multiples, plus nearly forty artists' books, self-publishing many and also working with publishers Carolina Nitsch Editions, New York; Revolver, Frankfurt; and Galerie Eigen + Art, Leipzig and Berlin. *AL*

Pfleger, Susanne, and Olaf Nicolai, eds. *Olaf Nicolai: Rewind Forward*. Ostfildern-Ruit, Germany: Hatje Cantz, 2003.

Hermann Nitsch

Born in Vienna in 1938. Lives in Prinzendorf, Austria. Performance artist, painter, printmaker, writer, composer, and a founding member of Viennese Actionism. Since 1957 has staged more than 100 often controversial performances as part of his Orgies Mysteries Theater (O.M. Theater), combining nudity, animal sacrifice, and blood and other props to invoke primitivism and violence as cathartic response to difficult, repressed emotions in postwar Austria. Incorporating both pagan and early Christian rituals and symbolism, explores issues of purification and redemption. Also makes related "action" paintings using blood or red paint, sometimes as part of his performances. Has also produced related texts, musical scores, and diagrammatic drawings. Often documents performances through photography or audio and video recordings. From 1984 to 1992 worked on major print series, *The Architecture of the O.M.*

Theater, published by Fred Jahn, Munich, comprising four portfolios totaling nearly 100 lithographs with etching and, in a few cases, hand additions. Has also completed a few single prints with publishers, such as Galerie Heike Curtze, Düsseldorf and Vienna, and Edition Krinzinger, Vienna, as well as a self-published monumental screenprint on fabric. See www.nitsch.org. *SF*

Gachnang, Johannes, et al. *Die Architektur des Orgien Mysterien Theaters/The Architecture of the O.M. Theatre*. Munich: Fred Jahn, 1987–93.
Klocker, Hubert, ed. *Wiener Aktionismus, Wien 1960– 1971: Der zertrümmerte Spiegel/Viennese Aktionism, Vienna 1960–1971: The Shattered Mirror, Günter Brus, Otto Mühl, Hermann Nitsch, Rudolf Schwarzkogler*. Klagenfurt, Austria: Ritter, 1989.

Paul Noble

Born in Dilston, England, in 1963. Lives in London. Draftsman and installation artist known for large-scale, visionary pencil drawings infused with literary, poetic, and political messages that utilize lexicon of architectural plans. Based on an invented alphabet and typeface, "Nobfont," intricately detailed fantasy landscapes display the geography, history, and mythology of the imaginary city Nobson Newtown. Work rooted in postwar British social programs as much as his own experience surviving on welfare in the 1990s. Produced a multiple, *Doley* (1996), a no-win board game in which players compete to remain on the public dole. Founding member of artist-run alternative exhibition space City Racing (1988–98). Editioned projects include artists' books and foldout maps. Has also experimented with etching, lithography, and wallpaper. Has collaborated with *Nest* magazine and publishers Alberta Press, London, and Verlag der Buchhandlung Walther König, Cologne. *AL*

Speck, Reiner, Gerhard Theewen, and Maureen Paley, eds. *Introduction to Nobson Newtown*. London: Interim Art; Cologne: Salon, 1998.
Spira, Anthony, and Heike Munder. *Paul Noble*. London: Whitechapel Art Gallery, 2004.

OHO

Artist's group active in Ljubljana, Yugoslavia (now Slovenia), from 1966 to 1971. Ever-shifting membership included visual artists, critics, filmmakers, and theoreticians. Notable for diverse mediums pursued, including installation, video, performance, drawings, visual and Concrete poetry, prints, and books. Established relationships with international avant-garde, developing variants of *Arte Povera*, Land art, Body art, and a form of spiritual Conceptual art. Created first Conceptual video works in the region and produced numerous experimental publications. Adopted name from a book by members Marko Pogačnik and Iztok Geister (I. G. Plamen), derived from a combination of Slovenian words *oko* (eye) and *uho* (ear) as well as an expression of astonishment. First works comprised comic strips and Happenings documented in films and photographs. Between 1966 and 1968 published a collection of about twenty books and other publications. On brink of international recognition, abandoned object-making to pursue spiritual connections among group members and between group and nature, founding the Family commune in the village of Šempas in 1971. *AL*

Zabel, Igor. *OHO: Retrospektiva*. Ljubljana, Slovenia: Moderna Galerija, 1994.

Julian Opie

Born in London in 1958. Lives in London. Painter, sculptor, filmmaker, installation artist, and printmaker who first emerged on the British art scene in the 1980s with series of playful folded-steel sculptures of everyday objects that bridged Pop art and Minimalist traditions. Later developed a style that draws on the visual language of signs, symbols, and computer simulation to explore a code of generic representation; recurrent subjects include simplified architectural and figural models, simulated landscapes, and virtual reality. Achieves signature aesthetic with the help of digital technology, either creating computer-generated images or manipulating existing photographs. In recent projects has focused on the nature of portraiture, using digital technology to transform photographic portraits into simple line drawings that depict standardized representations of universal types. First invited to make prints by publisher Alan Cristea in 1998, and has continued to collaborate with the publisher on a number of portfolios, individual prints, and various ephemera. Often works with digital or screenprint mediums to achieve smooth, uniform surfaces, flat color, and an aesthetic of mass production. Underscoring their essential seriality, recycles single images into different and frequently unconventional formats and contexts, including billboards, road signs, decals, LED screens, wallpaper, computer simulations, T-shirts, and album covers. See www.julianopie.com. *AG*

Horlock, Mary. *Julian Opie: JO*. London: Tate, 2004

Blinky Palermo (Peter Heisterkamp)

Born in Leipzig in 1943. Died in Kurumba, Maldives in 1977. Painter whose short career was dedicated to investigating the fundamental elements of form and color. Studied under Joseph Beuys at the Kunstakademie Düsseldorf from 1962 to 1967. Assumed pseudonym from American boxing promoter Frank "Blinky" Palermo in 1964. Between 1966 and 1972 produced radical series *Fabric Pictures*—for which he had his wife and others stitch strips of colored fabrics into horizontal bands—aligning himself with both Minimal and Conceptual approaches. Continuing to work with geometric shapes, after 1972 made paintings on aluminum and steel, often as series. Beginning in 1968, also created site-specific wall paintings (all now destroyed) that altered their architectural settings. Began making prints in 1966 and executed thirty-seven editions in total, some as series. Most are geometric abstractions rendered in an irregular, hand drawn style rather than with hard edges. Usually worked in screenprint, to attain uniform areas of color, and occasionally lithography. Published most often with Edition der Galerie Heiner Friedrich, Munich, but also with Edition Staeck, Heidelberg, as well as various German museums in conjunction with exhibitions. *SF*

Jahn, Fred, ed. *Palermo: Die gesamte Grafik und alle Auflagenobjekte 1966 bis 1975*. Munich: Fred Jahn, 1983.
Maas, Erich, and Delano Greenidge, eds. *Blinky Palermo, 1943–1977*. New York: D. Greenidge Editions, 1989.

Eduardo Paolozzi

Born in Edinburgh in 1924. Died in London in 2005. Sculptor, designer, and printmaker. Emerged in London in the early 1950s as founding member of the Independent Group, an organization of artists, architects, and writers exploring the impact of popular culture on modernism. Made abstract or semi-abstract sculpture incorporating machine parts, reflecting his

interest in technology as well as popular culture. Avid collector of printed ephemera, from pulp books and magazines to engineering diagrams. Introduced other British Pop artists to this commercial imagery and spearheaded radical thinking about art and mass media. Also used this material as basis for collages reflecting high saturation of media images in contemporary experience. Published first print in 1950. Working with Kelpra Studio in London beginning in 1962, created revolutionary screenprints based on his collages and exploiting the medium's potential for a hard-edge, mechanized look. Altogether completed several hundred prints as well as some illustrated books utilizing various techniques and working with publishers and printers such as Advanced Graphics London, Editions Alecto, Petersburg Press, and Bernard Jacobson Gallery, all in London. *SF*

Miles, Rosemary. *The Complete Prints of Eduardo Paolozzi: Prints, Drawings, Collages, 1944–1977.* London: Victoria & Albert Museum, 1977.
Spencer, Robin, ed. *Eduardo Paolozzi: Writings and Interviews.* Oxford: Oxford University Press, 2000.

Parkett

A contemporary journal of art and ideas, founded in Zurich in 1984, to foster a dialogue between art constituencies in Europe and the United States. Overseen by editor-in-chief Bice Curiger and editor Jacqueline Burckhardt, Zurich, two of the original founders, and by editor Cay-Sophie Rabinowitz, New York, and publisher Dieter von Graffenried. Published three times per year, presenting texts in both English and German. Each issue is conceived as a collaboration with one or more international artists, whose work is explored in essays by leading writers and critics. Each featured artist also creates an editioned print, photograph, or multiple as part of the interchange. Each issue also contains a specially conceived page-art insert by yet another artist. More than seventy volumes and some 150 editions have been published to date, representing "a small museum and a large library on contemporary art." Artists range from established figures, such as Sigmar Polke, Gerhard Richter, and Alex Katz, to newer talents, including Pipilotti Rist, Wilhelm Sasnal, and Eija-Liisa Ahtila. See www.parkettart.com. *SF*

Varadinis, Mirjam, ed. *Parkett: 20 Years of Artists' Collaborations.* Zurich and New York: Parkett, 2005.

Wye, Deborah, and Susan Tallman. *Parkett: Collaborations and Editions since 1984.* Zurich and New York: Parkett, 2001.

Simon Patterson

Born in Leatherhead, England, in 1967. Lives in London. While an art student at Goldsmiths College, London, was included in the seminal 1988 *Freeze* exhibition that launched the careers of a new generation of British artists. Using strategies from Minimalism and Conceptualism, makes paintings, wall drawings, installations, and films based on diagrams or maps, restructuring or reinterpreting information from a personal, often subversive, point of view. By manipulating familiar codes of representation, examines the ways we assess information and encourages new or unexpected connections in work that is often humorous, accessible, and poetic all at once. Has also made several site-specific public art projects, including three different wallpaper installations. Made his first print, a lithograph, based on the map of the London Underground, in 1992, and has since made more than a dozen prints. Works primarily in lithography and screenprint, but has also made digital prints. Most are self-published and produced at various workshops, including Advanced Graphics London for screenprinting. Since 1989 has also made several artists' books, as well as page-art projects commissioned for magazines and exhibition catalogues. *SF*

Bickers, Patricia, ed. *Simon Patterson.* Newcastle-upon-Tyne, England: Locus+, 2002.

A. R. Penck (Ralf Winkler)

Born in Dresden in 1939. Lives in Dublin and Düsseldorf. First exhibited his work in 1956. Rejected by the state art academies in East Germany, began to pursue art on his own. Developed an intense interest in cybernetics and mathematics during the mid-1960s, leading to the development of his "Standarts," a system of pictographic symbols. Adopted the pseudonym A. R. Penck in the late 1960s, allowing him to safely show his work in the West. Produced his first screenprint in 1970. Also turned to the book format at this time, publishing more than a dozen volumes within fifteen years. In 1978 cofounded an underground printing house in Dresden and produced etchings there. Emigrated to Cologne in 1980, after which the woodcut gained a prominent position in his

printmaking output. To date has made approximately four hundred prints as well as diverse ephemera, including record jackets for his experimental jazz band and inserts for the journal *Krater und Wolke*, which he edited. Has worked with several publishers, including Edition der Galerie Heiner Friedrich and Sabine Knust•Maximilian Verlag, both in Munich; Galerie Michael Werner, Cologne and New York; and Galerie Michael Schultz, Berlin. *GW*

Lehmann, Hans-Ulrich, and Theilmann Bernhard. *A. R. Penck: Verflucht weit weg.* Sonneberg, Germany: Comptoir-Kunstmagazin, 2003.
Thurow, Beate, and Siegfried Gohr. *A. R. Penck: Holzschnitte 1966–1995.* Reutlingen, Germany: Städtisches Kunstmuseum Spendhaus Reutlingen, 2003.

Giuseppe Penone

Born in Garessio, Italy, in 1947. Lives in Turin. Sculptor, Conceptual artist, and member of the Italian *Arte Povera* movement, which stressed the use of ordinary ("poor") materials as a means of bringing art closer to life, in the late 1960s. Has consistently used plant life, especially trees, as material and motif, highlighting organic processes and the relationship between man and nature. In the early 1970s began making casts and imprints of his hands and other body parts, reflecting the notion of body and skin as a field of psychic energy and tactile communication. Has also made rubbings from wooden planks, plants, and other materials. Sometimes incorporates poetic texts into sculptures and works on paper. Since 1971 has occasionally made artists' books and other printed ephemera, such as announcements and posters, as well as a few multiples. Other printed work consists of a large series of lithographs produced with Marco Noire Editore, Turin, in 1989; five lithographs with the Centre Genevois de la Gravure Contemporaine in 1993; and a book with etchings with Edition Jacob Samuel, Santa Monica, in 2000. *SF*

De Zegher, Catherine, ed. *Giuseppe Penone: The Imprint of Drawing.* New York: The Drawing Center, 2004.
Grenier, Catherine. *Giuseppe Penone.* Paris: Centre Pompidou, 2004.

Dan Perjovschi

Born in Sibiu, Romania, in 1961. Lives in Bucharest. Installation artist known for covering the interiors

of galleries and entire buildings with wry drawings. Produces thousands of simple compositions of line and text that take complex topics, such as politics, economics, and the art market, as their subject matter. Together with other Romanian intellectuals concerned with the country's post-Communist future joined the activist Group of Social Dialogue in 1991. At this time began contributing to the magazine *22*, a Bucharest-based opposition weekly for which he became art director. In the early 1990s, joining his wife, Lia, began amassing books, catalogues, postcards, slides, and videos as part of the Contemporary Art Archive (now the Center for Art Analysis), a resource for local artists and the general public. In addition to his large installations, considers his editioned artists' books, page inserts, and printed ephemera an important component of his work. Has published more than ten books, collaborating with Pont La Vue Press and Franklin Furnace, both in New York, along with several European museums. *GW*

Dan, Liviana, and Timotei Nădăşan, eds. *Dan Perjovschi: Walls, Floors, Museums and Mines 1995–2003*. Sibiu, Romania: Brukenthal Museum, 2003.

Grayson Perry

Born in Chelmsford, England, in 1960. Lives in London. Best known for ceramics, but also works in embroidery, photography, performance, and film. Since the early 1980s has made traditionally shaped earthenware vases subversively glazed with elements of class-based satire and pornography as well as images of himself, his family, his childhood, and his transvestite alter ego, Claire. Explores issues of psychology, sexuality, politics, and culture. Creating a tension between form and content, plays with accepted notions of pottery as a polite, decorative medium. Won the Tate's Turner Prize in 2003. Made first print, an etching, in 2004, and completed a second in 2005, both published by The Paragon Press, London. Both are monumental images modeled respectively on an antique map and a historic battle scene and covered with minute details that display the same level of consummate craftsmanship as his pottery. Also made a linoleum cut portrait diptych in 2005. Published a graphic novel, *Cycle of Violence*, in 1992 (reissued 2002). *SF*

Boot, Marjan, et al. *Grayson Perry: Guerrilla Tactics*. Rotterdam: Nai Uitgevers, 2002.

Great-Rex, Eric. "The Emotional Landscape Tradition: Grayson Perry as Printmaker." In Mark Hampson and Eric Great-Rex, *Contemporary British Printmaking 2005*. Purchase, N.Y.: Brownson Gallery and Manhattanville College, 2005.

Pawel Petasz

Born in Kalisz, Poland, in 1951. Lives in Elbląg, Poland. Painter, artist's book maker, and Mail artist who works in a vast array of modes and mediums, from Surrealist painting, collage, and hand-cut rubber stamps to photocopied bookworks and visual poetry. Participated in the first Mail art exhibition in Poland in 1977. Began publishing *Commonpress*, a Mail art journal with a unique rotating editorship, in 1977. Editors were selected from among contributors to prior issues. Undertook large underground series *This Is Mail Art*, consisting of several thousand small, recycled artworks whose recipients applied additional printed or collaged elements and then returned them to circulation. From 1980 to 1990 approximately 5,000 works were distributed in this way; many ended up in Mail art collections. Also made unique artists' books throughout the 1970s, often with full narratives made with stamps carved from rubber erasers. *AL*

Welch, Chuck, ed. *Eternal Network: A Mail Art Anthology*. Calgary: University of Calgary Press, 1995.

Jaume Plensa

Born in Barcelona in 1955. Lives in Barcelona and Paris. Catalan sculptor, installation artist, and printmaker who gained recognition in the 1980s with work resonating with primal themes relating to the body and its biological processes. Installations of doors or lampposts and sculptures of boxlike "containers" metaphorically reference the body or its individual organs. Incorporates text and poetry into both sculpture and printed work to strengthen personal and universal associations. Printed work extends body themes with imagery, including fragmented self-portraits, inventories of internal structures, and studies of human diseases, often interpreted conceptually to raise issues of identity and collective memory. Has completed more than 100 print projects in the last three decades, working extensively with the printer Magí Baleta, Barcelona, and a diverse selection of publishers, including Joan Barbarà, Galeria Carles Taché, Edicions T, and

Polígrafa Obra Gráfica, all in Barcelona, and Michael Woolworth, Paris. *AL*

Joubert, Caroline, and Laura Medina, eds. *Jaume Plensa: Livres, estampes et multiples sur papier/Books, Prints and Multiples on Paper, 1978–2003*. Caen, France: Musée des Beaux Arts; Lanzarote, Canary Islands: Fundación César Manrique; Valencia: IVAM Centre Julio González, 2004.

Point d'ironie

Broadsheet begun in 1997 by fashion designer agnès b. and curator Hans-Ulrich Obrist in conversation with artist Christian Boltanski. Presents a free work of art on paper in the age of electronic media, resulting in what agnès b. refers to as "a hybrid periodical, half magazine, half poster." Edited by Obrist, issues appear approximately six times a year, and are distributed worldwide through agnès b. boutiques, bookstores, museums, galleries, schools, and libraries in editions that range from 100,000 to 300,000. Each issue is identical in format—eight unbound pages folded like a newspaper—but invited artists have carte blanche in terms of the issue's content. More than forty issues have appeared to date, featuring a wide variety of international artists, including Christian Boltanski, Hans-Peter Feldmann, Gilbert & George, Annette Messager, and Rosemarie Trockel, as well as photographers, writers, musicians, architects, and filmmakers. See www.pointdironie.com. *SS*

Obrist, Hans-Ulrich. "*Point d'ironie*: A Conversation with Christian Boltanski." In *Point d'ironie*. Ljubljana, Slovenia: MGLC, International Centre of Graphic Arts, 2004.

Sigmar Polke

Born in Oels, Germany, in 1941. Lives in Cologne. Prominent figure in German art for more than four decades, working extensively in painting, photography, drawing, and printmaking. Moved with his family from East to West Germany in 1953. In 1963 cofounded, with Gerhard Richter and Konrad Lueg, Capitalist Realism, a German aspect of Pop art that focused on that country's growing consumer culture and media-saturated society. In images based on newspaper and magazine photographs subverted advertising aimed at Germany's new leisure class, often with ironic, slyly critical effect. Continued to

employ photographs as the basis of many later works, but often to more conceptual, political, or abstract ends. Incorporates techniques of transference, layering, and reproduction—all inherent to printed imagery—which may account for his interest in printmaking. Although he simulates photographic effects in his handmade paintings, he has utilized photographic techniques, such as offset or photo-screenprint, for almost all of his approximately 150 prints to date. Among these are several printed inserts for catalogues and magazines. Publishers include Edition René Block in Berlin, Griffelkunst-Vereinigung in Hamburg, and Edition Staeck in Heidelberg. *SF*

Becker, Jürgen, and Claus von der Osten, eds. *Sigmar Polke: The Editioned Works 1963–2000. Catalogue Raisonné.* Osfildern-Ruit, Germany: Hatje Cantz, 2000.

Paoletti, John T. "Higher Beings Command: The Prints of Sigmar Polke." *Print Collector's Newsletter* 22, no. 2 (May–June 1991): 37–44.

Markus Raetz

Born in Bern, Switzerland, in 1941. Lives in Bern. Works in a variety of mediums in a conceptual mode. Chiefly self-taught, began his career with comic strips displaying a masterful draftsmanship, a quality still at the core of his work. In the late 1960s began exploring the mechanism of perception to reflect the way a work of art is inherently fictional in nature. Imagery borders on the surreal, engaging illusion (particularly anamorphosis) and visual puns and metaphors that entice the viewer to unravel its puzzling qualities. Has created a diverse body of sculpture, installations, drawings, sketchbooks, and photography, often using simple materials and forms that belie the complexity of his work. A prolific and experimental printmaker; has made more than 300 prints, though far fewer have been editioned. Has worked in almost every technique, focusing on etching, a medium that suits his refined draftsmanship. Has collaborated with a variety of publishers in Bern, Amsterdam, and Zurich, particularly with Edition Stähli, Zurich, as well as Crown Point Press, San Francisco. *JH*

Mason, Rainer Michael, and Juliane Willi-Consandier. *Markus Raetz: The Prints, 1958–1991.* Geneva: Cabinet des Estampes, Musée d'Art et d'Histoire; Bern: Kunstmuseum; Zurich: Galerie & Edition Stähli, 1991.

Arnulf Rainer

Born in Baden, Austria, in 1929. Lives in Vienna and Enzenkirchen, Austria. Painter and printmaker. Influenced by Surrealism and Abstract Expressionism, made early experiments with "unconscious," automatist techniques of drawing and painting. In 1953 began making signature overpaintings by covering existing images—his own and other artists'—with layers of frenzied abstract marks evoking extreme emotional states. This aggressive, performative approach derives from the tormented reality of postwar Austria and links him tangentially to Viennese Actionism. From 1956 made many works on cross-shaped canvases, reflecting religious concerns and primal themes of life, death, and redemption. Began making prints in 1950. Started with lithographs and has since produced more than 500 works in various techniques, including, most prominently, drypoints in characteristically frantic and dense clusters of abstract lines. Also known for superimposing such marks over photogravure self-portraits, scratching the printing plate in an apparently violent, self-negating manner. Has collaborated on editions with Günter Brus and Dieter Roth. Has worked with various European publishers including Edition der Galerie Heiner Friedrich, Munich; Galerie Heike Curtze, Düsseldorf and Vienna; and Sabine Knust•Maximilian Verlag, Munich. *SF*

Adolphs, Volker. *Arnulf Rainer, die Radierungen.* Bonn: Wienand, 1997.

Breicha, Otto. *Arnulf Rainer, Überdeckungen, mit einem Werkkatalog sämtlicher Radierungen, Lithographien und Siebdrucke, 1950–1971.* Vienna: Tusch, 1972.

Gerhard Richter

Born in Dresden in 1932. Lives in Cologne. Preeminent painter of the postwar period. Moved from Dresden, in what was then East Germany, to Düsseldorf, in West Germany, in 1961. In 1963 was cofounder, with Sigmar Polke and Konrad Lueg, of Capitalist Realism, a German form of Pop art that focused on that country's media-saturated consumer society, often with a subtly critical or politically charged edge. Makes realistic paintings after photographs, snapshots, or newspaper illustrations, often manipulating his imagery to address issues of perception and illusion. Since 1976, deliberately defying categorization and questioning distinctions between representation and abstraction, has concurrently made

broadly gestural abstract paintings. Began making prints in 1965 and has completed more than 100 to date, most before 1974. Almost all have utilized photographic printmaking techniques, such as screenprint, offset, and collotype, which he appreciates for their mass-produced, "non-art" appearance. Has produced editions with various galleries and publishers including HofhausPresse, Düsseldorf; Galerie h, Hannover; Edition der Galerie Heiner Friedrich, Munich; and Edition René Block, Berlin, as well as numerous German museums. *SF*

Butin, Hubertus, et al. *Gerhard Richter: Editions 1965–2004. Catalogue Raisonné.* Ostfildern-Ruit, Germany: Hatje Cantz, 2004.

Paoletti, John T. "Gerhard Richter: Ambiguity as an Agent of Awareness." *Print Collector's Newsletter* 19, no. 1 (March–April 1988): 1–6.

Bridget Riley

Born in London in 1931. Lives in London. Studied at Goldsmiths College and the Royal College of Art, both in London, in the 1950s. Painter, often associated with Op art, who emerged in the early 1960s with bold black and white compositions of shifting geometric patterns that gave extraordinary optical sensations and the illusion of vibration and movement. Began working in grays and then color in the mid-1960s, creating compositions both subtle and penetrating, with the intent of stimulating emotional responses such as "repose and disturbance." Made first screenprint in 1962, a medium that would perfectly suit her hard-edged shapes and saturated colors. Experimented with printing on Perspex in 1965 with the now renowned Kelpra Studio, London. Has completed more than sixty screenprints to date, published by Robert Fraser Gallery, London; Pace Editions, New York; and Artizan Editions, Hove, England, among others. Has also produced benefit prints for museums and social causes. *JH*

Schubert, Karsten. *Bridget Riley: Complete Prints, 1962–2005.* London: Ridinghouse, 2005.

Dieter Roth

Born in Hannover in 1930. Died in Basel in 1998. An innovator and iconoclast who continually challenged conventions, evolving through several styles related to Concrete poetry, Fluxus, and Pop, Kinetic, and

Conceptual art movements. Blurred the boundaries between mediums, working in sculpture, painting, printmaking, artists' books, film, and poetry. Emphasized themes of metamorphosis and decomposition in radical works incorporating foodstuffs like chocolate, cheese, and sausage. Lived a mostly itinerant life, and made Iceland his adopted homeland in 1957. Began printmaking as a teenager and over his career completed more than 500 prints. Worked in virtually every traditional medium, and often experimented by reusing the same print surfaces but altering their colors, layers, or orientation to produce variants of an image. Devised unusual "pressings" and "squashings" of organic materials onto paper or other surfaces in order to make editions of numerous unique variants. Also produced exceptionally inventive multiples and artists' books. Frequently collaborated with peers such as Daniel Spoerri, Richard Hamilton, and Arnulf Rainer. Worked extensively with printers Hartmut Kaminski, Düsseldorf; Karl Schulz, Braunschweig, Germany; and Petersburg Press, London, among others; and with Rudolf Rieser, Cologne, for multiples. See www.dieter-roth-museum.de. *SF*

Dobke, Dirk. *Dieter Roth: Books and Multiples. Catalogue Raisonné*. London: Edition Hansjörg Mayer, 2004.
——. *Dieter Roth: Graphic Works, Catalogue Raisonné 1947–1998*. London: Edition Hansjörg Mayer, 2003.

Niki de Saint Phalle

Born in Paris in 1930. Died in San Diego, California, in 2002. Self-taught sculptor, performance artist, and filmmaker associated with *Nouveau Réalisme* who came to prominence with radical performance series from 1960 to 1961 in which plaster reliefs incorporating pockets of paint were fired at with a gun to create color staining. In 1964 conceived her *Nanas*, primal maternal figures that appear in every size, from small statuettes to monumental installations and outdoor public commissions. Began printmaking in 1962 with an invitation for a New York exhibition. In 1965, at first exhibition of *Nanas*, gallery owner Alexander Iolas suggested screenprint as new outlet, and published her first artist's book. Signature forms of colorful, imaginative creatures and monsters stem from experimentation in this medium, and became characteristic motifs in sculpture. Produced more than 400 prints, books, and multiples, including ephemeral materials such as stickers, stamps, posters, balloons and perfume packaging. Also made costumes, jewelry, and set designs. Published with Lapis Press, Santa Monica; Atelier Aldo Crommelynck, Paris; and Galerie Kornfeld, Bern, among others. *AL*

Perlein, Gilbert, et al. *Niki de Saint Phalle: La Donation*. Nice: Musée d'Art Moderne et d'Art Contemporain, 2002.

David Shrigley

Born in Macclesfield, England, in 1968. Lives in Glasgow. Prolific output since the early 1990s consists mainly of illustrations rendered in a rudimentary style that is often labeled faux naïve. Conceived as single paintings or drawings, compiled in artists' books, or translated into traditional prints or mass-media ephemera, his images range from incisively humorous to comically absurd, often employing crudely scrawled text, diagrams, lists, and charts to that effect. Though ostensibly simplistic, such works address the pathetic, melancholic, evil, bizarre, and traumatic aspects of life, love, and sex. Less known, his sculptures juxtapose unlikely objects and locales, resulting in witty, sometimes macabre creations. Has worked extensively with printed ephemera and mass-audience formats, ranging from billboards and newspapers to an illustration for the London Underground map. Has published nearly twenty artists' books, initially in small, photocopied editions through his own The Armpit Press, and more recently through Redstone Press and Book Works, both in London, and other small publishers. Began experimenting with formal printmaking in 2000 and has produced three sets of etchings and one set of woodcuts to date. See www.davidshrigley.com. *AG*

Cruz, Amada, and Russell Ferguson. *David Shrigley*. Annandale-on-Hudson, N.Y.: Center for Curatorial Studies, Bard College, 2002.

Daniel Spoerri (Daniel Isaac Feinstein)

Born in Galati, Romania, in 1930. Lives in Seggiano, Italy. Performance artist and sculptor of assemblages. After an early career in classical dance and theater, turned to art in 1959 and launched Edition MAT (*Multiplication d'Art Transformable*), a pioneering publisher of multiples. As a founding member of *Nouveau Réalisme* in Paris in 1960, began making his *tableaux-pièges* (snare-pictures), in which objects left over from a meal were glued to a tabletop, then hung on a wall. Highlighting materials and experiences from everyday life, they were often created during performance-based events. In 1963 staged exhibition at Galerie J, Paris, transforming the space into a restaurant, with art critics as waiters. Opened Restaurant Spoerri in Düsseldorf in 1968, and the adjacent Eat Art Gallery in 1970, presenting food-related Happenings and exhibitions there through 1972. Made several artists' books and occasional prints. Created sporadic multiples for his own Edition MAT as well as Edition Tangente, Heidelberg, and Galerie Seriaal, Amsterdam. Also made posters and other printed ephemera, including menus, stationery, and calling cards for his restaurant. Participated occasionally in Fluxus events. See www.danielspoerri.org. *SF*

Girard-Fassier, Géraldine, et al. *Daniel Spoerri Presents Eat Art*. Paris: Galerie Fraîch'attitude, 2004.
Hartung, Elisabeth, et al. *Daniel Spoerri presents Eat-art*. Nuremberg: Moderne Kunst Nürnburg, 2001.

Telfer Stokes

Born in Saint Ives, England, in 1940. Lives in Southwold, England. Studied at the Slade School of Fine Art, London, from 1958 to 1962, and started career as a painter. Established Weproductions imprint in London in 1971 to publish his own books. Joined at Weproductions by artist Helen Douglas in 1974; relocated to Yarrow, Scotland, in 1976, and installed an offset printing press (Flat Iron Press) in 1979. In addition to making books individually, between 1974 and 1994 created several volumes in collaboration with Douglas. Printed most of their books on their own press in the 1980s and early 1990s, publishing large editions usually in paperback format. Since the late 1990s, with advances in computer printing technology, the two have turned to commercial printers. Stokes has published twenty titles to date. Was an early advocate of the book format as a means of structuring visual narratives. Using sequences of photographs, sometimes embedded with text, creates books that promote art as a time-based phenomenon. Most offer a quasifilmic experience showing an object or scene as it changes or progresses, sometimes resulting in visual puns. See www.weproductions.com. *SF*

Courtney, Cathy. "Telfer Stokes." In *Speaking of Book Art: Interviews with British and American Book Artists*. Los Altos Hills, Calif.: Anderson-Lovelace Publishers, 1999.

notes on the publishers

**Compiled by Sarah Suzuki
with additional entries by Starr Figura,
Judith Hecker, and Gretchen Wagner**

These notes refer to publishers who issued works
featured in the Essays & Plates section of this volume.
Cities cited in the headings refer to current or last
place of operation.

//

Städtisches Museum Abteiberg, Mönchengladbach, Germany

See **Kassettenkatalog** in Notes on the Artists

//

Actes sud, Arles, France

Founded as cartographic book publisher ACTES (L'Atelier
de Cartographie Thématique et Statistique) near Arles,
France, in 1969 by Hubert Nyssen and Jean-Philippe
Gautier. In 1977 expanded publishing program to include
many general interest categories under the name Actes
sud with Françoise Nyssen, Bertrand Py, and Jean-Paul
Capitani, who continue to direct the organization today.
Moved to current headquarters in the Le Méjan quarter
of Arles in 1983, and opened Paris office in 1987. Today
publishes original poetry and literature as well as volumes
on a wide variety of subjects, including cuisine, history,
politics, and philosophy. Also issues series, including one
called *Sindbad*, which presents poetry and literature from
the Arab world. Has issued hundreds of titles about the
visual arts, including some artists' books, by Sophie Calle,
Annette Messager, and others. To date has published
more than 5,400 titles by over 2,500 authors in forty-five
languages. Le Méjan headquarters organizes lectures,
film series, and exhibitions, and includes an active
bookshop. See www.actes-sud.fr. *SS*

//

Alcool, Moscow

Established in 1996 in Moscow by artist Andrey Suzdalev
to publish his own and others' artists' books. With
sometime collaborator Leonid Tishkov, is an important
supporter of artists' books in Russia through publishing
and organizing and curating exhibitions. One of the
first Russian artists to consistently include new media
elements, such as sound, video, and digital technology,
as a component of his publications. Some projects,
including series *Genius Loci*, are inspired by Fluxus, and
begin with an action or Happening that is documented
in an artist's book. Since 2003 has published the hybrid
periodical/artist's book *B/W*, and continues to publish
actively. *SS*

//

Editions Alecto, London

Leading British publisher of Pop prints and multiples
during the 1960s. Founded in 1960 by Cambridge
University undergraduates Paul Cornwall-Jones
and Michael Deakin. Originally intended to publish
architectural prints of local colleges and campus
buildings for sale to alumni. Shifted focus to
contemporary art upon relocating to London in 1962 and
added four new directors, including Joe Studholme.
Worked closely with the screenprint workshop Kelpra
Studio. Collaborated with St. George's Gallery to
form The Print Centre, an exhibition space for new
editions, in 1963. Established printing facilities for
intaglio, screenprint, and lithography in 1964. Significant
projects include David Hockney's *A Rake's Progress*
(1963) and Eduardo Paolozzi's *As Is When* (1965), and
major works by Patrick Caulfield and Richard Hamilton.
Cornwall-Jones left in 1967 and would go on to found
Petersburg Press in 1968. From 1967 to the early 1970s,
established Alecto Gallery, a space to exhibit and sell their
publications. Had New York branch from 1967 to 1973.
Shortly after 1978 studio fire, publication of contemporary
editions stopped. In 1979 opened Alecto Historical
Imprints to publish new editions from historical plates
and medieval manuscript facsimiles, which continues
today under the direction of Studholme. See www.
editionsalecto.com. *SS*

Sidey, Tessa. *Editions Alecto: Original Graphics, Multiple
 Originals, 1960–1981*. Aldershot, England, and
 Burlington, Vt.: Lund Humphries, 2003.

//

ARC Musée d'Art Moderne de la Ville de Paris, Paris

ARC (*Atelier de Recherche et de Création*, or Workshop
for Research and Creation) is a center dedicated to
contemporary culture at the Musée d'Art Moderne de la
Ville de Paris (MAM), which is one of fifteen municipal
museums operated by the city of Paris. MAM opened in
1961 and is dedicated to collecting and exhibiting both
modern art, with primary focus on French artists, as well
as contemporary art, with a more international scope.
One important contemporary initiative was the exhibition
and publication series *Migrateurs*, organized by curator
Hans-Ulrich Obrist from 1993 to 2004. *SF*

//

Arrière-Garde, Elblag, Poland

Alias for artist Pawel Petasz, who used this nonexistent
entity to conceal his publishing activities in order to avoid
government censure in Communist-run Poland. Utilized
from approximately 1976 to 1986, primarily to publish
Petasz's own works. The name is a pun on the forward-
thinking artistic avant-garde, with Petasz's use of *arrière*

(rear or backward) alluding to the official government attitude toward the arts. *SS*

Art & Language Press, Coventry, England
See *Art-Language* in Notes on the Artists

Art & Project, Amsterdam
See *Art & Project Bulletin* in Notes on the Artists

Art & Public, Geneva
Established as a gallery in 1984 by Pierre Huber, who had previously owned a restaurant where he presented exhibitions. As his interest in art grew, he shifted from a role as restauranteur to gallerist and collector. Initially focused on work by Minimalist and Conceptual artists of the 1960s and 1970s, including Sol LeWitt and On Kawara. Soon began showing work by younger contemporary artists as well as photographers like Larry Clark and Nan Goldin. Became Art & Public in 1992. That same year initiated guest curator program in the gallery, and also expanded to publish artists' books, catalogues, and some multiples. Exhibition program continues today with mix of historical figures, including Lucio Fontana and Joseph Cornell, along with international contemporary artists. See www.artpublic.ch. *SS*

Galerie and Edition Artelier, Graz, Austria
Workshop, publisher of prints and multiples, and gallery founded in Graz in 1985 by Ralph and Petra Schilcher under the slogan "production, publishing, and presentation." During the 1970s, as a commercial printer, Ralph Schilcher occasionally had been asked to help artists produce posters at his screenprint shop. Intrigued by these collaborations, decided to open his own imprint and offer screenprint as an alternative medium for artists. Soon expanded to meet artists' growing demands, incorporating facilities for working with wood, metal, and plastic to create innovative three-dimensional multiples as well as for printing large-scale installations. Has worked with artists from both local and international art scenes, many of whom use conceptual approaches, including Martin Kippenberger, Peter Kogler, Joseph Kosuth, Eva Schlegl, Jörg Schlick, and Franz West. Continues to publish actively. See www.galerie-edition-artelier.at. *SS*

Weibel, Peter and Friedrich Tietjen. *Kunst ohne Unikat: Edition Artelier, 1985-1998.* Graz: Neue Galerie am Landesmuseum Joanneum; Cologne: Walther König, 1998.

Art for All, London
See **Gilbert & George** in Notes on the Artists

Art intermedia, Cologne
Progressive gallery and performance space founded by art critic and writer Helmut Rywelski. Open only from 1967 to 1972. Rywelski's experimental attitude was informed in part by the Fluxus concept of "intermedia"— art that crossed the boundaries of traditional mediums. Remained socially and politically engaged, and attempted to merge art and everyday life, as embodied by Fluxus Happenings. Art intermedia hosted groundbreaking performances by Joseph Beuys, Robert Filliou, and Wolf Vostell, among others. Published editions by gallery artists in unusual formats, including *Künstlerposte*, a collection of eight postal multiples by Beuys, Filliou, Dieter Roth, Daniel Spoerri, and others, and *Marktsgrafik*, a portfolio of ten prints that was intended for true democratic distribution, with each print priced at only 1 deutsche mark. *SS*

Art Metropole, Toronto
Not-for-profit organization founded in 1974 by Canadian artists' group General Idea (AA Bronson, Felix Partz, and Jorge Zontal) to provide an artist-run distribution center for artists' books, multiples, posters, videos, and other editions. At same time began amassing books and ephemera that formed the beginning of the Art Metropole Collection. Named for 1911 building where they opened their first space, which had housed one of Toronto's earliest galleries of the same name. Began publishing books and other works by artists in the late 1970s, with a special focus on Conceptual artists working in nontraditional and media-based techniques. Has also commissioned work in advertising and billboard formats. To date has published more than 300 editions by a wide range of artists, including Daniel Buren, Hans-Peter Feldmann, Ian Hamilton Finlay, Hamish Fulton, and David Shrigley. Although publishing activity continues, ceased collecting and, in 1997, the Art Metropole Collection of over 13,000 editions was donated to the National Gallery of Canada. See www.artmetropole.com. *SS*

Atelier Populaire, Paris
See **Atelier Populaire** in Notes on the Artists

Avery, Kenner and Weiner, Inc., New York
Formed in 1972 by Sharon Avery, Marty Kenner, and Lee Weiner to publish limited-edition prints to benefit the Youth International Party, a left-leaning, counterculture political party (also known as Yippies) led by Abbie Hoffman, which organized demonstrations at the 1972 Republican and Democratic national conventions. Published approximately nine projects by artists including Öyvind Fahlström, Claes Oldenburg, and Robert Rauschenberg, all of which have an antiwar or antiracism message. Collaborating printers included Chiron Press and Styria Studio, both in New York. When publishing activity ended in 1974, Avery went on to establish Redbird Editions. *SS*

agnès b., Paris
Fashion designer, collector, philanthropist, and gallerist, whose given name is Agnès Troublé. Began designing women's clothes at age nineteen, and opened first boutique, in Paris, in 1976. Today, privately owned company has 116 stores in Europe, the United States, and Asia. Paris store, in original location, has included an exhibition space, Galerie du Jour, since 1984, showing international artists, photographers, and filmmakers. Also features a bookstore/library with small displays, as well as agnès b. publications, including *Point d'ironie*, a mass-produced broadsheet circulated since 1997 and designed by artists from around the world. Also sells limited-edition artist-designed T-shirts. agnès b. has founded O'Salvation (with Harmony Korine) and Love Streams, film production companies that support cutting-edge, independent films, as well as her own personal projects. Has amassed a personal art collection focusing on contemporary photographers, ranging from Nan Goldin to Ryan McGinley. See www.agnesb.com and www.galeriedujour.com. *JH*

H. M. Bergs Forlag, Copenhagen
Established by H. M. Berg in Copenhagen in 1965 to publish literature by young Danish and international writers. After 1972 became involved with publishing artists' books on a modest scale, eventually issuing about

five projects by artists including Christian Boltanski and Annette Messager. Some projects were copublications with the Copenhagen-based Daner Galleriet, which also showed the work of Boltanski, Messager, and others. Publishing activities ceased in 1984. SS

//
Edition René Block, Berlin

Founded by René Block in 1964 along with his gallery to introduce avant-garde German artists associated with Fluxus, Pop, and Conceptual art practices. Inaugural gallery exhibition, *Neo-Dada, Pop, Décollage, Kapitalistischer Realismus*, included many artists central to the conception of German Pop. KP Brehmer, Gerhard Richter, Sigmar Polke, and Wolf Vostell would be included in the portfolio *Graphics of Capitalist Realism* in 1967, published by Block for Stolpe Verlag. Published the first of many Joseph Beuys multiples in 1966. Among nearly 100 publications are innovative projects by Marcel Broodthaers, Richard Hamilton, and Dieter Roth. Organized important exhibitions on prints and print techniques in 1972 and on the multiple format in 1974. Operated a New York gallery from 1974 to 1977, where he presented shows of Beuys and Fluxus artists, among others. In the mid-1970s began work as an independent curator which continues to this day, often publishing portfolios related to these projects. Berlin gallery closed in 1979. From 1982 to 1992 worked with Deutscher Akademischer Austauchdienst (German Academic Exchange Service), or DAAD, a federal program sponsoring a range of international artists to work in Berlin. Since 1997 has served as director of the Kunsthalle Museum Fridericianum in Kassel, Germany. SS

Block. Berlin: Edition René Block, 1981.

//
Book Works, London

Established in London in 1984 with the goal of commissioning, publishing, and distributing books by British and international contemporary artists and writers. Founded by a group of artists and bookbinders, including Jane Rolo, Pella Erskine Tulloch, Rob Hadrill, and Vanessa Marshall. Organization's first publications were issued in 1987. Since that time has established itself as a primary independent publisher of artists' works and writings, and has shown a dedication to supporting work that addresses political, social, racial, gender, and cultural issues. Initiates publications by both invitation and open submission, and usually produces print runs of 1,000 to

2,000 copies, with an accessible price of approximately $10 to $50. Has published approximately 120 books to date by such artists as Tacita Dean, Simon Patterson, and David Shrigley. See www.bookworks.org.uk. SS

Rolo, Jane, and Ian Hunt, eds. *Book Works: A Partial Anthology and Sourcebook.* London: Book Works, 1996.

//
Booth-Clibborn Editions, London

Established in 1990 by Edward Booth-Clibborn, former advertising art director and founder of Motif Editions. Published newsletter on communications and media by Marshall McLuhan, as well as posters by British artists, such as David Hockney and Patrick Caulfield, beginning in the late 1960s. In 1974 began publishing first of several award-winning annual industry publications on topics of creativity in media, including *European Illustration*, *European Photography*, *American Illustration*, and *American Photography*. Founded Booth-Clibborn Editions to reach a broader audience with innovative approach to publishing, and has issued some 150 titles, covering the fields of design, fine art (particularly contemporary), photography, new media, and architecture. Has worked with artists such as Antony Gormley, Damien Hirst, and Marc Quinn; and published design classics, including *Typography Now*, *Sneakers*, *Tibor*, *Mark Newson*, *Future Present*, and *Chicks on Speed*. Has also produced books for major institutions, including the State Hermitage Museum, St. Petersburg; the Kremlin, Moscow; and the Barbican Centre, The Saatchi Gallery, and the BBC, all in London, among others. Continues to publish actively. Booth-Clibborn's son, Charles Booth-Clibborn, founded The Paragon Press in 1986. See www.booth-clibborneditions.com. JH

//
Atelier Bordas, Paris

Workshop established in Paris in 1978 by Franck Bordas to further artistic experimentation with lithography through prints and books by a wide range of international artists, from Pierre Alechinsky, Jean Dubuffet, and Joan Mitchell to Jean-Charles Blais and James Brown. Founder and master printer Bordas comes from a family with a distinguished history in the print world: his grandfather was renowned lithographic printer Fernand Mourlot, and his father, Pierre Bordas, was a publisher. Ever interested in increasing the range of opportunities he can offer to artists, in 1985 restored and installed in his

studio a monumental press to allow work on a very large scale. Several years later was instrumental in opening a limestone quarry in Cevennes, France, to supply large-scale lithographic stones. Has published more than 200 projects to date, and continues to expand atelier's creative offerings, most recently with the introduction of digital mediums in 2001. Inaugurated new studio space and showroom in 2005. See www.atelierbordas.com. SS

//
BQ, Cologne

Established as a small project space by Jörn Bötnagel and Yvonne Quirmbach in 1998. Gallery space opened in 2002. Usually publishes an artist's book or catalogue in conjunction with each exhibition. Books are often designed by Quirmbach, who is a book and graphic designer. Has produced approximately twenty-five books to date by artists including David Shrigley and Richard Wright. SS

//
Kunstverein Braunschweig, Brunswick, Germany

Contemporary exhibition space established in 1832. Has long published editions in tandem with its exhibition program. The formal *Jahresgaben*, or annual editions program, began in 1967. Has since published dozens of editions by European and international artists in a wide variety of mediums, including multiples, etching, unique works, and photography, by Georg Baselitz, Joseph Beuys, and Martin Kippenberger, among others. Under current director, Karola Grässlin, publishes about fifteen editions per year. In addition, many of its exhibition catalogues are published in collaboration with Verlag der Buchhandlung Walther König, Cologne. See www.kunstverein-bs.de. SS

//
Benjamin H. D. Buchloh, Cambridge, Mass.

After studying literature and writing fiction in the 1960s, began working at German art galleries and publishing houses in the early 1970s. Edited the final two issues of the seminal artist's journal *Interfunktionen*, in 1974–75. Later moved to the United States, teaching and writing prominently on contemporary European art. Currently Professor of Modern Art at Harvard University. JH

Mehring, Christine. "The Story of Interfunktionen." *Artforum* 42, no. 9 (May 2004): 178–83, 233.

CCA Kitakyushu, Japan

CCA (Center for Contemporary Art) founded in the port city of Kitakyushu in southwestern Japan in 1997 by Nobuo Nakamura and Akiko Miyake, with governmental support and subsidy. Through exhibition and research programs, seeks to make Kitakyushu a world center for the study and exchange of ideas about contemporary art. Yearlong graduate-level education program is open to artists, researchers, and curators. Every year invites six to ten internationally recognized artists for residency, with each having an exhibition, and most making an accompanying artist's book. To date approximately sixty artists have participated in programming, representing a truly international selection, with artists from a wide variety of countries and at different stages in their careers including John Bock, Daniel Buren, Langlands & Bell, Olafur Eliasson, and Liam Gillick. See www.cca-kitakyushu.org. *SS*

Galerie Iris Clert, Paris

One of Paris's most important avant-garde galleries in the late 1950s and early 1960s. Founded by Greek-born Iris Clert in 1956, initially showed abstract painters. Through her friendship with Greek kinetic artist Takis and his circle, shifted the gallery's focus to Happenings, and became known for producing provocative, unconventional exhibitions. Described herself as "not a picture dealer, but a launching pad." Among her most famous exhibitions were Yves Klein's 1958 *The Void*, for which the gallery was totally empty, and Arman's artistic response of 1960, *Full Up*, for which he completely filled the gallery with trash. Also edited the short-lived journal *Iris-Time*, which combined fake advertisements with more serious articles. Gallery closed in 1971. Clert died in 1986. *SS*

Clert, Iris. *Iris-Time: L'Artventure/Iris Clert*. Paris: Denoel, 1978.

Sadie Coles HQ, London

Gallery founded in 1997 by Sadie Coles, a former director of Anthony d'Offay Gallery in London. Specializes in exhibitions in a range of mediums by young British artists, as well as emerging Americans and Europeans, including John Currin, Jim Lambie, Sarah Lucas, Laura Owens, Elizabeth Peyton, Ugo Rondinone, and Wilhelm Sasnal. Also shows established artists Carl Andre and Richard Prince. Has organized projects in locations outside the gallery, as well as exhibition exchanges with galleries in Glasgow, Berlin, Los Angeles, Istanbul, and Tel Aviv. Has published editions by gallery artists and a wallpaper project with Sarah Lucas. See www.sadiecoles.com. *JH*

Edition Copenhagen, Copenhagen

Publisher and printer established in 1959 by Carl Urwald as UM Grafik. Became Edition Copenhagen in 1984 when Urwald's son, Rasmus, took over as master printer with partners Peter Sørensen and Dannie Vieten. Specializes in stone lithography, and endeavors to provide artists opportunity to experience working and experimenting in this technique. Over its long history has produced more than 1,500 projects, with several generations of European and international artists, ranging from K. R. H. Sonderborg, Jörg Immendorff, and A. R. Penck to Yoshitomo Nara and Ryan McGinness. In 2003 began collaboration with World House Editions, in New Jersey, in which several artists are invited each year to spend a week at the atelier to work with stone lithography and make an edition. This collaboration has produced approximately twenty projects to date by artists including John Armleder and Luc Tuymans. See www.editioncopenhagen.com. *SS*

Coracle Press, Tipperary, Ireland

Founded in 1975 in a South London row house by artist and poet Simon Cutts. The press and related bookshop and gallery space published and exhibited the work of Cutts's contemporaries. Exhibitions held monthly, along with occasional events such as poetry readings. Since founding, artists' books have been issued on a regular basis. Coracle's publications are relatively informal and noncommercial and are produced mostly by the staff and artists, with many of its books printed, cut, sewn, and bound in-house. Others are made with local trade printers. Book projects, along with related ephemera, including invitations, cards, catalogues, posters, and broadsheets, account for Coracle's more than 1,000 publications to date by artists including Ian Hamilton Finlay, Hamish Fulton, Paul Etienne Lincoln, and Richard Long. Although their London gallery space closed in 1987, Coracle continues to publish artists' books from its current location in Tipperary, Ireland. See www.coracle.ie. *SS*

Bann, Stephen, et al. *The Coracle: Coracle Press Gallery, 1975–1987*. London: Coracle, 1989.

Cory, Adams & Mackay, London

Publisher, from January 1966 through August/September 1972, of the art magazine *Studio International*, which was founded in London in 1893 as a monthly periodical, *The Studio*. Its name was changed to *Studio International* in 1964. Issued by various publishers over the years, the magazine is currently published by The Studio Trust, New York, although still edited in Britain. The July/August 1970 issue departed from the traditional combination of exhibition reviews, essays, and reproductions, and contained a forty-eight-page "exhibition," organized by Seth Siegelaub. Six critics (David Antin, Germano Celant, Michel Claura, Charles Harrison, Lucy R. Lippard, and Hans Strelow) were each asked by Siegelaub to edit an eight-page section, for which they, in turn, invited an artist or group of artists to create page projects. The resulting volume featured page art by thirty-four American and European Conceptual artists, including Daniel Buren, Hanne Darboven, Joseph Kosuth, Sol LeWitt, and Giuseppe Penone. *SF*

Alan Cristea Gallery, London

Established in 1995 by Alan Cristea, when he bought and renamed Waddington Graphics, the print division of The Waddington Galleries (established in London in 1968 by Leslie Waddington), which he had directed since 1972. Has encouraged a wide range of British artists from various generations to work extensively in printmaking, from Joe Tilson and Patrick Caulfield to Julian Opie and Langlands & Bell. Has also worked with other European and American artists, including Jim Dine and Mimmo Paladino. Serves as the exclusive publisher of prints by Richard Hamilton and Michael Craig-Martin. Has published more than 650 editions to date. Contracts a wide range of mostly European printers to produce editions, including Advanced Graphics London, for screenprinting and woodcut; Atelier Crommelynck, Paris, and Kurt Zein, Vienna, for intaglio printing; and Omnicolour, London, for digital techniques. The gallery also offers prints by modern masters. See www.alancristea.com. *SF*

Tennant, Ivan. "Gallery in Focus: Alan Cristea Gallery." *Printmaking Today* 5, no. 2 (Summer 1996): 15.

Crown Point Press, San Francisco

Established in Berkeley in 1962 as community printshop by printor Kathan Brown. Was instrumental in revival of intaglio techniques, and has become one of the most prolific and preeminent workshops in the United States. Began publishing in 1965 with projects by West Coast artists Richard Diebenkorn and Wayne Thiebaud. Moved to Oakland in 1971, ceased publishing, and began six-year stint printing editions for New York's Parasol Press. Resumed publishing in 1977, and in 1982 added woodblock printing program with artisans in Japan and China to revive use of this traditional technique. Relocated to San Francisco in 1985. Has worked with nearly 100 artists from a wide variety of approaches including Minimalism, abstraction, and Conceptual Art. Among these are well-known Americans, including Helen Frankenthaler, Sol LeWitt, Brice Marden, and Edward Ruscha, as well as numerous European artists, Günter Brus, Daniel Buren, Peter Doig, and Markus Lüpertz among them. Continues to print and publish actively. See www.crownpoint.com. SS

Breuer, Karin, Ruth E. Fine, and Steven A. Nash. *Thirty-Five Years at Crown Point Press: Making Prints, Doing Art.* Berkeley: University of California; San Francisco: Fine Arts Museums of San Francisco, 1997.

Dablus Press, Moscow

Founded in 1990 by artist and poet Leonid Tishkov as a noncommercial organization devoted to publishing, collecting, and exhibiting Russian artists' books. Inspired by Russia's significant avant-garde movement of the early twentieth century, which included unconventional books, often issued in small editions of variants, by artists and poets, including Natalia Goncharova, Aleksei Kruchenykh, Mikhail Larionov, and Vladimir Mayakovsky. Stifled under Soviet rule, later artists turned to *samizdat*, self-published or privately copied and distributed literary works. As an early independent publishing house in post-Soviet Russia, Dablus sought to revive the artist's book format through a program of publishing, by furthering relationships with like-minded artists and publishers, collecting artists' books, and organizing international exhibitions. Has published approximately thirty-five books to date, including twenty by Tishkov, and in 2005 co-organized the first international biennial for artists' books in Moscow. SS

Éditions Daily-Bul, La Louvière, Belgium

Originally established as Éditions de Montbliart in 1955 by artist Pol Bury and writer André Balthazar, along with their Académie de Montbliart, named for a tiny village in Belgium. Located in a small rural house, their academy was where they developed their indefinable philosophy of "Bul." In March 1957 published the first issue of their journal *Daily-Bul*, which was produced sporadically until 1983, eventually numbering fourteen issues. In 1959 took on the name Éditions Daily-Bul and has since published catalogues, artists' books, and postcards. Among its most important projects was *Les Poquettes volantes*, a series of more than sixty artists' books in small format published between 1965 and 1979 by artists including Bury, Pierre Alechinsky, and Robert Filliou. Having recently celebrated its fiftieth anniversary, continues to publish actively. SS

Verheggen, Jean-Pierre, and Jean-Pierre Vlasselaer. *Le Daily-Bul: Quarante balais et quelques.* La Louvière, Belgium: Daily-Bul, 1998.

Daner Galleriet, Copenhagen

Not-for-profit exhibition space and publisher founded in Copenhagen in 1972 by the Danish collector and curator John J. A. Hunov. Exhibited works by international contemporary artists working in conceptual modes, including many individuals associated with Fluxus, such as Henning Christiansen, Joseph Beuys, and Ken Friedman. Before closing in 1976 produced six artists' books, by Christian Boltanski, Hans-Peter Feldmann, Per Kirkeby, and Annette Messager, among others. Collaborated either with Forlaget Sommersko or H. M. Bergs Forlag, both in Copenhagen, for these projects. GW

Deutsche Guggenheim, Berlin

Cooperative venture between Deutsche Bank and The Solomon R. Guggenheim Foundation established in 1997. Deutsche Bank has world's largest corporate art collection of over 50,000 objects, many of them contemporary works on paper that are displayed in the bank's more than 700 branches. Guggenheim has stated mission to collect, preserve, interpret, and present objects from twentieth-century visual culture, and has locations also in Bilbao, Las Vegas, New York, and Venice. Through partnership, Deutsche Guggenheim

presents four exhibitions a year, including monographic and thematic shows, as well as site-specific commissions by international contemporary artists, including Jeff Koons and Andreas Slominski. Limited-edition print or multiple is made in conjunction with each exhibition. Has published thirty-five multiples to date with exhibiting artists, including Hanne Darboven, William Kentridge, Kara Walker, and Rachel Whiteread. See www.guggenheim.org. SS

Dirizhabl, Nizhniy Novgorod, Russia

Publisher and printing house established by Eugene Strelkov in Nizhniy Novgorod, Russia. Publishes a range of materials including a literary almanac (twelve issues since 1991), as well as commercial publishing projects, mostly guides. Also publishes artists books, many of them by Strelkov. Maintaining a design studio and printing press, frequently collaborates with other entities on art projects. Has collaborated with Moscow artist's book publisher Alcool to produce books as well as the hybrid periodical/artist's book *B/W*, and continues to publish actively. See www.dirizhabl.sandy.ru. SF

Divers Press, Cologne

Pseudonym for Dieter Roth and his collaborator Rudolf Rieser, a trained bookbinder, who helped to fabricate several of Roth's chocolate multiples of the late 1960s. Jokingly called themselves Divers Press (sometimes cited in German as Taucher Verlag), referring to their multiples made of objects "diving" into melted chocolate. Used the name sporadically for other projects together, including several issues of the poetry "journal" *Poesie*. SS

Dobke, Dirk. *Dieter Roth: Books + Multiples, Catalogue Raisonné.* London: Hansjörg Mayer, 2004.

Estampa Ediciones, Madrid

Publisher and gallery founded in Madrid in 1978 to exhibit Spanish and international contemporary artists working in figurative and conceptual modes. Takes an inventive approach to various formats: limited-edition books pair artists and contemporary poets; *estampadillas* limit artists to very small prints; the *Estampa Engravings* series is sized to fit inside an audio cassette case; the *Transparent* series consists of screenprints on clear glass. Printing is done in collaboration with numerous studios. Also publishes multiples, including some, such

as fans and puzzles, in unlimited editions. Has published approximately 250 projects to date by artists including Ian Hamilton Finlay, Gilbert & George, Juan Hidalgo, and Antoni Muntadas. See www.galeriaestampa.com. *SS*

Flowers Graphics, London

Established in 1982 by Angela and Matthew Flowers as print publishing arm of Angela Flowers Gallery, which opened in 1970. Gallery promotes both younger and more established British artists. Publishing activity increased after move to larger Flowers East premises in 1988. Has actively encouraged gallery artists to make prints and, to this end, attempts to pair them with like-minded and well-suited master printers. Has collaborated with numerous print workshops in Britain and the United States, including Paupers Press, Thumbprint Editions, Hope Sufferance Press, all in London; Printmakers Workshop, Edinburgh; and Dieu Donné Papermill, New York. Among the artists published are John Bellany, Prunella Clough, Peter Howson, and Paula Rego. Galleries, both in London and in secondary New York space, and publishing remain active. See www.flowerseast.com. *SS*

Fluxus Editions, New York

Latin for "flow," Fluxus was an international network of avant-garde artists conceived in the early 1960s by writer, performance artist, and composer George Maciunas, which flourished until the late 1970s. Opposed to codified traditions, Fluxus promoted broader definitions of art and an experimental concept that fostered a breakdown of barriers between art and life, manifested in festivals, publications, and editions. Activities took place throughout Europe, as well as in New York, where Maciunas settled. Included performance artists, poets, musicians and composers, filmmakers, photographers, and painters and sculptors, with such participants as Joseph Beuys, John Cage, Robert Filliou, Milan Knížák, Yoko Ono, Ben Vautier, and Wolf Vostell. Central to Fluxus's mission, and spearheaded by Maciunas, were mass-produced, inexpensive publications and editions, including programs and newsletters distributed at events, and multiples and collections of multiples sold at fluxshops and by mail order. *JH*

Hendricks, Jon. *Fluxus Codex*. Detroit: The Gilbert and Lila Silverman Fluxus Collection in association with Harry N. Abrams, New York, 1998.

Hendricks, Jon, ed. *O que é Fluxus? O que não é! O porque/What's Fluxus? What's not! Why*. Brasília and Rio de Janeiro: Centro Cultural Banco do Brasil; Detroit: The Gilbert and Lila Silverman Fluxus Collection Foundation, 2002.

Kunstring Folkwang, Essen, Germany

Focused on the promotion of modern art as early as 1901 as the Essener Museumsvereins, later becoming the association for membership, education, and public relations at the Museum Folkwang (founded 1922). Became known by this name in 1935. Editions program began in 1971, and has included prints, multiples, and photographs printed by a variety of mostly local workshops. Since that time has continued to publish at least one edition a year, including several portfolio projects centered on specific themes, such as figuration and landscape. Program designed to encourage younger generation to collect, by providing affordable art, and to support emerging artists. Has published around 200 projects by a wide range of well-known German and international figures, including John Armleder, Joseph Beuys, Katharina Fritsch, François Morellet, Gerhard Richter, and Dieter Roth. See www.kunstring-folkwang.de. *SS*

Robert Fraser Gallery, London

Founded by Robert Fraser in 1962. Showed work of a new generation of British Pop artists including Patrick Caulfield and Peter Blake, and introduced American artists including Roy Lichtenstein and Andy Warhol to a British audience. Fraser was at the center of the 1960s art and music scene in London. Art directed Peter Blake's cover of Beatles album *Sgt. Pepper's Lonely Hearts Club Band*. Photograph of Fraser and Rolling Stones' Mick Jagger in handcuffs following a drug arrest became the basis for numerous works by Richard Hamilton including *Release* and *Swingeing London III*. Published works by gallery artists including Hamilton and Bridget Riley. Gallery closed in 1969, and was briefly and unsuccessfully reopened in 1983. Fraser died in 1986. *SS*

Vyner, Harriet. *Groovy Bob: The Life and Times of Robert Fraser*. London: Faber and Faber, 1999.

Edition der Galerie Heiner Friedrich, Munich

Established in the late 1960s as the publishing arm of Galerie Heiner Friedrich, founded in Munich in 1963 by Heiner Friedrich and Franz Dahlem. Soon began to exhibit work by Joseph Beuys, a friend of Dahlem's, along with a number of other international artists. In 1969 Friedrich asked Fred Jahn to publish prints on behalf of the gallery on a freelance basis. In 1971 Jahn became a partner in the gallery, overseeing its publishing program and Munich exhibition space, as Friedrich opened spaces in Cologne and New York. During this period, Jahn managed the production of hundreds of editions by gallery artists, including Georg Baselitz, Blinky Palermo, Arnulf Rainer, and Gerhard Richter, as well as Americans Dan Flavin, Donald Judd, and Fred Sandback, among others. Sabine Knust later became a partner in the gallery and involved in overseeing editions. In 1974 Friedrich founded Dia Art Foundation, and subsequently closed his gallery spaces. Jahn opened his own gallery and publishing program in 1979; Knust did the same in 1982. *SS*

Frith Street Books, London
Frith Street Gallery, London

Established by Jane Hamlyn in 1989 with intention of showing primarily works on paper by British and international contemporary artists. In 1994 expanded to show work in all mediums, including installation, video, and sculpture. Represents artists including Fiona Banner, Tacita Dean, and Giuseppe Penone. Has published some editions by gallery artists, such as Banner, as well as artists' books by Banner, Jaki Irvine, and Marlene Dumas under the imprint Frith Street Books. See www.frithstreetgallery.com. *SS*

Gagosian Gallery, New York

Art gallery founded by dealer Larry Gagosian in 1980 in Los Angeles. Opened first New York gallery in 1985; currently maintains a total of five spaces, including two in New York, one in Los Angeles, and two in London. Known as a major force in the contemporary art world, representing established figures, including Americans Ellen Gallagher, Edward Ruscha, and Richard Serra, and British artists Douglas Gordon, Damien Hirst, and Jenny Saville. Has also mounted exhibitions of other important postwar figures, such as Cy Twombly, Willem de Kooning, and Alighiero e Boetti. Has published multiples by Hirst

and Gordon, and artists' books and printed ephemera, such as posters and T-shirts, by them and other artists. See www.gagosian.com. *SF*

Gesellschaft Kunst Edition, Hamburg

Founded in 1990 by Helga Maria Klosterfelde. Initially intended to bolster Hamburg's role in the international contemporary art scene by publishing a series of editions for the Deichtorhallen, an exhibition space that opened in 1989. Proceeds from the sale of editions by German and international artists, including Hanne Darboven, Rosemarie Trockel, and Donald Baechler, supported the Deichtorhallen's exhibition program. An annual membership fee granted subscribers a discount on published editions. In 1992 became Helga Maria Klosterfelde Edition. *SS*

John Gibson Gallery, New York

First opened in Chicago in 1961 by John Gibson, before relocating to New York in 1963. Worked for dealers Martha Jackson and Marlborough Gallery before opening his own New York space in 1965, where he introduced American audiences to European artists such as Joseph Beuys and Marcel Broodthaers and exhibited the work of Christo, Richard Long, Ben Vautier, and others. Earliest publications in the 1970s were collaborations with fellow dealer Marian Goodman as John Gibson + Multiples. After several years began independently publishing prints and multiples by gallery artists, including Arman and John Armleder. Published artists' ephemera in the form of postcards and posters as gallery announcements. Ceased publishing in the late 1990s, after producing approximately twenty editions; gallery closed in 2001. *SS*

Coppet, Laura de, and Alan Jones. *The Art Dealers: The Powers Behind the Scenes Tell How the Art World Really Works.* New York: Cooper Square Press, 2002.

Gladstone Gallery, New York

Founded in 1980 by Barbara Gladstone on 57th Street in New York, relocated to Soho before moving, in 1996, to its current location in Chelsea; still active. Specializes in contemporary art, including photography, video, film, installation, painting, and sculpture, with an emphasis on artists whose conceptual practices encompass various mediums, such as Shirin Neshat, Matthew Barney, and Richard Prince. Also exhibits Thomas Hirschhorn,

Anish Kapoor, Sarah Lucas, and Lari Pittman, among others. Additionally, focuses on *Arte Povera*, presenting exhibitions and catalogues of Alighiero e Boetti and Mario Merz. Several gallery artists create editions, among them Carroll Dunham and Richard Prince, some distributed by the gallery itself. *JH*

Coppet, Laura de, and Alan Jones. *The Art Dealers: The Powers Behind the Scenes Tell How the Art World Really Works.* New York: Cooper Square Press, 2002.

Kunsthalle Göppingen, Germany

Exhibition space devoted to contemporary German and international art, established in city of Göppingen, in southwest Germany, in 1989. Active exhibition program often includes up to six shows a year. Publishes catalogues, artists' books, posters, and postcards in conjunction with exhibitions of artists including Joan Brossa, Per Kirkeby, Dan Perjovschi, and Jaume Plensa. Related art association, Kunstverein Göppingen, was established in 1986 to help promote the creation of this space. See www.kunsthalle-goeppingen.de. *SS*

Gorgona, Zagreb

See *Gorgona* in Notes on the Artists

Kunsthalle Göteborg, Sweden

A contemporary art center established in Göteborg, Sweden, in 1923. Presents exhibitions of contemporary art, often with an emphasis on Northern European or Scandinavian artists. Has been a leading partner in organizing and presenting the Göteborg International Biennial for Contemporary Art, established in 2001. See www.konsthallen.goteborg.se. *SF*

Griffelkunst-Vereinigung, Hamburg

Not-for-profit organization founded by Johannes Böse in 1925 as a means of stimulating public interest in art and encouraging artists to create prints. Sought to educate a broader public by making art collecting possible to a wide audience by regularly publishing editions, accessible in terms of price and availability. Publishing activity continues today. Annual subscription to the organization allows one to select several editions a year. Works with both well-known and younger artists in a wide variety of print techniques plus multiples and photography,

collaborating with many different printers and print workshops. To date has published almost 1,500 editions with more than 500 international artists including Joseph Beuys, Hanne Darboven, Peter Doig, Sigmar Polke, Gerhard Richter, and Rosemarie Trockel. *SS*

Rüggeberg, Harald, ed. *Griffelkunst: Verzeichnis der Editionen, 1976–2000.* 2 vols. Hamburg: Griffelkunst-Vereinigung, 2002–04.

Galerie h, Hannover

Established in 1965 by Herbert August Haseke. Interested primarily in young German artists, including Gerhard Richter and Sigmar Polke, both of whom exhibited at the gallery during its first year. Published photo-based prints, mostly offset and collotype, in large editions by Richter, Polke, and others. Also published some smaller-edition screenprints and multiples by other German and Eastern European artists. Gallery closed in 1970. *SS*

Hand Print Workshop International, Alexandria, Virginia

Not-for-profit screenprint workshop and publisher founded by Dennis O'Neill in 1973 as Hand Print Workshop in Washington, D.C. Moved operations to Moscow during final weeks of Soviet rule in 1991, and operated there as Moscow Studio, the first and only Russian-American collaborative printmaking workshop. Working in cooperation with Russian artist Boris Belsky, Moscow Studio provided artistic opportunities and materials for artists, particularly those who had worked outside the state-sponsored system. In 1997 returned to the United States as Hand Print Workshop International. Continues active residency and exchange program with Russian artists, as well as training for printers in both the United States and Russia. To date has published more than 300 projects with artists from Russia, Georgia, and Ukraine, including Komar & Melamid and Leonid Tishkov. Also works with local American, as well as Cuban, artists. Continues to print and publish actively. See www.hpwi.org. *SS*

Adaskina, Natalya, et al. *The View from Here: Issues of Cultural Identity and Perspective in Contemporary Russian and American Art.* Alexandria, Va.: Hand Print Workshop International; Moscow: State Tretyakov Gallery, 2000.

Emily Harvey Gallery, New York

Established in SoHo in 1982 by Emily Harvey as the Grommet Gallery. In 1984 bought gallery space, which had formerly been the studio of Fluxus artist and publisher George Maciunas, and changed name to Emily Harvey Gallery. Fittingly, specialized in Fluxus and Conceptual art, and showed international artists, including Dick Higgins, Nam June Paik, Daniel Spoerri, and Ben Vautier. Experimental shows featured video, performance, and printed ephemera, some of which she published. Moved to Venice in 1994 and in 2001 opened a second gallery space there, Archivio Emily Harvey. Before her death in 2004, established the Emily Harvey Foundation to preserve her archives and exhibition spaces, and to provide residencies to artists and writers in Venice and New York. *SS*

Friedrich W. Heubach, Cologne

Founding editor of the groundbreaking artists' journal, *Interfunktionen*, which was based in Cologne. Edited the first ten issues of the journal, from 1968 to 1973 (the final two issues, 11 and 12, were edited by critic and scholar Benjamin H. D. Buchloh in 1974–75). At the time he launched the journal, Heubach was a twenty-four-year-old doctoral candidate in psychology in Cologne. Inspired by his friend, artist Wolf Vostell and his magazine *Décollage,* conceived an activist journal featuring artists' projects and focused on the radical, emerging movements of Fluxus, Happenings, Action art, Conceptual art, Environmental art, and Land art. *SF*

Mehring, Christine. "The Story of Interfunktionen."
 Artforum 42, no. 9 (May 2004): 178–83, 233.

HofhausPresse, Düsseldorf

Established by printer Hans Möller in 1961 under his own name; became HofhausPresse the following year. Focused on screenprint, Möller's specialty, but also produced multiples, experimental relief prints on metal and foam, and prints with collage. Published editions with Arman, Christo, Yves Klein, Dieter Roth, and others, and was the first to publish prints by Gerhard Richter. Publishing activity slowed in 1975 when Möller began working as a printer at the Kunstakademie Düsseldorf, but was revived by daughter Dominique Möller in 1990–91 with a revised focus on traditional techniques, including woodcut, etching, and lithography, in addition to screenprint. *SS*

Das Hohe Gebrechen, Altona, and Hohengebraching, Germany

Established in 1976 by Arnulf Meifert to publish Günter Brus's first collection of poems, *Hohes Gebrechen.* Title referenced Hohengebraching, city where publisher was located. Meifert, founding member of the avant-garde German rock band Faust, began long and fruitful collaboration and exchange of ideas with Brus in 1972. Acted as a patron to Brus, especially encouraging of his work as a poet and author, combining word and image. Over the years published other artists' books by Brus, including *Morgen des Gehirns, Mittage des Mundes, Abend der Sprache,* from 1993, a 1,000-page volume that collected the artist's writings from 1984 to 1988. Publishing ceased in the mid-1990s. *SS*

Galerie Howeg, Zurich

Established by Thomas Howeg, publisher, collector, and curator. Publishes journals, books, multiples, and ephemera, with an emphasis on experimentation and crossing traditional boundaries between literature, art, music, graphic design, and commercial arts. Published the journal *Der Kunstabwart,* with contributions by lesser known writers and artists. Has also released series of multiples, called *Universalkasten,* which are "books" fashioned from wooden cases (originally used to house painting supplies) containing various types of imagery and objects. Other projects include artists' books, text-based ephemera, photography, prints, and combinations thereof. Has worked with approximately 200 artists and writers from Europe, mainly German and Swiss, both established and unknown. *JH*

Arlitt, Sabine. *376 Blätter für 365 Tage: 37 Jahre Edition Howeg.* Zurich: Edition Howeg, 2002.

Galerie and Edition Hundertmark, Las Palmas de Gran Canaria, Spain

Founded in Berlin in 1970 by young collector Armin Hundertmark, who sought a way to become more involved with the art world. He contacted a number of artists and invited them to contribute small-scale editions to what would be his first *karton,* a cardboard box filled with editioned artists' contributions. The first box contained work by Joseph Beuys, Günter Brus, Robert Filliou, Otto Muehl, Hermann Nitsch, Ben Vautier, and others, a selection that would characterize Hundertmark's editions over the next thirty-five years which continued to focus on Fluxus, Actionism, and Concrete poetry. Editions have included drawings, photographs, prints, multiples, sound recordings, and musical scores. Artists given the option of either making the edition themselves or sending a model to Hundertmark to fabricate. In 1979 Hundertmark relocated to Cologne, and in 2003 to the Canary Islands in Spain. To date has published 165 boxes by a wide range of artists, including Juan Hidalgo, Milan Knížák, Dieter Roth, and Endre Tót. Continues to publish. See www.hundertmark-gallery.com. *SS*

Hundertmark, Brigitte, ed. *25 Jahre Edition Hundertmark, 1970–1995.* Cologne: Kölnisches Stadtmuseum, 1995.

Edition I.A.C., Oldenburg, Germany

Acronym for International Artists' Cooperation, founded by Mail artist, scholar, and author Klaus Groh in 1971. Published photocopied newsletter of the same name from 1971 to 1978. Initiated innovative publishing program in which artists could have limited editions of their artists' books printed for a small fee ($6). Attracted a host of international artists interested in Mail art, including Gábor Attalai, Robert Filliou, Maurizio Nannucci, and Endre Tót. Published about fifty books before operations ceased in 1985. In 1985 founded Micro Hall Art Center, a gallery and publisher, in operation until 2003. In 2003 Groh founded Art Documentations to continue supporting and encouraging international dialogue among artists, primarily those from Eastern Europe and Latin America. Groh remains active as an artist and curator. *SS*

Imschoot, Uitgevers, Ghent, Belgium

Publisher and full-service printer of artists' books founded in 1987 by editor Kaatje Cusse and printer Dirk Imschoot as an offshoot of the printing firm Imschoot. Has since published more than 120 book projects with a wide range of international emerging and established artists, including Christian Boltanski, Hanne Darboven, François Morellet, Paul Morrison, and Antoni Muntadas, and continues to publish actively. Art historian and curator Cornelia Lauf and others have served as editors. Though many books are made in the A5 format (15 x 21 cm, or 5 7/8 x 8 1/4"), artists are given control of all decisions regarding content and materials, which are often unorthodox, as

Dirk Imschoot is known for enjoying the challenge of seemingly impossible proposals. Conceived of as a way to provide concise, portable, and inexpensive art to the general public. Edition sizes range from 500 to 1,500 copies, with prices from $30 to $250 for a signed and numbered example. Imschoot continues to print and publish books in collaboration with museums, galleries, and other institutions. Dirk Imschoot is also a partner in the Paris-based publisher of *livres d'artistes* TwoStar Books. See www.imschoot.com. *SS*

Institute of Contemporary Art, University of Pennsylvania, Philadelphia

Exhibition space for contemporary art at the University of Pennsylvania founded in 1963. With a roster of challenging exhibitions and an active education program, the ICA has developed an audience that extends well beyond the university community. Prides itself on identifying emerging artists who go on to have important careers, and was the first museum to host a solo exhibition by Andy Warhol in 1965. In the 1960s and 1970s published benefit editions by artists including Christo, Roy Lichtenstein, and Warhol, which were also given to major patrons. Established annual publishing program in 1978, inviting internationally known and emerging artists to create benefit prints, multiples, and photographs in conjunction with the exhibition program. In 1991 opened separate museum building on campus. Continues to publish actively today. See www.icaphila.org. *SS*

Item Éditions, Paris

Founded in Lyon in 1987 by Michel Bertrand and Patrice Forest. Relocated to Paris the following year, and rented presses in a studio formerly used to print movie posters. Today has printing facilities for a variety of techniques, including lithography, woodcut, linoleum cut, and collotype. In 1997 acquired the former studio of renowned lithographic printer Fernand Mourlot and renamed it Idem, which prints all Item editions as well as does contract printing. Has issued more than 300 prints to date with a number of European artists, including Jean-Michel Alberola, Carole Benzaken, and Claude Closky. Has also published Americans, including Richard Serra, and has recently collaborated with Paul McCarthy and Raymond Pettibon. Continues to publish actively. See www. itemeditions.com. *SS*

Fred Jahn, Munich

Dealer, publisher, and author. Principal and cofounder with science student Gernot von Pape of Edition X in 1967. Partnered with fellow dealer Bernd Klüser on some projects. Began freelance publishing for Galerie Heiner Friedrich several years later and, in 1971, became Friedrich's junior partner, overseeing the Munich gallery space and the publishing program, Edition der Galerie Heiner Friedrich. Oversaw hundreds of editions by international gallery artists, including Georg Baselitz, Markus Lüpertz, Gerhard Richter, and Fred Sandback. In 1979 started own Munich-based gallery and publishing program, and continued working with many of the same artists. Worked extensively with printer Karl Imhof, Munich. Wrote and published catalogues raisonnés of prints by Baselitz, Richter, Hermann Nitsch, and Blinky Palermo. Since 1985 engagement with publishing has been more limited but also more ambitious, including an enormous multivolume series of works by Nitsch. Gallery remains active. *SS*

Jänner Galerie, Vienna

Established in 1989 in Vienna by Peter Pakesch and Helga Krobath and artist Franz West, with the aim of showing works on paper and publishing prints and multiples; active until 1992. (Pakesch later became director of the Kunsthalle Basel, and is currently director of the Landesmuseum Joanneum in Graz, Austria. Krobath currently directs Galerie Krobath Wimmer, Vienna.) Exhibited mostly Germans and Austrians, including West, Martin Kippenberger, Otto Zitko, and Heimo Zobernig. Also worked with other international figures, including Julian Opie and Ugo Rondinone. *SF*

Niels Borch Jensen Gallery and Edition, Berlin and Copenhagen

Print workshop established in Copenhagen in 1979 by printer Niels Borch Jensen. Opened a second, smaller print workshop, along with a gallery, in Berlin in 1999, with Isabelle Gräfin Du Moulin as partner and director of business affairs. Known primarily for intaglio techniques, including, since 1990, photogravure; also offers woodcut and monotype. Facilities in Copenhagen allow for printing on a large scale, up to 10 feet. Began by working mainly with Scandinavian artists, including Per Kirkeby, but since the mid-1980s has also attracted many international figures, including Georg Baselitz, Albert Oehlen, and

Tal R. In addition to acting as printer/publisher for invited artists, also serves as contract printer for other publishers such as Sabine Knust•Maximilian Verlag, Munich; Helga Maria Klosterfelde Edition, Hamburg; and Galleri Nicolai Wallner, Copenhagen. Frequently produces serial projects, and often works with artists on more than one project over the course of several years, completing, for example, eleven portfolios with Olafur Eliasson since 1995, and six projects with Tacita Dean since 2001. See www.berlin-kopenhagen.de. *SF*

Helga Maria Klosterfelde Edition, Hamburg

Founded by Helga Maria Klosterfelde in 1990 as Gesellschaft Kunst Edition. Originally intended to publish editions to support a local contemporary exhibition space, the Deichtorhallen. Changed name in 1992 and continues to publish today. Works with a range of both emerging and established international artists, many in a conceptual vein, including Hanne Darboven, Rosemarie Trockel, and John Bock. To date has published approximately thirty-five prints and multiples in a variety of mediums, encouraging the use of nontraditional formats and materials. Many projects are published in editions of 30 or fewer, while others consist of series of unique variants. Has worked with many printers and fabricators, but frequently collaborates with Hamburg's Thomas Sanmann on screenprints. In 1996 Klosterfelde and son opened a gallery space in Berlin. See www.klosterfelde.de. *SS*

Sabine Knust•Maximilian Verlag, Munich

Founded by Sabine Knust in 1982, a former partner of Edition der Galerie Heiner Friedrich. In 1983 issued first project, an ambitious series of three portfolios with work by Neo-Expressionist artists, including Georg Baselitz, Jörg Immendorff, A. R. Penck, and Markus Lüpertz, called *Erste Konzentration* (First Concentration). For extended period, publishing focused on these German Neo-Expressionist artists, with whom long-standing and sometimes exclusive relationships were established. Has since expanded scope to work with international range of artists representing various approaches, including John Armleder, John Baldessari, Liam Gillick, Paul Morrison, Arnulf Rainer, and Rosemarie Trockel. Has published hundreds of editions in mediums including etching, woodcut, and screenprint as well as photographic techniques. Over the years

has collaborated with numerous printers, frequently working with Karl Imhof, Munich; Niels Borch Jensen, Copenhagen; and Till Verclas, Hamburg. Still publishes actively. See www.sabineknust.com. *SS*

Verlag der Buchhandlung Walther König, Cologne

Established in 1968 as Verlag der Gerbrüder König, Cologne–New York, by brothers Walther and Kaspar König. Opened first bookstore in 1969 in Cologne, which has become renowned for its selection of hard-to-find art-related publications and as an excellent resource for artists seeking to publish book projects. Other German branches have since followed, including several in museums specializing in modern and contemporary art. When Kaspar König left in 1983, became Verlag der Buchhandlung Walther König, Cologne. Now a major publisher of books on art, design, photography, architecture, film, and more, often in cooperation with international museums and galleries. Deeply involved with artists' books, including first book projects by Gilbert & George, Jörg Immendorff, and A. R. Penck, plus close to 300 volumes by a wide range of international established and emerging artists, including John Armleder, Christian Boltanski, Hanne Darboven, Dan Perjovschi, and Rosemarie Trockel, as well as reprints of earlier publications. Continues to publish actively. See www.buchhandlung-walther-koenig.de. *SS*

Edition Krinzinger, Vienna

Established in 1986 by Ursula Krinzinger to support the activities of her gallery, which she founded in Innsbruck in 1971 and relocated to Vienna in 1986. Has long been devoted to international performance art and Body art through early championing of Viennese Actionists Günter Brus, Hermann Nitsch, and Rudolf Schwarzkogler, as well as the generation of West Coast Americans influenced by these artists, including Mike Kelley, Paul McCarthy, and Raymond Pettibon. Also works with younger Austrian artists, such as Peter Kogler, Eva Schlegel, and Martin Walde, and other international figures. Has published about fifty editions to date, in mediums including etching, engraving, photography, and video. Has also authored and published numerous books on gallery artists. Continues to publish actively. See www.galerie-krinzinger.at. *SS*

Editionen. Vienna: Edition Krinzinger, 1994.

Yvon Lambert, Paris and New York

Contemporary art gallery, established by Yvon Lambert in 1966; opened a second gallery in New York in 2003. Was among the first to show works by Minimalist and Conceptual artists in France, including Europeans Daniel Buren and Richard Long and Americans Sol LeWitt and Richard Tuttle. Has continued to represent this and subsequent generations of international artists, such as Carlos Amorales, Anselm Kiefer, Jonathan Monk, and David Shrigley. From the beginning has been committed to publishing artists' books and illustrated books by many of its gallery artists. Since 2000 has also maintained Collection Lambert in Avignon, a public space where more than 350 objects from Lambert's personal collection of works by established and emerging contemporary artists are exhibited. Collection Lambert also publishes limited edition prints, photographs, and multiples by its artists, including LeWitt, Monk, and Shrigley. See www.yvon-lambert.com. *SF*

Lebeer Hossmann Éditeurs, Brussels

Founded in 1971 as Editions Hossmann, Brussels and Hamburg, became Lebeer Hossmann Éditeurs in 1975 under Paul Lebeer, Irmelin Lebeer-Hossmann, and Herbert Hossmann, all of whom were involved in the arts as curators, critics, and authors. Since its founding has followed artists of a Conceptual bent, from Marcel Broodthaers, Robert Filliou, and Dieter Roth to Christian Boltanski, Hanne Darboven, and Annette Messager. Has published approximately ninety artists' books, multiples, and portfolios to date as well as numerous monographs, exhibition catalogues, and volumes on art history, poetry, and philosophy. Has collaborated with printers and publishers, including Petersburg Press, London; Hansjörg Mayer, Stuttgart and London; and Yves Gevaert, Brussels. Now based solely in Brussels, continues to publish actively. *SS*

Daniel Lelong, Éditeur, Paris

Book publishing arm of Galerie Lelong, Paris, established by gallery directors Daniel Lelong, Jacques Dupin, and Jean Frémon in 1982. Gallery founded by Aimé and Marguerite Maeght as Galerie Maeght in 1945 with exhibition of Henri Matisse drawings; became Galerie Lelong in 1987. Has represented many highly significant artists over the years, including Louise Bourgeois, Alexander Calder, Alberto Giacometti, and Joan Miró.

Zurich branch opened in the 1960s, and New York office in 1979. Has long been involved with editions, beginning with influential Maeght Éditeur, which produced many lithographs, *livres d'artistes*, posters, and catalogues. To date has published nearly 200 artists' books and catalogues by Pierre Alechinsky, Günter Brus, Antoni Tàpies, and others, as well as catalogues raisonnés by gallery artists. Continues to publish actively. *SS*

Edition Malerbücher, Berlin

Publishing firm established collectively in 1987 by Sascha Anderson, Helge Leiberg, Frank-Wolf Matthies, Tom Niemann, Ulrich Panndorf, Hannes Schwenger, and Ernest Wichner, several of whom had emigrated from East Berlin. Specialized in artists' books and aimed to foster creative collaboration, pairing contemporary authors with contemporary painters. Worked with eleven artists, including A. R. Penck, to complete three books featuring screenprints and etchings. Eventually dissolved in 1989. Printed all publications on the presses of the Berufsverband Bildender Künstler Berlins at the Künstlerhaus Bethanien in Berlin. *GW*

Matthew Marks Gallery, New York

Founded in 1991 by Matthew Marks, who had collected American prints as a teenager, and who had worked at Pace Gallery, New York, and Anthony d'Offay Gallery, London, in the 1980s. Primarily a dealer, specializing in paintings, sculptures, and works on paper by a range of established and emerging artists, both American and European. Published all of Lucian Freud's prints between 1991 and 2003, and is American distributor of multiples by Katharina Fritsch. Has also published prints by British artist Gary Hume, and Americans Richmond Burton and Richard Serra. Continues to publish. See www.matthewmarks.com. *SF*

Coppet, Laura de, and Alan Jones. *The Art Dealers: The Powers Behind the Scenes Tell How the Art World Really Works.* New York: Cooper Square Press, 2002.

Marlborough Graphics, London

Graphics arm of the gallery Marlborough Fine Art, London (founded 1946), established in 1963–64 by Barbara Lloyd to publish and distribute editions by gallery artists, including Joe Tilson and Eduardo Paolozzi. Focused on British Pop, publishing numerous

editions by R. B. Kitaj, Paolozzi, Tilson, and others, often collaborating with master screenprinter Chris Prater of Kelpra Studio, London. Expanded into publishing international artists with opening of branches in New York in 1964, Rome in the 1960s, and Madrid in 1992. To date has published hundreds of editions with a wide range of international artists, including Frank Auerbach, Alex Katz, Robert Motherwell, Paula Rego, and Manolo Valdés (formerly of Equipo Crónica), and continues to publish editions in London, New York, and Madrid. Today Marlborough Fine Art maintains galleries in New York, London, Madrid, Santiago, and Monaco. See www.marlboroughgallery.com. *SS*

Locke, John. "Marlborough Prints." *Studio International* 172, no. 884 (December 1966).

//
Edition MAT/Galerie Der Spiegel, Cologne

Acronym for Multiplication d'Art Transformable, founded in Paris in 1959 by artist Daniel Spoerri and named in part to reference *material*, the art magazine he edited. Produced multiples in editions of 100 that were affordable as well as transformable, either as kinetic objects or by having variable contents, as in Arman's multiple *Garbage Can*, each example of which contained a different assortment of found refuse. First series, *Collection '59*, included works by Marcel Duchamp, Man Ray, and Dieter Roth, among others. Artist and designer Karl Gerstner and Galerie Der Spiegel, under director Hein Stünke, joined Spoerri in publishing the next series in 1964, with multiples by Arman, Roth, Niki de Saint Phalle, and others. In 1965 Stünke bought Edition MAT from Spoerri, who then founded publishing offshoots Editions MAT MOT and TAM THEK with Gerstner. Although Edition MAT ceased operations, Galerie Der Spiegel continued to publish under its own imprint works by American and international artists, including Robert Indiana, François Morellet, and Victor Vasarely, and under current director Werner Hillmann today continues to publish and exhibit prints and multiples. *SS*

Vatsella, Katarina. *Edition MAT: Die Entstehung einer Kunstform. Daniel Spoerri, Karl Gerstner und das Multiple*. Bremen, Germany: H. M. Hauschild, 1998.

//
Edition Hansjörg Mayer, London

Founded in Stuttgart by Hansjörg Mayer, from a locally based printing and publishing family, in 1962. As a student, produced his own films, experimental typography, and Concrete poetry. Met artist Dieter Roth during a stopover in Reykjavik on a flight to the United States. Produced the first of many books together in 1965 and began publishing a series of volumes to document Roth's collected works in 1969. Has lived part-time in London since 1965, when his own Concrete poetry was featured in the exhibition *Between Poetry and Painting*. From 1965 to 1968 published the innovative journal *futura*, which featured the work of Concrete and visual poets, including Robert Filliou, Ian Hamilton Finlay, and Dieter Roth. Has published hundreds of artists' books, monographs, and catalogues to date on a wide range of international artists and poets. Since 1978 his interest in ethnography has taken a primary role in his publishing program. Continues to publish in London. *SS*

Publications and works by Hansjörg Mayer. The Hague: Haags Gemeentemuseum, 1968.

//
Médecins du Monde (Doctors of the World), Paris

International humanitarian aid organization founded in 1980 by fifteen dissidents from Médecins Sans Frontières (Doctors without Borders) who broke away after a difference of opinion about how best to assist boat people fleeing Vietnam. A nongovernmental organization, Médecins du Monde aims to provide medical care to vulnerable populations in both developed and developing countries; respond to crises, natural disasters, and war; and bear witness to human rights abuses and violations. In 1994, working with Éditions de la Tempête, commissioned twenty-three international artists, including Alighiero e Boetti, Roy Lichtenstein, Jaume Plensa, and Robert Rauschenberg, to make benefit prints, with all proceeds going to Médecins du Monde's projects in Kosovo. First presented in Paris, the collection has subsequently toured galleries and museums worldwide. Médecins du Monde now has active humanitarian programs in well over fifty countries. See www.medecinsdumonde.org. *SS*

//
Éditions Média, Neuchâtel, Switzerland

Founded by printer and gallery owner Marc Hostettler in 1971. Initially focused on publishing editions by Swiss and French Concrete and abstract artists such as François Morellet and Daniel Buren. Later expanded to include many international installation and Conceptual artists including John Armleder, Ian Hamilton Finlay, Hamish Fulton, and Richard Long. Primarily produces screenprints, but has also published multiples, and editions involving photographic, typographic, and relief techniques. In 1983 established Furkart, a project in which he invited artists during the summer months to his renovated Hotel Furkablick in the Swiss Alps town of Furkpasshöhe to create site-specific projects. Continues to actively publish editions. *SS*

//
Edition Hervé Mikaeloff, Paris

Gallery with publishing arm founded by Hervé Mikaeloff. Exhibited contemporary artists, including Sylvie Fleury in the 1990s, also publishing a multiple by her. Mikaeloff has been an independent curator and art advisor specializing in contemporary projects with an international scope. Currently consults for LHMV Group, also organizing an exhibition for a gallery space run by Louis Vuitton in Paris. *JH*

//
Victoria Miro Gallery, London

Gallery established in London in 1985 by Victoria Miro. Represents a range of established and emerging contemporary international artists, including Yayoi Kusama and Tal R. and Britons Ian Hamilton Finlay, Chris Ofili, and Grayson Perry. Although publishing editions is not part of its program, in recent years has issued digital prints by Ofili. Represented Hamish Fulton in the late 1980s, and produced cards designed by him to announce his gallery exhibitions in 1987 and 1989. See www.victoria-miro.com. *SF*

//
Edizione Modern Art Agency, Naples

Publishing arm of Naples gallery opened by Lucio Amelio in 1965. In 1971 gallery name was changed to Galleria Lucio Amelio. Exhibited the work of leading American and European artists of the 1960s and 1970s, including Andy Warhol, Robert Rauschenberg, Jannis Kounellis, and Gilbert & George. Also championed the work of many German artists, including, most prominently, Joseph Beuys. Gave Beuys his first exhibition in Italy in 1971. Published Beuys's seminal print *We Are the Revolution* in 1972 as well as a few other editions by Beuys later in the 1970s, some independently and some in conjunction with Edition Staeck, Heidelberg. *SF*

Moderna Museet, Stockholm

Founded in 1958 as Sweden's premier museum of modern and contemporary art. Activities as a publisher center primarily on books and catalogues related to the museum's exhibitions. Beginning with the vision of Pontus Hulton, the Museum's director from 1959 to 1973, several of the catalogues devoted to contemporary artists have been produced at least partly in collaboration with the artists in question, and are creative or unconventional examples of the genre. Has also occasionally published artists' books and ephemera, such as a 1971 project by Niki de Saint Phalle, or, more recently, an edition of a deck of cards by Jockum Nordström in 2005. Continues to publish actively. *SF*

The Monacelli Press, New York

Established in 1994 by Gianfranco Monacelli, long-time publisher of art, architecture, and photography books, with the aim of reinterpreting conventional boundaries and encouraging provocative approaches to creating illustrated books. With a broad variety of subjects, has published over 250 books on architecture, fine art, interior and garden design, graphic design, and photography, with a predominant focus on the contemporary. Titles range from *S, M, L, XL* by Rem Koolhaas and Bruce Mau, to *Towards a New Museum* by Victoria Newhouse, to Robert A. M. Stern's documentary series on New York, to monographs on Jim Dine, Eric Fischl, Kiki Smith, and Betty Woodman, among others. Continues to publish actively. See www.monacellipress.com. *JH*

Moscow Palette Gallery, Moscow

Among the first private commercial art galleries in post-Soviet Moscow, housed in stately apartment building. Under direction of Nikita Andreivich, exhibited and collected work by twentieth-century Russian artists. Also ran publishing cooperative to help issue editions by gallery artists, including Leonid Tishkov. In 1996 was forced to close. *SS*

Egor'eva, Elena, and Ada Safarova. "Moskovskaya Palitra." *Dekorativnoe iskusstvo*, no. 2 (1991): 36–39.

The Multiple Store, London

Not-for-profit publisher established in 1998 by arts editor Sally Townsend and solicitor Nicholas Sharp. Financial support provided by Central Saint Martins College of Art & Design and the Arts Council of England. Commissions limited editions, mostly three-dimensional multiples, by established and emerging contemporary British artists, including Fiona Banner and Langlands & Bell. Aims to encourage new collectors of contemporary art via reasonably priced works, as well as provide new creative opportunities for artists. Has published works by approximately twenty-five artists to date, and continues to commission new projects. See www.themultiplestore.org. *SS*

Museum in Progress, Vienna

See **Museum in Progress** in Notes on the Artists

Museum of Modern Art Oxford, Oxford

Founded in 1965 by architect Trevor Green with intention of educating the general public about visual arts. Although original intention was to create a permanent collection, focus shifted to mounting temporary exhibitions with an ambitious international outlook. In 2002, following a refurbishment and abolition of entrance fee, renamed Modern Art Oxford to better reflect its role as an institution without a permanent collection. Has published numerous artists' books and editions by Christian Boltanski, Marcel Broodthaers, Jake and Dinos Chapman, and others in conjunction with its exhibition program. Still publishing actively today, it occasionally partners with London's Counter Editions for its publications. See www.modernartoxford.org.uk. *SS*

Music Cooperation Triple Trip Touch, London

The private record label that artist and musician A. R. Penck established to produce albums by his band Triple Trip Touch in the 1980s. Founded by Penck and guitar and bass player Frank Wollny in London in 1983, Triple Trip Touch is still active as a band, though Penck (who played drums and piano) left the group in 1995, and it was reformed several times with new members including, after 1999, artist Markus Lüpertz on piano. The band has toured regularly all over Europe and the United States, often performing with other musicians associated with experimental music or free jazz. More than forty Triple Trip Touch albums have been issued, under this label and others, including Weltmelodie (the label used by Penck's dealer Michael Werner in Cologne), usually in editions of only a few hundred copies and featuring jackets designed by Penck in his typically loose, pictographic drawing style. *SF*

Nest, New York

Magazine founded in 1997 as "a quarterly of interiors," by publisher and editor-in-chief Joseph Holzman. A nontraditional "shelter" or interior design magazine, looked beyond upscale interiors to unconventional dwellings such as igloos and jail cells. Elaborately designed, with issues appearing in different shapes and sizes, and frequently featuring deluxe commissioned items on its covers or interior, such as fabric by fashion designer Todd Oldham, or wallpaper by artist Rosemarie Trockel. With decidedly literary articles, contributors included writers, architects, interior decorators, and designers of fashion, furniture, and industrial goods, as well as artists such as Louise Bourgeois, Robert Gober, and Julian Schnabel. Beginning in 1999 commissioned designs for several commercially available products, including fabrics with decorative yet subversive patterns depicting copulating rabbits and marijuana plants, and wallpaper by Paul Noble. Publication ceased in fall 2004 after twenty-six issues. *SS*

Newlyn Orion Galleries, Cornwall, England

Community gallery that provides exhibition venue for local artists. Opened in 1895 as the Passmore Edwards Gallery, named after the philanthropist who donated construction funds. In 1957 administration and exhibition planning taken over by Newlyn Society of Artists. In 1977 incorporated as a registered charity, the Newlyn Orion Galleries, and administration was taken over by a small staff with financial support from the Arts Council, England. In the mid-1980s funding was taken up by regional South West Arts, and name became Newlyn Art Gallery. Gallery continues to run an active exhibition program, focusing on contemporary local artists. Occasionally publishes catalogues and artists' books, and the shop provides a means for artists to sell their paintings, prints, ceramics, and jewelry. See www.newlynartgallery.co.uk. *SS*

Carolina Nitsch Editions, New York

Established in 2000 by Carolina Nitsch, former director of Brooke Alexander Editions and Gallery. Publications frequently geared toward helping an artist realize a

special project through experimentation with a new medium, or toward projects that incorporate unique elements and variants, often in small editions of 3 to 25. Also involved in publishing on behalf of institutions, including the Whitney Museum of American Art, the New Museum of Contemporary Art, and the Merce Cunningham Dance Company, all in New York. Has worked with a wide range of established international artists, such as Louise Bourgeois, Robert Gober, Anish Kapoor, Olaf Nicolai, and Hiroshi Sugimoto. To date has published more than twenty-five projects in mediums including etching, illustrated books, multiples, photography, and more. Among collaborating New York–based printers are Greg Burnet Editions, Derrière l'Étoile Studios, Alexander Heinrici, and Laumont Editions. As a dealer, specializes in works on paper and editions by selected European and American printers and publishers. *SS*

Marco Noire Editore, Turin, Italy

Publishing venture founded by Marco Noire in 1982 to complement activities of his gallery, Marco Noire Contemporary Art. Gallery and editions focus on Italian *Arte Povera* artists, like Giuseppe Penone, and international artists, including Christo, Sylvie Fleury, Hamish Fulton, Richard Long, and Jannis Kounellis. Noire also has an atelier that oversees the printing of the projects. To date has produced monographs on many of these artists as well as traditional print projects, comprising some 200 editions in all. Continues to publish actively, recently embracing digital printing technologies and new media formats such as video. See www.marconoire.com. *SS*

Anthony d'Offay Gallery, London

One of London's most respected and influential art dealers. In the early 1980s was instrumental in introducing British audiences to Joseph Beuys, and represented such renowned artists as Willem de Kooning, Jasper Johns, and Andy Warhol. Over the years has also represented some of Britain's most internationally acclaimed artists, including Gilbert & George, Richard Hamilton, and Richard Long. In the 1990s took on a younger generation of accomplished artists, including Rachel Whiteread and Ellen Gallagher. Has published well over 100 monographs on gallery artists, including Francesco Clemente, Anselm Kiefer, and Gerhard Richter, among others. Closed all three of his public gallery spaces in late 2001. *SS*

Oktagon Verlag, Stuttgart

Established in Stuttgart in 1989 by Gerd Seibert and Marie-Hélène Perey; became a division of Verlag der Buchhandlung Walther König, Cologne, in 1996 and now publishes and distributes through König. Art book publisher specializing in modern art, photography, and architecture. Has also published monographs and exhibition catalogues in collaboration with various European and American galleries and museums. Publishes occasional artists' books, many of them as part of a series edited since 1993 by curator Hans-Ulrich Obrist, with titles by a range of international figures, including Matthew Barney, Christian Boltanski, Douglas Gordon, Annette Messager, and Anri Sala. Continues to publish actively. See www.buchhandlung-walther-koenig.de/verlag.htm. *SF*

The Paragon Press, London

Founded in Edinburgh in 1986 by Charles Booth-Clibborn, while still a university student. Born of his desire to work directly with artists whose work he admired. Moved to London in the same year, and has become among the most important and influential European publishers. Prescient 1992 *London Portfolio* included work by the generation of artists who would become known as the YBAs, or Young British Artists, and contained the first prints by Damien Hirst and Rachel Whiteread, among others. To date has worked primarily with British-based painters and sculptors, including Hamish Fulton and Richard Long, as well as artists of next generation, such as Jake and Dinos Chapman, Peter Doig, and Paul Morrison. Is now expanding scope to other European artists, including Georg Baselitz. Collaborates with several London-based printshops, including Coriander Studio, Hope Sufferance Press, Thumbprint Editions, and Paupers Press, as well as Niels Borch Jensen, Copenhagen. Frequently produces editions as portfolios, with a prolific schedule of as many as five major projects a year. To date has published more than ninety projects comprising 1,500 individual prints, and continues to publish actively. A recent exhibition of editions, organized by the British Council, traveled to countries including Israel, Japan, Russia, Singapore, and Slovenia. See www.paragonpress.co.uk. *SS*

Elliott, Patrick, ed. *Contemporary Art in Print: The Publications of Charles Booth-Clibborn and His Imprint The Paragon Press, 1995–2000*. London: Booth-Clibborn Editions, 2001.

Elliott, Patrick, ed. *Contemporary British Art in Print: The Publications of Charles Booth-Clibborn and His Imprint The Paragon Press, 1986–95*. Edinburgh: Scottish National Gallery of Modern Art; London: The Paragon Press, 1995.

Parkett, Zurich and New York

See *Parkett* in Notes on the Artists

Petersburg Press, London and New York

Founded in 1968 by Paul Cornwall-Jones after leaving Editions Alecto, London, which he cofounded in 1960. Became one of the premiere publishers of innovative Pop prints, portfolios, and illustrated books by young European and American artists during the 1970s. Publications included Richard Hamilton's *Release* and *Swingeing London III*, Dieter Roth's *Six Piccadillies*, and work by Patrick Caulfield, David Hockney, and Eduardo Paolozzi, among others. In addition to having own etching and lithography facilities, also contracted other top European printers including Kelpra Studio, London, for screenprint; and Aldo Crommelynck, Paris, and Maurice Payne, London, for etching. Opened New York office in 1972 with full printshop facilities. Ceased publishing and printing in 1991. *SS*

Ivan Picelj, Zagreb

Painter, printmaker, sculptor, and designer born in Yugoslavia (now Croatia) in 1924. Active in founding the Zagreb-based artist's group Exat-51 in 1951, which protested the state-sanctioned style of Socialist Realism and supported abstraction and artistic freedom. In 1961 cofounded the international movement New Tendencies, which sought to synthesize kinetic, Op, and Neo-Constructivist art, and bring Croatian artists together with international figures, including François Morellet and Piero Manzoni. In 1962 launched journal *a*, which included work by New Tendencies artists. Published seven issues through 1964. Although the content and number of pages varied in each issue, all were the same format (6 5/16 x 6 5/16 inches, or 16 x 16 cm) and bore the same cover design of a lower case *a* filling the sheet. Contributors included Picelj, Mangelos, and Victor Vasarely. *SS*

Djurić, Dubravka, and Miško Šuvaković, eds. *Impossible Histories: Historical Avant-Gardes, Neo-Avant-Gardes, and Post-Avant-Gardes in Yugoslavia, 1918–1991.* Cambridge, Mass.: The MIT Press, 2003.

Pocketbooks, Edinburgh

Established in 2000 under the guidance of editorial director Alec Finlay to publish series of fourteen artists' books that celebrated contemporary Scottish culture. With support from the Scottish Arts Council National Lottery New Directions Programme, commissioned writers and visual artists from Scotland and abroad. Series had uniform format (small paperback) and price (£7.99). Some were paired with CDs, some accompanied exhibitions, some were copublished by other local publishers or galleries. Project completed in 2001. Finlay continues publishing activities under his imprint Morning Star Publications, Edinburgh. *SS*

Galerija Gregor Podnar, Ljubljana, Slovenia

Established in Kranj, Slovenia, in 2003 by Gregor Podnar; moved to Ljubljana in 2005. Podnar, a Slovenian curator, had previously been artistic director of Galerija Škuc, a leading contemporary arts center in Ljubljana, from 1996 to 2003. In an effort to give representation to emerging artists from Eastern Europe, a region long without an established gallery system or art market, represents artists such as IRWIN, Dan Perjovschi, and Tobias Putrih, and promotes their work internationally. Has published a few digital prints and photographs in small editions by gallery artists, including IRWIN, Putrih, and Vadim Fiškin, as well as a poster edition by Nika Span. Still publishes actively. *SF*

Polígrafa Obra Gráfica, Barcelona

Commercial printing firm founded in Barcelona in 1914. In 1961, under direction of Manuel de Muga, began publishing art books, and eventually prints. In 1976 de Muga's son, Joan de Muga, opened Barcelona's Galeria Joan Prats, which has served as the primary means of distribution for Polígrafa's editions. Over its long history has worked with some of the leading figures of twentieth-century art, including Max Ernst, Joan Miró, and Antoni Tàpies. Although its early focus was on Spanish artists, now works with artists from France, the United States, Italy, Portugal, Latin America, and China. Joan Brossa,

Christo, Helen Frankenthaler, Jannis Kounellis, Markus Lüpertz, and Edward Ruscha are among the 250 artists whose editions they have published. With their own printing facilities for a wide variety of techniques, including lithography, etching, and woodcut, has published more than 1,000 prints and illustrated books to date, and continues to publish actively. See www.edicionespoligrafa.com. *SS*

Centre Pompidou, Paris

Officially the Centre National d'Art et de Culture Georges Pompidou, serves as Paris's headquarters for modern and contemporary art. Brainchild of former French president Georges Pompidou, focuses on an interdisciplinary approach through dialogue between the visual arts, theater, music, cinema, and literature. Opened to the public in 1977, underwent significant renovation beginning in 1997; sees approximately 6 million visitors a year. In addition to comprehensive exhibition and education programs, has vast reference library as well as a publishing program producing approximately fifty titles a year, including exhibition catalogues, monographs, essays and criticism, and more. Since 1979 has published the quarterly art journal *Les Cahiers du Musée National d'Art Moderne*, and frequently commissions artists to design its covers and page projects. The bookstore also produces postcards, posters, and exhibition- and museum-related products. See www.cnac-gp.fr. *SS*

Pont La Vue Press, Lake Placid, New York

Small, independent artist's book publisher, founded by book designer Karen Davidson in New York in 1992. Relocated to Lake Placid in 2004; still active, intermittently. Has published five titles to date by artists Dan Perjovschi, Stella Snead, Hans Waanders, and, forthcoming in 2006, Lawrence Fane. *SF*

Portikus, Frankfurt

Exhibition space for contemporary art founded in Frankfurt in 1987 by Kaspar König. Focuses on established contemporary artists as well as important emerging artists from around the world. Since 1987 has organized nearly 150 exhibitions, most of which are accompanied by a monograph or artist's book. Approximately fifty exhibitions have also been accompanied by editions in a variety of mediums, including deluxe edition catalogues, multiples,

photographs, screenprints, and offsets. Among the artists who have made such projects are Christian Boltanski, Gilbert & George, Jörg Immendorff, Ellsworth Kelly, Per Kirkeby, and Sol LeWitt. Printing and fabrication of these works is contracted out to numerous organizations. Publication is often undertaken with collaborators, among them Verlag der Buchhandlung Walther König, Cologne, and Hatje Cantz, Ostfildern, Germany. *SS*

Revolver, Frankfurt

Book publisher established by Christoph Keller in 1999 with a special focus on cutting-edge projects by such figures as John Bock, IRWIN, Jonathan Monk, and David Shrigley. Also produces exhibition catalogues, monographs, children's books by artists, collected writings on contemporary art, and more, often in collaboration with exhibiting institutions. Publishes as many as 150 titles a year, usually in print runs of 500 to 4,000. Since 2001, also runs innovative Kiosk program, a traveling selection of independent publishing projects, periodicals, and video and sound recordings on contemporary art. In 2006 owner and publisher changed to Annja Theobald with managing editor Katrin Sauerländer, and continues to publish actively. Keller now works as a freelance designer and editor. See www.revolver-books.de. *SS*

Galerie Rottloff, Karlsruhe

Founded in 1961 by Helgard Rottloff to show work of young German artists. Interested in introducing artists including Gerhard Richter, Arnulf Rainer, and Otto Piene to possibilities of print techniques. Established screenprint workshop in 1961 to produce gallery posters, invitations, and editions. Also published multiples and some etchings, opening an etching studio in 1977. In 1965, ran one-year project of Edition Kaufhof in which she published 32 prints available for sale in Kaufhof department stores in Cologne, Munich, and Düsseldorf. Ceased printing and publishing in 1985, but gallery continues to show the work of German artists. *SS*

Edition Jacob Samuel, Santa Monica, California

Publisher and printer established in 1986 by master printer Jacob Samuel, who worked with artist Sam Francis at his print workshop, The Litho Shop and its artist's book publishing arm, Lapis Press, also in Santa Monica, through 2003. Known primarily for intaglio editions that explore

serial imagery, with first projects issued in bound book formats, often including text by the artists. Subsequent publications issued in both bound and unbound versions, which has segued into loose portfolios, many of which retain some of the essential qualities of illustrated books, including sequence and seriality, text components, and letterpress typography. Has begun to work in other techniques including screenprint. Has published approximately forty projects to date with a wide range of established international artists including Mona Hatoum, Jannis Kounellis, Giuseppe Penone, as well as a younger generation of artists including Barry McGee. See www.editionjs.com. *SS*

Edition Schellmann, Munich and New York

Established in Munich in 1969 by Jörg Schellmann, in cooperation with Katia von Velden and Bernd Klüser, to publish editions by international contemporary artists. After 1971 became the primary publisher of prints and multiples by Joseph Beuys, and editor of three catalogues raisonnés on his editions. In 1974 became Edition Schellmann & Klüser. Opened New York gallery space of same name in 1983, but name reverted to Edition Schellmann in 1985. Has published prints, photographs, and multiples by a wide variety of artists, many of them conceptually based, including Beuys, Hanne Darboven, and Gilbert & George, as well as projects with Andy Warhol and figurative artists such as Francesco Clemente. Continues to publish actively with new generation of artists, including Tacita Dean, Mona Hatoum, and Rachel Whiteread, and produces editions in association with international art events, including the Venice Biennale and documenta. Without own press facilities, chooses printers and fabricators best suited for specific projects. See www.editionschellmann.com. *SS*

Edition Schellmann, 1969–1989. Munich and New York: Edition Schellmann, 1989.

Esther Schipper, Berlin

Established in 1986 in Cologne by Esther Schipper to publish multiples by emerging European and international artists. Between 1986 and 1991, when publishing activities ceased, produced approximately ten projects by artists including General Idea, Martin Kippenberger, and Rosemarie Trockel. From 1990 to 1991 ran multiples store with Daniel Buchholz. Opened first gallery space in 1989,

which later became a partnership with Michael Krome and from 1994 to 2004 was known as Schipper & Krome. Opened Berlin gallery space in 1995, which became sole location when Cologne gallery closed in 1997. Reverted to name Esther Schipper in 2004. *SS*

Seimannsverlag, Stuttgart and London

Pseudonym for Edition Hansjörg Mayer. In 1969 Mayer began publishing the many volumes of Dieter Roth's collected work, and the two briefly had the idea to invent a new publisher name for each volume. Following confusion on the part of book dealers, this practice ceased not long after. True to Roth's wicked sense of humor, name translates to "Be a Man Publisher." *SS*

Galerie Der Spiegel, Cologne
See **Edition MAT/Galerie Der Spiegel**

Edition Staeck, Heidelberg

Founded in 1965 by political poster artist Klaus Staeck under the name Edition Tangente. Begun in part to distribute his own prints and posters, and also to provide artists with an alternative to existing mechanisms of production and distribution. Became known as Edition Staeck in 1972. Has published more than 700 projects to date in a wide variety of mediums and formats, including prints, multiples, and artists' postcards. Of these, the greatest number were editions by Staeck's friend Joseph Beuys, whose work he published from 1971 to 1985. Has worked with numerous German and international artists, including Marcel Broodthaers, Robert Filliou, Blinky Palermo, A. R. Penck, Sigmar Polke, Dieter Roth, and Ben Vautier. Printing and fabrication done with numerous workshops. Continues to publish actively with a new generation of artists, including Olaf Nicolai and Rosemarie Trockel. See www.edition-staeck.de. *SS*

Gercke, Hans, et al. *Genommene Kurven: 20 Jahre Edition Staeck.* Heidelberg: Edition Staeck, 1985.

Edition Stähli, Recife, Brazil

Galerie Stähli founded in 1970 in Lucerne by Pablo Stähli. Opened additional spaces in Zurich in 1978, Cologne in 1988, and Recife, Brazil, in 1989. Editions program centered around Zurich location, where friend and renowned printer Peter Kneubühler had

a space downstairs to work with artists. To date has published approximately thirty-five editions by gallery artists, including Urs Lüthi, Markus Raetz, Dieter Roth, and André Thomkins. Served as the exclusive Swiss distributor for the editions of publisher Hansjörg Mayer, as well as Rainer Verlag, Berlin. Also published catalogues raisonnés of the prints and books of several artists, including Raetz. Closed Lucerne space in 1983, and Zurich and Cologne spaces in 2005. Ongoing publishing activities now run out of Recife. *SS*

Stempelplaats, Amsterdam

Gallery specializing in Mail art, Stamp art, and artists' books, with a particular emphasis on rubber stamps. Encouraged by artists and Mail art collectors John Held Jr. and Ulises Carrión, opened in 1976 under the direction of Aart van Barneveld. Located within the retail store of J. D. Posthumus (today known as Posthumus Stempelfabrieken), a long-standing manufacturer of rubber stamps in The Netherlands owned by T. A. van der Plaats, whose surname served as the basis for the name Stempelplaats. Exhibited works by a range of artists from the United States and Europe, with a special emphasis on those from Eastern Europe. Published artists' books and books on the subject as well as *Rubber*, a monthly bulletin that featured rubber stamp works by artists on view. Closed in the early 1980s, following the death of van Barneveld. *JH*

Stolpe Verlag, Berlin

Founded in 1966 by Rosemarie Haas in the year following the opening of husband Peter Haas's screenprint workshop. Named for the region in Germany in which the Haas family lived. Published prints and multiples predominately by young German artists. In 1967 released *Graphics of Capitalist Realism* with coordination by René Block. This landmark portfolio included work by KP Brehmer, K. H. Hödicke, Konrad Lueg, Sigmar Polke, Gerhard Richter, and Wolf Vostell. Discontinued publishing in 1969. *SS*

Tamarind Institute, Albuquerque

Established by June Wayne in 1960 in Los Angeles as Tamarind Lithography Workshop, through a grant from the Ford Foundation. Goal was revival of lithography in the United States through a program to train American master printers and the development of new lithographic

techniques. Influence has spread through Tamarind-trained printers, many of whom have founded print workshops around the country, and their books and articles about the medium. In 1970 became Tamarind Institute when it left Los Angeles for Albuquerque and began affiliation with University of New Mexico, which continues to this day. There began contract printing and publishing. More than 350 artists have worked at Tamarind; though the vast majority are American, approximately fifty Europeans, including Rafael Canogar, David Hockney, and Otto Piene, have worked there as well. Archives are housed at the University Art Museum of the University of New Mexico. See www.unm.edu/~tamarind. *SS*

Devon, Marjorie, ed. *Tamarind: Forty Years.* Albuquerque: University of New Mexico Press, 2000.

Edition Tangente, Heidelberg
See **Edition Staeck**

Galerie Tanit, Munich
Established in 1972 by Stefan and Naila Kunigk, was later joined by partner Walther Mollier. In the 1970s focused on Pop art, Conceptual art, and photography, featuring such artists as Robert Rauschenberg, Hamish Fulton, and Bernd and Hilla Becher. Also exhibited prints by Jasper Johns and David Hockney, among others. In the 1980s and early 1990s featured Minimalists, including Dan Flavin, Donald Judd, Sol LeWitt, and Robert Ryman. Also exhibited work by *Arte Povera* artists, including Michelangelo Pistoletto and Giovanni Anselmo. In the 1990s began working with a younger generation of German artists, including Thomas Demand, Ulrich Horndash, and Gerhard Merz. In 2003 started a new series of group painting exhibitions and solo shows focusing on an emerging set of international artists. Continues their representation of photographers. Still publishes actively. See www.galerietanit.com. *JH*

The Vanity Press, London
Founded in 2003 in London by British artist Fiona Banner to publish her own prints and artists' books. The term "vanity press" (or "vanity publisher"), implied literally and ironically here, refers to a publisher that publishes books at the author's expense. *JH*

Edition VICE-Versand, Remscheid, Germany
Pioneering publisher founded in 1967 near Cologne by collector and factory owner Wolfgang Feelisch. Interested in the idea of art as a consumer good, Feelisch invited artists to create editions that could be made of quotidian materials and available at a very low cost that would be accessible to the average shopper. With innovative marketing strategies, works were sold directly to the public and were distributed by mail, hence the name *Versand* (mail order). During VICE-Versand's most prolific years, 1968 and 1969, works were produced by Joseph Beuys, Robert Filliou, Dieter Roth, and Daniel Spoerri, among others, under the umbrella of *Zeitkunst im Haushalt* (Art in the Household), all available for 8 German marks. Although theoretically unlimited, edition sizes ranged from several hundred to more than 12,000 in the case of Beuys's 1968 wooden box, *Intuition*. Active sporadically through 1989, VICE-Versand produced over sixty editions. *SS*

Schmieder, Peter. *Unlimitiert: Der VICE-Versand von Wolfgang Feelisch.* Cologne: Walther König, 1998.

Wolf Vostell
See **Wolf Vostell** and ***Décollage*** in Notes on the Artists

Waddington Graphics, London
Founded in 1968 by Leslie Waddington (called Leslie Waddington Prints until 1973) following the opening of his Waddington Galleries a year earlier. Originally intended to publish editions by the contemporary British artists who showed at his gallery. Shortly thereafter expanded scope to include buying and selling other contemporary as well as modern master prints. Alan Cristea, formerly of Marlborough Graphics, London, joined the company in 1972 and extended publishing activity to include international artists outside the gallery's stable. Projects published by artists including Richard Hamilton, Patrick Caulfield, and Joe Tilson. Without own printing facilities, instead worked with printers including Kelpra Studio, London, Aldo Crommelynck, Paris, and Grafica Uno, Milan. Purchased by Cristea in 1995 and renamed Alan Cristea Gallery, which continues to publish with contemporary artists and to deal in modern prints. See www.waddington-galleries.com. *SS*

Galleri Nicolai Wallner, Copenhagen
Gallery established in 1993 by Nicolai Wallner to show the work of important young Scandinavian and international artists, including Douglas Gordon, Jonathan Monk, and David Shrigley. Began publishing editions by gallery artists in the late 1990s in mediums including intaglio, woodcut, and photography. To date has published projects by Shrigley and Peter Land, as well as artists' books by Shrigley, Joachim Koester, and others. Collaborating printers include Niels Borch Jensen and Schaefer Grafiske Vaerksted, both in Copenhagen. See www.nicolaiwallner.com. *SS*

John Weber Gallery, New York
Opened at 420 West Broadway in SoHo in 1971, eventually moving to Greene Street there and then to Chelsea in 1996. Closed in 2001. Before opening his own gallery, Weber was director of Martha Jackson Gallery, New York, and Dwan Gallery, Los Angeles and New York, in the 1960s. Brought many of their artists to his stable, focusing on earthworks by Walter De Maria and Robert Smithson, among others, as well as Conceptual and Minimalist works by Carl Andre, Daniel Buren, Dan Flavin, Hamish Fulton, Hans Haacke, Sol LeWitt, and Robert Ryman. Began exhibiting the works of *Arte Povera* artists, including Giovanni Anselmo, Mario Merz, and Lucio Pozzi, through a relationship with Sperone Gallery, Turin. Occasionally handled artists' books, multiples, and prints by many of these various artists. Regularly sold editions published by Parasol Press, New York, particularly prints by Sol LeWitt. *JH*

Coppet, Laura de, and Alan Jones. *The Art Dealers: The Powers Behind the Scenes Tell How the Art World Really Works.* New York: Cooper Square Press, 2002.

Weproductions, Yarrow, Scotland
Established in London in 1971 by Telfer Stokes as an imprint to publish his own artists' books. Joined by artist Helen Douglas in 1974. Moved to Yarrow, Scotland, in 1976. To date, has published approximately thirty artists' books by Stokes and Douglas, both individually and in collaboration with each other. A few titles have also been collaborations with other artists, such as Zoë Irvine, and other publishers, including The Museum of Modern Art, New York, and Pocketbooks, Edinburgh, among others. After installing an offset printing press (Flat Iron Press) in

1979, printed most of their books themselves in the 1980s and early 1990s. Since the late 1990s, with advances in computer printing technology, have usually employed commercial printers. Most books have been published in large editions, usually in paperback format. Still publishes actively. *SF*

Courtney, Cathy. "Telfer Stokes" and "Helen Douglas" in *Speaking of Book Art: Interviews with British and American Book Artists*. Los Altos Hills, California: Anderson Lovelace, 1999.

Phillpot, Clive. "Weproductions." In *0.6 Weproductions*. Exhibition brochure. Dundee, Scotland: Visual Research Centre, Dundee Contemporary Arts, 2000.

Modern Kunst Dietmar Werle, Cologne

Gallery opened in 1982 by Dietmar Werle. Had opened first Cologne gallery in the early 1970s, focusing on contemporary German artists, including Joseph Beuys, Sigmar Polke, and Wolf Vostell. Began publishing prints in 1972, with first project by Jürgen Klauke. Partnered with Galerie Möllenhoff, Cologne, in 1976 for a year. From the late 1970s to early 1980s worked as freelance artist's manager and curator on various exhibition projects, including film and video works. Modern Kunst Dietmar Werle exhibited this same group of German artists as well as Robert Stanley, *Arte Povera* figures, and others. Reinvigorated and expanded publishing program with mainly portfolios and artists' books by Beuys, Klauke, Michael Buthe, and Hamish Fulton. Closed gallery in 1997. Moved to Bellinoza, Switzerland, in 1999 and currently freelances as curator and dealer, focusing extensively on the work of Buthe. *JH*

Galerie Michael Werner, Cologne/ Michael Werner Gallery, New York

Michael Werner opened his first gallery in 1963, Werner & Katz, in Berlin, with Georg Baselitz's first solo exhibition. In 1969 opened Galerie Michael Werner, Cologne, showcasing works by emerging European artists, predominantly German. New York gallery opened in 1990. Over the years has exhibited Georg Baselitz, Joseph Beuys, Marcel Broodthaers, James Lee Byars, Jörg Immendorff, Per Kirkeby, Jannis Kounellis, Markus Lüpertz, and A. R. Penck, among others, publishing catalogues on most. Has also exhibited modern masters, among them Ernst Ludwig Kirchner and Francis Picabia. In addition to showing painting

and sculpture by these artists, also represents works on paper. Has published more than a dozen editions by Baselitz, Broodthaers, Kirkeby, Lüpertz, and Penck, among others, including portfolios and books. Also published the journal *Krater und Wolke*, with contributions by many of these artists, from 1982 to 1990. Continues to publish. See www.michaelwerner.net. *JH*

Whitechapel Art Gallery, London

Founded in 1901 as one of the first publicly funded spaces for temporary exhibitions in London. With a focus on contemporary art, has shown an international roster of artists, from Pablo Picasso and Jackson Pollock to Nan Goldin and Tobias Rehberger. Also showcases work by British artists, including Gilbert & George, Lucian Freud, Peter Doig, and Mark Wallinger. Has published editions on an ad hoc basis in conjunction with exhibiting artists, beginning with David Hockney in 1970 and more recently with Gary Hume in 1999. Began more formal publishing program, again featuring exhibiting artists, in 2001, with a series of etchings by Raymond Pettibon, with the aim of making work by contemporary artists affordable to a broad public. Also commissions one nonexhibiting artist annually to create an edition, known as the "Whitechapel Gift," to benefit their education program. Has produced more than thirty editions in all—prints, photographs, and multiples—contracting with a variety of printers and fabricators in London. Continues to publish actively. See www.whitechapel.org. *JH*

Wide White Space Gallery, Antwerp

Unconventional gallery space founded by Anny DeDecker and Bernd Lohaus in 1966. Opened in first floor of vacant house initially to provide a space in which to host performance art by local artists and friends. Unusual in its often noncommercial activities, with exhibitions having little or no work for sale. Sometimes show would consist only of artist-designed invitation or announcement, as with Daniel Buren's printed posters pasted along the exterior and interior gallery walls. Among its early activities was a makeshift gallery space in a hotel near *documenta 4* in 1968; also participated in the first Prospect exhibition, for which avant-garde galleries gathered in Düsseldorf, that same year. Early exhibition program focused on important avant-garde Belgian and European artists, including Joseph Beuys, Marcel Broodthaers, and Panamarenko. Later expanded program to include Christo, Richard Long, A. R. Penck, Gerhard

Richter, and others. Changed location in 1968, then opened second gallery space in Brussels in 1973. Gallery closed in 1977. *SS*

DeDecker, Anny, and Bernd Lohaus. *Wide White Space, 1966–1976: Hinter dem Museum/Behind the Museum*. Düsseldorf: Richter, 1995.

Wild Hawthorn Press, Little Sparta, Scotland

Founded in 1961 in Edinburgh by British artist and poet Ian Hamilton Finlay and Jessie McGuffie. Initially published works by a number of contemporary artists but gradually focused solely on Finlay's work, which began with Concrete poetry and remained language-based. In 1966 relocated to Stonypath, Scotland, the site of Finlay's elaborate poet's garden, now known as Little Sparta. Published nearly 800 books, booklets, pamphlets, cards, and prints, combining simple imagery and brief texts, as well as twenty-five issues of the literary journal *Poor.Old.Tired.Horse* (1961–68). See www.ianhamiltonfinlay.com. *SS*

Murray, Graeme, and Catherine Mooney, eds. *Ian Hamilton Finlay and The Wild Hawthorn Press: A Catalogue Raisonné*. Edinburgh: Graeme Murray, 1990.

World House Editions, South Orange, New Jersey

Founded by Donald Taglialatella in 1998, along with exhibition space World House Gallery. Prior to establishing World House, Taglialatella had published books, multiples, videos, and prints by Arman, Jenny Holzer, Graciela Sacco, and others. Collaborating printers included Axelle Fine Arts Editions, Brooklyn, and Karl Hecksher, New Paltz, New York. Through 2002, mounted roving exhibitions several times a year in gallery spaces in New York City. Ceased exhibitions program in 2002, but continues to publish actively. In 2003 began collaboration with Edition Copenhagen, in which several artists are invited each year to spend a week at the atelier to experiment with stone lithography and make an edition. To date the collaboration has produced approximately twenty projects by a diverse group of international artists, including John Armleder, Ryan McGinness, Ugo Rondinone, and Not Vital. See www.worldhousegallery.com. *SS*

///

Edition X, Munich
Founded in 1967 by Fred Jahn with financial backing of
university student Gernot von Pape. So named, says Jahn,
because he had to publish anonymously at the time, while
working for a gallery that did not encourage independent
pursuits. Projects often undertaken in collaboration with
galleries, including Galerie Heiner Friedrich, Munich,
and Michael Werner, Cologne, both of which represented
artists Edition X wished to publish, Blinky Palermo and
A. R. Penck among them. In 1969 Jahn began freelance
publishing for Galerie Heiner Friedrich, becoming
Friedrich's partner in 1971, at which time Edition X's
publishing activities ceased. After retiring in the 1980s,
von Pape returned to publishing, producing several
editions with German artists. *SS*

///

Zeit Magazin, Hamburg
Magazine supplement published from the 1970s until
1999 along with the Hamburg-based weekly newspaper
Die Zeit (translated as "Time"). First published in 1946,
Der Zeit, remains Germany's most widely read weekly
national newspaper, devoted to politics, business,
trade, and culture. The supplement, *Zeit Magazin*, which
was published in color, consisted of in-depth news and
features. *JH*

chronology

1979
— Joseph Beuys runs for European
Parliament as Green Party candidate.
— Artpool archive of experimental printed
art established by György Galántai and
Júlia Klaniczay in Budapest.
— Fred Jahn founds gallery and print
publishing firm in Munich (Jahn had
previously published as Edition X
beginning in 1967; and also in association
with Edition der Galerie Heiner Friedrich
beginning in 1969).

1980s

//
1980
Poland's Solidarity union
(The Independent Self-Governing Trade
Union Solidarity) is formed.
Premier and president of Communist
Yugoslavia, Tito (Josip Broz Tito),
dies in Ljubljana.

— A. R. Penck emigrates from East to
West Germany.

//
1981
Greece joins EEC.
Martial law is instituted in Poland;
Solidarity is banned.

— Archiv Sohm, an archive of artists'
publications and ephemera of the
1960s and 1970s, established in the
Staatsgalerie Stuttgart (FIG. 20).

//
1982
— Richard Hamilton begins etching series
based on James Joyce's *Ulysses* (P. 229).
— Musée du Dessin et de l'Estampe
Originale established in Gravelines,
France.
— Flowers Graphics, print publisher,
established in London.
— Sabine Knust•Maximilian Verlag, print
publisher, founded in Munich; Knust
previously partner in Edition der Galerie
Heiner Friedrich.
— Marco Noire Editore, print publisher,
founded in Turin.
— Journal *Krater und Wolke* begins
publication in Cologne; ends in 1990
(P. 157).

//
1983
— Artist's group IRWIN forms in Ljubljana,
Yugoslavia (now Slovenia); still active.

//
1984
— Book Works, artist's book publisher,
established in London.
— Journal *Parkett* begins publication in
Zurich; still active.
— Journal *Print Quarterly* established in
London; still active.

//
1985
Mikhail Gorbachev assumes power
in Soviet Union; followed by period of
perestroika and glasnost.

— Galerie and Edition Artelier, prints and
multiples publisher and workshop,
founded in Graz, Austria.

//
1986
Spain and Portugal join EEC.

— Joseph Beuys dies in Düsseldorf.
— Edition Krinzinger, print publisher,
established in Vienna, along with gallery;
previous gallery founded in Innsbruck
in 1971.
— The Paragon Press, print publisher,
founded in Edinburgh; moves to London
same year.
— MGLC, International Centre of Graphic
Arts, established in Ljubljana, Yugoslavia
(now Slovenia).

//
1987
— Robert Filliou dies in France.
— Mangelos dies in Zagreb, Yugoslavia
(now Croatia).
— Centre des Livres d'Artistes founded in
Saint-Yrieix-la-Perche, France.
— Imschoot, Uitgevers, artist's book
publisher, founded in Ghent, Belgium,
within the commercial printing firm
Imschoot.
— Item Éditions, publisher and print
workshop, founded in Lyon, France;
relocates to Paris in 1988.

//
1988
— Damien Hirst organizes exhibition
Freeze with work of fellow students from
Goldsmiths College, London; launches
Young British Artists movement.
— Centre de la Gravure et de l'Image
Imprimée opens in La Louvière,
Belgium.

//
1989
Berlin Wall comes down.
Communist power ends in
Czechoslovakia; playwright Václav Havel
becomes president.
Multiparty political system begins
in Hungary, ending Communist
domination.
Solidarity party is legalized and triumphs
in first free elections in Poland.
Deposed Romanian President Nicolae
Ceausescu and his wife executed.

— Städtisches Kunstmuseum Spendhaus,
devoted primarily to woodcut,
established in Reutlingen, Germany.

1990s

//////////////////////////////////

1990
East and West Germany reunified.

— Jake and Dinos Chapman receive degrees from the Royal College of Art, London; begin collaborating soon after.
— Leonid Tishkov establishes Dablus Press in Moscow.
— Museum in Progress, association for alternative exhibitions in printed formats, founded in Vienna (PP. 212–13).
— Journal *Printmaking Today* established in London; still active.

//////////////////////////////////

1991
Warsaw Pact, established in 1955, officially ends.
Gorbachev resigns as leader of the Soviet Communist Party; Soviet Union comes to an end.
Yugoslav federation begins to dissolve; Croatia and Slovenia gain independence.

//////////////////////////////////

1992
Siege of Sarajevo begins; war in Bosnia and Herzegovina ends in late 1995.

— Helga Maria Klosterfelde Edition, print and multiple publisher, founded in Hamburg; from 1990–92 published as Gesellschaft Kunst Edition.

//////////////////////////////////

1993
Czechoslovakia divides into Czech Republic and Slovak Republic.

— Rachel Whiteread casts *House* in east London; destroyed in 1994.
— Book Art Museum founded in Lodz, Poland (FIG. 18).
— *Migrateurs* exhibition and publication series begins at the ARC Musée d'Art Moderne de la Ville de Paris; ends 2004 (P. 105).

//////////////////////////////////

1994
Channel Tunnel opens; enables travel between England and France in about 35 minutes by train.

//////////////////////////////////

1995
Austria, Finland, and Sweden join the European Union (EU), formerly known as EEC.

— Adam Dant begins publishing *Donald Parsnips Daily Journal* in London; stops production in 1999 (P. 253).
— Antoni Muntadas begins ongoing series *On Translation* (P. 215).
— Alan Cristea Gallery and print publisher opens in London, when Cristea acquires and renames Waddington Graphics, which he had directed since 1972.

//////////////////////////////////

1996
Conflict erupts in Kosovo; NATO begins air strikes against Serbian military targets and Slobodan Miloševic is indicted for war crimes in 1999.

— Journal *Grapheion* founded in Prague; begins quarterly publication the following year; ceases regular publication in 2000, continuing on a sporadic basis.

//////////////////////////////////

1997
— KP Brehmer dies in Hamburg.
— Martin Kippenberger dies in Vienna.
— Centre National de l'Estampe et de l'Art Imprimé (CNEAI) founded in Chatou, France (FIG. 19).
— agnès b. begins publishing broadsheet *Point d'ironie* in Paris (P. 103).

//////////////////////////////////

1998
— Dieter Roth dies in Basel.
— Wolf Vostell dies in Berlin.
— Joan Brossa dies in Barcelona.
— Gerhard Fietz dies in Arnsberg, Germany.
— The Multiple Store, publisher, opens in London.

//////////////////////////////////

1999
— Archive for Small Press & Communication (ASPC) is acquired by the Neues Museum Weserburg Bremen, Germany and forms core of their Research Centre for Artists' Publications.

2000s

//////////////////////////////////

2001
Al-Qaeda crashes two airplanes into the World Trade Center in New York City, another into the Pentagon in Washington, D.C., and another in southern Pennsylvania.

//////////////////////////////////

2002
Euro becomes common currency for EU member countries.

//////////////////////////////////

2003
U.S. and British forces lead an international coalition that invades Iraq.

//////////////////////////////////

2004
Cyprus, the Czech Republic, Estonia, Hungary, Latvia, Lithuania, Malta, Poland, Slovakia, and Slovenia join the EU.
Terrorist bombings at rail stations in Madrid.

— Wolfgang Mattheuer dies in Leipzig.

//////////////////////////////////

2005
Terrorist bombings occur on Underground trains and bus in London.

— Patrick Caulfield dies in London.
— Eduardo Paolozzi dies in London.

//////////////////////////////////

2006
— Ian Hamilton Finlay dies in Edinburgh.

bibliography

Compiled by Deborah Wye and Wendy Weitman with the assistance of Anjuli Lebowitz

Included in this selected bibliography are general references for art and specific references on prints, books, multiples, and ephemera for the period considered in this volume. Journal articles referring to these topics, and catalogues for recurring regional and international exhibitions, are not included. Monographs on artists and publishers appear in Notes on the Artists (PP. 263–87) and Notes on the Publishers (PP. 288–306).

//

General

Armstrong, Elizabeth, and Joan Rothfuss. *In the Spirit of Fluxus*. Minneapolis: Walker Art Center, 1993.

Babias, Marius. *Das neue Europa: Kultur des Vermischens und Politik der Repräsentation/The New Europe: Culture of Mixing and Politics of Representation*. Vienna: Generali Foundation; Cologne: Walther König, 2005.

Blistène, Bernard, et al. *Poésure et Peintrie: D'un Art, l'autre*. Marseille: Musées de Marseille; Paris: Réunion des Musées Nationaux, 1993.

Bonito Oliva, Achille. *Europe/America: The Different Avant-Gardes*. Milan: Deco, 1976.

Brand, Jan, Nicolette Gast, and Robert-Jan Muller, eds. *De woorden en de beelden: tekst en beeld in de kunst van de twintigste eeuw/The Words and the Images: Text and Image in the Art of the Twentieth Century*. Utrecht, The Netherlands: Centraal Museum, 1991.

Buchloh, Benjamin H. D. *Formalism and Historicity: Essays on American and European Art Since 1945*. Cambridge, Mass.: The MIT Press, 1999.

———. *Neo-Avantgarde and Culture Industry: Essays on European and American Art from 1955 to 1975*. Cambridge, Mass.: The MIT Press, 2000.

Bussmann, Georg. *Kunst und Politik*. Karlsruhe, Germany: C. F. Müller, 1970.

Camnitzer, Luis, Jane Farver, Rachel Weiss, et al. *Global Conceptualism: Points of Origin, 1950s–1980s*. New York: Queens Museum of Art, 1999.

Celant, Germano. *The European Iceberg: Creativity in Germany and Italy Today*. Toronto: Art Gallery of Ontario; Milan: Mazzota, 1985.

Collings, Matthew. *Blimey! From Bohemia to Britpop: The London Artworld from Francis Bacon to Damien Hirst*. Cambridge, England: 21 Publishing, 1997.

Contensou, Bernadette, et al. *1960: Les Nouveaux Réalistes*. Paris: Paris-Musées and La Société des Amis du Musée d'Art Moderne de la Ville de Paris, 1986.

Cowart, Jack, ed. *Expressions: New Art from Germany, Georg Baselitz, Jörg Immendorff, Anselm Kiefer, Markus Lüpertz, A. R. Penck*. Munich: Prestel in association with the Saint Louis Art Museum, 1983.

Crow, Thomas E. *The Rise of the Sixties: American and European Art in the Era of Dissent*. New York: Harry N. Abrams, 1996.

Djurić, Dubravka, and Miško Šuvaković, eds. *Impossible Histories: Historical Avant-Gardes, Neo-Avant-Gardes, and Post-Avant-Gardes in Yugoslavia, 1918–1991*. Cambridge, Mass.: The MIT Press, 2003.

Fluxus Virus, 1962–1992. Cologne: Galerie Schüppenhauer, 1992.

Fogle, Douglas. *The Last Picture Show: Artists Using Photography, 1960–1982*. Minneapolis: Walker Art Center, 2003.

Garrels, Gary. *Photography in Contemporary German Art: 1960 to the Present*. Minneapolis: Walker Art Center, 1992.

Gintz, Claude, et al. *L'Art conceptuel: Une perspective*. Paris: Musée d'Art Moderne de la Ville de Paris, 1989.

Glasmeier, Michael. *Buchstäblich wörtlich, wörtlich buchstäblich: Eine Sammlung konkreter und visueller Poesie der sechziger Jahre in der Nationalgalerie Berlin*. Berlin: Staatliche Museen, Preussischer Kulturbesitz, 1987.

———. *50 Jahre documenta 1955–2005, Band 1: Diskrete Energien/50 Years documenta 1955–2005, Vol. 1: Discrete Energies*. Göttingen, Germany: Steidl, 2005.

Gohr, Siegfried, and Rafael Jablonka, eds. *Europa/ Amerika: Die Geschichte einer künstlerischen Faszination seit 1940*. Cologne: Museum Ludwig, 1986.

Goldstein, Ann, and Anne Rorimer. *Reconsidering the Object of Art: 1965–1975*. Los Angeles: Museum of Contemporary Art, 1995.

Gould, Claudia, and Sarah Rogers-Lafferty. *Breakthroughs: Avant-Garde Artists in Europe and America, 1950–1990*. New York: Rizzoli in association with the Wexner Center for Arts, The Ohio State University, 1991.

Hegyi, Lóránd, et al. *Aspects/Positions: 50 Years of Art in Central Europe 1949–1999*. Vienna: Museum Moderner Kunst Stiftung Ludwig Wien, 1999.

Hendricks, Jon. *Fluxus Codex*. Detroit: The Gilbert and Lila Silverman Fluxus Collection in association with Harry N. Abrams, New York, 1988.

Hendricks, Jon, ed. *O que é Fluxus? O que não é! O porque/What's Fluxus? What's not! Why*. Brasília and Rio de Janeiro: Centro Cultural Banco do Brasil; Detroit: The Gilbert and Lila Silverman Fluxus Collection Foundation, 2002.

Hoptman, Laura J., and Tomáš Pospiszyl, eds. *Primary Documents: A Sourcebook for Eastern and Central European Art Since the 1950s*. New York: The Museum of Modern Art, 2002.

indices

artists

These indices refer to the artists whose works are illustrated in this volume, and to the publishers, printers, and fabricators who collaborated with them. Numbers correspond to page numbers, and numbers in bold reference illustrations.

publishers, printers, and fabricators

Lenders to the Exhibition

Mrs. Zdravka Bašičević, Zagreb

Staatliche Museen zu Berlin, Kupferstichkabinett

Franck Bordas, Paris

Neues Museum Weserburg Bremen,
 Research Centre for Artists' Publications/ASPC

Kunstsammlungen Chemnitz

Tacita Dean

Flowers Graphics, London

Peter Freeman, Inc., New York

Johanna and Leslie J. Garfield, New York

Griffelkunst, Hamburg

Hamburger Kunsthalle

Niels Borch Jensen Gallery and Edition, Berlin and Copenhagen

Krefelder Kunstmuseen, Kaiser Wilhelm Museum

Lisson Gallery, London

Matthew Marks Gallery, New York

MGLC, International Centre of Graphic Arts, Ljubljana, Slovenia

Archives Otto Muehl, Paris

Museum of Modern Art, Ljubljana, Slovenia

The New York Public Library

Private Collection, London

Private Collection, New York

Dieter Roth Foundation, Hamburg

Sackner Archive of Concrete and Visual Poetry

Fine Arts Museums of San Francisco

John Sayegh-Belchatowski, Paris

The Gilbert and Lila Silverman Fluxus Collection, Detroit

Galerie Der Spiegel, Cologne

Staatsgalerie Stuttgart, Archiv Sohm

Tate

The UBS Collection

Universidad de Cantabria, Santander, Spain

Philippe Vermès, Paris

Walker Art Center, Minneapolis

Published on the occasion of the exhibition *Eye on Europe: Prints, Books & Multiples / 1960 to Now*, October 15, 2006 – January 1, 2007, at The Museum of Modern Art, New York, organized by Deborah Wye, The Abby Aldrich Rockefeller Chief Curator, and Wendy Weitman, Curator, Department of Prints and Illustrated Books.

The exhibition is supported by the Sue & Edgar Wachenheim Foundation and by Anna Marie and Robert F. Shapiro.

Additional funding is provided by BNP Paribas, by Pro Helvetia, Swiss Arts Council, by the Cultural Services of the French Embassy, by The Danish Arts Agency, by the Austrian Cultural Forum New York, and by The Consulate General of The Netherlands in New York.

This publication is supported by The International Council of The Museum of Modern Art.

The accompanying educational brochure is made possible by The Contemporary Arts Council of The Museum of Modern Art and by The Cowles Charitable Trust.

Produced by the Department of Publications
 The Museum of Modern Art, New York
Edited by Libby Hruska
Designed by Pure+Applied
 (Paul Carlos and Urshula Barbour)
Production by Elisa Frohlich
Typeset in FF Bau and Fedra Serif
Printed on 170 gsm Luxosamt Offset and
 140 gsm Merida Cream Freelife (insert)
Printed and bound by Dr. Cantz'sche Druckerei,
 Ostfildern, Germany

Library of Congress Control Number:
2006932751
ISBN: 978-0-87070-371-3

Published by The Museum of Modern Art
11 West 53 Street, New York, NY 10019-5497
www.moma.org

Distributed in the United States and Canada by D.A.P./Distributed Art Publishers, Inc., New York

Distributed outside the United States and Canada by Thames & Hudson, Ltd, London

COVER: Langlands & Bell, *Air Routes of the World (Day & Night)* (detail). 2001. Two screenprints, SHEET (EACH): 33 1/16 x 56 9/16" (83.9 x 143.7 cm). The Museum of Modern Art, New York. Miranda Kaiser Fund, 2005. See P. 244

ENDPAPERS: Peter Kogler. *Untitled*. 1992. Courtesy the artist. See PP. 182–83

PAGE 2: John Armleder. *Supernova* (detail). 2003. One from a portfolio of nineteen lithographs and one monoprint, SHEET: 22 x 30" (55.9 x 76.2 cm). The Museum of Modern Art, New York. General Print Fund, 2003. See P. 191

PAGE 4: Olafur Eliasson. *The Colour Spectrum Series* (detail). 2005. Series of forty-eight photogravures, SHEET (EACH): 13 9/16 x 17 15/16" (34.5 x 45.5 cm). The Museum of Modern Art, New York. Riva Castleman Endowment Fund, 2006. See PP. 188–89

PAGE 6: Martin Kippenberger. *VIT 89* (detail). 1990. Screenprint from a portfolio of twenty-three screenprinted, one Xeroxed, and four offset posters, SHEET: 46 15/16 x 33 1/4" (119.2 x 84.4 cm). The Museum of Modern Art, New York. The Associates Fund, 2001. See P. 195

Printed in Germany

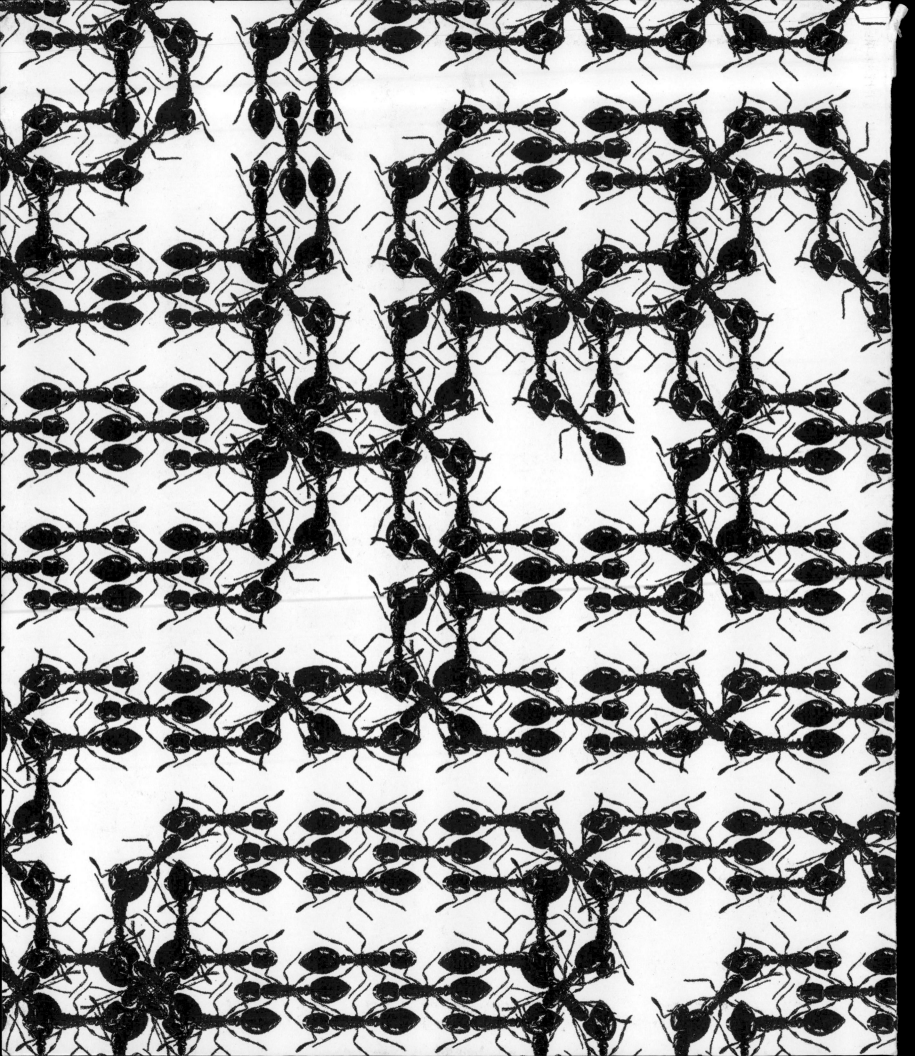